TALES OF ESPIONAGE

TALES OF ESPIONAGE

Edited by
Eleanor Sullivan & Chris Dorbandt

CASTLE

Printed in the United States of America.
ISBN 1-55521-527-0

Grateful acknowledgment is made to the following for permission to
reprint their copyrighted material:
Stories by Robert Eckels: *Double Jeopardy, Milk Run, Game with One
Rule, To Catch A Spy, The Munich Courier, The K'ang Shen Memoran-
dum, Attention to Detail, The Kapalov Proposal* copyright ©1969, 1970,
1971, 1972, 1974, 1976, 1983 by Davis Publications, Inc., reprinted by
permission of the author.
Stories by Brian Garfield: *Checkpoint Charlie, Charlie's Vigorish, Chal-
lenge for Charlie, Charlie in Moscow, Charlie in the Tundra, Charlie's
Dodge, Passport for Charlie, Charlie's Chase* copyright ©1978, 1979 by
Davis Publications, Inc., reprinted by permission of the author.
Stories by Edward Hoch: *The Case of the Third Apostle, The Case of the
Modern Medusa, The Case of The Musical Bullet, The Case of the Terror-
ists, The Case of the Flying Graveyard, The Case of the Devil's Triangle,
The Case of the Five Coffins* copyright ©1971, 1973, 1974, 1975, 1977,
1978 by Davis Publications, Inc., reprinted by permission of the author.
*The Spy Who Traveled with a Coffin, The Spy in the Pyramid, The Spy at
the End of the Rainbow, The Spy in the Toy Business, The Spy and the
Cats of Rome, The Spy in the Labyrinth, The Spy and the Snowman, The
Spy Who Didn't Defect* copyright © 1970, 1972, 1974, 1977, 1978, 1980,
1981 by Davis Publications, Inc., reprinted by permission of the author.

CONTENTS

INTRODUCTION

Over the years, *Ellery Queen's Mystery Magazine* has introduced many memorable characters including detectives, criminals, cops, and of course, spies. In this volume we're pleased to present a quartet of spies who have been perennial favorites in the magazine over the years: Robert Eckels' anonymous men of the CIA, Brian Garfield's Charlie Dark, and Ed Hoch's Jeffrey Rand and Sebastian Blue.

The "real world" of international espionage is a damned cold place, complex and often violent, where ethical issues and respect for human dignity are treated flippantly. But you'll warm up to the spy's world as it is painted in the stories in this collection.

Messieurs Eckels, Hoch and Garfield illustrate any number of facets of the life of the spy through their stories. You'll meet some characters that you won't soon forget and find yourself laughing when you might not ordinarily expect to.

Robert Edward Eckels' anonymous men of the CIA may in fact be the same character. The author paints the CIA agent as the ultimate chameleon, constantly changing its colors to suit its habitat.

Brian Garfield's Charlie Dark is an aging, obese CIA agent who by present CIA standards would be kicked out for his appearance. While his supervisor may be trying to put Charlie out to pasture by giving him all the really tough assignments, one can only wonder whether the Agency wants him out because he manages to get his job done without sacrificing lives.

Ed Hoch's Jeffrey Rand is a crytographer for Britain's Department of Concealed Communications. Laced with humour Hoch's Rand stories make one point clear: no matter who you are or what you do, there's someone who will want to know about it.

In contrast, Hoch's Interpol stories are set in a more idealistic world, where nations work together to solve the most bizarre of international crimes, employing the services of former Scotland Yard agent, Sebastian Blue and the beautiful Laura Charme.

Enjoy, and remember ... someone wants to know why you're reading this book!

Chris Dorbandt

TO CATCH A SPY

by Robert Edward Eckels

There were signs in three languages over the ramps that fed into the airport from the passenger disembarking area; the signs directed nationals to the right, incoming foreigners to the left. There were no porters about, so I shifted my suitcase from one hand to the other and followed the crowd to the left into customs.

For a country that was beginning to build a reputation as a tourist attraction, they certainly didn't go all out to make a visitor feel welcome. The customs room was stark and bare except for a long wooden table and a huge picture of Lenin staring suspiciously down from the wall. Or maybe he just seemed that way to me. Maybe to a dedicated Communist he looked sternly paternal.

But in any case I was an old hand at being stared at suspiciously. So I met his eyes blandly and handed my passport to the uniformed customs official without a visible qualm.

Not that I needed to worry about the passport. The same people who made them for the State Department did the C.I.A.'s. And the stamps and seals were as good as you'd find anywhere. The name inside wasn't the one I'd been born with, of course, but by now I'd got used to changing my name. You get used to a lot of things when you work for the C.I.A.

The official frowned professionally and began to leaf through the green and gold booklet. He was a tall man with close-cropped hair, no sideburns at all, and a smooth arrogant face. "Is this your first visit to our country?" he said without looking up.

"No," I said. It always pays to be truthful in small things, because it's the small things that can trip you up and expose the big lie. "I was here once before. Shortly after the war."

"I see," the official said. He turned another page. "And what is the purpose of your visit? Business or pleasure?"

I smiled. "A little of both," I said. "Business and pleasure." Truthfully again, too, because that was just the way Giddings had put it to me.

"How'd you like a little trip east?" he had said. "You've earned a rest after that affair with Heussinger and young Herold.

And this would give you a chance to mix a little business with pleasure." We were in his office overlooking the Ku'damm; I was in my usual chair opposite his desk and he was lounging behind it and toying with his ever-present pencil.

I looked at him skeptically. My experience was that these trips generally turned out to be more business than pleasure.

Giddings caught my gaze and waved the pencil protestingly. "No," he said, "I'm serious. Southeastern Europe's becoming quite a tourist attraction these days, what with the mountains and the beaches. And all things considered nobody would object to your spending a couple of days or weeks there after the job's done. What's more, if you aren't too blatant about it, you might even get a good part of it covered on your expense voucher too."

"Sure," I said. "And what's the job?"

Giddings pursed his lips and looked up at the ceiling. "One of our people got himself killed over there last week," he said. "We'd like you to go in and find out why."

"I don't have to go in," I said drily. "I can tell you why without leaving this room. He found out something the Commies didn't want him talking about."

It had to be that, of course, and Giddings knew it as well as I. If the dead man's cover had merely been blown, they'd have set up a show trial or arranged a trade for one of their people we held. That's the way things work these days. Killing agents just because they're agents went out with Mata Hari. Killing them to keep them from talking will, of course, never go out of style.

"What you really want," I said, "is for me to find out what he knew that was worth killing him for."

Giddings made a little dismissive motion with his pencil. "If you want to put it that way," he said, "yes."

"I want to put it that way," I said, "particularly since they just might kill me too."

"Only if they caught you," Giddings said easily. "Which if you're reasonably careful they won't do." He straightened in his chair. "Of course," he went on, meeting my eyes just as earnestly as if he really meant what he was saying, "if you *really* don't want this assignment—"

But of course he knew I'd go. Because I knew somebody had to. . . .

Now the customs official was asking me what my business

was. He listened patiently while I recited the cover story that Giddings had arranged; then he closed my passport with a snap and nodded to his assistant. Together they went through my luggage with a thoroughness that would have put a horde of ravaging locusts to shame. I'll say this for them, though; when they were done they put everything back in with roughly the same degree of neatness.

The official handed my passport back. "Have a pleasant visit," he said with no particular show of caring one way or the other.

I smiled at him anyway, said I was sure I would, and went out to catch a taxi to the hotel that the local version of Intourist had arranged for me. I stopped there just long enough to register and drop off my bag. Then I went back out and hailed another cab.

The driver's eyes began a nervous little flick when I gave American Embassy as my destination, but that was all. He didn't try to make any conversation on the way over, though, and I noted with wry amusement that he didn't waste any time scooting off after depositing me a couple of yards from an open iron-grilled gate, with the eagle in a circle seal of the United States set square in the middle of it. I watched the cabbie until he swung around a corner out of sight, then I turned and went through the gate and up the graveled drive.

There was a pleasant-faced girl seated at a desk just inside the door. I gave her the name on my passport and five minutes later was in an upstairs office seated across from a man whose eyes were every bit as unfriendly as Lenin's, even though theoretically at least he and I were on the same side. His surname was Arnold and he was the Deputy Chief of Mission—Number Two man under the Ambassador.

"So you're the one they've sent in to replace Johns," he said coldly.

"In a manner of speaking," I said, "yes. But what I'm really after is to find out why they killed him."

"The official verdict," Arnold said, "was that Johns died in an automobile accident."

"I know," I said. "I read the official verdict. I also read the autopsy report by the doctor who examined the body once it crossed over into West Germany. It says there were injuries to the back of the skull that couldn't have been caused by the accident."

"And all undoubtedly very true," Arnold said. "Nevertheless, it might still be best for all concerned to let the matter rest with the *official* verdict."

"Perhaps," I agreed. "But then it isn't my decision to make." I smiled at him cheerfully. "Or yours either, for that matter."

Arnold looked at me with undisguised distaste and pressed a buzzer on his desk. "I'm going to turn you over to our Mr. Murphy," he said. "Murphy served as Johns's liaison within the Embassy, and he will help you all he can. But," Arnold added with heavy emphasis, "instructions from on high or no, I will not stand for anything that will embarrass the Embassy or our efforts here. Do you understand that?"

"Perfectly," I said.

Murphy popped in so promptly after that that he must have been waiting in the wings for his cue. Almost as if in contrast to Arnold who was a lean crusty Yankee aristocrat, Murphy turned out to be a stocky man with smooth black hair, fashionable sideburns, and a plump friendly face.

"I've just been explaining to Mr."—Arnold looked down and read my name off the card the receptionist had sent up—"the limits on the assistance we can afford him."

"Sure," Murphy said. He shook my hand. "Why don't I take you down to my office," he said, "and fill you in there on what I know about Johns?"

"Fine with me." I said goodbye to Arnold, who nodded formally in return and went back to his work.

"Friendly type," I said to Murphy as we walked down the corridor to his office.

"Who? Arnold?" Murphy said. "Oh, he's not so bad. He just grew up under Sumner Welles, and he still believes gentlemen don't read each other's mail."

"And you?" I probed.

Murphy grinned. "Me?" he said. "I'm a security man. Everytime I see an envelope my fingers start to itch." He opened a door and waved me into his office. It was smaller than Arnold's and more cluttered.

Murphy took off his jacket and hung it carelessly over the peg of a standing coat rack. "All right." he said, sitting down at his desk and loosening his collar. "What can I tell you that you don't already know?"

I sat down opposite him. "You might start with what really happened to Johns," I said.

Murphy pulled a wry face and shrugged slightly. "You read the official report," he said. "That just about sums up all we know. We got a phone call from the local police—the regular police, not the secret—that there'd been an accident involving one of our citizens. When we got there, it turned out to be Johns." He shrugged again. "None of us who were in on who Johns really was believed it was an accident, of course. But there were no survivors or witnesses and a blank wall of Communist official silence that we couldn't have gotten around even if Arnold had been inclined to let us try."

I nodded understandingly. "What was Johns working on at the time?" I said.

Murphy grinned ruefully and shook his head. " I haven't the foggiest notion," he said. "I know Arnold told you I was Johns's liaison, but that's only a fancy way of saying I was his mailbox. Whenever Johns had anything to transmit, he'd drop it off with me to put in the diplomatic pouch. Arnold didn't like it, but he had his orders."

I nodded again. It wasn't an unusual arrangement. The Communists knew we did it, of course. Just as we knew their pouches leaving Western capitals contained the same kind of packages. But long tradition made the pouches inviolable, and since it suited the purposes of both sides, I supposed that they would remain so—at least, for the time being anyway.

"Still," I persisted, "you were Johns's only official contact and an old security man to boot. You must have been curious."

"Sure," Murphy said, still grinning. "But never to the point of trying to satisfy that curiosity. The messages were sealed when I got them. I just added my own seal as a double safeguard and left it at that. It kept Arnold off my back and to tell you the truth I think I was happier not knowing. The things you cloak-and-dagger boys get up to are enough to give anybody the willies."

"And Johns never said anything that would give you a clue?"

"Never a word," Murphy said. "Oh, we talked, of course, but mostly about going back to America and things like that." Murphy's grin grew lopsided. "He was due to leave in another three months, you know."

I sighed. "Yes, I know." I stood up. "Well, I thank you for your

time. And I'll be in touch."

Murphy nodded. "Where to now?" he said.

I winked at him. "You'll be happier not knowing," I said.

Actually, I'd done enough for one day, I felt. Particularly since I was supposed to be combining pleasure with business. So I went back to my hotel and slept the sleep of the just. There was a microphone concealed behind the headboard of my bed, but all it picked up were my snores.

I was followed as soon as I left the hotel the next morning.

I had decided to walk, partly because it was a nice day and partly because when I'd been here before, the cab drivers had been required to report the destinations of all foreign passengers to the secret police. And I wasn't sure they didn't still. It hadn't mattered about the Embassy, but I definitely didn't want to risk drawing attention to any of the other places I had to visit.

In any case, I hadn't gone two blocks when I spotted my tail. He was a nondescript little man as all good tails should be. The only thing that gave him away was that he was working too hard at keeping the distance between us constant. I wondered if he was alone or part of a team.

To find out I rounded the next corner and stopped almost immediately to look in a store window. Out of the corner of my eye I saw my little man saunter across the street and another man equally nondescript move up into his place. That meant there were at least three of them—two in line behind me and one across the street. The technique of changing places at corners was supposed to keep me from catching on. And it worked very well with amateurs, but to a pro—especially a suspicious one—the unvarying ritual was as obvious a sign as a light in a window.

The big question, though, was how to get rid of them.

The first thing, of course, was not to let them realize I had caught on. So I stopped checking on them. They weren't going to lose me and I had nothing to gain by trying to pick out the third man. So I just kept on walking, stopping at occasional windows and turning enought corners at random to keep them guessing about the direction I was actually headed In.

Finally I spotted what I wanted—a cab discharging a passenger. I hopped in before anybody could say boo.

"Airport," I said to the driver.

He had opened his mouth to protest. But at the thought of that juicy fare he shrugged and set his meter. And off we went .

As I'd hoped, my tails didn't have motor transport available. Not that it really mattered. After all, they had the cab's number and the cab had a radio, didn't it?

We'd gone about six blocks when that radio crackled and the driver held a short dialogue with it. It was in a dialect I wasn't familiar with, but then I didn't have to know it to be pretty sure he was passing on our destination to his dispatcher. I smiled to myself and settled back on the seat.

I waited another two blocks, then began patting my pockets and making pantomime signs of panic. "Cigarettes," I said. "I'm out of cigarettes." I leaned forward and pointed to get the driver's attention. "Hey, look," I said, "stop at that shop up ahead and let me run in and get some."

The driver gave me an exasperated look. "I can't stop in this traffic," he said.

Of course he couldn't. That was the whole point. "Well, don't stop then," I said. "Drive around the block and pick me up on the way back."

The driver's face turned suspicious. So I took the universal persuader—$10 U.S.—from my wallet and dropped it on the seat beside him.

"If you're worried about the fare," I said, "that'll more than cover it."

Reassured, he pulled over to the curb and let me out.

Of course, by the time he got back I was long gone. The only problem was that now my tails would realize that I'd gone to a lot of trouble to shake them. They'd wonder why and that wouldn't make things any easier if I had to deal with them in the future.

The girl in the florist's shop was small and dark and not really pretty—not in the conventional sense anyway. But she carried herself with such regal grace and self-possession that you were willing to overlook that. Her name was Anna Cappron and she had been one of John's network.

"May I help you?" she said.

"I'm here to buy some flowers for a friend," I said.

Her eyes flickered slightly and she moved to a display. "Roses

are for friends," she said, touching one lightly with her hand.

"White roses," I said, feeling slightly ridiculous as I always did when I went through these rituals, "not red."

Anna Cappron nodded. "In the back," she said, lowering her voice despite the fact that we were alone in the shop.

I went through a curtained doorway at the rear of the shop into a smaller room furnished half as an office, half as living quarters. There were a few feminine touches that tried bravely to dress it up, but all in all it was a pretty grim place to spend a life. I sat down in the only chair, facing the doorway.

A few moments later Anna Cappron came in, brushed aside the slight movement I made in the direction of rising, and perched on the edge of the office desk. She had extremely nice legs, I decided, wondering if she had sat there deliberately to call my attention to them.

"Do you have instructions for me?" she said.

"None at the moment," I said. "They just sent me in to find out why Johns was killed." I paused and looked up at her. "Any ideas?"

She shook her head silently. Her face was set and controlled, deliberately expressionless.

"What was he working on at the time he was killed?" I said.

Anna's face didn't change, but her eyes grew suspicious. "Your people got his reports," she said. "You should know."

I nodded. "I'm talking about the report he didn't get to make," I said.

She relaxed somewhat. "We hadn't made contact to pass information for almost two weeks before he was killed," she said. "The only report I had then concerned cabinet reactions to our premier's maneuverings to loosen the Russian grip on our country. Nothing startling and certainly not the sort of thing they'd kill for to keep secret."

"Something from one of his other agents then," I said, half to myself.

Anna shook her head vigorously. "Not possible," she said. "There were five agents in the network besides myself: Karl, Georg, Franz, Lilo, and Michael. None of them knew Johns. They all reported to me and I passed it on to him to protect his cover."

"I see," I said. I pulled my mouth to one side ruefully. "That

means it had to be something he found out himself and didn't tell anybody about. Which complicates things enormously." Understatement of the year. It made my job impossible.

Anna Cappron started to say something, then caught herself and held back.

"Go ahead," I said. "Say it."

She looked away. "Nothing," she said.

"Let me decide whether it's nothing or not," I said.

She threw back her head and set her chin defiantly. "I would have known if he'd had any information," she said. "He would have told me and we would have worked on it together."

I looked at her closely. She sounded very positive. I wondered what gave her that confidence. "Maybe," I said slowly, an idea forming in my mind. "But you hadn't seen him for two weeks before he died. He could have learned a lot in two weeks."

Anna's eyes dropped. "That's not quite true," she said. "I said we hadn't made contact to pass on information. And we hadn't, because I had nothing to pass on. But"—her voice faltered—"we did see each other. We saw each other regularly." She brushed at her eyes with one hand. "We were in love," she said simply. "He was going to take me out with him when he went back to America."

I sighed. It was what I'd suspected. "When was the last time you saw Johns, Anna?" I said.

"The night he was killed," she said. "They must have caught him shortly after he left me."

"And he said nothing that evening that would indicate he was on to something important?"

"No."

"How did he seem? Nervous? Excited?"

She shook her head. "No. Very relaxed and happy. In fact, if anything he was more relaxed and happy that evening than he had been for a long time."

"I see," I said, and stood up. "If you think of anything else that might help, get in touch with me the same way you made contact with Johns. I'll be around the next couple of weeks anyway. Perhaps longer." I smiled at her. "Okay?"

She nodded and tried to smile back, but somewhere along the way it broke down.

I put my hand on her shoulder. "I'm sorry," I said.

She shied away from my touch and pulled herself together. "I'll show you out," she said. Her face wore the same regal mask it had when I'd first entered the shop.

At the door she said, "I'll be getting reports from the agents. Do I pass them on to you?"

"Yes, for the time being," I said. "I'll let you know when a permanent replacement arrives."

She nodded and unlocked the door for me to leave.

After the flower shop the sun felt good on my face and hands, and I walked along enjoying it. The first warning I had that everything wasn't all right came from the sudden panic on the face of a pedestrian approaching me. I swung around, back to the building, but it was already too late. The car had swerved up on the sidewalk, door already swinging open to block me off and pin me between car and wall.

A balding man with a thin scholarly face and mild eyes behind rimless glasses leaned toward me from the driver's side. "Get in," he said. He was smiling, but the gun in his hand wasn't. I got in.

The door scraped against the wall as he started off. "Close that thing," he said with a show of irritation.

I leaned out, caught the door handle, and debated briefly whether I could risk diving out. But out of the corner of my eye I caught a glimpse of the mild-eyed man watching me. He seemed amused. I pulled the door shut.

"Very good," he said approvingly. "That's the decision I would expect a professional to make. And I must say you've behaved most professionally since coming to our country. I did expect you at the flower shop sooner, though," he added almost as an afterthought.

"What flower shop?" I said.

His eyes mocked me. "The one you just left," he said. "Where no doubt you bought some flowers for a friend. White roses, to be precise."

I looked at him with interest. "Who are you anyway?" I said.

He stopped laughing and concentrated on his driving. "I won't bore you with my real name," he said, "any more than I'll ask you yours. But Johns knew me as Georg." His eyes flicked back to me briefly. "I was one of his agents."

"Now that's interesting," I said. "Because the girl said she was the only one who knew Johns."

"That was the way it was supposed to work," Georg said. "But six months ago Johns was blown to the secret police. As soon as I found out, I made my own contact with him."

"I see," I said. "And just how did you find out, Georg?"

He was amused again. "Didn't the girl tell you?" he said. "Ah, but then all she knows is my cover in the Ministry of Finance." His smile broadened. "I'm a major in the secret police," he said. "I pick up a lot of useful information that way."

"And use it to play both ends against the middle."

Georg shrugged. "You can call it that if you like," he said. "Personally, I prefer to think that I'm merely hedging my bets. Something every careful gambler does."

"Sure," I said. I twisted on the seat so that I could watch Georg more closely. "If the secret police were on to Johns six months ago," I said, "why didn't they stop him then?"

"For the same reason they haven't stopped you," Georg said. "They knew who he was. Stop him and somebody new and unknown would take his place. But even more important, they knew what he was doing and what information he'd picked up." Georg paused, then added vehemently, "Somebody was leaking everything that went into Johns's reports."

I asked the obvious question. "Who?" I said.

Georg shook his head. "I don't know," he said. "Nobody below the very top level does and they aren't talking." He shot a quick glance at me and added hastily, "At least not to a lowly major." Which was a pretty good indication that he'd lied about his rank. But I'd expected that anyway. Nobody in Georg's position would throw out details that might give away his true identity. "That's why I made contact with Johns. It was risky, but not as risky as letting one of my superiors begin to realize that some of Johns's information had to come from within the organization. I hadn't had any luck in uncovering the leak, but I figured Johns just might from his end." He grimaced. "And it looks like he might have too—not that it did any of us any good," he added.

"No," I said. We rode in silence a while. Then I said, "Why did you take that risk, Georg? Why didn't you go through Anna Cappron the way you usually did?"

Sunlight glittered on Georg's glasses. "Because Anna Cappron was the only one I know who had access to *all* the information Johns received," he said. When I didn't respond, he added after a moment, "But then you don't believe that about her, do you?"

"No," I said. "But then I don't *not* believe it either."

I had Georg drop me off some six blocks from the American Embassy, because I was sure my tails would be watching for me there as well as at the hotel.

"Our people," he said with something like pride in his voice when I told him about them. "We were on to you as soon as you arrived in the country."

"Interesting," I said. "Now how do I get in touch with you if I want you?"

Georg shook his head. "You don't," he said. "I'll get in touch with you."

"All right," I said. "But make it something less drastic than hauling me off the street at the point of a gun."

Georg smiled briefly. "I regretted the necessity. But you understand that I had no time to waste on explanations and yet I had to be sure you'd get in. Next time"—he paused as if in thought—"a message to your hotel room. Misdirected, of course. For Miss White. Miss Rose White."

He was still laughing at his own joke when I got out of the car. I watched him drive off. Then I walked the rest of the way to the Embassy, thinking my own thoughts. And not particularly liking them.

Murphy was in his shirt sleeves behind his cluttered desk, just as I had left him the day before. "Well," he said, flipping the cover of a manila folder closed and shoving it to one side as I came in, "I didn't expect to see you again so soon.."

"I'm a fast worker," I said drily. "I have to be to keep ahead of my competition." I dropped into the same chair I'd used before. "I was followed when I left the hotel this morning."

Murphy raised his eyebrows and whistled soundlessly. "Now isn't that something," he said. He leaned back in his chair and regarded me thoughtfully. "You want us to help you get out of the country before they pick you up?"

"It may come to that," I said. "But right now I want to find out more about the diplomatic pouch."

"The pouch?" Murphy shrugged. "There's not much to tell," he said. "It's made up in the Administrative Section and sent out once a week by courier. Oftener if there's a need."

"I see," I said. "And everyone in the Embassy has access to it?"

"No," Murphy said, dragging the word out. "In fact, if anything, we're stricter than your usual garden-variety Embassy on that score. It's pretty much taken for granted here that all the local help—maintenance people and the like—are reporting to some intelligence organization or the other." He grinned suddenly. "Even Arnold goes along with that. No Communist could be a gentleman, of course." When I didn't smile back, he shrugged and pulled a face at me. "In any case," he went on, "besides the Ambassador, Arnold, and myself, the only person who has direct access to the pouch is the officer in Administration who makes it up. We're pretty liberal about what goes in, of course. But anybody who has anything to put in passes it through him."

"Including Johns's reports?" I said.

Murphy shook his head. "No," he said. "Those I put in myself just before the pouch was sealed. Before that they were kept in my safe." He swiveled around to kick at a squat iron box against the wall behind his desk. "And believe me, nobody gets into this baby unless I'm here to help them with the combination."

I believed him; I'd seen safes like that before. I'd even tried to break into some. "What would be the possibility of the pouch's being opened and resealed?"

"Without our knowing about it?" Murphy shook his head again. "My first, offhand inclination is to say it's impossible. Except that as a security officer I know that nothing is impossible when you really set your mind on it. Even so, I'd say the most anybody could do it would be once or twice. If it got to be a routine thing, they'd be sure to notice on the other end that the seals had been tampered with."

"Perhaps," I said.

"Yeah," Murphy said. He leaned forward and put his elbows on the desk. "Why all the questions about the pouch anyway? And don't tell me I'd be happier not knowing. You've been hitting pretty close to questions of Embassy security and that's my bag, not yours."

He had a point, of course, and I had no choice but to confide in

him if I wanted his continued cooperation. So I told him about Anna Cappron and Georg. Not everything, of course. Like Georg earlier, I identified them only by code names and blurred any details that might betray their true identities. When you've been at this game long enough, ingrained habit makes you cautious.

When I finished, Murphy whistled his silent whistle again. "Now isn't that something?" he said. "A traitor in Johns's network." He cupped his chin in his hand and rubbed his fingers along the side of his jaw. "It has to be the girl," he said at last.

"If we can believe Georg," I said.

"Why should he lie?" Murphy said.

I shrugged. "With a man like Georg, who knows?" I said. "For that matter, though, why should the girl betray Johns? She was in love with him."

Murphy smiled ruefully. "Oldest motive in the world," he said. "Spurned love. I told you earlier that Johns talked to me a lot about what he planned to do when he got back to the United States. And believe me, nothing he said indicated it was going to be anything but single blessedness." He shrugged and cocked his head briefly to one side. "The girl found out and goodbye Johns."

"Could be," I said. "Let's find out for sure."

Murphy was interested. "How?" he said.

"Well," I said, "if she is the leak she'll pass on anything I tell her to her superiors and in turn it will filter down to Georg. So why don't I give her some deliberately false information? Like, for instance, the name of John's replacement."

Murphy grinned. "Who'd you have in mind for the fall guy? You or me?"

"Neither of us," I said. "Who's the newest member of the Embassy staff?"

"A commercial officer named Caldwell," Murphy said. "But it seems kind of a rotten trick to put the secret police on to him."

"Not really," I said. "For a while he won't be able to go to the bathroom without somebody reporting it. But the secret police here are pros. It won't take them long to find out he's only what he claims to be and they'll drop him. And," I added, shrugging, "if it turns out the girl isn't the leak, they'll never hear about him at all. In which case, I'll just have to keep digging."

Murphy looked thoughtful. "Yes," he said. He slapped his hand down on the flat of his desk. "All right," he said.

I spent the next two weeks devoting myself to the pleasure part of my trip. I'm not much of a mountain man, but the local beaches were almost everything that Intourist had claimed them to be. I was followed everywhere, of course, and was more than a little suspicious of some of the ladies I met. But that's the way it is in my job, and you soon learn to make the best of it.

And then the message for Rose White came. I was more than a little disappointed. I'd begun to hope I was wrong.

I left the hotel as usual the next morning with the usual nondescript little man on my tail. But ten minutes of twisting and turning through the downtown traffic shook him off. Two weeks of following me to the beaches and to what passed for night life hereabouts had made them a mite careless.

But not that careless. I took it for granted that someone I hadn't spotted and wasn't likely to was still trailing me.

It really didn't make any difference. I found a bench in the park in the main square and spent an hour feeding pigeons, then went back to my hotel.

Once inside my room I bolted the door and went silently about my work. The message was taped to the headboard of my bed right next to the microphone. While I had led my watchers on a wild goose chase, Georg had slipped in as we had arranged and put it there. I read it once, then burned it.

It was short and easy to remember: "Word is that Johns's replacement is named Caldwell. Cover—commercial attaché at Embassy."

If anything, Arnold's eyes were even unfriendlier than on our first meeting. "I believe," he said, biting the words off short, "that I specifically warned you that I would not tolerate anything that would embarrass the Embassy and yet you deliberately spread word around that an Embassy employee—a career foreign-service officer—is really a spy for the C.I.A."

Murphy mopped his brow. We were in Arnold's office—a warm room and getting warmer. "Well, yes," he said. "But no real harm was done and we did catch a spy. A spy who was a murderer as well."

"That's right," I put in mildly.

Arnold's eyes swiveled to me. "No harm was done, was it?" he said bitterly. "Don't you realize that now the whole Embassy

staff is compromised?"

I met his gaze evenly. "I'm afraid the Embassy was already compromised," I said. "The girl isn't the leak. Murphy is."

I smiled slightly and turned toward Murphy. "I was pretty sure it wasn't the girl all along. Because I was followed by the secret police when I left the hotel to meet her. She couldn't have put them on to me because she still didn't know about me. Only you and Arnold knew."

I sensed rather than saw Arnold stiffen. "I didn't discount Arnold entirely," I went on, "but you were the one who had access to Johns's reports. So I set up a little test—and you failed it, Murphy.

"The girl didn't tell anyone that Caldwell was Johns's replacement. Again, she couldn't have. I never mentioned Caldwell to her. I told only *you* that I was going to. So you had to be the one who leaked it to the Communists.

"Just as you leaked Johns's reports to them. Johns found you out. That's why he was happier that last night with the girl; he no longer suspected her. The trouble is, he played it too close to his chest and you had him killed before he could expose you."

I shook my head. "That's a mistake I'm not going to make. That's why Arnold is here and that's why there are a couple of Marine guards outside that door."

Murphy didn't move, but his eyes were full of hate.

I let my smile broaden and turn rueful. "Don't take it so hard, Murphy," I said. "You're an old security man. You ought to know you can't trust anybody."

GAME WITH ONE RULE

by Robert Edward Eckels

The guard on the Communist side of the checkpoint had been well briefed. He waved me through with only a pro forma glance at the papers I thrust out of the car window. This small bit of German efficiency heartened me—even from *their* Germans.

Not that the papers wouldn't have held up under closer scrutiny. They were the real thing; the fact that practically every bit of information on them was false was only incidental. It was just that this morning I didn't fancy waiting while he went through the rigamarole of checking every nook and cranny of the car to insure that I wasn't smuggling in something to contaminate the Marxist purity of the GDR.

I acknowledged his curt nod with a false, friendly smile and following instructions drove slowly down the empty early-morning street. Off to my right loomed the bulk of the Brandenburg Gate, a monument to an old and no longer relevant victory. Behind me lay a monument more appropriate to today when clearcut victories no longer seemed possible—the Berlin Wall.

I turned off Friederichstrasse to Unter den Linden, still driving at the same steady slow pace. Just past the great open expanse of Marx-Engels Platz I pulled over to the curb and cut the engine. And waited.

Ten minutes passed and nothing happened. I began to sweat even though the coldly rational part of me knew that they were making me wait just so I would sweat. But I still couldn't help the tight, creepy feeling that being on the wrong side of the wall gave me.

As I had told Giddings, when he'd broached the assignment to me: " I don't like going over there. Too many people know me by sight if not by name."

"Of course they do," Giddings had said cheerfully. Giddings was C.I.A. controller in Berlin and like his counterparts everywhere was inclined to look at things from what sometimes turned out to be an overly optimistic viewpoint. "Of course they do," he repeated. "After that little deal you pulled in Munich I'd be surprised if there was anybody in the business on either side

of the wall who didn't know you."

He washed his hands together with obvious relish. "But since this isn't a secret mission your being known is actually an advantage. Otherwise," he explained, "we'd have had to blow one of our regular agents or risk using an outsider."

That answered one question: why I'd been dragged back to Germany on such short notice. It also explained why Giddings wasn't taking no for an answer. I rubbed my hand across my eyes and sighed. "All right," I said. "What is the mission?"

Giddings leaned forward, elbows on his desk. At the moment he looked very much the rising young executive. Which in fact was what he was. Only when he'd been graduated from Harvard or Yale or whatever college he had gone to, he'd opted for the C.I.A. instead of Madison Avenue or Wall Street.

"Simplicity itself," he said briskly. "The East Germans have been holding an American named Roger Herold for the last few weeks. Now they're making noises like they might be willing to let him go if the right kind of deal can be worked out." He pointed at me with the eraser end of a pencil. "All you have to do is go over and find out what their proposition is."

"Is he one of ours?" I said, meaning is he an agent.

Giddings shook his head. "No," he said. "He's just a college-boy tourist who wanted to find out for himself what life is really like on the other side of the wall." Giddings made a wry face. "He must have decided it wasn't all milk and honey because the East Germans caught him trying to smuggle a girl over to the West in the trunk compartment of his car."

"Not very bright of him." I said drily.

"No," Giddings said, "it wasn't. But that's beside the point. Out job is to get him out."

I looked Giddings square in the face. "Why?" I said bluntly. "Other Americans have gotten into trouble with Commie governments and the thing's worked out through regular channels. What's so special about this boy that the C.I.A. has to get involved?"

Giddings' eyes shifted away from mine. "In the first place, as you know, there are no regular channels as far as the East Germans are concerned. And in the second place, the boy's father is Frank Herold—Senator Frank Herold. He wants his boy out fast and he doesn't care how it's done. So far we've been able

to keep the story hushed up. But we can't much longer, and once the news breaks there'll be hell to pay."

I nodded my understanding. And perhaps my sympathy, too. Frank Herold was one of the most powerful men in the Senate. When he chose to, he could bring a lot of pressure to bear. I suspected that now was one of those times.

That was yesterday. Today in the cold light of an East German dawn I was beginning to have second thoughts about the wisdom of Giddings' scheme. If they wanted to, the East Germans could have a propaganda field day with the news of the arrest of a U.S. Senator's son. Capturing a C.I.A. agent sent in allegedly to rescue him would be icing on the cake.

I was just beginning to wonder what would happen if I made a sharp U-turn and headed back to the checkpoint when the door away from me was pulled open and a man climbed in.

"Good morning," he said brightly, smiling cherubically at me. "I am your contact. My name is Kramer." He was a stocky man with a bald bullet head and a knobby Slavic face. There are enough traces of the Slav in East Prussia for his family to have been German for generations back. But somehow I doubted it.

"I'm sorry to be so late," he went on, "but you know how it is with traffic these days." He spread his hands in mock helplessness.

I glanced significantly down the empty street. "Sure," I said. I handed him my papers, but he pushed them back without looking at them.

"You and I are professionals," he said. "We know enough not to trust papers."

"Very true," I said. "So how do I know you can deliver the goods?"

Kramer pursed his lips. "Would it convince you if I took you to the boy?"

I nodded. "It would be a step in the right direction," I said.

Kramer inclined his head to indicate the street. "If you will drive," he said, "I will tell you where to turn."

I started the engine and pulled away from the curb. Kramer settled back on the seat beside me, the cherubic smile once again on his lips.

During the drive he spoke only to give directions. Which suited me fine, since it gave me a chance to study the city. The

last time I'd been in East Berlin had been shortly before the wall went up—more than nine years ago. Then the city had been pretty much of a mess from the war. They still had a long way to go to catch up with the Western Sector, but I had to admit they were making progress.

Finally Kramer told me to stop in front of a gray-stone building and we went inside. At the entrance two Border Command guards snapped to attention and saluted Kramer. They might not have existed for all the attention he gave them. Let *them* forget to salute, though, just once.

Inside, he took me to a small office off the main corridor. It was simply furnished with a desk and three straight chairs. There was a picture of Ulbricht on one wall and one of Lenin opposite it. Next to Lenin was a lighter rectangle where presumably Stalin had hung before he became an Unperson.

Kramer sat down at the desk and pulled out a sheaf of photographs. "Just so there is no misunderstanding about the nature of our case against this Roger Herold," he said, handing them to me. "These are stills from a motion picture that will be introduced as evidence at his trial." He stood up. "And now," he said briskly, "I will arrange to have the prisoner brought here."

He bustled out and I sat on the edge of the desk to look through the pictures. They were pretty standard fare. The first showed a young man—Herold, from the picture of him that Giddings had shown me before I crossed over—helping a young woman into the open trunk of a car. The next showed him locking the trunk. And so on until the inevitable discovery at the wall. I bunched the pictures together and threw them on the desk.

This time they didn't keep me waiting. Barely five minutes passed before the door opened and a young man, dirty, disheveled, and badly in need of a shave, but obviously the same one as in the photos, stumbled in an blinked at me.

"Hello, Roger," I said.

He looked at me suspiciously. "They said you were an American," he said. "Is that right?"

I nodded and handed him my credentials. Not being a professional, he accepted them at face value. "Thank God," he said. He sank down on one of the wooden chairs. "Are they going to let me go?"

"Not just yet," I said. "But soon."

I saw relief cross his face, only to be replaced a second later by a new anxiety. "What about Ilse?" he said. "Will they let her go, too?"

"Ilse?"

"The girl I was trying to smuggle out." He caught at my sleeve. "We can't just leave her here. You see," he went on earnestly, "it was because of me that she wanted to got to the West." He looked down, somewhat shame-faced. "We're in love and we want to get married. But we knew that if we tried to go through channels it would be years before all the red tape and petty legalisms were cleared away."

"What made you think you could get her through the wall?" I said. "You went through it once coming in. You knew the kind of check they make." The room was bound to be bugged, of course. But I wanted to know and we wouldn't be telling the Communists anything they didn't already know.

"Ilse said they only checked you coming in," he said, "not going out. Anyway, we had to risk it."

I glanced down at the photographs. "You can't have known her very long?" I said.

"It's not how long you know someone that counts," Roger said simply. "It's how you feel about them."

"Yeah," I sighed. "All right, I'll work something out." And hated myself for saying it, because of course there was nothing to work out about the girl and I knew it. But there was no point in disillusioning him now; time enough for that when he was safe across.

Roger looked at me like a grateful puppy, which didn't help either. To cover my embarrassment I said, "Any messages I can pass on for you?"

He shrugged. "You can tell my father I'm all right, I guess," he said. "Other than that I can't think of any."

I nodded and looked around for a way to signal Kramer. There was a buzzer on the desk. I pushed it. There was no sound but two seconds later the door opened and Kramer came in, flanked by a pair of uniformed guards.

At the sight of the guards Roger stood up immediately. They'd trained him well in the weeks they'd had him. I winked at him. "Keep your chin up," I said. "It won't be long now."

He grinned, weakly at first, then more confidently, and went out between the guards. Kramer leaned back against the wall and smiled at me.

"Well," he said, "are you satisfied I am who I say I am?"

"Satisfied enough," I said. Kramer would never be exactly what he said he was. "The question now is," I went on, "what—or rather who—do you want in exchange?"

Kramer's smile broadened, pushing his cheeks even further up into his eyes. "Felix Lewis," he said.

"Felix Lewis!" Giddings exclaimed. "They can't be serious."

"Why can't they be?" I said. "They're in the driver's seat and they know it." After Kramer had made his proposition I had driven back through the wall without incident and now I was back in Giddings' office overlooking the Ku'damm.

"I know," Giddings said. He tossed down the pencil he habitually toyed with, got up, and walked over to the window to gaze on the busy street. "I know," he repeated, shaking his head. "But Felix Lewis—"

I could appreciate his distress. Ten years earlier Felix Lewis had been a laboratory assistant to one of the top men in the rocket-missile field. He had also been a spy, dutifully copying his employer's notes and forwarding them to his Russian masters. Somehow his employer had found out, but instead of going to the F.B.I. with his discovery, he had faced Lewis with it himself. It was a bad mistake. Lewis killed him and tried to disguise the murder as a lab accident. But he was clumsy about it and was arrested in a matter of days.

After that it didn't take long for the whole sordid story to come out, and the case quickly became a *cause celebre*, complicated by conflicting Federal and State jurisdictions. In the end Lewis had been tried by the State on the murder charge, convicted, and sentenced to life imprisonment.

There had been, I recalled, considerable public dissatisfaction that he hadn't been executed. Even today if you wanted to start an argument all you had to do was mention the name of Felix Lewis.

This then was the man the Communists wanted for the return of Roger Herold. They might almost have asked for the head of the C.I.A. himself.

When I said nothing, Giddings went on slowly, "Lewis isn't even a Federal prisoner; we'd have to go to the State to get him released. Even without that the political implications are staggering."

He turned back to face me and his voice had grown firm with decision. "No, sir," he said, "I'm not taking the rap on this one. I'm bucking it right back to Washington." He sat down at his desk and picked up his pencil. "You stick around," he said, "in case I need you."

I stuck around, but when there was no answer to his coded cable by 8:00 p.m., even Giddings was willing to call it a day. I ate a solitary restaurant meal and walked back to my hotel.

Even before I turned on the light I knew somebody was waiting in the room: some clue too subtle to register in my conscious mind gave him away. For one panicky second I considered slamming the door and diving back into the hallway. But then I realized that if it were an assassination attempt I'd already given him all the target he needed. So with barely a pause I reached out and flicked on the switch.

He had moved the room's one armchair so he could sit facing the door. Both his hands were in sight. They were empty.

"Good evening," he said in German. The sudden brightness must have hurt his eyes after sitting there in the dark, but if it did he gave no sign of it.

He was a heavy-set man with powerful shoulders and a coarse-featured face.

"Good evening yourself," I said, "and who the hell are you?"

Not a flicker of emotion showed on his face. "My name is Heussinger," he said. "But that's not important. What is important is that I'm the man who's going to get your Senator's son back for you."

"What Senator's son?" I said.

Heussinger permitted himself the luxury of looking annoyed. "Oh, come off it," he said. "You know what Senator's son. And you know too that your side can't agree to the Communists' terms."

"Maybe," I said cautiously, "maybe not. But what does it mean to you either way?"

Heussinger leaned forward in the chair. "I make a business out

of bringing people over from the East—for a fee, of course. I've got the routes and I've got the organization. I can bring your man over"—he snapped his fingers—"like that."

"How?" I said.

Heussinger settled back again and smiled grimly. "Every trade has its secrets," he said.

"He's in jail," I said. "Who'd have to bust him out—you or us?"

"I would," Heussinger said calmly.

"And the fee?"

Heussinger's mouth twisted into another bleak smile. "Only my expenses," he said.

When I looked my disbelief he added, "And a job. Oh," he went on, holding up a hand, palm out, "I'd earn my keep. This is no polite form of blackmail. But, you see"—he paused, wet his lips—"people in my profession are looked on as some sort of criminals. This hampers my operations in the West and needless to say the consequences would be most serious if I were caught in the East. But as a C.I.A. agent I would acquire a certain status. The West German police might be more inclined to look the other way. And who knows"—Heussinger smiled again, more warmly this time—"the Communists might even be willing to exchange me for one of their own agents if they caught me."

"I see," I said. I didn't like Heussinger, but I decided to borrow a leaf from Giddings' book and kick the decision upstairs. "Wait here," I said. "I have to make a phone call."

Heussinger inclined his head slightly. "At your service," he said.

I could have called from the room, but I didn't want Heussinger picking up Giddings' phone number. So I used one of the phones in the lobby. Giddings answered on the second ring.

"This is me," I said. "You know the voice. Anything from Washington yet?"

"Yes," Giddings said after a slight pause. "I just decoded it. They're taking the matter under advisement."

"Which means no," I said.

"Perhaps not," Giddings said unconvincingly.

"Yeah," I said. "Well, in any case, there's man in my room who says he can deliver the goods for a cheaper price."

"Who?" Giddings said. His voice was as short and sharp as the word itself.

"He says his name's Heussinger," I said, "Know him?"

"Yes," Giddings said. "He's no better than a gangster."

"He wants to change the image," I said and briefed him on Heussinger's proposition.

When I finished, the silence stretched out taut between us. Finally Giddings broke it. "All right," he said. "When there's a job to do you have to use the tools at hand. If Heussinger can deliver, it's a deal." Then he added fiercely, "But just to keep him honest you've got to be part of the operation from start to finish."

"I was afraid of that," I said and hung up.

I went back to my room to tell Heussinger the good news. As I expected, he balked at my joining in the fun.

"No," he said flatly. "My route across the wall is worth a lot of money to me. I don't share it with anyone."

I shrugged. "Then it's no deal," I said.

For just a second I saw a flicker of indecision on Heussinger's face. Then it was gone. "I'll have to think about it," he said. "I'll let you know."

"You do that," I said and closed the door after him. "You do that," I said again to the empty room, not sure what decision I was hoping Heussinger would reach.

I thought of calling Giddings back to report Heussinger's reaction, then decided to wait a while. It was just as well I did, because half an hour later the phone beside my bed rang. It was Heussinger.

"All right," he said. "You can come along—provided you understand it's my show and you do as you're told."

"I wouldn't have it any other way," I said drily. "Just tell me what you want me to do."

"First," he said, "you arrange to get the boy out of jail." And he told me how it should be done.

When he had finished I lay back on my bed and stared thoughtfully at the ceiling.

I met Kramer the next morning in his office in East Berlin.

"You have a deal," I said. "Lewis in exchange for the Herold boy."

Kramer nodded with exaggerated gravity. "Very sensible of you," he said. "What's an aging spy compared to a Senator's son?" He clapped his hands together briskly as if recalling

himself to duty. "But enough. When and where do we make the exchange?"

"Tonight," I said. "At the checkpoint where I first met you. Lewis will start walking from our side just as Herold leaves yours. They pass each other in the middle and neither one will look back."

I waited for some expression of surprise at the timing. Usually these things take much longer to arrange. But in this case any delay would give Kramer's people a chance to check and find out that Lewis hadn't really been released from prison.

All Kramer did, though, was nod again. "Very good," he said. "Shall we say eleven o'clock then?" From his tone he might have been arranging and after-theater dinner party.

I wasn't followed when I left Kramer's, but I knew he would check when I crossed back into the West. Any unexplained time lag would have got him all upset; nobody likes one of the other side roaming loose aroung his territory. So I drove straight back through the checkpoint by the Brandenburg Gate, making sure the guard got a good look at me.

As soon as I was sure I hadn't been followed from the wall, I switched cars and drove back into East Berlin through a checkpoint much farther south. This time I presented a different forged set of papers identifying me as a U.S. Army officer stationed in Berlin. As I'd expected, the guards were used to Americans traveling back and forth just to re-emphasize the right of access and they waved me through without too much fuss.

This time, though, I was followed—just the usual Border Command escort who made no effort to conceal the fact that he was tailing me. He was used to the drill too and expected me to swing around in a loose half circle and then leave by a different checkpoint. Which is just what happened, except that once when I was temporarily out of his sight around a corner, I slipped out of the car and one of Heussinger's men slid in to drive back through the wall.

Heussinger was waiting for me at his safe house.

"It's all arranged," I said. "Eleven o'clock tonight."

"Good," he said. He spread out a large map of the city on a table before us. "That means they'll leave the jail about ten

thirty. They'll take this route"—his pencil traced along the map—"because it's the fastest and the most open. We'll be waiting for them here."

The pencil stopped, then lined in a bold X where a sidestreet intersected the main route. It was, I noticed, called Frieden-strasse. Peace Street.

At 10:30 Friedenstrasse was dark and empty; the workers who were building a Socialist paradise in its warehouses and small factories had long since departed for the day. There had been a street lamp on one corner across from where I sat alone in a parked sedan, but a well-aimed rock had taken care of that. In the dark I could make out the bulk of a truck parked just back from the intersection, across from me on the other side.

I glanced at my watch. If Heussinger was right they'd be leaving the jail about now. And it should take them no more than five or six minutes to get here.

I began to feel the old familiar tightening in my stomach, even though I was in a perfect getaway position and my orders from Heussinger were under no circumstances to mix in—orders which, incidentally, I had no intention of disobeying.

Heussinger over in the truck heard it first—the faint whine of rubber against pavement that told of an approaching car. He must have, because my first notice was the sound of the truck motor coughing into life. I tensed behind the wheel of my own car.

Lights off, the truck rumbled out into the intersection and stopped just in time to block off a dark sedan, with Neues Volks Armee markings, coming up on the right. A capped head appeared at the right-hand sedan window and shouted some-thing that I couldn't quite make out over the clatter of the truck's diesel.

Without answering, Heussinger turned off the motor, climbed out of the truck, and went forward to lift the hood and peer under it. A second man sat stolidly in the cab. Out of sight on his lap he held a Schmeisser machine pistol, ready to fire. Heussin-ger also had a gun out of sight.

More shouted German which Heussinger continued to ignore. The capped head disappeared back into the sedan. A moment later a uniformed NCO got out on the driver's side and walked

up to Heussinger.

"Get this truck moving," he said. "You're blocking the intersection."

Heussinger gestured toward the engine and began to rattle off some sort of explanation why the truck couldn't move. The NCO listened impatiently, hands on hips.

The other door of the sedan swung open and a man in officer's uniform got out. *"Was fehlt hier?"* he said.

He never found out what was the matter. The Schmeisser chattered and he went sprawling across the pavement. Startled, the NCO turned toward the sound. Heussinger whipped out his gun, shot, and the NCO crumpled beside the truck. Heussinger slammed the hood down, dragged the NCO's body out of the way, and signaled his man in the cab to get the truck moving. The motor kicked over effortlessly and a second later the truck lumbered past me and on down the street.

Instinctively I had started my own engine the moment the Schmeisser had opened up. Now I put the car in gear and drove out in front of the NVA car. Heussinger had opened the rear door and was bending over something inside. "You'll have to help me," he called over his shoulder. "He's been drugged."

I got out, leaving my motor running, and together we got the unconscious Roger into my car. Heussinger climbed into the rear seat beside him. "Get going," he said. "This place will be crawling with police in seconds."

I got going.

When we were seven or eight blocks away, Heussinger told me to pull over to the curb and we changed places. As we drove off again, I said, "I hadn't counted on any shooting."

He grinned into the rear-view mirror. "You can't make an omelet without breaking eggs," he said.

"So they tell me." I said grimly. "But now that border's going to be closed up so tight an ant won't be able to get across without a passport signed by Ulbricht himself."

Heussinger's grin widened. "Don't worry, my friend," he said. "We're going in the one direction no one will ever dream of lookng for us—East."

I'll say this for Heussinger, he was a cool one. He drove at a steady five Km's below the usual rate of traffic, keeping to the

main roads and picking up the Autobahn at the edge of the city. We passed a lot of police and NVA cars headed in the opposite direction. But as Heussinger had predicted, nobody paid any attention to the eastbound traffic.

We had gone perhaps fifteen or twenty miles beyond the city when Heussinger exited off the Autobahn and picked up a side road. We followed it for a while, then turned off onto a dirt track that eventually led us to a long flat meadow flanked on three sides by tall trees.

A single-engine plane stood at the near end of the meadow.

"This is it," Heussinger said.

"You've got to be kidding," I said.

"Not at all," Heussinger said. "We're less than twenty minutes flying time from West Berlin. We fly low under their radar until just before we hit the city. Then we're over and home free before they can scramble a jet to find out what it's all about."

"If it's so easy," I said, "why hasn't it been done before?"

Heussinger grinned. "Who says it hasn't? But if you're nervous we can leave you here."

"Not a chance," I said, and got out of the car with him.

Between us we lifted Roger out of the car and a thin man in a leather jacket—the pilot—ran forward to help us get him into the plane. It was a four-seater. Heussinger sat up front with the pilot, and Roger and I were in back. Roger hadn't stirred since we'd picked him up, but he was breathing easily and his pulse was normal, so I wasn't worried. I put my hand on his shoulder to brace him for the takeoff.

The pilot punched the starter. The propeller jerked around twice. Then the motor caught, gusting out a gout of black smoke, and steadied down to an even roar.

The pilot wet his lips and faced Heussinger. "It would be a safer takeoff," he said, "if you turned on your car lights."

Heussinger's eyes flicked back toward me. "No," he said, "too dangerous."

The pilot set his face obstinately. "More dangerous not to," he said.

With a sigh Heussinger unstrapped himself, climbed down, and ran back to the car. A second later, light beamed down the length of the meadow. Heussinger ran back to the plane.

"I hope you're satisfied," he said irritably to the pilot as he

refastened his seat belt.

The pilot adjusted the controls and we began to move. Aside from a few bumps at the start the field was surprisingly smooth and we were airborne well before the clump of trees at the end loomed up. The pilot banked sharply, then settled on a north-westerly course.

For just a second, though, I'd had a last glimpse of the lighted field below—and of the dark figures running out of the woods toward the car.

Forty-five minutes later, we were in Giddings' office—that is, Heussinger, Giddings, and I were in Giddings' office. The pilot had been taken God-knows-where and young Herold was in the hospital for a thorough checkup.

The flight itself had been uneventful—almost anticlimactic—except for one bad moment just after we'd crossed over into West Berlin. Two jets had screamed out of nowhere to meet us. But they had the familiar blue and white markings of the USAF and had been content to shepherd us into Tegernsee Airport.

Now Giddings was sitting behind his desk, frowning and tapping furiously with his pencil. "There's going to be hell to pay about that shooting."

Heussinger studied his finger-nails. "It's a dirty game," he said. "At least this time you have a success to report."

Giddings looked at him distastefully for a long moment, then sighed. "I suppose that is the position we'll have to take," he said. "All right. You two can go. I'll be in touch later."

I didn't move. "It's not over yet," I said. "There's one question that still needs to be asked." When they were both looking at me I said, "Why did the Communists want Felix Lewis?"

Heussinger shrugged it off. "Who knows?" he said. "What does it matter now anyway?" He rose from his chair and would have left, but Giddings held up a hand to forestall him.

"Make your point," Giddings said to me, his eyes intent on my face.

"My point is this," I said. "It *is* a dirty game, just as Heussinger says. But it's a game with one rule: nobody does anything without a reason and the reason never is what they say it is.

"Now the Communists went to a lot of trouble to frame

Roger. Oh, it was a frame all right. They couldn't have got the pictures they had unless their cameras were set and waiting for the girl to maneuver Roger into range. But why? Ostensibly to get Felix Lewis in exchange. But when you come right down to it, what would they want Lewis for? They could never use him as an agent again and any information he's got is at least ten years out of date." I paused.

"So?" Giddings said. He was still watching me intently.

"So," I went on, "my guess is that they didn't want Lewis at all. They just threw his name out as a red herring and because they knew he's one person we couldn't manage to exchange. It was all Kramer could do to keep a straight face when I showed up to tell him the deal was on. But the real giveaway was that Roger was drugged. Why should they do that when the deal was for Roger and Lewis to *walk* across the border? The only answer is that they knew there was going to be trouble along the way and they wanted to make sure Roger was kept out of it. Another example of that famous German attention to detail. Only this time it backfired."

I turned to face Heussinger. "The whole thing," I said, "was just an elaborate scheme to plant a double agent on us. They sent our friend here knowing we'd be sure to fall in with his quick and painless proposition."

"You're crazy," Heussinger said.

"Am I?" I said. "You couldn't make a decision on my joining the caper without first checking back with someone. And second, we had an unseen audience when we took off in the plane—an audience you didn't want me to know anything about or you would have had one of them switch on the car lights rather than run back and do it yourself. I'd guess it was Kramer you checked with and Kramer's men at the airfield.

"Oh, I'll admit it threw me a minute when you shot those two NVA types, but that was just an act—blank cartridges, of course. The entire hijack was a phony."

Heussinger mocked, " 'My guess,' 'I'd guess'—all pure guess-work." He shook his head. "You can't prove any of it."

"That's right," I said cheerfully. "But the Communists can. All I have to do is leak it out—without mentioning your name— that the double agent they so cleverly planted on us is really a

triple agent—someone who's been working for us all along. If you *aren't* a double agent, you won't have a thing to worry about. But if you *are*"—I smiled grimly—"your chances of survival are pretty small, wouldn't you say?"

And when we looked into his face and saw the fear there, Giddings and I had our answer.

DOUBLE JEOPARDY

by Robert Edward Eckels

The girl behind the counter—crisp and trim in her dark blue airlines uniform—smiled brightly and handed me the ticket envelope. "There you are, Mr. James," she said. "You're ticketed through to Copenhagen and from there to Warsaw. They'll be calling your flight in about half an hour. And you will be required to show your passport and visas prior to boarding. Have a nice flight, sir."

"Thank you," I said. I stuffed the envelope into my jacket pocket and stopped to pick up my attaché case.

"Oh," the girl said, "there's a message here for you. Mr. Roy Wilson asked that you meet him in the cocktail lounge."

"Roy Wilson?" I said, frowning. "I'm afraid there must be some mistake. I don't know a Mr. Roy Wilson."

"I'm sure it's for you," she said slowly. "The note says specifically, Mr. James going on to Warsaw."

I shrugged and smiled wryly. "One way to make sure, isn't there?"

Her bright smile flashed again. "Yes, sir."

Wilson, I suspected, would turn out to be a salesman of some kind—flight life-insurance most likely. But I had half an hour to kill, so what did I have to lose? All I had to do was say no after he'd made his pitch.

If I'd had the slightest inkling of what I did stand to lose, I would have avoided that cocktail lounge like the plague.

But I crossed over to the lounge and stood in the doorway long enough to take off my topcoat and let my eyes adjust to the dimness within. As soon as I could see clearly I glanced around and tried to pick out Wilson. It wasn't difficult. Groups of two, three, or four clustered about most of the occupied tables. Only one man was sitting alone, at a table near the wall. He rose, half smiling, when I caught his eye and came forward to meet me.

"Mr. James? I'm Roy Wilson." He grasped the hand I'd extended automatically to meet his. "I'm glad you decided to take me up on my invitation. I hope it didn't sound too mysterious."

"Just mysterious enough," I said, "to make me curious."

"Fine," Wilson said, ushering me politely but firmly toward

his table. "Curiosity is a trait that should be encouraged. And satisfied. So let me buy you a drink and tell you what it's all about. Here, I'll take your coat."

He whisked my topcoat off my arm and folded it neatly over the back of one of the chairs. Another topcoat—his own, I guessed—was similarly draped over the opposite chair.

We sat down facing each other and Wilson signaled the waitress.

"Another martini here," he said, "and—"

"Dry manhattan," I said. "Very dry."

After the waitress had left, Wilson steepled his fingers in front of his face and said thoughtfully through them, "You do a lot of traveling behind the Iron Curtain, don't you, Mr. James?"

I didn't like the implications of his question. "I have legitimate business interests that take me there," I said.

Wilson dropped his hands and smiled engagingly. "If that's any of my business," he said, putting my thought into words. "You're right. Why you're going to Poland is no concern of mine. All that matters is that you're going."

He paused for the waitress to set our drinks before us and bustle off again. He toyed with the bill for a moment, then casually slipped it into his pocket. When his hand emerged it held a small laminated plastic card which he slid across the table to me.

"Don't pick the card up, Mr. James," he said. "Just read it from where you are."

The lamp on our table cast enough light for me to make it out. It identified Roy Wilson as an agent of the Central Intelligence Agency.

I swallowed hard. "And just why," I said in what I hoped was a normal tone, "is the C.I.A. interested in my trips to Eastern Europe?"

"Not your trips, Mr. James. Just this specific trip to Poland. And the reason, I think, should be fairly obvious. We want you to work for us."

I started at him for a long moment, then bust out laughing.

"What's so funny?" Wilson asked as if he wanted to share the joke.

"You. Me. The whole idea. Look," I went on when he didn't respond, "I'm forty-three years old and according to my doctor

fifteen pounds overweight. I haven't fired a shot in anger in my life or even hit anyone since junior high school. What's more, I have a wife and two teen-age daughters, all three of whom I love dearly." I shook my head slowly and perhaps a trifle sadly. "All in all," I said, "I'm about the most unlikely candidate for spy you could find."

"Which," Wilson said seriously, "is precisely the reason we want you."

I stopped laughing and Wilson continued in the same sober tone, "We don't expect you to go in and steal the plans to the latest Russian-built rocket or kidnap Gomulka or anything like that. That kind of stuff happens mostly in the movies anyway. But there is a man—pretty highly placed in the party too—who wants to come over to the West. Of course, we want to help him. But it's an extremely delicate situation. The slightest whiff of a rumor—" Wilson snapped his fingers sharply—"and that's it. That's why we can't use any of our regular people or try to bring the man out over the usual political refugee routes. Instead we plan to smuggle him into this country disguised as a U.S. tourist returning from abroad." He nodded toward his topcoat. "Sewn into the lining of that coat," he said, "is an American passport and the other papers he'll need for the trip. We want you to take them in to him."

"Who is this man?" I said. I was surprised to find that my hands were trembling.

"It's better if you don't know."

"Then how could I contact him?"

"You wouldn't. In fact, you and he would never meet. The way we have it planned is like this. On your second night in Warsaw you go to a small restaurant not far from the Old Town Market Square called The Golden Eagle. It's an excellent restaurant, so it wouldn't be out of line for a foreigner to visit the place.

"Arrange to get there about seven and hang your topcoat on the coatrack near the door." I noticed that Wilson had subtly shifted his tenses as if I had already accepted his proposal, but I didn't interrupt him. "Our man will arrange for someone to be in the restaurant ahead of you. When he leaves he'll simply take your coat as if by mistake. All you have to do is not 'discover' that the coat is missing until he's had twenty minutes or so to

get clear." Wilson laughed shortly. "And considering the quality of service in Polish restaurants these days that should be no problem at all."

"You're very persuasive," I said. "But how would this man recognize me?"

"Simple," Wilson said. "He'll arrange to get a glimpse of you when you check into your hotel." He smiled. "Don't worry. It's not difficult. Americans aren't that common in Poland these days. In any case, that's the plan. Now it's up to you. If you decide to go along with it just pick up my coat instead of yours when you leave." He glanced at his wrist watch. "Not to rush you, but if you're going to make the plane you'll have to leave now."

I rose involuntarily and stood beside my chair trying to organize the thoughts crowding into my brain.

As I think back on it I realized that I really had no choice—not with Wilson gazing up at me, his eyes half mocking, half challenging, and ready to reflect that terrible judgment, pity, if I refused.

I picked up his coat.

Wilson nodded approvingly. "You made a good decision, Mr. James," he said. "And don't worry. Positively nothing can go wrong with this one."

I didn't answer. I turned and left the lounge. As I stepped out into the lobby they were just beginning to call my flight.

Each time I go east of the Iron Curtain two things impress me anew. One is the ubiquitous red banner with its awkwardly phrased, bombastic slogan that even without the cold-war connotations would be embarrassing to the Westerner. The other is the almost paranoid preoccupation with espionage and security.

I spent my first fifteen minutes alone in my hotel room searching for the hidden microphone I knew would be there. I finally found it clipped to the inside of one of the bed legs. Not that I intended to destroy it or block its use in any way. That would have been foolish, not only because there were probably others more cunningly hidden, but also because any tampering would have merely called official attention to me—something which even under normal circumstances I could do without. No, it just made me feel better to know were the bug was located.

The next day—my first full one in Warsaw—was filled with the details of business that had brought me to Poland in the first place. The people I dealt with made some vague suggestions about dining that evening, but I think they were secretly relieved when, pleading fatigue from the long flight, I begged off.

As Wilson had said, The Golden Eagle was just off the Old Town Square. It was an unpretentious building and looked almost out of place beside the elegant, lovingly restored façades of the coffeehouses, restaurants, and wine cellars that comprised so much of the square itself. But I'd traveled enough to have learned that the best restaurants are often the least pretentious. Wilson had been wrong about one thing, though. The coatrack wasn't near the entrance. It was about halfway back on the wall leading into the interior of the main dining room. But that seemed a minor point, so I hung my topcoat on it and followed a black-jacketed waiter to my table.

I was no sooner seated than a small man on the other side of the room left his table and beelined for the coatrack. Once there he glanced around furtively, grabbed my coat, and scuttled toward the door with it still clutched in his hand.

He couldn't have done a better job of calling attention to himself if he'd tried.

My waiter dropped his order pad and shouted after him. I don't understand Polish, but there was no mistaking his cry: Stop thief!

The small man panicked and began to run. A second waiter materialized to block his path. The small man swerved and careened into a table. The two waiters pounced and dragged him kicking and screaming from the jumble of chairs, plates and food.

By the time it occurred to me that I should have slipped out in the confusion it was too late. The police were there. Nothing can go wrong, Wilson had said. Positively nothing can go wrong. But somehow it always does.

My waiter pointed me out to one of the policemen as the small man was carried, still protesting loudly, out of the restaurant. I felt my stomach curling into a tight knot as the policeman approached me with that deliberate arrogance you see in certain types of police the world over. He spoke abruptly, in Polish.

I tried to smile. "I'm sorry," I said, "I don't understand—"

Without waiting for me to finish, the policeman turned and beckoned peremptorily to my waiter. They spoke together at some length. Or rather the policeman spoke and the waiter listened.

When the policeman stopped, the waiter turned to me and said almost apologetically, "That man want to steal your coat. He must be punished. You must go with this man to the police station and make statement."

"Look," I said in what I hoped was a reasonable tone, "I'm a stranger here and I don't want to cause any trouble. Tell him I don't want to press charges against the man who took my coat."

The waiter stared at me blankly.

"I don't want to go to the police station," I said. "I don't want to make a statement. Tell the police they can let the man go. It was all just a mistake."

"No," the waiter said. "You must go. You must make statement." His voice had grown desperate as if he knew he would be punished if I failed to obey the police.

Throughout all this the policeman was regarding us both contemptuously. And I had a sudden intuition that he spoke English at least as well as the waiter.

I rose wearily. "All right," I told the waiter, "tell him I'll go."

I sat for three hours on a hard bench in the police station, forlorn and ignored, while a bored desk officer doodled on a pad before him and a sleepy-eyed guard braced his back against the wall beside the entrance. The bench grew harder and harder. And as my physical discomfort increased, my apprehension mounted. It didn't help my peace of mind, either, when another policeman appeared and held a whispered conversation with the desk officer and afterward the officer ceased his doodling to gaze speculatively at me.

It also didn't help that my topcoat with the incriminating papers sewn inside had been taken by the police as evidence.

It came as a relief when the policeman who had brought me from the restaurant appeared at a doorway at the far end of the room and beckoned to me. Not a word was said—just that curt peremptory motion of his hand and I responded like a puppy after a morsel of meat. And, of course, that was the reason I had

been left sitting and fidgeting for three hours.

The policeman waited for me by the door, then closed it immediately behind me.

The room was bare of furnishings except for a wooden table and three chairs. Two men were sitting at the table and a third stood at the single window, gazing out. They were in civilian clothes but they had policemen's eyes. What captured my attention, though, and what I fought to keep from staring at lay on the table: a small pile of papers topped by the green and gold pasteboard oblong that was a U.S. passport.

The man at the window glanced at me without curiosity, then resumed his study of the outdoors. As if on cue, one of the men at the table—a thin man with a pale triangular face as expressionless and predatory as a fox's—said harshly, "Come forward."

I stepped up to the table, uncertain as to whether I was expected to sit or not. Apparently I wasn't, because Foxface went on, "Who sent you to Warsaw?"

I cleared my throat nervously. "I came here on business," I said. "I work for a firm of American importers—"

He cut me off with an impatient wave of his hand. "We know all about your 'firm,' And we know it is a cover for your criminal acts of espionage against the Polish People's Republic. Now, who sent you here and why?"

"No one," I said, and my voice was the barest whisper.

Now the man at the window spoke up. Still without looking at me he said, "Does the prospect of twenty years in prison please you?"

Twenty years! Irrationally a scene from a novel I'd read years before flashed through my mind. In it the author had conveyed the astonishment and shock that a group of young men who had joined the Irish Republican Army as a lark had felt when one of their number captured by the British had been sentenced to twenty years in prison. To those young men, barely out of their teens, twenty years had seemed a lifetime.

Well, twenty years *was* a lifetime—the rest of my lifetime anyway. I thought of never seeing my wife and daughters, of never walking down a free American street again.

The man at the window had whirled to face me. "Well," he insisted, "does it?"

I finally managed to croak, "No."

"Then answer this man's questions if you hope to avoid it."

"Well?" Foxface said when the silence had dragged on too long.

I took a deep breath. "Before I say anything," I said, "I want to talk to someone from the United States Embassy."

Foxface's eyes flicked toward the window, then back to me. "As you wish," he said coldly. To the policeman rigid beside the door: "Take him away."

For some reason the picture of a Polish prison I had built up in my mind was something out of *The Count of Monte Cristo*: a dungeon deep underground, dark, with dripping stones and a straw pallet and perhaps a small barred window high up on one wall. Instead, the cell I was taken to was a steel cage—stark and modern and filthy. A metal bunk was set into one wall, and sanitation was provided for by a bucket in one corner. Out of reach overhead and screened by a fine wire mesh that in no way diminished its intensity, a light bulb burned fiercely. It wasn't turned off even once the whole time I was in that cell.

Because my watch had been taken from me along with my necktie, belt, and shoelaces, I quickly lost track of time. I tried for a while to keep count of the meals brought to me, figuring that three would make a day. But I began to suspect that they were deliberately brought at irregular intervals, and since they were always the same—watery soup and a chunk of coarse bread—breakfast became indistinguishable from lunch or dinner and I soon gave up the attempt.

Hell, I thought, must be like this: time stretching on interminably and filled with an improbable mixture of boredom, fear, and anguish. I wondered about my wife and daughters. Had they been told of my arrest? And if so, what did they think of it? Were they like the wives and families of other men held captive behind the Iron Curtain, seen occasionally on television, hoping against hope that all would come right in the end? What was Wilson doing to get me out? Anything? Unlikely. What *could* he do?

And where above all else—where was that man from the Embassy? The longer he delayed, the more convinced I became that he wasn't coming at all. I would rot here in this cell.

And then one day—or night—the door clanged abruptly open and two guards filled the doorway. To my shame I found myself crouching beside my bunk in terror. The guards exchanged contemptuous grins, then one of them motioned me to come with them.

As I left the cell, I flet a sudden panic. The cell was known to me; I was familiar with every square inch of it. Now I was leaving it—but for what? The urge to turn and flee back into its safety was almost overwhelming. As if he could read my thoughts, one of the guards clamped onto my arm and pulled me roughly along.

And perhaps he did know what I was thinking. This must have been an old story to him and certainly one prisoner wouldn't react too differently from another.

I was taken through a maze of echoing steel corridors to a door at the end of a short hallway. The guards halted at the mouth of the hallway and shoved me forward.

"In there," one said in English.

Clutching the last shreds of my self-control I went forward and opened the door.

The room was similar to the one where I had been interrogated before: the same kind of wooden table and a scattering of chairs. But this time only one man awaited me. Tall, youngish, sandy-haired, with the round smiling face of a friendly Irish pug, he half sat, half leaned on the edge of the table.

"Mr. James?" he said. "I'm Paul Lafferty. From the American Embassy."

Like a marionette with cut strings I dropped onto one of the chairs. "Thank God," I breathed.

Lafferty had started forward at my sudden collapse; now he leaned back against the table. "Looks like they've been giving you the deluxe treatment," he said. "How long have they been holding you?"

I shook my head. "I don't know. Day—night, it's all one. They picked me up on the fifth."

"Two weeks then," Lafferty said thoughtfully. "Today's the nineteenth."

"It seems longer." I was surprised at how old and tired my voice sounded.

Lafferty nodded sympathetically. "I imagine it does." He

paused, then blew out a great gust of breath. "To put it mildly, Mr. James," he went on, "you're in a mess. The Embassy will, of course, do everything in its power to help you. But quite frankly there's very little we can do. Espionage is a serious charge in any country and especially for a Westerner in a Communist country. Serious not only for the individual accused but for his country as well.

"So you'll understand that our official position must be that we know nothing about you." He smiled wryly. "And oddly enough that happens to be the truth. We *don't* know anything about you. Oh, it's not inconceivable that the C.I.A. would send in an agent without informing us at the Embassy. But if that agent were caught and we queried Washington about him we'd be told the truth. And the word from Washington is that nobody there has ever heard of you. So whoever you're working for it's not the U.S."

"But," I blurted out, "he had an identification—"

"I'm sure he did," Lafferty said. "But tell me honestly, Mr. James, would you recognize a C.I.A. or F.B.I. identification card? I mean, do you know what they're supposed to look like?"

"No," I said weakly.

"So," Lafferty said, "the 'identification' you were shown could very easily have been counterfeit." He pushed himself off the table and walked over to the window. "If you want my honest opinion, Mr. James," he said, looking out, "you were suckered into this by the Communists themselves."

"No," I said incredulously, "I can't believe that." Or could I? If it were true it would explain the extreme clumsiness of the attempt to switch coats at the Golden Eagle. But on the other hand—

"Surely," I said half to myself, "if they wanted to arrest me they wouldn't have to go to all that trouble. It would be simpler to find some pretext after I arrived in Poland."

Lafferty pounced on my words. "Simpler," he said, "but not as effective. This way they've got your guilt feelings working for them."

I sighed. "Perhaps you're right," I said. I turned my face up to him. "But why *me?*"

Lafferty shrugged. "There could be several reasons. I suppose they could be planning one of their propaganda trials. But I'm

inclined to doubt that. Nobody really believes those trials any more—not even their own people. And, secondly, there's been no publicity about you at all. In fact, your wife was even sent a cable—ostensibly from you—saying that complications in your business dealings would delay your return. We didn't even hear about you ourselves until the day before yesterday, and they know we'll stay quiet to keep from prejudicing your chances.

"No, all in all, I'd be inclined to say that they were trying to recruit you as an agent of their own."

I started to speak but Lafferty held up a forestalling hand. "Don't look so shocked. A man like yourself who has a legitimate reason for traveling back and forth across the Curtain could be very valuable to them. Anyway, let's hope that *is* the case. It's your one hope of getting out of here."

I said slowly, "Are you seriously suggesting that I—"

"Work for the Communists?" he finished for me. "No, not really. We'll let them *think* you're one of theirs, but we'll set it up so that you're actually working undercover for us. Somebody will contact you shortly after you get back to the United States. Remember that. You will be contacted. Don't you try to contact anybody on your own." He laughed shortly. "You were fooled once and there's no sense taking any chances you don't have to."

"That's right," I said. "That's why I won't go along with your scheme."

"No?" Lafferty seemed amused. "I really don't think you have any alternative, Mr. James. Refuse the Communists and you spend twenty years in one of their prisons. Refuse us and you stand to spend twenty years in one of ours. A case, you might say, of double jeopardy. Either way it's not a pleasant prospect."

Lafferty had been standing during this speech. Now he sat down against the edge of the table and let one foot swing idly. "By the way," he said, "just to satisfy my own curiosity, what were those documents you smuggled in supposed to be used for anyway? Help some poor devil defect?"

I shrugged. "Just the opposite," I said. "Make the Communists think somebody was planning to defect when he wasn't, so they wouldn't trust him any more. That's what I was told anyway."

Lafferty stroked his chin thoughtfully. "I see," he said. "Well, you think over what I said." He rose, went to the door, and signaled the guards that the interview was finished.

I did think about what Lafferty had said. And I worried. I did more than worry. I sweated.

Finally the Communists broke the tension. I was taken from my cell a second time and brought back to the fox-faced man and his two companions. As Lafferty had predicted, I was given the choice of working for them or of disappearing into one of their prisons.

I told them I'd work for them. Again, as Lafferty had said, I really had no choice.

Twenty-four hours later, shaved and scrubbed and looking on the surface at least the same man as the one who had come to Poland those short weeks before, I was put on a plane bound for Copenhagen and home. As soon as its wheels left the ground I began to tremble uncontrollably.

I lay over a week in Copenhagen to bring some semblance of order to my jangled nerves before facing my family. On my third night there, I had a visitor: Wilson, disguised as a room-service waiter.

"You get around," I said from the bed where I was lying fully clothed.

"The wonderful world of jet travel," Wilson said. He pushed the cart he'd brought into the room off into a corner. "Weren't you expecting me?"

"Yes," I said wearily. I sat up, swinging my legs over the side of the bed. "I was expecting you."

"All right then. What happened?"

"Your man muffed switching the coats and I was arrested." I smiled ruefully. "I'd still be in jail if I hadn't agreed to be a spy for the Communists."

"And they believed you?" Wilson was watching me intently.

I let the smile grow more rueful. "Why not?" I said. "I'm supposed to think I'm really a double agent for the C.I.A. That's their way of insuring that I do what they want and don't run screaming to the nearest American Embassy or F.B.I. agent." As briefly as I could I told Wilson what had happened after my arrest.

"Well," he said when I finished, "to coin a phrase, very interesting. But, tell me, what made you so sure I wasn't what Lafferty claimed, a Commie myself?"

"Lafferty," I said. "No Embassy man—particularly not one as competent as Lafferty seemed—would have talked so freely in a room that a kindergarten child would have known was bugged. And when the Communists still went ahead and put their offer to me, I knew I was right about him."

"Good thinking," Wilson said. "And good thinking too when you lied about why we sent you in. You just may have saved our man's life." He grinned widely and clapped me on the shoulder. "We'll make a professional of you yet."

"That's what I'm afraid of," I said.

MILK RUN

by Robert Edward Eckels

I glanced into the rearview mirror again. The headlights were still there. They'd been there for the last half hour, maybe longer. And it was past time for me to find out why. Gradually I eased up on the gas pedal. The lights in the mirror grew larger, then diminished as the car dropped back to its original distance behind me.

No question about it now—somebody was following me. And was either being very stupid or didn't care if I knew. Probably the latter, because with only the long stretch of autobahn ahead of me there was very little I could do about it.

I cursed silently. That's supposed to help, but of course it didn't. Mainly, I supposed, because I had no one to blame but myself. I'd let Averill talk me into this assignment against my better judgment.

"No," I had said when he'd broached it, "I've been working this area too long. Too many people know my face." Averill was the CIA controller for southern Germany and had been my boss for five years. Five years is a long time to maintain a cover.

"But," Averill had protested, "this is no more than a milk run. You pick up a small package in Munich, catch a plane, and deliver the package twenty-four hours later in New York. Simplicity itself." Averill didn't mention what the package was and I didn't ask. In this business, lack of curiosity is a positive virtue.

"And," he had added slyly, "you're planning to go back to the States anyway. Here's your chance to let Uncle Sam pick up the tab" . . .

So now I found myself rolling down the night-darkened autobahn with a confident tail wagging behind me. Too confident. I'd remembered something that my tail might not have taken into account.

I speeded up. It caught my tail by surprise and his lights dropped back momentarily. Then he was back to his accustomed distance, even decreasing it slightly once or twice to let me know he could do it whenever he wanted to.

That didn't bother me at all. I'd never thought I had a chance of outracing him in the bug that Averill had provided for me. In

fact, it was even questionable whether its motor could stand the pace I was now setting much longer. But if I'd decided right it wouldn't have to.

Luck was with me because there just ahead was what I'd remembered—a convoy of 7th U.S. Army jeeps and trucks filling the right-hand lane as far as the eye could see. I swung out into the left lane and began to pass them.

Apparently they'd been on the march for some time and road discipline had begun to slip. The rear trucks in particular were dropping farther and farther back, but throughout the length of the convoy the gaps between the trucks were far too wide. I waited until I was about halfway up the line, then cut sharply in between two trucks.

The effect was immediate. The truck behind me pulled up on my tail and began blinking its lights to tell me to get the hell out. I paid no attention and soon the driver gave up. But the one break in the convoy had alarmed the other drivers and they promptly closed up.

That left my tail out in the cold—and in something of a bind. He could either drop to the end of the column or hang on in the left lane and keep an eye on me. He chose the latter. And that was a mistake—although as with most mistakes he didn't realize it until it was too late.

I stayed with the convoy until we rolled into Munich. Then I swung smoothly off to the right at the first promising side street, leaving my tail blocked by the continuing line of trucks.

I wondered if he swore silently to himself. And if it helped him any.

The plan called for me to leave the car at the airport where Averill would arrange for someone to pick it up. But the car was too dangerous for me to keep now. I parked it where it wouldn't attract any attention for several days, walked to where I could catch a cab to the Bahnhof, then walked an additional three blocks to a not quite respectable commercial hotel where they wouldn't wonder that my only luggage was a small back attaché case. And settled down for a good night's sleep, confident that no one would track me down.

Of course, someone did

He stood beside my breakfast table, beaming down at me.

"Ah," he said, "it is you. Last night when I see you check in I think, perhaps. But then—" he cocked his head to one side and frowned to dramatize his bafflement—"the name on the registration card is not the one I remember from Zurich. But now," he went on, his expansive smile back in place, "I see it is the same man behind the name."

"Hello, Dietrich," I said. "Or has your name changed since Zurich too?"

He sat down quickly and leaned forward on the table, spreading his hands. He was a round man with a round body and a round face on which a perpetual film of perspiration glistened. "No," he said, "I am still Dietrich. It is my name and everyone knows who and what Dietrich is."

And that was the best reason I could think of for his changing his name. I'd known him for some time but had only dealt with him once. Several years before I'd bought some information from him and then had got out of Switzerland a bare jump ahead of the police he'd sold me out to. To give Dietrich his due, there was nothing personal about it; it was just a matter of business to him. All the same I trusted him about as much as I would an electric eel.

"How'd you happen to find me, Dietrich?" I said.

"By chance," he said, slapping the table. "By chance. I had business here in the hotel last night. And there you were, checking in at the desk."

"And that's all there was to it?" I said. "Nothing more than chance?"

"Of course not. What else could there be?"

"Someone tried to follow me into town last night. It could have been you."

"No," Dietrich protested, "not me." The denial was automatic, but I believed it. Because for just a second his eyes had been unguarded, and I could almost see his busy mind at work speculating on how this information could prove useful to him.

I picked up half a roll and began to butter it. "Well," I said, "whoever it was, he was wasting his time. I'm quitting the business. Going home."

"Good," Dietrich said, slapping the table again. "Good for you. I too have quit the business. I have my own now—here in *Muenchen*." For proof he fished a grubby business card out of his

wallet and offered it to me.

I shrugged, popped a piece of roll into my mouth and took the card. It identified Dietrich as a Private Inquiry Agent and gave an address and phone number.

"Perhaps," Dietrich said, "you can throw a little something my way sometime." He smiled. "In this world friends should help one another."

"Sure," I said. I slipped the card into my breast pocket. I figure I would find it there the next time I sent the suit to the cleaners and throw it away.

Dietrich glanced ostentatiously at his watch. "I must go," he said. He stood up and shook my hand formally in the German manner. "*Vieles Glueck*," he said.

I wished him the same good luck and watched his broad back depart. Then I went back to my breakfast.

Of course, when I left the hotel he tried to follow me. I wandered apparently aimlessly through the business district and lost him.

There is something about camera shops that fascinates spies. Perhaps it's a case of life imitating art since all spy movies seem to have mysterious camera shops in them. Be that as it may, my contact was in a camera store on a side street not far from the Frauenkirche.

It was a small place sandwiched in between two larger buildings and identifiable only by the clutter of Agfa and Kodak displays in the windows flanking the door.

A bell set above the door tinkled as I entered. There was no one about, so I stepped up to the counter and waited. When I decided I had waited long enough, I coughed twice, waited again, then called out into the silence, "Anybody here?"

No answer. No scurrying of feet as the shopkeeper rushed in to greet a customer. No movement of the curtain screening off the doorway behind the counter.

I didn't like it. The shopkeeper had been alerted to my coming. He would have made the contact—unless something prevented it. And the sick feeling in the pit of my stomach said that the something that prevented it wouldn't be pleasant.

I moved around the counter intending to pull aside the curtain—and never completed the movement.

There, crumpled on the floor, was the old man who had been my contact. Someone using a small-caliber gun had shot him neatly through the forehead.

Reflexively, my eyes flicked around the room. There was no sign of its having been ransacked. Which said it had been a professional job. The package—and I had to assume the killing was tied in with the package somehow—could be disguised as anything—microdots are versatile. And no professional would waste time looking for something he wouldn't recognize even when it lay right in front of him.

And it had lain right in front of him—or almost. A cardboard box stuffed with envelopes containing processed film sat on a shelf on the wall behind the counter. The package was an envelope made out in the name of Erich Hofstadter.

"You've been seeing too many bad movies," I had told Averill when he had explained what I was to ask for. Now, considering the body at my feet, I wished I'd seen a few of those movies myself.

After a quick glance at the door and windows I stepped over the old man's body and riffled through the envelopes. The one I sought was where it should have been—under the H's. I pulled it out and gazed at it thoughtfully.

Question: Was this really the package I'd come for or had the old man talked before he died, leaving me to find only a red herring left by his killer?

Answer: there was no way I could tell. I would just have to proceed on the assumption the package was the right one.

I tossed the envelope in my attaché case, closed the case, and was just snapping the metal catches when the tinkling bell over the door brought my head around in what I knew could only be interpreted as a guilty start.

A small, slightly dowdy woman was standing in the doorway and staring at me with wide timorous eyes. She looked half ready to turn and run screaming from the shop. And that was the last thing I wanted to happen.

I cleared my throat. "*Bitte?*" I said. Please—the standard greeting of a German shopkeeper to a customer. Five years of practise had smoothed most of the rough edges off my German accent, so I might just get away with it—provided she wasn't the old man's wife or daughter. Or an agent. Or someone who

wanted a long technical discussion on cameras and photography.

"Isn't Herr Gregorius here?" the woman said. The question was a cross between an accusation and a bleat.

I fought the impulse to look down at the body. "No," I said. "He had to go out. Perhaps I can help you though."

"Perhaps," she said. Her voice was still tentative, uncertain, but the suspicion had gone from it. "Herr Gregorius thought my pictures might be ready today."

"Pictures?" I said blankly. I followed her gaze to the carboard box of envelopes and caught on. "Ah, yes," I said. "What is the name, please?"

"Kallmann."

I riffled through the envelopes swiftly, then shook my head. "Sorry. Perhaps tomorrow."

The woman smiled sadly, like someone used to being disappointed, and left without another word. I gave her three minutes to get clear before beating it out of there myself.

Point One in favor of my having the right package: I was followed when I left the shop—and not by Dietrich. This one was a tall man in a gray suit. I let him tail me for several blocks, then shook him by the simple expedient of hopping on a street car just as the car began to pick up speed. Thirty feet behind me, the man in the gray suit didn't have a chance of catching up and didn't even try.

I had been shaking tails with such ease these last few days that it never occurred to me that this time it had been too easy.

I checked in at the airline ticket counter a half hour before flight time. They like you to be there even earlier for international flights. But for reasons of my own I didn't want to be loitering around the airport for any appreciable length of time. And if the customs people had to rush me through—well, that wouldn't displease me either. As it turned out, though, I had plenty of time.

The clerk behind the counter stamped my ticket and slipped it into an airline envelope. He glanced casually at my attaché case. "Just the one bag?"

I nodded. "I'll carry it on," I said.

"Very well," the clerk said and handed back my ticket, "There

will be a slight delay in boarding," he went on. "Time and gate will be announced later." He moved away before I had a chance to ask the reason.

"A slight mechanical difficulty," a voice to my left said pleasantly. I turned toward it. A tall heavy-set man with a cherubic face under a Prussian haircut was smiling at me. His cheekbones were so high that his eyes seemed almost Oriental. He looked to be about 50, but could have been younger or older.

He went on, "The radio was damaged and needs to be replaced, I understand. Of course, the airline cannot tell you that. Any hint that their machines are less than perfect might worry you. So they act mysterious and leave you prey to all sorts of imagined fears." He drew himself erect, inclined his head smartly forward, and said formally, "Otto Heinsdorf at your service." He smiled again. "Forgive me for speaking so abruptly, but I noticed your concerned look."

I muttered something that was meant to pass as thanks.

"Ah," Heinsdorf said, "an American. It must be pleasant to be returning to your own country." He moved close to me. "Perhaps," he continued, "you will let me buy you a coffee and talk about America and your happy return there?"

I tried to step back; the German habit of speaking into your face from inches away is one I've never got used to. "Thank you," I said, "but I don't thing so."

"Oh," Heinsdorf said admonishingly, "I think so. I think so very much. If, that is, you hope to see your homeland again." He smiled and gestured with his hand for me to precede him to the coffee shop.

I did.

Heinsdorf sat happily at the small table, holding the silvered coffee pot in one hand and a cream pitcher in the other, and poured simultaneous streams of coffee and cream into his cup. "Tell me, my American friend," he said, "do you know what it is that you're carrying?"

"What I'm carrying?" I said in my best bewildered-tourist voice.

Heinsdorf smiled patiently. "Denials," he said, "are for amateurs. But—" he sighed—"if you insist." His voice became

brisk again. "We know the old man at the camera shop had it. You were seen to visit his shop. And when you left you made no attempt to recontact your superior. Therefore, you found what you were looking for. Secondly, you made no effort to pass it on to anyone else. Therefore, you still have it."

"Therefore," I said, "you want it."

Heinsdorf's smile broadened. "Let us say that my employers do. But that doesn't answer my first question: do you know what the package is?"

When I said nothing, he went on blandly, "Ah, as I suspected, you don't. Well, put delicately, what you have is a list of unreliable people in positions which—shall we say—require a great deal of reliability. Such a list would be valuable to the intelligence service of any country. And quite frankly, my friend, there are enough people interested in taking it away from you to insure that you'll never reach your destination with it. If you think you'll be safe once you get on the plane, think again. It would be simple enough to skyjack it to Cuba."

"Very interesting," I said drily. "But why tell me all this? Why not just let me find out about it when I got off at Havana airport?"

Heinsdorf shook his head vigorously. "You misunderstand me. I didn't say that I had arranged to have your plane skyjacked. No, my employers would regard a landing in Cuba as much of a tragedy as you would."

"Just who are your 'employers'?"

Heinsdorf shrugged. "Why don't we just say that they are the people who are prepared to pay you ten thousand dollars for the package."

Point Two in favor of my having the right package: Nobody would offer that kind of money for the wrong envelope.

Heinsdorf resumed: "If you're concerned about what *your* employers would think, they need never know. All you would have to do is report that you found nothing at the camera shop. And who is there to contradict you? Certainly not the old man. He was very dead when I left him."

"You killed him?" I asked, almost casually.

Heinsdorf spread his hands in a classic gesture of helplessness. "What was I to do?" he said. "He was a witness." He saw my

face and added quickly, "But surely he meant nothing to you?"

"No," I said, "I'd never met him. I was just thinking that I'd be a witness too."

Heinsdorf shook his head slowly. "No," he said, "you will be either an accomplice—or dead." He stood up, pulled an old-fashioned watch from his vest pocket and studied its dial. "You have," he said, "until your plane leaves to decide which. I shouldn't imagine that would be very long now." He snapped the watch lid shut and slipped it back in his pocket. "By the way," he said as an afterthought, "I trust you aren't foolish enough to think you can leave this airport. You wouldn't get ten steps beyond the entrance."

"I could yell copper," I said, "and leave with a police escort."

Heinsdorf let out a great guffaw. "And turn your package over to the West Germans for nothing? I know your allies, but surely there are limits to even the closest friendship between countries. Especially since there may be American names on that list." He shook his head again. "No, my friend, I don't think you will do that." He put his hand on my shoulder. "When you want me—and you will want me—I will be on the Observation Deck." He was still laughing as he walked out the door.

I was beginning to resent the way first Dietrich and now Heinsdorf had promoted me to the status of friend on the least provocation.

Dietrich.

I sat at the table for a few moments, biting lightly on my knuckle. Then I went to a phone booth.

I waited for Dietrich in the coffee shop, ignoring the preliminary announcement of my flight. Things shouldn't get really critical until the final call was sounded, but just the same I was beginning to sweat when Dietrich finally arrived.

Following instructions, he ignored me and sat down at a table slightly to my rear. I let him get settled, then drained the last of my coffee and stoop up. He followed me out and across the lobby to the Observation Deck, keeping a good twenty feet behind me.

Heinsdorf was standing at the railing, watching a huge jet, its wingtips trembling, lumber by on its way to the takeoff point. He glanced at me briefly as I came up, then turned back to the jet.

"These machines fascinate me," he said. "So massive and yet so fragile."

"If you say so," I said. "Look," I went on, "I've been thinking over your offer. And the money's not enough. I want fifty thousand—U.S. dollars."

Heinsdorf frowned. "I have no authority to go beyond ten thousand," he said slowly.

"Then do what you have to and get that authority," I said harshly. "Otherwise I destroy the package. And I don't think your employers would like that."

Heinsdorf pursed his lips and thought that one over. "I'll have to make a phone call," he said. "Will you wait for me here?"

I shook my head. "It's a little too open out here to suit me. I'll wait back in the coffee shop."

He nodded and left the platform. I waited a minute, then left, still trailed by Dietrich. Instead of going straight back to the coffee shop, though, I cut over to the public washroom. Dietrich followed me in a couple of seconds later.

"All right," I said as soon as I was sure we were alone, "that man I was just talking to—who is he and who does he work for?" Dietrich would know if anybody did. A freelance operator's survival depended on his keeping an accurate Who's Who of Spies in his head.

He shrugged. "Like you," he said, "he uses many names. One I heard recently was Heinsdorf. It may have changed, though."

"It hasn't," I said. "Now, who does he work for? The highest bidder?"

"No." Dietrich's voice reflected his distaste. "He's a fanatic. A Maoist." Fanatic was the worst epithet Dietrich could use. It meant someone who acted out of ideology rather than selfish interest. And who was, therefore, even for this business in which everyone was a liar and a cheat, particularly untrustworthy.

"Such nice people I'm meeting these days," I said. "See anybody else you know around the airport?"

"No one I know," Dietrich said. "But there were two KGB types resting in your flight lounge." He shook his head. "Some day they will learn, perhaps, not to go to the same Stalinist tailor."

That at least bore out Heinsdorf's allegation that he wasn't the

only one after the package. It was beginning to look too as if he'd also been right when he said I didn't stand a chance.

I took five 100-DM notes from my wallet and handed them to Dietrich. "Go back to your office," I said. "If I want you again, I'll call you there."

Dietrich folded the bills lengthwise and wrapped them carefully around the first two fingers of his left hand. "It puzzles me, though," he said slowly, "what all these people are doing here, in this airport, at this time.' "

"Keep that up," I said, "and you may find out what happens to curious people. You wouldn't like it. Now," I went on, "we'd better not be seen leaving together. You first." I turned and bent over the washstand to scrub my hands.

Five minutes later a machinery salesman from Dusseldorf pushed open the door and was the first to discover me sprawled on the floor, the attaché case open and empty beside me. There was a strong odor of chloroform still hanging in the air.

Being a good German, he ran yelling for Authority. And within seconds an airport policeman was there, bringing behind him the inevitable crowd of the morbidly curious.

By now I was sitting up and the policeman knelt beside me. "What happened here?" he said.

I grabbed the attaché case and stared into it. "My God!" I cried. I swallowed hard and shook my head as if to clear it. "This is too important a matter," I said. "I want to see someone from the Verfassungsschutz immediately."

The policeman stared at me blankly. Then he did what every policeman does when faced with an unfamiliar situation—he fell back on routine. He took out his notebook and poised his pencil over it. "Your name, please?" he said.

Over his shoulder I could see Heinsdorf at the rear of the small crowd turn and whisper something to the man next ot him. Then they both were gone.

"There's no time," I said to the policeman.

"Your name?" he insisted.

In the end I was taken to a police station where I was allowed to tell my story to a series of officials of ascending rank until finally I was brought before one who made only a token pretense

of not being connected with the Security Police.

"So," he said, "you admit to being an espionage courier operating on the soil of the Federal Republic."

"Yes," I said. "It would be senseless to deny it, because I need your help in keeping that list out of the wrong hands. You've got to stop Dietrich and Heinsdorf from getting away."

He picked up a pencil and tapped the eraser end idly on the desk he was sitting behind. "No one is going to get away—or go anywhere for that matter," he said, "except you." His voice was cold and professionally unsympathetic. "You're worse than a spy. You're a spy who has failed. You've compromised yourself, your country, and the Federal Republic in such a manner that the affair cannot be hushed up. However, to avoid further embarrassment to an allied power, we will give you the option of leaving the country immediately without contacing anyone."

He stopped tapping and looked up at me. "The alternative is prosecution in the Federal courts for an infringement of German sovereignty."

I chose the plane.

As I was being hustled out of the police station I caught a glimpse of Dietrich being brought in. His face was pale and frightened. I almost felt sorry for him. The police are never gentle with his kind. Still, better the police than Heinsdorf.

My regular contact was waiting for me at Kennedy International. His name was Kiefer and he was a tall gangling man with a prominent Adam's apple and a nervous habit of blinking his eyes every two or three seconds.

"I wasn't sure whether or not you'd be here to meet me," I said.

Kiefer blushed. He'd obviously been told to give me the boot and he didn't relish the job. "Oh," he said, "there was no question of not meeting you. But, well, under the circumstances, this will have to be our last contact. Your usefulness to the Agency is, well, seriously compromised and—"

"Fine with me," I said." I was planning to retire and write my memoirs anyway. So if we can go some place where we can make the transfer safely, I'll give you the package and be on my merry way."

Kiefer stopped short in midstride. His mouth dropped open and for once he forgot to blink. "The package?" he finally managed to gasp out. "But that was stolen."

I took his arm and started him moving again. "There's an old saying, Kiefer," I said, "that you should bear in mind as long as you stay in this business: Believe nothing you hear and only half of what you see. There was no robbery. I faked the whole thing by emptying a bottle of chloroform down a drain and then lying down on the floor. It was the only way I could think of to get out of Germany in one piece."

It had been a lousy trick to play on Dietrich, though. Nobody with half a brain could have missed him following me like a puppy dog from the coffee shop to the Observation Deck to the washroom. And then coming out first and alone. It was a short and logical step from there to the conclusion that he'd grabbed the package and run. But then, I'd owed him one for Zurich.

THE K'ANG SHENG MEMORANDUM

by Robert Edward Eckels

It was warm and fine even for a Sunday in late May and the Garden of Remembrance was crowded—ironically, since this was a Russian memorial, with tourists from the West. One result of that, though, was that my tie and western-cut suit weren't conspicuously out of place, so nobody paid any particular attention to me as I strolled past the drooping stone flags and kneeling figures into the garden proper. Once there I mingled with the crowd for a while, then drifted casually over to the side to pretend to study one of the plinths inscribed with quotes from Great Wartime Leader Stalin.

Several yards away a short stout man with a pale knobby face and bald bullet head stood staring impassively at another plinth. In his left hand he held a copy of *Neues Deutschland* folded into a tight flat square. Which marked him as my contact—whoever that was.

"It's a simple matter really," Giddings had said, leaning back in his chair and gesturing with the pencil he seemed always to have in his hand. "All you have to do is run over to East Berlin and meet this man."

I looked over at him suspiciously, having learned in the years we'd worked together—he as C.I.A. controller, me as agent—that his definition of a simple matter and mine didn't always agree. "What man?" I said. "And, more importantly, what does he want?"

"To tell the truth," Giddings said with another wave of the pencil, "I don't know. It's a blind meet, pure and simple. But from the way the message setting it up was delivered, it looks as if he might be a professional."

"Working on his own," I said, "or under orders?"

Giddings smiled at me disingenuously. "That's what I want you to find out," he said.

Which was why I now found myself in a Soviet war memorial

in East Berlin, on the wrong side of the wall from all my friends, trying to decide whether the contact was clean or not. In the final analysis, though, the only way to find out for sure was to go ahead and make the contact. So after another moment or two I took a similarly folded newspaper from inside my jacket and went over to join the short man.

He took me and my paper in with a glance, then tucked his into his side pocket. "You're late," he said without preamble. His voice was harsh and brusque and more than a little irritating. "You weren't followed, were you?"

"No," I said.

"You're sure?"

"Of course I'm sure," I said, letting the annoyance show. "Do you think I'd be here if I weren't?"

The short man studied me for a long moment. Then he nodded, a slight, barely perceptible movement that seemed to reflect more an inner decision than a response to my question. "You must forgive me," he said. "But when one is on the run—as I have been for over the past month—one becomes excessively cautious. It's how one stays alive."

"On the run from whom?" I said.

The short man permitted himself a brief smile. "At times it seems everyone," he said. He paused and looked out beyond me as if to survey the crowd. "My name is Grigor Ulanov," he said. "The name means nothing in itself, of course. Which in a sense is the measure of my success. Because for the past twenty years I've been a member of the foreign section of the KGB. Which would make me pretty much your Russian opposite, wouldn't it?"

"Pretty much," I agreed. "What is it you want now? To change sides?"

Ulanov shook his head. "No," he said emphatically. "Circumstances which I would rather not go into have made it necessary for me to—ah—terminate my relationship with the KGB. But I have no desire to exchange one set of masters for another. I've had enough of this damn business and I want to retire. Unfortunately, I can't get out of this city with its wall and ring of border guards without help."

He turned to look me full in the face. "Of course," he said, "I've been around long enough to know that no one does some-

thing for nothing. So before I left, I took the precaution of photocopying dossiers of Soviet agents operating in your territory. Not all, of course, but enough to make up a fairly bulky package, which I will turn over to you when you get me out of East Germany and onto a plane for Switzerland."

"Where is the package now?" I said.

"In a safe place," Ulanov said. "But, of course, I understand your concern. You don't want to commit yourself without some assurance I can produce what I promise. So I'm prepared to make a down payment, give you what you call a free sample. One name in advance. You check it out and if you're satisfied I'm telling the truth, we have a deal. If not"—he shrugged—"you simply forget we ever had this conversation. All right?"

I nodded slowly. "What's the name?" I said.

"Arnold Ruth," Ulanov said without hesitation. "At the present time he is a senior political officer in your diplomatic mission to West Berlin. He's been our agent, however, for the past four years and in that time he's passed over an invaluable amount of sensitive information—the latest being complete details on the K'ang Sheng Memorandum." He paused and cocked his head to one side. "Is that sufficient for you to go on?"

"I'd think so," I said. "How do I get in touch with you if I decide I want to?"

Ulanov took a slip of paper from his pocket and passed it over. "Call that number," he said, "and ask for Heinrich. You'll be told when and where he can be reached. Double the house number one street west will be our meeting place. And," he added, "when you do call, do it from an *East* German phone, please. Having gotten this far, I'd take it very badly if my former colleagues caught me because someone was careless."

And with that he gave me a curt nod and walked off to melt into the crowd. I gave him a few minutes to get clear, then left myself. As far as I could tell, nobody in the crowd was paying the slightest attention to me.

The Chief of the U.S. Diplomatic Mission to West Berlin was a frosty New Englander named Collins, and he made it clear when I called at his house that he didn't much like having his Sunday afternoon disturbed. He liked it even less when I told him why I had come.

"That's impossible," he said. "Why, I've know Arnold Ruth for years, and the man would no more turn traitor than I would."

"Nevertheless," I said mildly, "the accusation has been made. And I have to follow it up—one way or the other."

Collins sniffed. "I take it that's intended to mean that if I don't cooperate you'll just bull ahead on your own. Very well then, what is it you want to know?"

"For a start," I said, "whether there is such a thing as a K'ang Sheng Memorandum. And whether Ruth was aware of its contents."

Collins hesitated, then nodded. "Yes," he said, "there is. And yes, Arnold knew about it." He sighed. "And somebody did leak it to the Russians, didn't they? I hate to think it was Arnold. But then I'd hate to think it was any of the others either."

"Who else knew?" I said.

"Here in Berlin, myself and George Eidem our cryptanalyst. Perhaps half a dozen others in Washington."

I looked at him curiously. "It must be a pretty special piece of paper," I said, "to rate such a restricted audience."

Collins smiled wryly. "In a sense," he said, "very special. And under the circumstances I see no harm in telling you that it purports to be a memorandum from one K'ang Sheng, head of the Communist Chinese espionage service, to Premier Chou En-lai detailing and requesting approval of plans to assassinate the President of the United States. It was dated October 1963—which, of course, made it political dynamite. Because one month later a President *was* assassinated. And as sensitive an issue as that assassination still is, knowledge of Red Chinese involvement would alienate the entire American public and make any policy of rapprochement with China political suicide for decades to come.

"Be that as it may, the document surfaced here in Berlin about two months ago in the possession of a rather unsavory character named Ferguson. This man Ferguson claimed to have deserted from the Army in Vietnam and to have made his way via Hanoi into Red China, where he was employed by K'ang Sheng's department.

"There's no need to go into details, but essentially Ferguson's story was that he had come across the memorandum by accident, recognized its implications, and stole it, escaping across

the border into Russia and working his way west by various stratagems. And now that he was safely this side of the Iron Curtain he was prepared to turn the memo over to the U.S.—for a price, of course.

"Put simply, he wanted $50,000 plus full amnesty on the desertion charge. Which wasn't an unreasonable offer at all—given Ferguson's assumption that the government was so committed to its present policy of closer ties with China that it would pay to hush the matter up.

"If we didn't meet his terms, he was prepared to offer the document to the Russians—who would be only too glad to publish it, because if there's one thing the Russians fear it's that the U.S. and China will form an alliance against them. And, frankly, I found myself in something of a dilemma, complicated by the fact that neither I nor any of my staff can read Chinese. So I did what any sensible bureaucrat would do. I fired off an immediate cable to Washington explaining the situation and asking for instructions."

Collins sighed and showed me another wry smile. "Their response was predictable, of course: they wanted to examine the document before making any commitment. That posed a problem of a different sort, though, because Ferguson wasn't about to let the document out of his possession in advance of payment. Nor, because of the desertion charge still hanging over his head, would he undertake to deliver it in person. In the end, however, he agreed to let me make a photocopy and that was forwarded to Washington by special courier. Arnold Ruth was the courier."

"Was he aware of what he was carrying?" I said.

"Of course," Collins said. "You must remember that Arnold is a *senior* officer and that I had every reason to trust both his loyalty and his discretion. Besides, as my full deputy he was able to bring the decision back with him."

"Which was?"

Collins smiled again. "To forget the whole thing," he said. "Because, you see, the document was a forgery."

"You're sure of that?"

Collins nodded. "It wasn't even a very good one," he said. "To begin with, it had been written by someone unfamiliar with the language reforms introduced by the Communists in the 1950's. Moreover, there were a number of small anachronisms reflect-

ing knowledge of events that occurred after the assassination. I'm quoting from the report Arnold brought back, of course. But Ferguson confirmed it all by breaking down when confronted with the evidence and confessing that the whole thing was a swindle."

Collins' lips curved down disdainfully. "The only truth to his story was the part about his deserting fom the Army, and he was—ah—persuaded to surrender to the military authorities here. The last I heard he had been sent back to the States for court-martial."

"And the memorandum?"

"Languishing in some file drawer in Washington, I presume," Collins said, "where, except for this, it would have been mercifully forgotten. Arnold, George Eidem, and I discussed it at some length when Arnold got back and agreed to keep it among ourselves unless and until Washington decided to publicize the incident. So far they haven't. And that really is all I can tell you. I trust you've found it helpful."

"Very," I said.

Collins nodded solemnly. "Then I'd appreciate it if you'd reciprocate," he said, "and keep me informed of the results of your investigation."

I said I would and rose to go. Before I left, though, I got Arnold Ruth's home address from him.

Ruth's apartment occupied most of the top floor of a modest building not far from Templehof. There was no answer to my knock and the mail still in his box down in the lobby indicated he'd been gone at least since yesterday. Which, of course, made me more than a little curious. So I forced the lock with a strip of plastic and went inside.

It was a standard three-room apartment: combination living room and dining room, bedroom, and kitchenette. Not luxurious, but comfortable and immaculately kept.

I found Ruth in the bath. He sprawled on the bottom of the tub, looking pathetically old and shrunken. The technical term is death by disensanguination, and there was no need to wonder how it had happened. Both wrists faced up, exposing bone deep slashes from the heels of the hands across past the bases of the thumbs. The razor that had made the slashes lay on the floor

beside him, rusting through the stains.

I backed out quickly and then when my stomach and nerves had settled began to search the apartment. Nothing was obviously out of place. But in one corner of the living room was a small writing stand with a typewriter on it. Some paper had been left in the machine and on it was typed: "Ulanov has run. Only a matter of time before I'm exposed. God, why did I get involved in this?"

The message was rolled up off the platen but was unsigned. I left it where it was and went back outside, carefully locking the door behind me because I didn't want Ruth "found" officially just yet.

Later that evening I dialed the number Ulanov had given me and asked for Heinrich.

I met Ulanov the second time in a small café near the Friederichstrasse Bahnhof. It was early the following morning and he sat at the table mopping up the last of his breakfast.

"So," he said, "my down payment was satisfactory, was it?"

"Satisfactory enough," I said. "We'll expect a lot more, though, when you're over on our side."

"Of course," Ulanov said. He popped a piece of toast in his mouth, chewed and swallowed. "How do you intend to take me across?" he said.

"Does it matter," I said, "as long as I get you across?"

Ulanov stopped eating and looked at me steadily. "Yes," he said. "It matters very much. Because before I commit myself to any plan I want to be sure I'm increasing my chances of survival and not lessening them. So, please, no midnight swims across the canal or crawls through the barbed wire."

"As a matter of fact," I said, "I was thinking of getting you a false passport and slipping you right through one of the checkpoints. Assuming that meets with your approval."

Ulanov thought for a moment, then nodded. "It has the virtue of simplicity," he said, "and I like that. So I approve. When will you do it?"

"As soon as I can get the passport fixed up," I said. "Later today."

Ulanov nodded again. "Very good," he said. Then he pushed back his chair and rose. "After dark would be best, I think. So I

shall meet you back outside here tonight at seven o'clock. All right?"

"Fine," I said.

Ulanov gave me another curt nod, turned briskly on his heel, and marched out of the restaurant. Through the window I saw him cross the street rapidly, and when I left myself a few minutes later he was already nowhere in sight.

I was a good ten minutes late making the rendezvous at the café, but Ulanov was even later, and I stationed myself in the shadows by the corner to wait for him.

I had barely gotten settled, though, when a small furtive man sidled up to me. "God, I thought you'd never show up," he said. Then he added quickly, "I'm Heinrich. We spoke on the phone. Double the house number and one street west?"

"I remember," I said. "Where's Ulanov?"

He smiled bitterly. "Where that false passport of yours won't help him any more, I'm afraid. The police came to the rooming-house right after he left to meet you this morning—looking for him. I would have warned him, but they wouldn't let any of us out of the house. And then when he came back, they hid behind the door and grabbed him as he came in." Heinrich shuddered. "It was awful," he said. "I was just lucky they didn't know I'd helped him. Otherwise, they'd have taken me too."

I nodded thoughtfully. "What happened to the package he had for me?" I said.

"I don't know," Heinrich said. "It was hidden somewhere, but he never would tell me where. And with the police nosing about now—" He paused and his eyes slid past me. "Look," he said, "it's not really safe for me to be seen talking to you too long, and I've told you all I know. So with your permission I'll say 'Lebe wohl.'"

I nodded, and he scuttled away down the street. As his footsteps faded out, another sound came in to replace them: a car motor—in the distance still, but coming fast and headed this way. It could have meant anything or nothing, but I didn't stay to find out.

There were three of us in Giddings' office when I reported: myself, Giddings—lounging as usual behind his desk and toying

with his pencil—and, because of my promise to keep him informed, Collins from the Diplomatic Mission.

"I don't suppose second-guessing serves any purpose at this point," Collins said when I had finished. "But it does seem a pity you didn't have a plan ready for smuggling Ulanov across this morning."

"It wouldn't have made any difference," I said. "Because Ulanov never intended to come over."

"That's ridiculous," Collins said. "Of course he intended to come over. Why else would he have contacted us?"

"I can think of one very good reason," I said. "Here were the Russians sitting on what must have seemed the hottest story of this or any other year. Only they couldn't do anything with it without tipping us off that there was a leak somewhere in our top circle. So they brought Ulanov in. The whole purpose of his 'defection' was simply to convince us Ruth was the traitor and keep us from finding and plugging the *real* leak.

"And that's a little more than mere speculation. Things started to smell sour when I found Ruth so conveniently dead with that note explaining all stuck in his typewriter. It was just a little too good to be true. Besides, *both* his wrists were slashed right down to the bone. And he couldn't have done that himself, because when you cut that deep you sever muscles controlling the fingers as well as the artery, and he literally couldn't have continued to hold the razor. Verdict: murder. Not suicide.

"Then there's the matter of Ulanov's 'arrest.' If Heinrich was telling the truth, if he really was held prisoner in that house and Ulanov was picked up as he came in the door, then they had no chance to communicate. So how did Heinrich find out Ulanov and I were to meet back at the café—or, more importantly, that I was going to furnish Ulanov with a fake passport?" I shrugged. "From there," I said, "it was just a matter of reasoning it out and eliminating the impossible until—"

"Until you arrived at the probable," Collins finished for me. He nodded heavily. "And no doubt your reasoning is correct. Unfortunately, it still leaves us with only half of the answer. Unless, of course, you know who the real traitor is."

"No," I said. "But we do have a pretty good clue, don't we? The Russians wouldn't have gone to all this trouble if they'd known the document was a forgery. So all we have to do is look

for a source they *couldn't* have learned that from."

Collins smiled wryly. "Your logic's holding up very well," he said. "But unfortunately for your theory everyone on our side involved with the memorandum knew it was false."

"Then there's no question, is there?" I said. "They must have got the information from you."

Collins recoiled and looked at me aghast. "You must be out of your mind?" he said.

"No," I said. "And I'm not calling you a traitor either. But the fact is, the Russians know pretty much what you sent in your cable. They never learned what was in the report that Ruth carried back with him—and which any one of you could have passed on to them. So the answer has to be that they've tapped the cable and broken your code."

"Good Lord," Collins said, looking even more profoundly shocked. "You mean they've been reading everything I've sent out!"

"That's right," I said. I glanced over at Giddings, who was sitting forward eagerly now and obviously calculating how we could use a broken code the Russians didn't know we knew about to feed them false information. I smiled wryly. "Something gentlemen never do. Unfortunately, there don't seem to be many gentlemen left—on either side."

THE KAPALOV PROPOSAL

by Robert Edward Eckels

The first thing that struck me was the heat. It had been a long time since I'd been back and I'd forgotten how hot a Washington summer could be. Fortunately, the limo in from the airport was airconditioned and so was the hotel. But I made a mental note anyway to get some clothes that were more suitable for the climate—assuming, that is, the I'd be staying long enough to need them.

All Giddings had told me was that I was wanted back in Langley "soonest." Giddings is CIA controller in Berlin, which makes him my boss, and he usually has a good reason for wanting me to do things—although it goes without saying that his perception of what is good and/or desirable frequently differs from mine. This time, though, when I asked him all he did was smile and twist the pencil he was constantly toying with lightly between his thumbs and forefingers.

"They'll tell you when you get there," he said.

Which meant, of course, that they hadn't told him either. But just the same he was right. Sooner or later somebody would have to tell me something, and with that in mind I began to unpack.

Ten minutes later the phone rang. It was Jacobsen telling me he was on his way up.

I'd known him before, of course—first in Austria when he was running a net into Czechoslovakia and a couple of the other southern satellites, and then later in Berlin where he was Giddings' predecessor as controller. From there he'd moved on to Southeast Asia, somehow emerging from that quagmire with his reputation intact. The last I'd heard he had been appointed something fairly high in internal security at Langley. In any case, he was a little balder now than I remembered him, and plumper. But he still had the same petulant baby face and large pouchy eyes whose heavy lids drooped continually as if to hide the quick intelligence that lurked behind them.

"Welcome to the land of the big PX," he said. "This must all seem pretty strange to you. How many years has it been?"

"More than I like to remember. Things come back pretty quickly, though."

"Isn't that the truth? How's my friend Giddings doing these days?"

"Same as usual," I said. "I think he was a little disappointed when he wasn't on the list for Vietnam, but he got over that quickly enough when he saw how things were turning out over there."

"No silver lining within its cloud," Jacobsen said. "What did he tell you about this current caper—that it's the usual piece of cake?"

"Not quite," I said.

Jacobsen laughed. "No, I guess not. There's a big difference between sending somebody back to this country and getting them to slip behind the curtain to meet an agent who may or may not be who he says he is. Actually, though, that's all we want you to do here. Meet somebody."

"Who?"

"That's what we want you to tell us." He looked at me quizzically. "Ready?"

"Now?"

Jacobsen smiled. "Initial impressions are always the best ... "

The Jefferson Memorial is on the wrong side of the tidal basin to be in the main tourist stream, but it gets its share and there were a scattering of people about when Jacobsen and I got there.

He paused at the top of the step just inside the dome to take his pipe from his jacket pocket and ostentatiously begin to fill it.

He hadn't brought me there just for the view, of course, and in any case there's no smoking in any of the monuments. "What happens now?" I said.

"That depends. See anybody you know?"

At first I didn't, but then I spotted a lightly built man moving slowly around the rotunda, seemingly engrossed in the inscriptions around the top. Like me he was wearing a suit that was just a little too bulky and heavy for the climate. I nodded to indicate him. "That the one?"

"If you know him, yes."

"His name's Juri Kapalov," I said. "At least that's what he was calling himself at the time. That would have been five or six

years ago—he was working as a chauffeur for the Soviet Embassy in Brussels."

"Now he says he's a major in the KGB."

"Could be," I said. "He was a captain then. I was playing an Air Force sergeant with secrets to sell—on the assumption that if we could find out what they wanted to know we'd know where they were weak—and Kapalov was supposedly just a flunky sent out to pass on messages. Although I wouldn't bet I fooled him any more than he fooled me."

"Nor would I," Jacobsen said. "Because, you see, it was Kapalov who suggested we bring you over to verify his bona fides." He put his unlighted pipe back in his pocket. "Let's go," he said.

"And that's it?"

"For the moment," Jacobsen said.

We drove down to a small restaurant across the bridge in Arlington.

Not surprisingly, Kapalov was already there waiting for us in a back booth.

"Were you followed?"

"Of course not," Jacobsen said. "There's no reason we should have been."

"No? Perhaps not. But you checked anyway."

"Of course."

"Good. So did I. But then I have perhaps more to lose than you." He smiled faintly. "It's been a long time, my friend," he said to me. "I hope you don't mind my calling you my friend. After all, we are professionals and what our jobs require us to do shouldn't be allowed to impact on our personal relations. Wouldn't you agree?"

"Sure," I said. "As long as you can tell where the job ends and the personal begins."

Kapalov's smile broadened. "Granted," he said. "But perhaps I can ease your mind with evidence of my good faith. You have in your organization what I believe your allies the British call a mole—a highly placed official who is really one of ours."

"That's hardly news," Jacobsen said.

"No, you've known it since Golitsyn defected last year. But what Golitsyn couldn't tell you was who."

Jacobsen took his pipe from his pocket and lit it thoughtfully. "And you can?"

Kapalov shook his head. "Not directly. I do know this, however. Unlike the Britisher Philby, this man was not ours from the beginning. He was corrupted by an agent he thought he was running, turned, and was carefully groomed and assisted to rise to his present position. The agent's code name is Alex."

"Golitsyn told us that too."

"But not who Alex is. That is *my* contribution."

"For what in return?"

"Assistance," Kapalov said. "The people in the Kremlin think Golitsyn is ripe to redefect."

"They can't be serious!"

"Why not?" Kapalov asked. "He was no ordinary defector. Look at him—the youngest staff colonel in the history of the Soviet Army. A man with a brilliant future. And then, as the result of a run-in with a superior whose only glimmer of intelligence was the sense to realize he ought to be jealous, he chucks it all and flees to the West. And for what? Six months of intensive debriefing by your military intelligence services and then, when every last drop of useful information has been drained from him, a quiet brushoff to a tract house in a dreary suburb, and an even drearier job translating documents in some obscure corner of your State Department. That must gall a man of his talents and intelligence like wormwood.

"My masters' idea, then, is that I approach him with the proposition that he agree to redeem himself by acting as our agent. Thus, in time, he can return as a hero and his whole defection can be passed off as a clever plot to deceive the wicked capitalists. And, in fact, an important side benefit would be to discredit the information he gave you as the obvious lies of a planted agent. My superiors are convinced he'll jump at the chance."

"But you're not."

"Far rom it," Kapalov said. "Golitsyn has his own peculiar code. As a point of honor, he took nothing from Russia but his brains, which he could hardly leave behind. He would do the same for you. Once returned, he would tell us what he knew but he would not spy or lie or cheat to achieve that return. He's not fool enough, however, to believe that we would honor any

commitment or promise.

"It would be a different matter, though, if you were to urge him to cooperate as a double agent as a means of proving his loyalty to his new country and thereby qualifying himself for the kind of work for you that he did for us."

The Russian smiled. "I have no illusions, of course, that he would not in fact *be* a double agent. Still, I'm sure there would be enough good information mixed in with the bad to make his performance credible. And that, for my purposes, is good enough."

"And when Golitsyn eventually declines to return to Russia?" I said.

Kapalov continued to smile. "By then," he said, "I trust I shall have moved on to other, more important matters. And in any case I imagine you'll contrive to find a way to make it appear someone else's fault and not mine in any way. You see, I also have no illusions that this will be a one-time arrangement. Once we 'cooperate' I become your man for life. And I'm a young man. It's not inconceivable that I could become a general someday. All the more so since it would be to your interest as much as mine to see that my career prospered. All of us would benefit."

"So it would seem," Jacobsen said. He sat silently for a moment, cupping the bowl of his pipe in his hand. "I'll have to kick this upstairs, you know," he said at last.

"Of course," Kapalov said. "And so that *your* superiors will know that I can deliver what I promise, I'll give you Alex's name now. It's Victor Kolia. He left your service some years ago and is now living happily in retirement in Florida." He smiled and rose. "That's how much I trust you not to be so foolish as to turn me down. You know how to get in touch with me."

He went out. I noticed he left his check for Jacobsen to pay.

Macready sat with his hands clasped lightly in front of him on the big wooden desktop. He was a tall, spare man in his mid- to late-fifties with a thin patrician face and thinning blondish hair brushed impeccably back from a high forehead. He would never be Director, agency gossips said—too abrasive. Which meant he wouldn't play politics, office or otherwise. But he had come in back in the early Dulles years, and despite a lack of field experience—or perhaps because of it—had risen steadily if not spectacularly to become head of internal security and, those

same gossips said, the one man the Director, whoever he was, always listened to.

Now he sat listening himself as Jacobsen outlined Kapalov's proposal. Finally he said:

"Do you trust him?"

Jacobsen made a show of getting out his pipe, filling and lighting it. "About as far as I can throw that desk," he said. "But that's prejudice rather than facts. And I have to admit that no intelligence agency in its right mind anywhere would jeopardize a highly placed mole just to plant a double of Kapalov's caliber. On the other hand, they may have written their man off already, figuring that once we knew he existed we were bound to ferret him out eventually, and are just making the best of a bad situation. The only way to find out for sure is to give Kapalov rope and see if he hangs himself."

"You assume then that he's telling the truth about Kolia being Alex."

"There's one way to find out," Jacobsen said. "Pull Kolia in."

"Perhaps," Macready said. "But I want to precipitate action—nothing that would cause Kolia or the mole to bolt. I want them both ready and waiting for the ax when it's ready for them. In the interim, there's the matter of this man Golitsyn. You debriefed him. Will he cooperate?"

"I think he could be persuaded," Jacobsen said. "Kapalov didn't lie about one thing anyway. Golitsyn *is* wasted where he is now. He knows it and so does everybody else. The problem is that the kind of work he'd really be competent at requires a security clearance, and, of course, no defector's ever going to get that because there's always that slight possibility he's really a double in disguise or someday will pull a double dutch and run back home to the motherland. Tell Golitsyn this is the way to get that clearance and, to coin Kapalov's phrase, he'll jump at it."

"Do so then," Macready said.

"And when it's time to deliver?"

"We'll worry about that when it's time to worry about that," Macready said. He looked coolly over at me. "So far," he said, "no one outside this room other than the Russians—defectors or otherwise—knows anything about any of these matters. It will stay that way."

"I understand."

"I'm sure you do. But for security's sake we must operate very much like the Mafia. Once in, you get out only when we decide to let you. Which will be when this mole business is settled for good and all."

Macready smiled briefly, without warmth. "I suggest you buy some summer suits. Otherwise I'm afraid you'll find the climate around here very uncomfortable. But then you've probably already realized that."

Golitsyn's home wasn't a mansion by any means, but it was hardly a tract house in a dreary suburb either. It was a pleasant split level on a quiet street with enough space between it and its neighbors to afford its occupant a fair degree of privacy whenever he wanted it—which, considering Golitsyn's circumstances, I suspected he usually did.

He sat on the sofa in the living room lighting a fresh cigarette from the stub of his previous one. "Always before," he said, "I have dealt with either the man Macready or his deputy Jacobsen. Why is it different now?"

"That's something you'd have to ask them," I said. "Maybe they thought a new face would attract less attention." Actually the reason was to give me a chance to form an independent judgment of Golitsyn the man—or at least that's what I had been told.

Golitsyn shook his head. "Pah! Why bother? They have contacted me at my work—or what they call my work—and told me I may speak freely with you." He laughed harshly. "As if that were not always my problem. I spoke freely in the Soviet Union and it led to my defection. I spoke freely here to your man Jacobsen and it led to what? This." He swept his hand around to indicate the room.

"I ask myself often how would it have been if I had said nothing. Not about the military and technical things—that they knew I knew. The other, though—that is not information that is usually shared with staff colonels. But X says something here and Y says something else there and a clever man can piece it together into a whole. And I thought if I show these Americans just how clever I am, then they will really appreciate the prize they have in me. What I forgot is that only bearers of good news

are rewarded and not always even then. There! Do I speak freely enough?"

I nodded.

"But that is not why you came, to hear me speak freely."

"No," I said. "We have information that the Russians believe you're ready to redefect."

"To return to the Soviet Union?" Golitsyn smiled sadly and shook his head. "No. That door was closed forever."

"They don't think you realize that," I said. "They plan to offer to let you earn your way back into their good graces by spying for them. We'd like you to pretend to go along with them."

Golitsyn looked up sharply. "Why?" he said. "So I can be your spy and tell them only what you want them to know?"

I nodded again. "I was told to tell you that if you did, you would afterwards be given a security clearance and allowed to do the kind of work you're qualified for."

Golitsyn's face sobered and he looked at me earnestly for a long moment. Then he leaned back against the sofa and laughed loudly. "A very revealing statement," he said. "Your were told to say. Not 'you *will* be given.' Tell me, you who are so careful with your words—do you think they will keep their promise?"

I'd been lied to too often myself to lie now. Nor would I have fooled him if I had. "I don't know," I said.

"Nor do I," Golitsyn said, his face sobering again. "But what choice have I? I can't go back. Oh, they wouldn't shoot me as in the bad old Stalinist days. They've learned that much from you. Instead, they would parade me in triumph—the man who had been to the West and seen through it. What an object lesson to others who might be tempted to do as I had. Then, when my usefulness was at an end, I would be quietly shuffled off to obscurity.

"But neither can I stay as I am. Each week now the vodka bottle empties a little faster. Soon—" he shook his head "—soon I will no longer count or care. So what else can I do but plunge ahead and once more trust?"

I had no answer, and two weeks later he called me to report that Kapalov had contacted him and that they had arranged to meet that night in a shopping-center parking lot.

It wasn't the sort of spot a film director would have chosen for

a spy thriller, but as meeting places go in the real world it wasn't a bad choice—convenient, easy of access, and, more importantly, a place where both parties could easily have legitimate reasons for being. The only drawback was that the same crowd that Kapalov hoped to merge into would also effectively screen anybody who knew about the meet and took the precaution to show up early—which, of course, is what Jacobsen and I did, he ostensibly waiting his turn in a barbershop three stores down, me slouched unobtrusively in my car just beyond the reach of the lights.

Golitsyn arrived first, walking down the line of shops to stand finally before a lighted hardware store window as if contemplating a purchase. Twenty-five minutes later he was still there, still alone. But now his nervousness was obvious as he strained to prolong his cover beyond its reasonable span. He began to fidget, then pace. Finally when he could bear it no more, he turned and stepped off the curb to start back toward his car. As he did, a car motor roared to life at the far end of the lot. Reflexively my head swiveled toward the source of the sound. As a result I didn't see the figure dart out from the dark passageway between buildings, fire twice, then dart back—then, of course, it was too late.

"A setup," Jacobsen said bitterly. "A goddamn lousy setup."

I had been the first to reach Golitsyn. His eyes, I suppose, should have been reproachful, but they were merely dead. A crowd had begun to form, and since there was nothing more we could do for him—or to him—we had simply melted back into it and were long gone by the time the police arrived. It was later that same evening—or morning, rather, by now—and the three of us sat in Macready's office assessing the damage.

"Not necessarily," Macready said. "Not from the beginning anyway. It may simply be that someone on the other side tumbled to what Kapalov was up to and decided to take corrective action."

Jacobsen shook his head. "No," he said. "If that were the case, it would be Kapalov's body lying on that lot. Instead I suspect it won't be long before *Colonel* Kapalov turns up again on some plum assignment, his just reward for another dirty job successfully completed. And not much we can do about it either."

"So where does that leave us?" Macready said.

Jacobsen shrugged. "About where we were before," he said. "Although," he added thoughtfully, "I suppose on the positive side we can scratch Kolia off as a possible Alex. They'd never give up the real name for an operation they planned to blow almost as soon as it got off the ground."

"Maybe that's what they want us to think," I said.

Macready looked at me sharply. "Do you have a reason for saying that," he said, "Or is it just speculation?"

"Call it speculation with reason," I said. "But there are just too many things about this whole affair that don't add up. For one thing, what reason would the Russians have for wanting to kill Golitsyn after all this time? We'd already milked him for all he knew, and we sure as hell weren't using him effectively against them.

"I suppose it could have been for revenge or to prove to other would-be defectors that they'd never be safe no matter where they went. But then why go through all the mickey-mouse? From what Kapalov said, they knew where he was. Why not just cut him down as he left the house some morning? Why bring us in at all? Unless, of course, Golitsyn is just a smoke screen and the real purpose is something else."

"Such as?"

"Protecting the mole," I said. "And what better way than to give us the information we were after in such a way as to lead us to discredit it? At the very least, it would set us back months if not years. And by then who knows what other schemes they could have worked out to protect their man?

"But then, of course, they'd have had to know we were aware of the mole's existence. And that's the other thing that doesn't add up. Golitsyn said it himself. It isn't the kind of information that's normally shared with staff colonels. For that matter, it isn't the kind of information that's normally shared with KGB field majors either.

"But the issue isn't how Kapalov knew. He could have stumbled on it inadvertently or pieced it together the same way Golitsyn had. The question is how he knew Golitsyn knew. How did *anybody* on the other side know? Obviously, they were told."

"That's impossible," Macready said. "Until you came in, only —" He broke off.

"That's right," I said. "Only you and Jacobsen knew. So one of you is the mole."

The corners of Macready's mouth turned down. "It isn't me," he said.

"No," I said, "it isn't. By all accounts the mole was turned by one of his agents, and you've never run agents in the field. But Jacobsen has. Check into it and I think you'll find that Kolia was one and that the string of successes that have put him where he is date from that time too."

"Speculation with reason," Jacobsen sneered. "If that's what you call reason, I'll take nonsense every time. You can't prove a shred of that."

"No," I said, "but Kolia can, and what do you want to bet he won't fall all over himself doing just that once he realizes the hot spot he's in."

Jacobsen's eyes held mine for a long moment, then his hand went down into his pocket. I shot him twice before he could pull it out, the bullets catching him high in the chest and knocking him and the chair over together. As he fell the pipe flew from his fingers and clattered on the wall opposite.

Macready stood for a long time staring at the fallen body, his face ashen. Finally he found his voice. "That was unfortunate," he said. "We could have turned him again. Gotten him to work for us against them."

"I know," I said. I'd known too that it was his pipe he'd been reaching for, not a gun. But Golitsyn's options had been a lot less than he'd bargained for. I thought his betrayer's should be too.

THE MUNICH COURIER

by Robert Edward Eckels

The rain started in earnest just as I left the train station and to cap it off there wasn't an Army car waiting for me. I hadn't really expected one although Giddings had assured me that of course there would be one. But then Giddings worked out of a nice warm office in Berlin and it tended to give him an overly optismistic viewpoint.

"It's really the Army's job more than ours," he had said, his ever-present pencil clasped between his two hands as he swiveled back in his chair and gazed up at the ceiling. Giddings had opted for the C.I.A. when he was graduated from an Ivy League college, but he affected the same rising-young-executive mannerisms as his classmates who'd chosen Madison Avenue or Wall Street. "An Army courier traveling north from Munich was murdered on a train and some passports he was carrying were stolen," he went on. "But the Army's criminal investigation people haven't been able to come up with anything solid so far. Since we have at least a peripheral interest because some of those missing passports are going to turn up in the hands of agents trying to infiltrate the U.S., I volunteered your services."

He brought his eyes down to mine and smiled ingenuously. "After all, you did prove yourself a pretty good detective in that Murphy affair behind the Iron Curtain. And when I mentioned you to General Cole he was most enthusiastic about giving you a crack at it."

"Thanks a lot," I said drily. Despite General Cole's enthusiasm I had no illusions about the kind of reception I'd get from the men in the field. It's only in television, movies and books that investigative agencies welcome outsiders coming in to tell them their business. Nevertheless, Giddings was my boss, and where he said go I went.

Now, with fine rain soaking into my topcoat and no Army car to meet me, I found nothing to convince me I was wrong. Still, a job was a job. I shrugged, turned up the collar of my coat, and ducked out to compete with the rest of the passengers for a cab.

The lieutenant who came in answer to my call from the quard

post at the main gate to the U.S. Army post just outside town was properly apologetic. He was also very young and very sincere. So he just might have really believed that the whole thing had resulted from a mixup in dates. I didn't contradict him and he took me straight to the post adjutant.

Who was something else again. He was a short barrel-shaped man named Donovan—a captain and well aware of the fact that he was growing old in grade. His graying hair was cropped Prussian short, and his eyes were small and bitter. He glared at me sourly from behind his desk. "So you're the man from Berlin," he said. There was no welcome in his voice.

I nodded. Besides Donovan and myself there were two others in the room: a tall sleepy-eyed man in civilian clothes named Hurley who was a sergeant in the Army's Criminal Investigation Division and a uniformed corporal named Lassiter.

"Well," Donovan went on, "I don't know what you expect to accomplish." He shot an angry glance at Hurley. "The C.I.D. has been raking the thing over for the past three weeks. With no luck."

Lassiter smiled nervously, but Hurley's face didn't change.

Donovan waited another moment, then turned back to me. "Are you acquainted with the facts in the case?" he said.

"Only in general," I said. "They told me in Berlin that you'd fill me in on the details here."

Donovan nodded curtly. "I don't know if you're familiar with the passport situation or not," he said. "Military personnel don't travel on passports, of course. But their dependents do, and so do U.S. civilian employees of the Army.

"Now, German law requires that all aliens residing more or less permanently in Germany have their passports stamped each month at a police station. To spare our civilians this inconvenience the Status of Forces agreement exempts anyone with a properly validated passport that identifies him as an Army dependent or employee. Unfortunately, the validation is good for only eighteen months. Don't ask me why, because the normal overseas tour for a career soldier or civilian employee is three years."

"So," I said, "the passports have to be revalidated at least once during each tour of duty."

"Right," Donovan said. "And the only place it can be done is

at Army Headquarters at Heidelberg." He smiled wryly. "Originally each post would send its own courier to Heidelberg whenever it had a batch of passports needing revalidation. But then we got organization.

"A system was set up whereby the courier from Munich would take the train up once a month. And at each stop he would meet a local courier who'd turn over his passports to be taken on to Heidelberg for revalidation. On the return trip the process would be reversed."

Donovan paused and made a slight negative gesture with his hand. "Like so many things that don't work out, it seemed a good idea in theory. It saved the expense involved in each post sending a man all the way to Heidelberg, and Headquarters didn't get its work piecemeal."

"On the other hand," I said, "the Munich courier would be carrying a pretty large number of passpports by the time he got to Heidelberg."

Hurley decided it was time to put his two cents' worth in. "I'll say," he said. "The courier who was killed was only halfway through his run and he already had one hundred and fifty passports with him. Each of them is worth five hundred dollars on the black market—more probably when you're dealing with so many."

I whistled. "Which gave him a load worth at least seventy-five thousand dollars!"

"Right," Donovan said impatiently. He held up a hand palm forward as if to forestall me. "But we recognized the temptations involved and set up strict controls.

"In the first place, every passport is accounted for at every step of the way, and there's no ducking responsibility. For example, the individual turning one in to me for revalidation gets a signed receipt from me, and the passport itself is locked in my safe until it's time for the run. Then at the time the passports are batched up for shipment to Heidelberg, a blanket receipt listing every name and passport number is prepared. The local courier signs one copy when he picks up the passports and takes another copy with him for the Munich courier to sign as his receipt."

"And you better believe we're careful," Lassiter put in. I turned to face him. He was a lanky individual with a pleasantly bony face, sandy hair, and a ready grin. "I ought to know," he

said. "I'm the local courier and I walk on eggs every time I have a batch of passports in my hands."

"He's right," Donovan said. "Everyone who handles passports knows he doesn't stand a chance of going uncaught if he tries to steal one.

"The other possibility, of course, was that somebody would try to hijack the Munich courier. To guard against that we varied the day he'd make his run and the train on which he'd travel, keeping it a secret even from the local couriers until just before they had to make their own runs down to the station. The Munich courier would be in civilian clothes to keep himself inconspicuous. On top of that he was armed with a .45 and he traveled in a private compartment which he kept locked and was under orders to open to nobody."

"How would he get the passports from the local courier then?" I said.

"At each stop," Donovan said, "he'd leave the compartment, locking it behind him, and meet the local courier on the plat- form outside. Together they'd check the local man's passports against the list-receipt. If everything checked out, the Munich courier would sign the receipt and thereafter assume responsi- bility for the passports. If anything did not check out, he'd refuse to sign and the local man would have to explain it to his Commanding Officer. Of course," Donovan added gruffly, "ev- erything always checked out, so there was never any question of that."

"I see," I said. "This would be the time when he was most vulnerable, though—when he was going back and forth between the compartment and the platform."

Donovan gave me another sour look. "Yes," he said, "but it was also the time when he was most on guard. And with the number of people always around on the platform the possibility of pulling off a hijack undetected was nil." He shrugged and gave his head a slight toss. "It was a good system," he said, "and it worked."

"Until three weeks ago," I said.

Donovan looked at me for a long moment, then nodded grimly. He turned to Lassiter. "You want to tell him about it, Corporal?" he said, "It was your run."

"Why not?" Lassiter said cheerfully. "It'll only be for the

thousandth time." He grinned. "There's not much to tell, though, really. Three weeks ago I made my regular passport run down to the *Bahnhof*. As usual I was ten or fifteen minutes early. So I waited around on the platform for the train to come in. Only this time when it did, the Munich courier didn't get off."

"What did you do?" I said.

Lassiter shrugged. "Nothing," he said. "The train stops a little longer than usual here because this is where the crew changes. So I thought maybe he was just waiting until most of the crowd got down before he got off."

"You didn't get on the train and go looking for him?" I said.

Lassiter shook his head. "No, sir," he said emphatically. "I didn't know which car his compartment was in and I was afraid I might miss him if he did get off."

"But he never did?"

"No," Lassiter said. "The train pulled out leaving me there on the platform. It was the first time anything like that had ever happened and the only thing I could think of was that somehow there'd been a mixup on the trains. There was another one due from Munich in another hour. So I waited around for it. When there wasn't a courier on that one either, I came back to the post and returned the passports to Captain Donovan."

The captain cleared his throat. "The first thing I did, of course, was to phone Munich. They said the courier had left as scheduled."

"That's where our people came into it," Hurley said. There was a decisiveness in his voice that belied his sleepy eyes. "A couple of MP's met the train at Heidelberg and went through it with the German authorities. They found the Munich courier all right—dead in his compartment. He'd been knifed in the throat and all the passports were gone. Apparently he'd been taken by surprise because his gun was still in its holster and it didn't look as if there'd been a fight."

"Was he the regular Munich courier?" I said.

Hurley nodded. "One of the regulars," he said. "A Master Sergeant named Bruton. He and three other NCO's rotated the duty." He smiled tightly, without humor. "And that's about all we know. We checked back on his run and he made every stop between Munich and here and none after. Which pinpoints it as

happening somewhere between the last stop—Rundesheim—
and here. We questioned the train crew but none of them saw
anything out of the ordinary on that particular stretch of track—
or for that matter anywhere from Munich up to here."

"How about the other passengers?" I said.

"You tell me who they were," Hurley said heatedly. "Nobody
makes lists of train passengers. By the time we found the body
the train was almost empty and nobody's come forward to
volunteer anything." He subsided into his chair. "We had the
crime lab boys go over that compartment with the proverbial
fine-tooth comb. They found nothing. Oh, plenty of fingerprints,
of course. But they were all Bruton's or the crew that cleaned the
compartment before the train left Munich. And the crew all had
ironclad alibis."

I turned to Donovan. "What did you do with the passports
Lassiter brought back?" I said.

He raised his eyebrows at me. "Left them right in his brief
case and locked them back up in my safe until we can work out a
new way of shipping them to Heidelberg," he said.

"May I see them?" I said.

Donovan hesitated, then shrugged and went to the safe. He
opened it with his back to me and pulled out a thick plastic brief
case. He came back to his desk, sat down, and pushed the brief
case across to me. All without a word.

I smiled briefly, unzipped the case, and emptied it of all its
contents—25 green-and-gold U.S. passports. Worth, if Hurley
was correct, over $12,000 on the black market. I arranged them
into neat piles, aware that everyone was watching me.

"How many stops did the train make between here and
Heidelberg?" I said to Hurley.

"Three," he said. "Four if you count the suburban station at
the north edge of town here. But only three where passport
pickups were scheduled."

I nodded slowly. It all fit together now. I said, again to Hurley,
"Did anybody check with the crew taking the train north from
here to see if they noticed anything out of the ordinary?"

"No," Hurley said coldly. "There was no point to it, because
whatever happened had to happen before the train reached
here."

"Not necessarily," I said. "I'm not a policeman and I don't

know police routine. But I do know clandestine operations, and I've been sitting here thinking just how I would pull this kind of operation off. And there's only one way it could have been done."

I smiled at Hurley whose eyes were no longer sleepy. "The obvious first move would be to corrupt one of the local couriers."

"Impossible," Donovan said. "Nobody's going to put himself in a position where he's sure to be caught and punished."

"He will if the price is right," I said drily. "But when you come right down to it, the only one who couldn't duck responsibility was the Munich courier. All one of the local men would have to do is turn his passports over to Bruton in the usual way, get his signed receipt, then follow him on to the train to find out where his compartment was located. It would be simple enough for the local courier to get the man from Munich to open up. After all, he would know the local man and if the local man called out something like 'I've got a passport you signed for—' "

I paused and smiled grimly. "And unless I miss my guess that's just what happened. Only Bruton got a knife in the throat instead of a passport."

"My God!" Hurley said. "The Rundesheim courier."

I shook my head. "No," I said. "It was Lassiter here."

"No, you don't," Lassiter exploded. Blood had suffused his face, turning it ugly. "You're not going to hang me with a lot of blue-sky speculation. You get yourself some proof before you start throwing accusations around."

Donovan nodded in agreement, and Hurley turned his eyes on me.

"It had to be Lassiter," I said. "Only a fool would admit to being the last to see Bruton—which eliminates the Rundesheim courier. The smart man would turn his own passports back in and claim never to have met Bruton. Which is exactly what Lassiter did. The timing works out, too. Instead of waiting for the next train, as he claimed to, he rode up to the suburban stop and got off there. That's where he must have called from."

"You're still guessing," Lassiter said.

"True," I said. "But if you want concrete proof—where's the Munich courier's receipt?"

Hurley frowned. "I don't follow that," he said. "He wouldn't

have a receipt if he didn't meet Bruton."

"Precisely," I said. "But he would have brought back *the unsigned copy* and it should have been in the brief case with the passports. But it wasn't because Bruton had signed it and Lassiter didn't dare let that be found." I turned and smiled at Lassiter. "And that missing receipt is what's going to hang you," I said.

ATTENTION TO DETAIL

by Robert Edward Eckels

The U-boat lay low in the water, its decks almost awash, and shrouded by night fog so thick that from the conning tower even the outline of the forward gun was hazy and indistinct. But only fools lingered on the surface so close to danger, and by the time Steiner came up on deck the crew had already got the rubber raft inflated and over the side.

Steiner found himself shivering—and not from the damp. From excitement. Because less than a hundred yards beyond the fog bank lay the enemy coast—Long Island—and no one in the six months that the U.S. had been in the war had got closer. Not yet anyway.

Arrogantly he looked up toward the conning tower where Prien and the captain were stationed and smiled sardonically. Prien was all right—a good party man. But the captain— Still smiling, Steiner saluted them both, knowing it would infuriate the captain but that he would respond punctiliously anyway.

Beside him, one of the sailors said, "All ready."

The "sir" was omitted deliberately, Steiner knew, but he didn't say anything. The two sailors who would row him were already in the raft. Steiner cast one last glance at the occupants of the conning tower, then let himself be lowered into the bobbing boat. As it began to make way, one of the sailors still on deck knelt to pay out the line that would haul it and its crew back through the surf after Steiner had been safely put ashore.

Steiner sat stiffly in the rear of the raft. He was no boatman and now, as the fog closed in, the confidence he had felt back on deck ebbed fast. He was frightened by the pitching and tossing, and, worse, he knew, showing it.

Then almost before he was aware of what was happening, a wave larger than the rest shot them forward dizzyingly. Steiner opened his mouth to shout, but no sound came. Then suddenly the water was foaming back away from them and somehow, miraculously, they were ashore. In almost blind panic he scrambled out of the boat and up above the wave line.

The two sailors watched him impassively, waiting until he had got control of himself again. One of them tossed him the

waterproof bag with his American clothes, then both sailors dragged the boat back into the surf.

Steiner made no move to help them. They could drown for all he cared. The clods. His was the important mission, and only he could accomplish it. The Commandant himself had said as much back at the training camp.

"The reports are uniformly excellent," Reinboldt had said. "Which in a way, of course, is only to be expected since you were well screened before you were selected. But even so, your progress in response to the training has been much faster than any of us anticipated."

"Thank you," Steiner said quietly. He sat at ease across from the Commandant's desk, behavior unthinkable under any other circumstances, but insisted on here as an essential part of his "Americanization."

"As a result," Reinboldt went on as if uninterrupted, "the Fuhrer has decided to move your mission forward. You will leave for the United States next week. Your targets remain unchanged, of course. First Roosevelt, then Marshall." Reinboldt paused to light a cigarette. "I don't have to tell you the consequences of success," he said. "Or of failure."

Steiner smiled faintly. "I won't fail," he said.

"No," Reinboldt said, "you won't." He took an envelope from his desk and passed it across to the other man. "Your cover has been well prepared. These are the documents you will need to start: driver's license, draft registration—deferred status, of course—Social Security number and all the other paraphernalia Americans seem to find indispensable."

Steiner looked at the papers approvingly. All had a slightly worn look as if they'd been carried about in a man's wallet for some time, and included among them was a certified copy of a birth certificate indicating he had been born in Milwaukee, Wisconsin, on October 14, 1918. It was, he reflected, his real birthday.

"Your name," Reinboldt went on, "was chosen with equal care—Frederick William Johnson. Frederick William because it's close to your own and thus, like the birth date, easy to remember. Johnson because it's one of the most common American names but yet not suspect like Smith or Jones. You should

practise writing it until your signature flows naturally."

"I will," Steiner said.

"We have also arranged for you to be given $10,000 in various denominations of American currency. Used carefully it should be more than enough. One word of caution, though. For security reasons it was necessary to obtain the bills from sources solely within the Reich and the larger denominations are from a single shipment received by the Berliner Kreditanstalt in 1932. Ten years is a long time, but the serial numbers are consecutive, and it would be less than wise to assume that no record exists by which they could be traced. For safety's sake spend or exchange them in different places and where you are not known or likely to return."

Steiner smiled wryly. "You don't overlook anything, do you?"

Reinboldt didn't return the smile. "The secret of success," he said, "is attention to detail. Remember it. It pays."

It did indeed, Steiner thought, shivering purely from the cold now as he stripped to change from his submariner's uniform to his American clothes. It was a pity, though, that all that careful planning hadn't taken the American climate into account and provided some sort of heating arrangement.

Or perhaps it had been considered. Steiner smiled to himself as he pulled his trousers on. It would be just like Reinboldt to have thought of it and then discarded the idea on the theory that the cold would drive his man to work faster. And in any case Steiner did finish quickly, stuffing the discarded uniform into the bag and then carrying it down to bury it below the wave line where the lapping water would erase the last traces of digging. The small shovel—a child's toy really—he simply discarded several yards farther down the beach where it would appear just another piece of holiday litter.

Now all he had to do was head inland away from the water. Here the fog—great gray billows that reduced visibility to a matter of yards at most—was a complicating factor. But he had his compass and even if he did drift slightly off course, sooner or later he was bound to hit the rail line that ran parallel to the coast for miles in both directions. Then it was just a matter of following the tracks to the next town and picking up the first train out in the morning.

All the more then was his surprise when he stumbled onto the dog halfway across the beach.

It was a shepherd dog, not yet fully grown, running free but trailing a leash. It stopped, hackles rising, when it saw Steiner and for a moment man and animal eyed each other warily. Then Steiner began to edge around it, careful to keep the distance constant and his eyes steady on the dog's. The dog continued to bristle but didn't move. Steiner began to breathe easier.

Then he heard the voice calling out of the fog, "Rex! Rex! Where are you, boy?"

The dog hesitated, distracted momentarily by its master's voice; then as Steiner reached too quickly for his gun the dog launched itself straight at him.

Steiner forgot the gun and ducked down instead to grab the leaping animal's extended forepaws and jerk them violently apart.

The dog died instantly. Steiner let it fall, then crouched beside its dead form, his hand tight on the gun again. The voice was more urgent now and coming closer.

"Rex! Rex!"

Go back, you fool, Steiner thought. Go Back!

But he came on, first the glow of his light visible through the murk, then the man himself. He was young—in his early twenties—and wearing a blue sailor's uniform but with military leggings and web belting. As far as Steiner could see, though, he wasn't armed, and Steiner rose slowly to face him.

"What's going on here?" the sailor said. His flashlight picked up the dog's limp body. "Rex?" He bent over the dog. "My God, what happened?"

Steiner struck swiftly, smashing the gun into the base of the sailor's skull. The man dropped like a stone. Steiner hit him twice more to make sure, then felt for the carotid pulse. There was none.

Steiner knelt beside the dead sailor. He felt no remorse or regret, only annoyance that this might complicate his mission. The bodies were bound to be discovered and that would bring questions about who and why that Steiner didn't want raised. Or maybe not. Maybe he could confuse the issue at least long enough to let him get clear, and that was all he really needed.

The trigger guard on the gun had bent slightly under the force

of his blow and there was a smear of blood along the underside of the barrel. Steiner wiped it clean on the sailor's blouse before tucking the gun back under his jacket. Then catching hold of the man's body under the arms he dragged it down into the surf, soaking himself in the process and losing his sense of direction so that he wasted ten precious minutes searching for the dog.

But luck was still with him, and finally he found it. The dog wasn't a heavy animal and there was no blood. He picked it up in his arms and carried it into the woods beyond the beach, hiding the animal's body under a pile of rotting underbrush. The leash and collar he took with him to throw into a field on the other side of the railroad tracks.

By then his clothes had begun to dry and he felt more himself again. It helped too when he found a town sooner than he had expected. The train station was closed for the night, but there was a convenient patch of woods across from it. Steiner found himself a spot near the middle where he was sure he couldn't be seen, put his back up against a tree, and closed his eyes ...

He awoke to find it full light, the sun already high enough to have burned off the last traces of the night's fog. That confused him, because even exhausted as he'd been, the noise and clatter of trains arriving and leaving should have awakened him. Even more confusing, though, was the station itself. It should have been crowded with commuters headed for the city, but in fact it looked as deserted now as it had the night before.

Steiner watched the station quietly for several more minutes, then got up cautiously and went over to investigate. It was deserted. The door was locked and the ticket window shuttered, but there tacked up on the wall beside it was the schedule: 5:18, 5:45, 6:14, 6:40, and so on up to 8:13, then every hour thereafter.

Steiner looked down at his watch: 8:05. And that was the right local time—he'd set it himself on the U-boat from a New York radio station they had monitored. But 8:05 became 8:30 and then 8:35 and still on train appeared. Steiner began to sweat. What had gone wrong? A breakdown on the line? Or something worse? Something that had to do with a body on the beach—and with him?

He was still trying to make up his mind when he heard someone approaching up the path from the town, whistling as

he came. Steiner hesitated, then stepped back carefully against the wall in case the whistling wasn't as innocent as it sounded.

Moments later a tall thin-shouldered man with a bony young-old face came around the corner of the building. The man stopped whistling when he saw Steiner but otherwise went on about his business, pulling out a large key and unlocking the door.

Steiner tried to follow him in, but the man shook his head. "Station's closed. Buy your ticket on the train."

It hadn't been covered in his training, but Steiner reacted the way he thought as American would. "What the hell happened to the 8:13?" he demanded.

The stationmaster looked at him impassively, then tapped the tacked-up schedule. "Memorial Day, mister," he said. "Same schedule as Sundays." He went on inside, closing the door after him.

Steiner almost laughed with relief. There was nothing wrong after all. It was just a holiday. It would be a good joke to share with Reinboldt when it was all over—assuming Reinboldt was ever in a joking mood. In any case, his good humor restored, he turned back to the schedule, this time noting the smaller one at the bottom, the one for Sundays and holidays.

The train was at 10:23—less than two hours. Too long just to hang around the station, though, and to kill the time he strolled casually down into the town itself.

It was a pleasant little place, especially in the quiet of a holiday morning, and Steiner decided he might like to come back sometime—on vacation after the war perhaps—when he would have the leisure to really enjoy it. Now, however, he was content to stroll about, until the sight of an open restaurant reminded him he hadn't eaten since the day before. Suddenly ravenously hungry, he went in.

It wasn't crowded and he had no difficulty picking a booth near the rear where he could watch the entrance without being seen himself. The varied bill of fare astounded him, and he ordered heavily: hot cakes, eggs, sausages, and coffee—real coffee. If was almost as if there were no war. They'd learn differently quickly enough, but for the moment, Steiner reflected, the plentiful food was there to enjoy, and he ate with gusto, remembering, at the last minute to cut with his right

hand and then transfer the fork to eat. That, strangely enough, pleased him more than anything else.

The good feeling died quickly, though, when a policeman came in and headed toward him. He was a big man in his mid-fifties with a lined weatherbeaten face and a heavy gun worn butt forward on his right hip. Automatically Steiner's own hand slid under the table to close over the gun beneath his jacket. But then the other man pulled out a chair and sat down at a table across the aisle, refusing the menu the waitress proffered.

"Just coffee, Sal."

Steiner took his hand off his gun.

"I guess that was some excitement down at the beach this morning," the waitress said.

The policeman looked up at her wryly. "Well, now, word sure does get around fast, doesn't it?" he said.

The waitress shrugged. "Well, you know," she said, "small town and all that. One of the Coast Guard boys, wasn't it?"

Steiner stiffened. So the tide hadn't taken the body out after all. He cursed himself for a fool for having wasted the night. If he'd kept on, even hiking, he'd have been well clear by now instead of sitting here possibly trapped and, being obviously a stranger, suspect.

"Got himself killed, didn't he?" the waitress said.

"Something like that," the policeman said. "You can read all about it in the paper tonight. Now, how about that coffee?"

"Sure," the waitress said. She wasn't the least offended and poured the coffee nonchalantly. "While I think about it, Charley's looking for you. He picked up some Indianheads he wants you to look at."

"I'll stop by on my way out," the policeman said. He picked up his cup, then, leaning back in his chair, looked around casually, stopping as his eye caught Steiner's. "New around here, aren't you?" he said.

Steiner's hand started to slide back toward the gun.

"Come up for the fishing?" the policeman said.

Steiner's hand stopped. "Yes," he said, picking up the cue easily. "Yes, of course."

The policeman nodded slowly. "Seems half of New York comes out these days," he said. "Don't know where they get the gas. Still, you've got a nice day for it."

"Yes," Steiner said. "A very nice day." He turned back to his food. Half of New York! An exaggeration, of course. But still it meant a crowd of strangers among whom he could safely lose himself.

Deliberately he finished the last of his breakfast, then signaled the waitress for his check. The policeman, Steiner noted with satisfaction, had lost all interest in him—had in fact taken his coffee forward and was chatting earnestly with the cashier, presumably about those Indianheads.

American fashion, the waitress left his check face down on the table. It came to $1.70, and feeling generous Steiner tossed two of Reinboldt's one-dollar bills on the table to cover the amount plus tip, then sauntered out.

He was halfway down the street when he heard someone calling after him.

"You! Hey, you!"

He paused and looked back. The policeman had followed him out and was striding toward him now, holding something in his hand.

Fear rose like a hot floood in Steiner's throat. Because even at this distance he could recognize what it was—the two bills he'd left. Without really thinking what he was doing he began to run.

He heard the shout behind him, full of surprise, then the pounding footsteps, and ran faster. Then as suddenly as he had begun he stopped and swung around, pulling the gun out smoothly and dropping down onto one knee to steady his aim.

Caught off guard, the policeman threw himself desperately to one side, clawing—much too late—for his own gun. Steiner tracked him expertly. His finger tightened on the trigger.

It moved a fraction of an inch, then jammed, and the last thing Steiner remembered before the policeman's bullet smashed all thought in him forever was the bent trigger guard and Reinboldt saying, "Attention to detail . . . "

"Who was he actually?" the reporter said.

"No way to tell for sure," the policeman said. It was much later, and they sat together over coffee in that same small restaurant. "The address on his driver's license was a phony, and none of his other papers checked out either. The Coast Guard thinks he might have come in off a U-boat because of that

murdered beach-pounder, but there's no way to prove it."

The policeman's weatherbeaten face looked even more leathery than usual. "Funny thing, though, all I really wanted to do was ask him about the money. Money's my hobby, you know."

"Mine too," the reporter said, grinning.

"No, I mean seriously. Old coins, old bills—that sort of thing. And here was somebody paying a restaurant check with two practically mint-condition greenbacks. Of course," he added ruefully, "anybody would have spotted it. Hell, those old big bills have been out of circulation for close to eight or nine years now—ever since Roosevelt took us off the Gold Standard in '33."

CHARLIE'S CHASE

by Brian Garfield

"I've got a paper chase for you." Rice was unusually mellow. He neither bared his teeth our puffed cigar smoke in my face. "I want you to look through the Hong Kong reports for the past ten weeks."

"What for?"

"You tell me."

When I returned to his fourth-floor office he cocked his head to one side. "Well?"

Some weeks ago someone began systematically to double our China agents."

"So it would seem. I wanted to make certain of my readings of the reports—that's why I didn't give you any hint what to look for. But you saw it too."

"It's a visible pattern."

"Yes. Well, you'd better get out there and put a stop to it, hadn't you." Then for the first time he smiled. Rice's smile would frighten a piranha. It meant only that he hoped I would end up in trouble to my hairline.

As I went to the door he said to my back, "You've got to go on a diet, Charlie. You hardly fit through doors any more—you haven't got any sideways." He was still smiling—a wicked glitter of polished teeth.

I caught the noon flight from Dulles. The next day, fuzzy with jet lag, I descended on the China Station.

Pete Morgan, the chief-of-station, was dour and dismal, his normal hey-buddy ebullience crushed under a weight of worry. I had known him for years and never seen him so morose. "I've been wondering when somebody would show up with a hatchet. In a way I'm glad it's you, Charlie. You're tough but you're fair. I never heard of you railroading anybody just for the sake of marking up a score on your record sheet."

"I'm obliged for the vote of confidence, Pete, but if you know about the trouble why haven't you done something about it?"

"You think I haven't? I've given seven men the chop so

far—two of them damned useful informants."

"You've interrogated them?"

"Certainly."

"And?"

"Four of them denied it. Three of them admit it." He showed his despair. "They *admit* they've been bought—bribed with huge sums in Swiss banks and new passports and visas that will set them up in South America like baronets."

I stood at the window of his office and tried to make sense of it. Below me the Kowloon traffic of pedestrians and cars and tricycle-rickshas thronged the narrow street. I said, "The whole point of doubling an agent is not to let his employers know he's been doubled."

"Exactly. They're busting all the rules."

"So they're not really being doubled, are they?"

He said, "I can only see one answer. They're trying to destory my network."

"Why?"

"You tell me and we'll both know."

Pete's network wasn't concerned with mainland China; that was antother—and far more vast—outfit with headquarters in Langley itself and branch monitoring stations in Kyoto, Seoul, Hong Kong, Taipei, Rangoon, and Delhi. Pete's more modest operation covered Singapore, Djakarta, Formosa, Macao, and Hong Kong itself—the seething corrupt smuggling ports of the western Pacific. We had a substation in each of them but their operations were under Pete's direct control. And it appeared he was right: someone was systematically tearing the network apart.

Pete said, "It's so damned methodical. Like a bulldozer. I don't know who and I don't knwo why. We used everything but rubber hoses on the seven people we've busted so far. I'll show you the interrogation reports. Three of them cooperated, more or less, but all they know is they were offered six-figure bribes. The offers came by phone from public call boxes and everything else came in the mail, plain envelopes, untraceable. Now I've got taps on most of my remaining agents' phones—if the opposition calls again maybe we can get some voiceprints."

It was a crude destructive attack without any of the clandes-tine finesse that usually characterized warfare in our field—it

was as if someone had decided to conclude a game of chess by blasting all the pieces off the board with a fire hose.

"I don't know how to fight this kind of thing," Pete complained. "It doesn't make any kind of sense. They must know we know they're doing it—and they just don't care. What kind of espionage is that?"

I said, "It's cover for something. They want us to be deaf and blind so that they can pull off something they don't want us to know about."

"They. Who's they?"

"Anything could be happening out there—right now we wouldn't know about it, would we?"

"If you want the ball, Charlie, I'll be happy to toss it over in your court."

Yes I thought. That was why Rice had picked me for the job. He hates me so much that he drops all the dirtiest ones in my lap.

Pete said, "Does Langley want my scalp?"

"Not yet. They're as baffled as you are. Nobody's putting the finger on you."

"Ultimately it's my responsibility. The buck stops here."

"Why didn't you make a full report on this?"

He was surprised. "I did. To the Security Executive."

Rice.

"Didn't you read it?" he asked. "I thought that was why you came."

Rice, I thought. Rice and his "need-to-know" compartmentalization. He'd had Pete's report in his drawer all the time but he'd withheld it from me. I could picture his mock-sweet smile: *I didn't want to clutter your head with Pete Morgan's prejudged opinions, Charlie. Better you go into it with an open mind.*

I said, "Let me have those interrogation debriefings. And can you have sandwiches sent up?"

"Didn't you have breakfast at the hotel?"

"I did. But I'm hungry."

The Agency keeps threatening to put me out to pasture and Rice keeps intervening in my behalf—not because he likes me but because he needs me: without me to sweep up his messes he'd be out on his own ear.

One of the reasons the Agency hasn't made good its threat to retire me is that my head is a computer-bank of facts, experiences, and associations stretching all the way back to the days of the OSS when I cut my teeth in the trade. Often a remembered iota will put me on the track of something vital when the same trival item might pass straight over the heads of the pushbutton whiz kids in Covert Operations. It pays to keep one fossil around for the sake of continuity.

It was such an item from the deep past that provided me with a pointer toward the solution of this case. Going through the transcripts of the interviews with the three doubled agents who'd confessed, I found a clue that kept appearing like a bad penny.

"And then this voice on the phone said I could live out my days in paradise with the visas and all that money."

"He said I'd be able to quit grubbing around in these stinking Macao sewers and move my whole family to paradise."

"He asked me how I'd like to be rich and carefree and spend the rest of my days in paradise."

It echoed in my mind various conversations I'd had down through the years with Karl Jurgens. A slim and possibly misleading hint to be sure; but Karl had been smitten with the idea of a paradise for his retirement. It was one of his favorite words.

"Karl Jurgens?" A look of alarm passed across Pete Morgan's face. "He's a scary one. But didn't he retire from the Abwehr?"

"Some years ago."

That made him dubious. "If that's all you've come up with, it seems to me we're back to square one."

"Just the same I want to send out a few coded cables."

The replies to my cables trickled in during the next 24 hours. In the meantime Pete's office was a shambles, trying to deal with three more defections that had come to light. Pete's security people dragged one of them in for questioning and I sat in. The compromised agent was a Chinese cleaning lady with a sheepish expression; she kept shaking her head apologetically and wringing her hands‹ "I knew I should not have accepted this temptation but it was so very much money—enough to support my children in comfort for the rest of their lives. Not like the

bits of money you pay me." She gave Pete a pathetically defiant look.

He made a face and said in an aside to me, "I ought to get a transcript of this to those idiots that keep trimming our budgets."

I drew the woman's attention. "What did he say to you when he made the offer? Do you remember his words?"

"Not really, sir. It was just a voice on a telephone."

Pete said, "We got a voiceprint—the call was taped. The man spoke Mandarin Chinese with a Peking accent."

"More people in the world speak Mandarin Chinese than any other language," I said drily. "In any case it's probably a red herring. This isn't a Chinese operation."

"What makes you think that?"

"The Chinese have been dealing in subtle intrigue for three thousand years. This isn't their style—it's far too crude." I went back to the frightened woman. "Did he offer you anything specific besides the money and visas?"

I was fishing for a word but I didn't want to put it in her mouth.

She sighed wistfully. Her head tipped back and she murmured, "He offered me paradise."

I assembled the cables in order and dropped them on Pete's desk. "He's been living in retirement on Tahiti."

"Karl Jurgens? He found his paradise then."

"But he's not there now." I indicated the cables.

Pete sat up and looked.

I said, "He left eleven weeks ago on a plane for Djakarta. Coincidence? Within a week of his arrival in Djakarta you started losing agents. Djakarta, Taipei—he was sighted there two weeks later—they're both major substations on your network and that's where you lost the first two agents. If we keep digging I'm sure we'll find traces of him in Macao and here in Hong Kong. It's Karl all right. No doubt of it."

"But what's he up to ? Surely the West German government can't be running this caper. They're on *our* side, aren't they?"

"It's not a German caper. It's got to be a freelance job. He's hired himself out as a mercenary. Probably started to run short

of money to sustain him in paradise."

"Hired himself out where? Who's the villain and why's he doing these things to us?"

"I guess I'd better ask Karl," I said.

Karl Jurgens and I had formed a warm friendship during the hottest of the Cold War years and I didn't enjoy the prospect of dismantling him, but I'd had unpleasant jobs before and I didn't intend to do half-hearted work on this one. If Karl had set himself against us he could expect no quarter; I had little sympathy to spare for him.

The first task was to find him. I couldn't employ Pete's people for the legwork because I didn't know which of them might have been compromised; there were too many rotten apples in that barrel. So I had to use Rice's authority to call in security people from Kyoto and various floating departments. The hunt fanned out across East Asia and the Malay Archipelago; I directed the operation from our communications center at Guam.

Gradually reports began to drift in from Mindanao, Tokyo, Rangoon, Macao, Singapore—Karl was careful, but he had left a spoor here and there, partly because he'd gone a bit rusty from disuse but mainly because he probably felt no one would have reason to be looking for him. It was only on a hunch that I'd been able to connect the defections with him.

It appeared he was all over the map; we kept finding his trail twelve or 24 hours too late.

During that week Pete Morgan found that the rot had spread to four more agents. He had no choice but to spread the dictum throughout his network that all agents in the system were under suspicion and surveillance until further notice.

Whether the threat succeeded was not immediately clear, but defections appeared to be on the decrease: either the agents were impressed or Karl was laying off, or perhaps his job was concluded. I suspected the latter because none of Pete's agents came forward after the middle of that week to report attempts to bribe them.

By then we had lost 17 agents—about 20 percent of the station's complement—and this made the issue so grave that Rice personally flew out to Guam to light a fire under me.

I gave him a cool welcome. Rice has no head for tactics. He

was not going to be of any material help and I didn't want him underfoot.

He favored me with his most menacing smile. "I'm not interested in your preferences, Charlie. I want this thing wrapped and I intend to sit on you until you wrap it. I'm getting flak from stations as far away as Beirut and Marseilles and even Mexico City—a flood of trouble coming in from the Far East without any prior warning from China Station. We've got to get this network back in operation before the trouble spreads all the way into Langley."

I gave him a cold eye. "If you can do a better job than I'm doing, then I'll stand aside. Otherwise don't call me—I'll call you."

A stringer in Djakarta had his eyes open and spotted Karl Jurgens from the photo he'd memorized. The stringer phoned in from the airport and I was on the runway at Singapore with an armed crew when Karl's plane landed. We took him into custody and bundled him aboard a cabin cruiser. Out at sea I conducted the interrogation personally. No witnesses; but I had a tape deck rolling.

Karl was urbane and stoic. He managed a bleak smile. "I thought you must have retired years ago—you're even older than I am. If I'd known they would pit you against me I think I might have refused the job. I never was quite a match for you, Charlie. How did you tumble to me?"

"Legwork." I wasn't about to tell him how he'd revealed himself through his attachment to paradise. In a poker game you don't tell another player that he wiggles his ears when he's bluffing.

I said, "Who's footing the bill?"

"I've no idea."

"Don't force me to make tedious threats, Karl."

"The offer was made by telephone, just as my offers have gone to your agents by phone. I was given a list of names of agents to be subverted."

"And the visas, passports, and millions of dollars?"

"The visas and passports were sent to me at a general-delivery post-office box in Djakarta. They came in a plain carton. If it matters, it was postmarked Hong Kong. As for the millions of

dollars in bribe money, it was mostly fictitious. The numbered Swiss accounts exist, but they contain only a few hundred francs each."

"Then you intended to double-cross all these people who thought you were making them rich."

"I intended nothing, Charlie. I was paid in cash, through the mails, and I've done the job I was paid to do. I didn't ask my employer his intentions. If I had, do you suppose he'd have told me? It was only on my own initiative and from my own curiosity that I inquired into those Swiss accounts. After all, he had to give me the account numbers so that I could pass them on to the defectors."

"The Mandarin Chinese who made the phone calls for you?"

"An unemployed Formosan actor of no account. I paid him to make the calls. He read from prepared scripts. He knows nothing more than that. Forget him."

"You're telling me it's a dead end?"

He spread his hands and smiled faintly. "You have me in custody. That should solve your problem for the moment."

"Hardly. Why'd you do it?"

"Money. What else? It's hardly been stimulating to my ingenuity."

"Why did they choose you?"

"I suppose I'd let the word go out that I was available for freelance work. And I flatter myself I still have a reputation for efficiency and secrecy. I cover my tracks fairly well—I doubt any man but you could have tumbled to me. In any case I swear to you I have no knowledge of the identity of my employers."

"You weren't curious?"

"I was, but I curbed it. Does the postman care who the postmaster is? My job was simply to deliver mail and messages. Menial—beneath me, really, but the money was attractive." His smile dwindled and departed. "I'm an old man, Charlie. I take what I can get."

"Describe the voice on the phone."

"Disguised. Muffled with a handkerchief and artificial falsetto. High-pitched, nasal. A man, not a woman."

"Language?"

"German. Not a native German accent. Possibly English, American, Australian, Canadian, South African—English-

speaking at any rate, but the falsetto confused things. I couldn't be specific."

"All right. What was the operation designed to cover?"

"I've no earthly idea. That's the truth. I wasn't told and I didn't ask."

"You've certainly come down in the world."

"I'm an old beggar," he agreed. "You know, oddly enough I don't think I've broken any laws. Isn't that curious? At least not to the extent that it could be proved in court against me. What do you intend doing about me? Is Miles Kendig still in charge of your Security Executive?"

"No. Kendig's gone. Rice runs the office."

Karl made a face. "Him. The ultimate Philistine bureaucrat. Well, what will you do with me?"

"Nothing. Go back to Tahiti and lie on the beach. You're too old."

"You're unkind but truthful."

"How much were you paid?"

"One hundred thousand marks. About forty thousand dollars. Plus expenses—I spent those. Air fares, so forth."

"Send an international money order for forty thousand dollars to the UNESCO children's fund. When you get the receipt send it to me in Langley. If I don't get it I'll come to Tahiti after you."

"What am I to live on?"

"Sorrow," I told him. "We'll send you a Care package now and then."

"You probably ought to kill me."

"I know," I said, "but I don't kill people. I never have and never will. It's one of the silly crosses I bear. *Auf Wiedersehen*, Karl."

I met Rice in Pete Morgan's office in Hong Kong. The rains were intense. The narrow passages of Kowloon ran with rancid floods. I scraped my wet shoes on Pete's carpet, tossed my voluminous dripping raincoat on a chair, and sank into the couch. "Have them send me up three or four roast-beef sandwiches."

Rice had commandeered the desk. He lit a Havana. "Do you ever stop eating?"

"It takes a lot of food to sustain all this. You wouldn't want

me to faint from hunger."

"It might be good for a laugh." He squinted at Pete. "Any more defections since last week?"

"No, thank God. Things are easing back to normal. We've done some recruiting. It looks as if they—whoever they are—decided to abandon the attack rather than find a replacement for Jurgens."

Rice growled, "I don't like leaving a file wide-open. I want this one closed." He glared at me.

Pete said, "How can we close it? We haven't got any leads."

I said, "That's a matter of knowing where to look."

Pete flushed. "Look, this whole mess was my responsibility. I can't solve it but at least I can tender my resignation. It's the only thing I can do in good conscience." He dipped an envelope from his inside pocket and tossed it on the desk. "There's the resignation. Maybe I'll join old Jurgens in retirement on Tahiti."

His voice sounded bitter. He got up and went slowly toward the door—too slowly: he was waiting for Rice to tear up the letter of resignation. It was a bluff, meant to appear as a conscience salve.

Rice opened his mouth to stop him but I got in first. "If we refuse to accept that resignation, Pete, what will you do?"

He stopped and favored me with a sour smile. Then he shook his head. "Keep on going out the door, I guess. You've got to accept it. I blew this job. Everybody on the station knows it. Everybody in Langley will know it soon enough. How can I go on working in the Agency when everybody has good reason to ridicule me?"

"Would you accept a transfer?"

"I guess not. To tell you the truth I'm sick of the whole back-alley trade. I imagine I've been looking for an excuse to quit for a long time."

"Not to mention the wherewithal," I remarked.

"What?"

I said, "I'll accept the idea that you're sick and tired of the job I'll accept the idea that you've wanted to get out for quite a while. But you haven't got enough time in, Pete. You're ten years too young for a retirement pension. What do you intend to use for money?"

"I'll get a job." He mustered a smile. "You can live cheap in Papeete, I hear. Maybe I'll become a beachcomber."

Rice stubbed his cigar out. The room reeked of its noxious fumes.

I said, "Pete, sit down."

He didn't move; he only shifted his feet and his bewildered gaze fled toward Rice, who said to me, "What's on your mind, Charlie?"

I said, "Not long ago we lost our station chief in Moscow, remember? We caught him selling secrets to the Comrades. The turnover in section chiefs is always pretty high, especially in the thankless and unglamorous stations like this one. Grueling work load, indifferent pay, not much patriotism left to bolster a man after the Bay of Pigs, and all the assassination attempts and Vietnam and Watergate. It's turned into a me-first world, hasn't it? People see cynicism and corruption and greed all around them—they decide it just doesn't matter any more, there aren't any good sides or bad sides, the only thing to do is make sure you get your own piece of the action. We've seen it right here on this case with poor old Karl Jurgens. Twenty years ago it never would have entered his mind to betray his friends. But times have changed. Nothing's sacred any more. You agree, Pete?"

Pete exhaled a gust of air. "Yeah, Charlie, I guess I do."

I said to Rice, "One of the chief functions of this station is to keep tabs on shipments of opium coming out of China and the Indochinese montagnard country. Since we shut down the Saigon station that's been one of the main preoccupations of Pete's section."

Rice said drily, "Is this supposed to come as news to me?"

"It might have rung a bell with you—it did with me—when you mentioned you'd been getting complaints about the lack of East Asian forewarnings in Beirut and Marseilles and Mexico City. That's one of the principal routes for the heroin traffic into the States."

Rice sat up.

I said, "Suddenly a senseless caper knocks off agents on this station—which just happens to have the effect of drying up drug-shipment information all along the route to America, thereby opening up that route to God knows how much heroin

traffic—maybe enough to stockpile the dealer honchos with enough drugs to last a year on the street. Is that a coincidence, Pete?"

Pete had nothing to say.

I went back to Rice. "I don't know how much the opium people paid him to sabotage his own station. It must have been a hell of a lot of money—enough to finance his early retirement in style. In any case he was able to pay Jurgens out of it, forty thousand dollars, and set up several Swiss accounts, one of which probably is his own and contains the bulk of the money. Maybe he got half a million, maybe as much as a million. They can afford it. The heroin people deal in eight-figure sums."

Rice said, "Let me get this straight, Charlie. Are you accusing Pete of blowing his own network?"

"With regret, yes."

Pete said, "I deny that."

"Naturally," I said. "The voice that hired Jurgens over the phone spoke German with an English-speaker's accent. Jurgens said it could have been an American."

"Proving nothing," Pete said.

"I agree. But neither does it rule you out."

"So?"

I said, "Jurgens was given a list of names of agents to be taken out. Those were the agents whose areas included the routes of the major drug shipments—Hong Kong, Taipei, Djakarta, Singapore, and on toward the Middle East and France and Mexico. As chief-of-station you were the only executive with that information at your fingertips—the names and covers of all those agents. It couldn't have been anybody else, Pete. You doubled your own agents."

I turned to Rice. "He wanted out. Maybe he can't be blamed for that. But he had to get rich first."

Pete said, "I deny it. It's ridiculous!"

Rice lit another Havana. "In that case you may as well go, Pete. I expect we're finished with you for the moment." He picked up Pete's letter of resignation and put it into his pocket. "Now that we know what to look for we'll be able to put men on it. I wouldn't try to withdraw any money from Switzerland if I were you. Sooner or later we'll find evidence against you and then we'll come after you."

"Even if you have to manufacture fake evidence."

Rice snarled. "What do you think this is? A game of croquet? You're all finished, Pete—accept it."

After Pete left the office I ate my sandwiches. Rice glowered through his cigar smoke at the dreary rain outside the windows. "He won't do anything dramatic, will he? Like kill himself?"

"No," I said. "Pete's a survivor. He'll run as long as he can."

"Do you want to chase him?"

"Give that job to somebody else. I want to get out where the air's cleaner."

"All right." Rice certainly is mellowing. "Anyway, I've got a job for you in Kenya ... "

PASSPORT FOR CHARLIE

by Brian Garfield

Rice lives for the day when I fall down on the job. I suppose he thinks it will prove I'm no better than he is after all. He keeps throwing impossible jobs my way; the only way I can get revenge is to bring them off and show him up. One of these days I will come a cropper—or I'll bring off a feat so incredible it will blow all his fuses. That's the nature of the tug-of-war between us.

Rice said, "The van was hijacked between the printer's and the Atlanta office. The Bureau traced the shipment to Miami. A day too late."

"How many?" I asked.

"Four thousand. Genuine U.S. passport blanks."

"Uh-huh. Worth a bloody fortune on the illegal market," I observed.

"Not if you recover them. That's your job. I don't think you can do it—I don't think anybody can—but it's in your ample lap." He blew smoke from his noxious Havana toward my face and favored me with his barracuda smile. "Bon voyage, Charlie. Don't come back without the passports."

The F.B.I. agent didn't resent the imposition; he was relieved to pass the buck and said as much—he was convinced the shipment had left his jurisdiction and that was fine with him; the headache was ours now.

"It was organized. They weren't two-cent stickup men. Two or three private cars were used to bring the passports to an assembly point here in Coral Gables. We nailed one of the hijackers, you know—blind luck but we've got him and he's willing to testify. A deal for a light sentence provided we give him protection. The Bureau's taken it to the Justice Department and I'm pretty sure they'll agree to it. Trouble is, he doesn't know enough to help you."

"I'll talk to him anyway if you don't mind."

His name was Julio Torres and he was a sad man—a Cuban, down on his luck. He was heavy, nearly as fat as I am, but not

so tall. I guessed his age at 45. He had a black mustache and calloused hands. In the interrogation cell we both overlapped our wooden chair seats.

"Who recruited you for the robbery?"

"He calls himself Obregon. I never heard his first name."

"Cuban?"

"No. I think Puerto Rican."

"What was your job?"

"To follow the van and drug the crew."

"How?"

"They stopped for lunch in a truckers' café. I followed them in and put something in their coffee."

"Chloral hydrate?"

"I don't know. Obregon gave it to me and told me to put it in the coffee." He gave me a wry look. "I'm not a pharmacist, you know."

"Then?"

"Then I drove the car. When we saw the van pull over we waited a few minutes to make sure they were asleep; and then Obregon drilled into the van and one of the others got behind the wheel and started it up, and we convoyed it to the hiding place at the farm."

"Whose farm was it?"

"I don't know. Some sharecropper's. I think it must have been abandoned for years. The driveway was all overgrown. Anyway I followed the van in my car and Obregon drove another car and there was a third guy in a third car. We transferred the cartons to the trunks of our three cars and drove away separately."

"So that if one of you were caught, it would only cost one-third of the shipment."

"I guess that was the idea, yes. I delivered my car in Coral Gables last night."

"To where?"

"A private house a couple blocks off the Tamiami Trail. I gave the F.B.I. people the address, they already checked it out. I don't think they found anything. It was just a drop, you know. I guess Obregon or one of the other guys picked up the car from there. I left the keys under the mat and walked away after I collected my money, which was in the mailbox like they said it would be.

"Then the next day I was arrested because one of the van

drivers saw me on the street and recognized me from the truckers' café. See, I tripped against one of the drivers in the café and spilled a littel root beer on him—that was how I distracted them when I dumped the drug in their coffee, so the guy noticed me then and he recognized me the next day. An unbelievable stroke of bad luck, you know, but that's been my life. But I guess you don't want the story of my life, do you?"

"Who does Obregon work for?"

"I have no idea."

"Describe him."

"Well, he's thin. Let's see, sort of bald, no chin. Thirty, maybe thirty-five. A mustache—not bushy like mine, a thin neat mustache. He looks like an Indio."

"Did he speak to you in English?"

"Spanish. His English is poor."

"Puerto Rican accent?"

"Yes. I think he must live over there. Something he said. I can't remember what it was, it made me think he only came over to the mainland for this job."

I checked into the Condado Beach in a rainstorm and had a big meal in the Sheraton's Penthouse restaurant with a lovely view of the sprawled urban lights of San Juan. From 20 stories high at night you don't see the poverty.

In the morning I went through the ancient walls into Old San Juan down to the harborfront Federal Building and met for half an hour with F.B.I. and customs men, after which we trooped over to police headquarters and I went through mug files with the help of a San Juan detective lieutenant. We turned up a sheet on a man named Jorge Ruiz Orozco, a/k/a José Raoul Obregon, a/k/a Juan R. Ortiz, and so forth; his picture met the description I'd had from Julio Torres in Miami and his rap-sheet seemed to fit: he'd been arrested several times for smuggling and receiving stolen goods and had taken two falls in prison, once in Florida and once in Mexico.

We sent a bulletin out via the Bureau and Interpol and the Agency. There had been no public announcement of the Torres arrest and there was a chance Orozco-Obregon-Ortiz might not have gone to ground; if he felt he was safe he might be out in public somewhere. The Puerto Rican police had copies of his

mug shot in their cars but when he turned up four days later it was over in Charlotte Amalie and I went there to visit his cell before they extradited him to Florida.

He was sullen and not very talkative. I had to make a few threats. We can be testy about that sort of thing because the Agency doesn't concern itself with courts and appeals; I didn't care if they convicted him or not—I wanted information from him. He had a sister in Ponce and a brother in Mayaguez and an elderly mother in San Juan. I mentioned a few things that might start happening to them: the sister could lose her driver's license, the brother could lose his taxicab in an accident, the aged mother could learn that her Social Security payments and Medicare were being discontinued because of irregularities in her records—a hundred little harassments like that. After a while Obregon gave me a name.

From St. Thomas I flew back to San Juan on a twin-engine Islander and made the connecting flight to Washington with an hour to spare—time to eat a fair meal between planes. I was in Rice's office by half-past four.

I said, "Obregon was hired for the job by Parker Dortmunder."

Rice blew Havana smoke at me. "Obregon actually gave you Dortmunder's name?"

"No. Dortmunder wouldn't be that stupid. Obregon gave me a description and a name. The name's one of the aliases Bertine has used before and the description fits Bertine. Bertine works for Dortmunder, or did last time I heard. I think if we find Dortmunder we find the passport blanks."

"Find Bertine," Rice said. "Leave Dortmunder alone, Charlie."

"Why?"

He shook his head. "No need to know."

I was a littel angry. "Bertine's just a gopher. Look, Dortmunder doesn't paint himself into corners. He's a broker, not an inventory dealer—he doesn't steal things on spec. He wouldn't have run this caper if he didn't have a prearranged buyer for the passports. They were stolen to order. Now the fastest way to find them is to pull him in and find out who he sold them to."

"I'm sorry, Charlie. We're using Dortmunder at the moment. We need him." He jabbed the cigar toward me. "Don't touch

him. Find the passports but don't annoy Dortmunder."

"If I nail Bertine does that come under the heading of annoying Dortmunder?"

"Yes. You can shadow him but don't touch him."

"Tell me, how many more obstacles do you intend to toss in front of me?"

"Just get the passports back, Charlie." I think it was his grin that infuriated me to the point where I resolved to do it—just to show him up.

Dortmunder was a free-lance espionage middleman; he bought and sold secrets as well as international arms and various clandestine goods like bullion, slaves, and narcotics. His stamping ground was the Mediterranean. Despite my anger I could understand Rice's point; Dortmunder was a pill, but he was a useful one. He sold information to us that we wouldn't otherwise get. Therefore we tolerated him and let him run. Such is the cynicism of the trade; such is the mechanism by which the Dortmunders survive. All his customers have a vested interest in his survival.

I didn't care about Dortmunder one way or the other, but Rice's stricture made the job much harder than it had to be— that was what annoyed me. It would have been a simple matter to harass Dortmunder into selling out the passport buyer to us; it wouldn't have hurt Dortmunder to do so, but Rice didn't want to ruffle his feathers, so I had to do it the hard way.

I ran a trace on Bertine and the computers sent me to a 42-foot diesel cabin cruiser the registry of which drew me along a course from San Juan to Tortola to St. Maarten to Nassau. She was tied up in a marina in the Bahamas when I arrived there and I disassembled her bewildered captain in a hotel room on Paradise Island with the help of two Agency stringers.

The captain was a hired charter operator who ran the Matthews boat for a Swiss company that belonged to Gerard Bertine. After a few hours of defiance and ridicule he eventually saw the light and admitted the cartons of "ledgers" had been collected from him out at sea: a refurbished PBY Catalina flying boat had landed on the water and the transfer of cargo had been made by dinghy. Bertine had gone aboard the airplane with the cargo. A neat dodge, professional—it had the Dortmunder stamp. All this

had taken place about 200 miles due east of Nassau four days ago.

Back to the computer. I dug up the registries of half a dozen boats and freighters that tied in with Dortmunder in one way or another. During the time frame in question one of the boats had been in the Atlantic about halfway from Trinidad to Casablanca; another was a half day out of the Azores; and a third was off the Canaries. It suggested a possibility: mid-ocean refueling for the flying boat. At low cruise a PBY has a range of nearly 2000 miles. Plotting a course from ship to ship I found that it pointed toward the mouth of the Mediterranean. It persuaded me that the passports were somewhere between Gibraltar and Istanbul.

That was a bit of help; it was a start. It still left a lot of ground to cover. A PBY can land anywhere on the open water; the passports could have been transferred to a fishing boat off any port in the Med—no customs inspections.

But I thought I knew where they'd gone.

Algiers is where the runaways go. Fugitives from politics and justice are drawn there because of a governmental no-questions-asked attitude. But it's a drab bureaucratic place with little romance or comfort; if you're not rich it's oppressive. After a while the exiles begin to hate it. The place becomes their prison. That's when they begin to inquire into sources of false passports. The trade in high-priced documents is brisk in Algiers.

Four thousand genuine U.S. passport blanks would be worth more than $2,000,000 on that market.

The station stringer in Algiers was a passed-over veteran named Atherton who had no image left to polish. He was contentedly serving out his last hitch before retirement.

In Atherton's travel-agency office I went through the station's files of known dealers in black-market documentation. After several hours of it Atherton gave me a bleak look. "Is this getting us anywhere, Charlie? There's just too damned many of them."

"We can rule out the small ones. Whoever bought the shipment had to put up cash. Probably half a million dollars or more. It's got to be a big dealer."

"That still leaves a dozen names or more. You want to pin the list on the wall and throw a dart at it" He made a face and

pushed the files aside. "It won't work. Hell, we'd do as well to canvass the fishing docks. The shipment had to come into Algeria somewhere—if it's here at all. It could just as easily be in Marseilles or Alexandria or—"

"If I don't tumble the goods here, I'll go to Marseilles next and then Alexandria and then et cetera. But my nose tells me it's here. The odds are on Algiers."

"If I had four thousand blanks to sell I'd bring 'em here," he agreed. "But it would require an impossible amount of legwork to find them in this maze. The population of dealers is too big, Charlie. We haven't got a hundred investigators on this staff."

"What about Bertine? Has the trace come up with anything?"

"Bertine flew out of Gibraltar two days ago. By now he's in Zurich."

"Gibraltar—that's another clue in favor of Algiers," I said.

He sighed. "Twelve, fourteen, maybe sixteen dealers big enough to handle it. Well, I guess we can go to the cops and start having them tossed."

"Canvassing won't do it," I said. "After we hit one or two of them the rest will get the word. They'll all go to ground. No, we've got to hit the right target with our first shot."

"That calls for fancy shooting."

I said, "We'll need a Judas goat."

I went through all the station's Immigration Surveillance Reports for the past week and selected a card from the stack:

Andrew Grofield—entered Algiers 10/17 via GibAir #7415, carrying U.S. Passport #378916642393 in name of Alan Kelp. Passport is presumed forgery. Inquiry forwarded to Washington in dip bag 10/18. Algeria authorities not informed. Ident Grofield made by Peter McKay, personal observation airport. File #78BV8.

Atherton said, "Grofield. Yeah. Ran some small arms into the Philippines while I was on station there. We had to chase him out. He was supplying guerrillas with AK-47s. He's a petty crook, not a bigshot."

"Does he know your face?"

"We never met. I know him from photographs."

"He ought to do," I said.

Atherton sent four men out in two cars to look for Grofield. On the second day one of them found him. Atherton said, "It's a girl's flat in the casbah."

"Has he got a hotel booking?"

"No. Staying with the girl. She's professional. He'll be paying for the time. It suggests he doesn't plan an extended stay in town."

"Good. If he's got appointments in another country he'll be anxious not to be delayed."

"When do we hit him?"

"After I have my dinner."

We sent the two stringers around to cover the rear and posted ourselves in a cramped 2CV at the curb across the street from the stucco warren in which the Turkish call-girl had her flat. Lights burned in her windows and I was hoping they'd soon emerge to go somewhere for a late supper; it was about ten o'clock. The street was emptying of pedestrians: burnoused bedouins, besotted beggars, business-suited bwanas.

We were on the edge of the casbah, its tortuous passages winding away over cobblestones. The smells were pungent, the air heavy. One wonders if the Arab cities attract miscreants and evildoers because of their fetid atmospheres or if it's the other way round.

They didn't come out that night. We wasted it in the car, talking about the old days. Another team took over during the day and we were back the next evening at sundown.

Finally the girl and our mark emerged from the narrow dark entrance. Atherton said, "That's him. Grofield."

The man was burly in white seersucker; he walked like a sailor, a belligerent thrust to his shoulders. The girl had the opulence of a belly dancer: she'd soon be fat.

We gave them a lead and I got out to follow them on foot. Atherton trailed along at a distance in the car in case they snagged a taxi.

We were at the bar when Grofield came away from his table to seek the men's room. He was a little drunk; that was an aid to me. I stepped back from the bar talking heartily to Atherton

with wide gestures: "So would you believe the damned crook tried to sell me Chianti for Bardolino?"

My gesticulating arms made Grofield hesitate and then Atherton stepped out from the bar toward me: "Come on, Joe, you're blocking traffic." In reaching for my arm Atherton lost his balance and blundered against Grofield. I steadied Grofield and leered at him drunkenly, brushing him off. "S'all right, buddy, sorry, these freeways are murder, ain't they?"

Atherton blurted apologies to Grofield in French and English. Grofield brushed us off with a stony glare, squeezed past, and went on toward the agents. I had my hand in my pocket; I turned and walked out of the place. A few minutes afterward, having paid the tab, Atherton followed me out. "Okay?"

"Sure," I said. "I missed my calling. I should have been a dip."

In the morning I went into Atherton's office and reclaimed the passport from his desk. "Did you get a report on it yet?"

"It's phony all right. But a good forgery."

"Then he'll insist on the best when he goes to buy a replacement."

Atherton and I exchanged smiles.

Since his original passport was a phony, Grofield couldn't go to the embassy for a replacement of the one I had stolen from his pocket. That was what we were counting on. He'd have to buy a replacement from an under-the-counter dealer. He wouldn't settle for the kind of counterfeit that most ignorant fugitives would buy; Grofield knew the ropes. We were counting on that.

Atherton's operatives kept a tight tail on Grofield. He emerged that morning from the call-girl's flat with rage on his face and went around Algiers by taxi from one shop to another. Altogether he visited five of them. We kept records of all five addresses. Four of them were on Atherton's list of known dealers.

"We hang back," I said. "At the moment he's just shopping. Looking for the best paper. Keep the reins loose, but don't lose him." I wasn't interested in how many dealers he visited; the one who concerned me was the one to whom Grofield would return.

He gave us a scare that night: he disappeared. He must have

used the back door of the girl's building and slipped away into the shadows. When the girl emerged alone from the building in the morning, one of Atherton's men went in wearing the guise of a municipal electric-service repairman and the flat was unoccupied. We did quite a bit of cursing but Grofield returned to the flat in the afternoon, using a key the girl must have given him. He was fairly well drunk by his walk. We sent the electrical repairman back in. He knocked at length and there was no reply, so he got through the lock again and found Grofield happily passed out; he went through Grofield's clothes, found no passport, and reported back to us.

Atherton said, "I don't like it."

I said, "It's still running. Look, he didn't come to Algiers for fun. He's got business here, never mind what kind. He must have transacted it during his absence—that was the reason for the secrecy. He didn't think he was being followed, but he made the standard moves anyway. A pro always does. He's probably bought a few cases of rifles and grenades from somebody. Now he'll be ready to leave the country—all he's got to do is wait until his new passport's ready."

"Suppose you're wrong, Charlie?"

"Then I'm wrong and we start over again with another Judas goat. In the meantime we'd better beef up the surveillance on him. Can you spare another two men for a day or two?"

"I can scrape up a couple."

"Stake him out front and back, then. Let's not lose him again."

He led them a merry run that night; we thought we were onto something, but it turned out to be a meeting with a Lebanese armaments smuggler in the back room of a country store about forty kilometers inland from Algiers. Our men watched with eight-power night glasses and had a glimpse of black steel, most of it crated: Kalashnikovs and, they guessed, Claymore mines.

"That's what he's here for," I told Atherton. "He's making a buy. The stuff will go out by boat. Eight weeks from now it'll turn up in Thailand or Indonesia."

"We'll keep tabs on it," he agreed, "find out where it goes. But this isn't getting us to the passports."

"You want to bet?"

One of the paper dealers on Atherton's list was the proprietor of a half-dozen curio shops one of which was situated in the rue Darlan. At eleven in the morning Grofield left his flat, walked two blocks, flagged a taxi from a hotel rank, rode it to the waterfront, walked through an alley, picked up another taxi at a cruise-ship pier, got out of the second taxi at the western end of the casbah wall, almost lost our operatives in a network of passages, and finally led them back to the rue Darlan—his second visit to the curio shop in three days.

"All right," Atherton said. He was exulting. "Let's give it a toss."

"Not yet," I told him. "Let's make sure."

Grofield went to the airport that evening and bought a seat on the nine-o'clock flight to Geneva. When he checked in at passport control one of Atherton's men had a look at his papers and reported back to us: "You were right. The contents are fake, but the booklet is genuine. How did you know?"

Atherton said, "Do we toss the shop now?"

"No. They wouldn't warehouse the blanks in the shop. If we raid the shop we won't find the shipment. We'll wait for them to lead us to the blanks."

We picked another transient out of the file that night and I did my pickpocket number on him the next afternoon; the transient was no help—he bought a cheap forgery from a bartender in the Avenue Faisal. We had to track three crooks through Algiers before one of them went into the curio shop in the rue Darlan to order a replacement passport. After that it was simple procedurals.

A clerk from the curio shop led us to a house on the mountain-side in the high-rent district; when he came out of the house the clerk had a 6×9 manila envelope with him. We took it away from him and found a mint passport blank inside.

That evening six of us raided the big house. We found the cartons of blanks in a safe in the basement. We turned the owner of the house over to the Algerian authorities.

It was anticlimactic. We recovered the passports but didn't touch Bertine, let alone Dortmunder. To this day both of them are buying and selling illicit goods around the Mediterranean; we ourselves are among their steady customers. Such is the cynicism of the trade.

But I did have the satisfaction of beaming in Rice's sour face. Once again he'd given me a job he thought couldn't be done; once again I'd showed him up. I think he lives for the day when I foul one up.

He actually offered me a cigar. He knows how much I hate them. Without even bothering to acknowledge the offer, I turned to leave the office after handing in my report. Rice said, "All right, since you're obviously dying for me to ask. How'd you bring it off?"

"Genius. A tablespoon with every meal." I smiled cherubically.

If Rice thinks I'll give him the satisfaction of telling him how I brought it off, he's crazy. Let him try to figure it out for himself. Maybe he'll get so worked up he'll blow one of his fuses.

That's the day *I* live for.

CHARLIE'S DODGE

by Brian Garfield

Streaks of falling gray rain slanted across the silhouette of Sydney Harbour Bridge and when the taxi decanted me under the shelter of the porte-cochère canopy my poplin suit was still steamy from the dash at the airport. I carried my traveling bag inside the high-rise, found my way to the elevators, and rode one up to the ninth floor.

The door had frosted glass and a legend: *Australamerica Travel & Shipping Agency Ltd—New York, Los Angeles, Sydney.*

The girl at the reception desk sent me down a sterile hall. I could hear typewriters and Telexes in the warren of partitioned cubicles.

The conference room had wrap-around plate glass; it was a corner suite. The view of the stormy city was striking.

Two men awaited me. The ashtray was a litter of butts and the styrofoam coffee cups had nothing left in them but smeared brown stains. Young Leonard Myers hurried like an officious bellboy to relieve me of the B-4 bag. "I hope you've got a spare suit in here. You're drenched. How was the flight? Bill, I guess you know Charlie Dark?"

"Only by reputation." The tall man came to shake my hand.

"Good to meet you, Charlie. I'm Bill Jaeger, chief of station down here."

When the amenities were out of the way and we'd sent out for sandwiches I settled my amplitude into a wooden armchair at the table. It was a bit of a squeeze. "Now, what's the flap?"

Myers said, "Didn't Rice brief you?"

"No."

"That figures," Jaeger said. "I may be stepping out of line but it baffles me how Rice keeps his job."

I let it lie. It wouldn't have been useful to explain to Jaeger that Rice keeps his job only because of me. Either Jaeger would refuse to believe it or he'd resent my conceit.

"The flap," Myers said, "goes by the names of Beth Hilley and Iwan Stenback. They purport to be journalists."

Jaeger made a face. "Underground press. They're tearing our station to pieces."

"Systematically," Myers said. "Causing a great deal of embarrassment for both the Australians and us." Then a wan smile. "You and I were sent in to get rid of them for Bill. Actually that's not quite accurate. You were sent to get rid of them. I was sent to hold your coat." With his collegiate good looks Myers was the picture of earnest innocence but I'd known him a while—sometimes he was astonishingly naive but he was brighter than he seemed: a quick study. One day he'd be in charge of a department.

A girl brought us a tray of sandwiches and rattled something at Jaeger in 'Stryne—I didn't get but one word in four; the accent was more impenetrable than Cockney. Jaeger said, "I'll have to call them back later." The girl smiled, nodded, and departed, legs swishing; Myers' eyes followed her until she was gone.

Jaeger was one of those lanky Gary Cooperish people who seem to have flexible bones rather than joints. I knew him as he knew me: by reputation. Easygoing but efficient—a good station chief, reliable, but not the sort you'd want running a vital station in a danger zone. He was a good diplomat and knew how to avoid ruffling feathers; he was the kind of executive you assigned to a friendly country rather than a potential enemy.

He said, "Iwan Stenback publishes a weekly rag called *Sydney Exposed*. Part soft-core porn, part yellow gossip and cheap scandal, part health food recipes and diagrams for Yoga positions, part radical-left editorializing. Until recently it didn't have much of a circulation—mostly just freaks. Very youth-oriented. Always just skirting the libel and obscenity laws. Then a couple of months ago Stenback hired a hot new reporter by the name of Beth Hilley. Since then the circulation's shot up like a Titan missile because the rag announced in a page-one box under Hilley's byline that they were going to start naming and identifying American C.I.A. spies who were working undercover in Australia."

Myers said, "It's happened before, of course. In Greece that time, and—"

I cut him off. "Have they made good on the threat?"

Jaeger said in his dry way, "So far they've named seven of our people."

"Accurately?"

"Yes."

I decided I liked him. He didn't make apologies; he didn't waffle. He looked like a cowboy and talked with a prairie twang, but I suspected there was nothing wrong with his brain.

I said, "Where'd they get the names?"

"We think one or two of our people may have been indiscreet. They aren't all paragons, the people we buy information from. And in a country like this they're not scared into secrecy—they don't need to worry about jackboots in the hall at midnight. In some ways it's harder to run a secure intelligence network in a free country than it is in a dictatorship."

"You've made efforts to plug the leaks?"

"Yes, sure. I think I know how it may have happened. I'm told Beth Hilley's attractive—seductive as hell."

"You've never seen her?"

"No. Not many people have, evidently. I'm sure she goes under a variety of cover identities. After all, if her face were known, people wouldn't talk to her."

"Is 'Beth Hilley' a pen-name?"

"No." Jaeger deferred to Myers.

"Born in Australia but schooled in England and Switzerland." Myers was reading from his notebook. "Beth Hilley's her real name. She's twenty-seven. The Berne file suggests she may have had contact with members of the Baader-Meinhof gang. In any case she returned to Australia a year ago with a head full of radical revolutionary anti-capitalist theory."

Jaeger said, "Typical immature anti-establishment Anti-American notions. Australia already has a socialist government but that doesn't seem to satisfy these idiots. They want blood. Preferably blue. It doesn't seem to penetrate their thick heads that this capitalist free-enterprise system they hate so much has graduated more people out of poverty than any other system in history."

"Still," I said wanting to get him off his political stump, "for an idiot she seems to have done a capable professional espionage job against us."

"Every week," Myers said, "the name of another of our agents appears in *Sydney Exposed*. They promise to keep doing it until they've named every last American spy in Australia, New Zea-

land, and New Guinea."

"Can they make good on the threat?"

Jaeger smiled. "We don't know. But they've done it so far."

Myers said, "We're working with the Australians on this—they don't like it any better than we do. It embarrasses them as much as it does us. After all, the Australian government knows we're here. But they can't be seen to infringe the freedom of the press, and obviously Washington can't be seen to bully the press of an independent nation. It's got to be handled in such a way that it doesn't look like official repression. That's why you're here, Charlie. To think of something clever."

"At least Rice hasn't lost faith in my ability to work miracles," I remarked. I brooded at Myers, then at Jaeger. They seemed to be waiting for me to provide an instantaneous solution to their difficulty. "My problem," I confessed, "is a deep-down fanaticism in behalf of absolute freedom of the press. Wherever censorship begins, that's where tyranny begins."

"I agree," said Jaeger, "but the Australian press tends to be a bit lurid anyway, and this particular rag goes far beyond the limits of responsible journalism."

That was putting it diplomatically. The real issue was the fact that *Sydney Exposed* was blowing the covers off our agents. When you expose an agent you render him inoperable. The newspaper was systematically closing down our network. Given the premise that the survival of nations depends on the accuracy of their intelligence, we had no choice but to stop publication of these revelations. Yet I could not bring myself to think in terms of strong-arm methods. There has to be a difference between the good guys and the bad guys.

I said, "Has anyone tried to reason with them?"

Jaeger said, "I had a talk with Stenback. He listened politely, then laughed in my face."

"Tell me about him."

"Sort of a guru type. Brown scraggly beard shot with gray. Wears his hair in a ponytail. Myers has the official details."

Myers turned a page in his notebook. "Thirty-four years old. Born in Sweden. Was a lieutenant in the Swedish army—a crack shot, by the way. Emigrated here five years ago. Naturalized Australian citizen. Background reports indicate he used to hang out with American Vietnam draft dodgers in Sweden. Earlier his

father was a quisling in Norway during the War, which may explain why Stenback grew up with a chip on his shoulder. Before he came down here he worked a while as legman on a few of the cheap London tabloids, publishing cheap filthy innuendoes about prominent Members of Parliament and the like. Digging up dirt seems to be his mission in life—the worse it smells the better he likes it." Myers closed the notebook. "Rice would prefer it if you arranged a fatal accident for them, Charlie."

"I don't much care what he prefers. I don't kill people, it's not my style. Any fool can kill people."

"Maybe this time you haven't got a choice. How else can you stop them publishing this stuff?"

We sat in a four-door Humber across the street from the shop-front office of *Sydney Exposed*. It was a shabby old part of the city—cheap flats, a boarded-up cinema, rubbish in the gutters. In the newspaper's windows the lights burned late—tomorrow was this week's publication day and Stenback was in there with his staff composing the late pages. "She never comes to the office personally?"

"Apparently not," Myers said. "We've had it staked out for ten days. If she's set foot in the place we're not aware of it. Of course we're not sure what she looks like. The last available photograph is from nine years ago when she was eighteen. Blonde hair, gorgeous face and figure—the beach-beauty type. You know these athletic Australian girls. But who knows. Maybe she's gained weight, changed her hair, whatever. She could be any one of a dozen women who've wandered in and out of there."

I said, "Assuming she doesn't report in person to the office, it follows she must send her copy in. Not by the post; I think she'd be too paranoid to entrust her copy to government mails. Her articles would be hand-delivered."

Myers began to smile. "Then—"

"It'll take man-hours and legwork but let's try to put surveillance on anyone who brings an envelope to this office ... "

Through the wrap-around corner windows the sky was cheerful but Jaeger was glum. "Our security's all right—I'm pretty sure we've plugged all possible leaks. But it's a case of locking the barn door after the horse thieves have made their getaway.

Probably they've got all the names already—they're publishing one a week, holding back to keep the circulation up. It's like a week-to-week cliffhanger serial. Every week the public clamor grows—they're starting to call for blood in Adelaide and Melbourne. Our blood. If it keeps up we'll all find ourselves deported. It'll be done with man-to-man shrugs and smiles and abject apologies but they'll do it all the same—they'll have no option if the public pressure grows bad enough. You'll have to move fast, Charlie."

"I'm ready to," I said. "We've found Beth Hilley."

She was clever but all the same she was an amateur and it hadn't occurred to her that a cut-out and blind-drop setup can be breached. For a week we had backtracked all the messengers who had delivered envelopes to *Sydney Exposed*. We doubted she would use a formal messenger service; we were right.

The drop was mundane but adequate: a luggage locker in a railway station. But the thing about lockers is that you have to transfer the locker key. Once we knew the system we broke it easily. Hilley would leave the envelope in the station locker and put the key in another envelope and leave that with the landlord of a pub she frequented near the waterfront. The kid—a bearded long-haired boy in frayed denims and a patchwork jacket—would collect the key from the bar, go to the locker, get the envelope, and carry it by hand to *Sydney Exposed*. The kid, like five others who made deliveries regularly to the newspaper, was shadowed for a week and when he picked up the key and opened the locker we knew we were onto Beth Hilley: we simply staked out the lockers until she arrived to deposit the next week's copy.

She lived in a small flat on a suburban street near a shopping center. As it turned out she hadn't resorted to any disguise. She was still blonde and gorgeous with a leggy showgirl look. Three nights in a row she emerged in evening dress, drove her white MG into the heart of Sydney, and rendezvoused with a man: each night a different man, each night a different posh waterhole. Each night she and the man—two politicians, one diplomat—would go to a luxury hotel afterward.

Myers laughed. "So that's how she meets so many prominent guys. She's a call girl!"

We requisitioned revolvers and special-effects equipment

from Jaeger's station. We were leaving when Jaeger met us in the corridor. He glanced at the revolvers as we fed them into our attaché cases. "Then you're going to kill them after all."

I shrugged.

"You want any help? I can give you a back-up squad."

"Let's keep it quiet," I replied.

Myers said cheerily, "We'll handle it, Bill."

Jaeger was still dubious when we left.

When she answered the door I pushed the gun up under her nose and she backed away in alarm. I stepped inside and closed the door. "Stay loose, birdie. No screams, all right?"

A veil slid across her eyes. "What do you want?"

"Sit down and don't talk. We're waiting for somebody."

"Who are you?"

"Does it matter?"

"You're an American."

"Really? I thought I was doing a fair 'Stryne accent there."

She managed a snort of contemptuous laughter. She wore a white jumpsuit with a yellow scarf at the neck—crisp, very smart. She had a tan complexion as soft and smooth as Japanese silk; she'd have inspired desire even in a jaded centerfold photographer. I had no trouble with the notion that she would be able to extract information from men.

"Come on," she said impatiently, "what *is* this?"

"Sit down." I wiggled the gun. "It's only a .32 but they're hollowpoint bullets—they make a terrible mess of flesh and bone."

Making a face she took a seat on the divan and tucked her long legs under her. I crossed the room to close the drapes. It was a comfortable efficiency flat, not terribly big, the furniture a bit Bohemian: an old door on bricks served as a coffee table and the divan was one of those pull-out convertible beds. Apparently she spent most of her money on clothes.

"I suppose if I sit here long enough you'll tell me what this is all about?"

"Count on it, Beth."

"You're the C.I.A., aren't you? Which one? Cole? Ludlow? Fortescue?"

"What's in a name?" I sat down and rested the revolver on my

knee. "Be patient, Beth."

With enviable aplomb she rested her head against the wall and closed her eyes, feigning boredom. A very tough young lady. I hoped we could crack her. It wouldn't be easy.

Myers brought Iwan Stenback into the flat at gunpoint. The Swede was a short man with a beard and long hair tied back with a rubber band. His pale eyes took in the scene quickly. "So. The C.I.A. brings us together to murder us. I suppose you'll give it the appearance of a lovers' quarrel. Do you honestly think anyone will believe such a crude sham?"

"We like to think we're a bit more sophisticated than that," I said. "Sit down, Stenback."

He moved to stand beside Beth Hilley. She touched his hand possessively and not without fear. I flicked the gun in his direction and he eased past the arm of the couch and sat down next to Beth Hilley. He wasn't a bad-looking man. There was a jaded professorial cynicism about him—the kind of *weltschmertz* that sometimes appeals to women: they see immediately through the bitter veneer and convince themselves that beneath it is a sensitive being who needs coddling and protecting.

I said, "We need to have a little talk."

Myers snarled. "What do you want to talk for? Let's get it over with." He cocked his revolver. It made a nasty sound in the room.

"Patience," I told him. To Stenback I said, "My associate favors brute force but I suspect we'd all prefer to avoid that."

It was the old two-cop dodge: the good cop offers you a cigarette, the bad cop slaps it out of your mouth. After a while you begin to look on the good cop not as your jailer but as your friend.

I sat down facing them and placed my revolver on the tabletop in front of me to free my hands so that I could take out my wallet and flash it at them. "My name is Charles Dark. Security officer with the United States Government."

I heard Myers' melodramatic sigh of exasperation.

Stenback wasn't falling for it. "You've got no jurisdiction here," he said coolly.

Beth Hilley leaned forward to read my ID laminate. "Charles

Dark. A new name for our list, Iwan." She favored me with an icy smile.

I returned it in kind. "Now that you've demonstrated your fearlessness shall we get down to business?"

Stenback yawned. "What business?"

"You're an entrepreneur," I said. "You publish at a profit. Suppose we sweeten it?"

They looked at each other with cynical amusement. It was clear there was an attachment between them—a strong bond.

I said, "For every week's issue in which you refrain from publishing the name of an American agent, a payment of ten thousand dollars."

"Australian dollars?"

"American if you prefer."

The woman laughed. "They think they can buy anyone off. Isn't it just like them?"

I said, "How about it, Stenback?"

"I'm glad to knwo how much Judas money you're willing to offer me. Of course my answer is no. Did you think I'd be that easy to bribe? I can't compromise the people's right to know."

"Good for you," Myers said. "That's all we wanted to know, ain't it, Charlie? Let's get it done."

Beth Hilley reached for Stenback's hand.

Myers spoke again, the snarl increasing. "I told you it would be a waste of time, Charlie."

"In conscience," I said wearily, "we had to offer them the option." I stood up and went over to the side of the room to get out of the line of fire; I put my back to the wall and shoved my hands in my pockets. "You can change your minds, of course. My associate—well, I'm afraid he enjoys rough and tumble. Regrettable but there you are. We're forced by people like you to employ people like him. Acutally I detest the young oaf. I'd hoped to one-up him by denying him his pleasure."

Myers turned angrily toward me. His revolver rode around in my direction. "You fat old buzzard. "I've had all I can take of your sanctimonious—"

It was the distraction Stenback must have been praying for. He pounced on the .32 revolver that I had left lying on the table; in an instant it was in his first and roaring.

In that confined space the blasts were earsplitting. My jaw

went agape. Deafened, I saw Myers spin wildly around and slam against the wall. The gun dropped from his fingers. He clutched at the wall and slid down, leaving a wet red smear on the plaster. His shoes drummed the floor and reflex made him curl up; then he went still.

My hand belatedly whipped out of my pocket with the flat automatic pistol I'd concealed there. I leveled it at Stenback's profile. "Drop it. Now!"

He hesitated. His revolver was still aimed at Myers, who lay in an untidy heap. The woman sat wide-eyed, motionless.

I spoke quickly. "I won't kill you unless you force me to defend myself."

It wasn't so much that he believed me; it was that I had the drop on him. By the time he could turn his gun through the ninety-degree arc toward me I could put two or three bullets into him. He'd been a soldier; he knew that.

Slowly he lowered his arm to his side and let the revolver drop to the carpet.

"Smart," I observed. "Kick it to me. Gently."

When he complied I got down on one knee and picked up the .32 by inserting my ballpoint pen into its muzzle. When I stood up I flapped the automatic toward him. "Sit down, sit back, relax."

He sank onto the divan and leaned back warily. I dropped the .32 into my jacket pocket and sidled around toward Myers, keeping my automatic trained on Stenback and Beth Hilley; knelt by Myers and laid my fingers along his throat to test for a pulse. There was a good deal of blood. I removed my hand and stood, grunting with the effort. "He's dead."

"Self-defense," Stenback snapped.

"Sure." I gave him a crooked smile. "Who's going to believe that?"

I saw realization grenade into Beth Hilley. She clutched his arm in fear.

I looked down at Myers. "Everybody knows you two had it in for the C.I.A. Now you've murdered a C.I.A. agent. Man, you'll be a hundred and five before they let out out into the light of day again. Both of you," I added, looking up sharply at the woman. "It's felony murder—she's as guilty as you are. And I'll testify to that." Then I gave it a slow chilly smile. "Come to think of it

you've done me a couple of favors. I never could stand the punk. I'm glad you've taken him out—they'll never stick me with him again. And you've done my job for me. The assignment was to stop you from publishing the rest of those names. You can't publish in a prison cell."

Beth Hilley sat up straight. "But we can still talk. We can talk in court and we can talk to our lawyers and they can talk to the press. We can still make those names public. Then what happens to you, superspy? It's a black mark on your record, isn't it?"

I regarded her with suspicion. "Maybe you're right. Maybe the punk had a point. Maybe I've got no choice." I lifted the automatic.

"Wait." She stared at me.

Stenback seemed mesmerized by Myers' huddled body. Then he looked up at me, at my pistol.

Beth Hilley gripped his hand tighter. He didn't pull away. He seemed to have shrunk; it was the woman's strength that supported both of them.

She said, "You wanted to make a deal with us. All right, we'll take the deal."

"Don't make me laugh, Beth. With the evidence I've got now? I've got Stenback's fingerprints on the murder weapon. Not to mention my own testimony."

"But you still can't stop us from revealing the names of your agents. Only Iwan and I can do that."

I contrived an indifferent expression. I picked up Myers' unused revolver and dropped it in my pocket for safekeeping; it balanced the weight of the .32 in the other pocket. Then I went toward the phone, the guns dragging my jacket down.

She watched me pick up the receiver before she spoke. "Wait a minute."

"For what?"

"Let us go. We'll leave the country. You'll never hear from us again. We'll never publish those names."

"How do I know that, lady?"

"If we ever reveal the names," she said shrewdly, "you'll find us. Nobody can hide from you people. You'll find us and kill us, or you'll have us extradited and brought back to Australia to stand trial for murdering that man."

I still had the phone in my hand. The dial tone buzzed at me. "It's not my habit to trust your kind."

Stenback said, "She's right, Dark." He seemed to have found his spine. "It's the only chance you've got of keeping those names secret. We're offering you the only way out. For you and for us. You let us go—we save our lives, or at least our freedom—and you get what you want. The paper stops publication."

I spent a while thinking about it. Finally I put the phone down on its cradle. I squinted dubiously at the two of them.

I saw the silence begin to rag their nerves. I let it grate for a bit. Then abruptly I said, "All right. Get out. I'll give you six hours to get out of Australia before I report his death. We'll keep the murder weapon out of it unless you double-cross me—in which case I'll manage to 'find' it damn quick. You keep that in mind."

"Yeah," she said.

"We will," he said.

"Get out fast now—before I change my mind."

They fled. They looked as if they were holding their breath. I left the door open until I heard them enter the elevator. Then I shut it and locked it, glanced down at Myers' bloody body, and went across to the window. I parted the drapes and watched Stenback and Beth Hilley emerge from the canopy below me. They got into ther white MG and I watched it squeal away.

Then I let the drapes fall to. Turning around, I said, "They're gone."

Myers grunted and got to his feet.

Looking down at himself he grumbled, "Do these phony blood capsules wash out? If not I've just ruined a good suit. Godd grief but I'm cramped. Couldn't you have done it faster? I think I bruised a rib when I fell. Incidentally I didn't take kindly to you calling me 'punk' and 'oaf' and all that stuff."

"Are you about out of complaints now?"

He grinned at me. He was an awful sight. "Why, Charlie, I've barely started."

"Look at it this way, Myers. You've got something to tell your grandchildren about. You've just assisted Charlie Dark in pulling a brand-new twist on the oldest con game in the world—the blank-cartridge badger game. Now doesn't that just fill your heart with pride and admiration?"

"I believe you are by all odds the most infuriatingly smug conceited arrogant fat old man I've ever met," he said, "and I thank you for the privilege of allowing me to work with you."

CHARLIE IN THE TUNDRA

by Brian Garfield

"Attu," Rice said.

"Gusundheit," I replied.

He sneered. "The island of Attu. Westernmost island in the Aleutian chain off the coast of Alaska. Nearer to Siberia than to North America. Pack your woolies, Charlie."

I scowled. "Attu has been of utterly no importance to anybody since May 1943. Is this your version of sending me to Siberia? What are my transgressions?"

"They are too many to enumerate. In fact, it might be an interesting idea to see about stationing you there permanently. Do you have any idea how many American soldiers got frostbitten up there in the War?" He blew cigar smoke in my face. "The limo's waiting—Ross will brief you on the way to the airport. It seems one of our gadgets is missing."

"It would be tedious for us if the Russians got their hands on it," Ross said in the car on the way to my digs to pick up my clothes. "We'd have to change all our codes and computer cipher programs."

"Is the pilot all right?"

"Concussion and a few fractures. He should be fine, eventually. Up there they learn how to crack up easy. The Air Force collected the plane and most of the debris and barged it over to the island of Shemya—it's only a few miles away and that's where the Air Force Base is."

"I know."

"You've been there before?"

"Twenty-odd years ago on the U-2 program."

Ross was intrigued; he's still a collegiate at heart—young enough to be eager-beaverish. "What's it like up there?"

"The end of the world."

Ross sat on the window sill and watched me pack my thermal socks and longjohns. "Anyway," he said, "it wasn't until they hauled the wreckage back to Shemya and sorted through it that they realized the computer code transceiver was missing. Con-

clusion is it's till on Attu but they're reluctant to send a team of men back to go over the crash site with microscopes—if the Russians spotted the activity they'd realize something important is missing. I suppose if we merely send one man to scout around it won't draw that much attention from their satellite cameras. But one thing I don't understand—why did they pick on you? It's not your sort of job. Why not use an Air Force man already stationed up there at Shemya? It's only a few miles away."

"It wasn't an Air Force caper," I said. "It was ours. The pilot was ours. the mission was ours. and the CCT box is ours. I'm sure the Air Force volunteered to keep looking for it but the Agency told them to lay off—'We'll take care of it ourselves.' The usual interservice nonsense. As for why me, it's probably because I've been there before. And because if there's a miserably uncomfortable job, Rice always likes to see that it gets tossed in my lap."

"Why don't you quit, Charlie? He makes your life hell and you're past retirement age anyway."

"What, and give Rice the satisfaction of knowing he drove me out?"

The long trip entailed a change of planes at Seattle, an overnight stop in Anchorage, and all-day island-hopping flight over the thousand-mile length of the Aleutian chain aboard one of Bob Reeve's antiquated but sturdily dependable DC-6 bush transports. Flying regular schedules through that weather Reeve's Aleutian Airways has somehow managed to maintain an astonishing record of safety and efficiency—indeed, it is one of the few airlines in the world that conducts a profitable business without Government subsidy.

I was dizzy from crosswind landings and wild takeoffs at Cold Bay, Dutch Harbor, and the Adak Naval Base. We bypassed Amchitka because they had fog blowing across the runway at 90 knots. Eventually we mushed down onto Shemya, the penultimate Aleutian—a flat dreary stormy atoll hardly big enough to support the runways of its airfield. It was only October but the island was slushy with wet snow. A typical gray Aleutian wind drove the cold mist through me as I lumbered down the portable aircraft stairs and ducked into the waiting blue 4×4 truck.

The only above-ground structures were the enormous reinforced hangars that sheltered our DEW-Line combat planes and the huge kite-winged high-altitude spy planes that had supplanted the U-2 in our Siberian overflight program. The hangars were left over from the War—they'd been built to house B-29 Superfortresses for the invasion of Japan that never eventuated. Everything else on the island—a top-secret city housing several thousand beleaguered Air Force personnel—was underground out of the weather. The weather in the Bering Sea is the worst in the world.

I checked in with base command and was trundled to a windowless motel-like room in Visitors' Quarters, ate an inadequate supper in the officers' cafeteria, then went to visit the injured pilot.

He was a chunky Texan with thick short sandy red hair, freckles, and an abundance of bandages and plaster casts. His eyes were painfully bloodshot—evidence of concussion.

"Paul Oland," he said. "Afriad I can't shake hands. Mr. Dark. Pull up a pew there."

I sat, not quite fitting on the narrow chair. "How're you making it?"

"They tell me I'll be flying again in a few months, to my surprise. Sheer dumb luck. I should've been dead."

"Tell me about the accident."

Well, I'd been at 120,000 feet over Kamchatka and I was on my way back with a lot of exposed film. They've recovered all the film, by the way. It's all in the debriefing report."

"I've read it. But I'd like to hear you describe it."

"You know much about the weather patterns up here?"

"I helped set up the U-2 program here."

"Then you know what it's like. Half the time you're in thick fog and hundred-knot winds at the same time. You can't tell up from down. You have to rely on your instrumetns and if the instruments start to kick around you've had it."

"That's what happened? Instrument failure?"

"They didn't fail. They just weren't a match for the williwaw. I'd made my descent into the muck—I was down to four thousand feet and still dropping. The only way you can see anything around here is get right down on the deck. The pilots who get lost and get killed are the ones who try to climb out of

it. There isn't any top on it. It just goes up forever, right clear to the moon. Anyway, I was circling in from the west to line up for my landing approach. They had me on radar and I had my Loran bearings—it should have been fine. But there's an incredible amount of electrical activity in these clouds. My needles were jumping around like they got stung by red ants.

"I figured that would pass, they'd calm down when I got closer to base and the signals got stronger. But then I got a squeal from the tower—I'd gone off their screen behind a mountain on Attu. I figured it had to be the north end of Attu, so I pulled hard left and started to climb—I still couldn't see a thing, it was a williwaw blowing out there, and my radar screen was useless because of dozens of false images reflected back from the moisture in the clouds. The next thing I knew I was bellyflopping across Fish Hook Ridge."

"Belly landing?"

"Landing? No. Accident. Ten feet lower and I'd have crashed nosefirst into the cliff. Blind luck, I slid across the top of it instead. I was about three miles south of where I'd thought I was—the wind blew me that far off course in something like forty-five seconds while I was off the Shemya radar screen. I mean it's fantastic up here, the elements. This weather goes up and down, up and down—"

"So you hit the top of the ridge—"

"And flipped over and busted most of my bones. The plane came apart but it wasn't too bad. Bits and pieces went in various directions. The canopy saved me—it didn't cave in. God knows why. Most of the dashboard fell apart, though."

"Including the code box."

"Yeah. Including the code box."

He looked morose.

There isn't a single tree on Attu—or for that matter on any of the Aleutian Islands—but the tundra growth is a matte on everything and makes for difficult boggy walking, especially for someone as heavy as I am.

We'd had to wait 36 hours for a break in the weather. Then the helicopter shuttled me across to the big island and left me there with a sort of Boy Scout camping outfit in my backpack in case the weather didn't permit the chopper's picking me up at sundown—a strong likelihood.

The chopper pilot had done a bit too much plain-English talking into his microphone and I reprimanded him because he'd said enough to alert a sufficiently sharp-eared Soviet radio monitor to the fact that we were searching for something crucial, valuable, and portable on Attu. It added a sense of urgency to my job and made me glad of the portable radio in my pack. We weren't far off the Soviet coast, after all. And I was dismally aware of the fact that if the Soviets sent people in to "help" me hunt for the code box, my own people weren't likely to start World War III over it. Langley's attitude is to do your best but take your losses.

I was dropped off within a hundred yards of the crash site but it took me 20 minutes to get there on foot; I had to crab my way up the cliffs. I wondered how the devil the Japanese and American infantries had managed to fight a war here. In 1943 the entrenched Japanese defense force had been annihilated by 15,000 American troops who somehow made amphibious landings on the beaches. The fighting was wild and vicious. Half of the U.S. soldiers had been evacuated on stretchers or left buried on the island—combat wounds, frostbite, shock, trenchfoot, williwaw madness.

All those lives had been expended for it and ever since then it had been ignored by the world: nobody needed it; Attu was as useless as any piece of ground on earth. Uninhabited and unloved. Technically it belongs to the United States and officially it is a National Battlefield Park—like, say, Gettysburg; it has an obscenely large military cemetery. But tourists do not queue up to go there. Nothing exists on the mountainous tundra except mud, grass, brush, snow, and the rusting relics of old warfare: abandoned artillery, wrecked planes, discarded canteens, bent M-1 rifles, ruined Japanese caterpillar trucks, crushed infantry steel helmets.

The morning was fairly clear—unusual. I could see down the length of Massacre Valley to the foam of Massacre Bay. These place-names dated back to Soviet sealing days in the Nineteenth Century when Aleut Indians had been decimated by Russian sailors; in World War II they were eerily fitting. To the east I saw an Air Force jet lift above the Shemya runway and circle away toward Amchitka, the Atomic Energy Commission's private test-hole island, an hour's flight away over the horizon.

I was alone on Attu with the volcanos and the tundra—a rare distinction in which I took no pleasure. I removed my backpack, anchored it with boulders in case of a sudden williwaw, and began to prowl.

I was resigned to a long dismal search. If the code box had been in plain sight the Air Force people would have found it. So it had fallen into a crevice or tumbled into a pool of mud or rolled down a cliff.

First a snack—two roast beef sandwiches to keep my strength up. They tasted like styrofoam. Then I unlimbered the portable metal-detector and put my nose to the ground, cursing Rice in a dreary monotone.

The day was wasted. The chopper managed to collect me at sundown; I spent another 36 hours on Shemya shooting pool and assuaging boredom before the weather broke and allowed me to return to Attu. Resuming the search I spent five hours clambering cautiously over the east side of the ridge. The metal-detector unearthed dozens of cartridges, rifles, canteens, and other souvenirs—but no CCT box.

I worked a checkerboard pattern and decided to keep the current sweep inside a seventy-yard radius of the spot where the plane had come apart; my first search, a fifty-yard circle, had proved fruitless. When the seventy-five-yard circle produced nothing I ate lunch and expanded the search area to a hundred-yard radius.

In the afternoon the clouds built up and the wind began to cry across the ridgetops. I went back to my campsite and shouldered into the heavy parka and continued my work muffled in a thick earflapped hat and heavy gloves. I kept one eye on the weather, ready to seek shelter, but it held—the clouds remained a few hundred feet above my 2000-foot ridge, although I could see snow-squalls offshore that came right down to the water.

At about half-past three my search brought me around to the west rim of the ridge. By a fluke the sun broke through at that moment and a painful blade of reflected light stabbed at me from a rubble of volcanic rock 200 feet below me at the foot of the cliff.

It excited me because rusty relics don't gleam like that. It was the shine of fresh new metal or possibly of glass.

It was a long climb down because I had to go around. A mountain climber might have rappelled down in five minutes but I'm too old and too fat for athletics. I took my time, going down from rock to rock on the rubber soles of my insulated boots, hanging onto a rope I'd anchored to a boulder at the top.

By the time I made my way around to the point where I'd seen the glimmer, the sun had long since vanished again. But I found it anyway, knowing where to look, and it was indeed the Agency's CCT code box—a device similar to an ordinary pocket calculator, full of transistorized printed miniature circuits designed to send and receive messages in codes that were virtually impenetrable by anyone who didn't possess an identical CCT with identically programmed circuitry.

The box was battered and mangled from its fall; unserviceable—but that wouldn't matter to the Russians if they'd got their hands on it. Damaged or not, it would have yielded up its secrets to any examiner of its circuitry. I was relieved to have it in hand.

I contemplated the steep climb back to camp and I made a face. Out of habit and procrastination I turned to survey the horizons—and saw through a notch in the sodden hills a dark silent bulk sliding along the waves, heading out to sea. Even as I watched the submarine its decks began to run awash; it submerged quickly and I might have imagined it except for the motorized rubber dinghy that came birling through the surf onto the strip of volcanic sand that the invaders of 34 years ago had code-named Beach Red.

The submarine had come up on the blind side of the island, launched its dinghy, and fled immediately. It meant only one thing: they were Russians.

"I'm sorry, Mr. Dark. Ain't nothing flying around here except the hangars. We've got a class-A williwaw in progress. Wind gauge is gusting to a hundred and fifteen knots. Maybe by morning—"

"Tell the base C.O. there are strangers on Attu. Possibly Soviets. And a submarine lying off the western beach. You got that?"

"Yes, sir. Acknowledge."

Low sunbeams slanted onto the sea through a distant hole in

the overcast. From the rim of the cliff and against the shimmering glare on the ocean I saw the tiny outline of a solitary figure climbing toward me.

I gathered my gear, stowed the CCT in my parka, and carried the backpack away down the east face of the ridge toward Massacre Valley. It was slow going in the sucking tundra but I wanted to be well away from the crash site. It was a big island; all I had to do was stay out of sight until I could be picked up.

I secreted the heavy metal-detector under an overhand; I had no further need of it. Then I buckled into the backpack and pressed on.

The light drained out of the sky; the wind came and with it fog. I knew I needed shelter.

The best I could find was a sort of hollow in the rocks. It broke most of the wind. I wrapped up in blankets and dug out an inadequate dinner of sandwiches and bottled vitamin-fruit concentrate. Then I rummaged in the pack for my sole weapon—an airman's lightweight survival carbine. I loaded it and laid it beside me.

The williwaw struck at nightfall and I spent most of the night emphatically miserable in a cringing huddle, clutching the blankets around me with my face buried in cloth and my ears deafened by the cry of the storm.

By the time it eased away, the luminous dial of my watch told me it was only midnight, but I was battered and exhausted and dismally cold.

I rooted dry socks out of the pack. My fingers were tingling numb; I had trouble getting the boots off and on. I ate another sandwich and waited for daybreak, thinking about that man I'd seen climbing the ridge. If he found me he wouldn't leave me alive.

My survival through several decades of intelligence capers and Cold War conflicts has been a matter of wits rather than atavistic toughness. I am a poor marksman and have never bothered to learn anything about unarmed combat or pressure-points or outdoor tricks. I have never been painted into a kill-or-be-killed corner; it's not my fashion. I had never killed anyone or tried to. It is my conceit that any fool can kill people. I fancy myself a bit better than that.

But if a Soviet scout found me . . .

"It's pea soup up here."

"It's often like that, sir, but if you can make your way down to the beach at the foot of the valley it may be clear down there. We'll try to get a helicopter in after you've reached position. We chased their submarine out past the twenty-mile limit. If they've still got anyone on the island he'll keep—just stay out of their way."

"You can bet on it." I packed the radio and began the slow descent. Fog and light rain swirled about me.

The wind sluiced down the slope behind me, carrying sound. That was how I got my first warning.

He was making noise with his canteens and metal impedimenta and heavy boots. No more noise than I'd been making—but the wind was in my favor. I heard him first.

I wheeled in alarm and saw him bearing down, vague in the mist—a big man made bulkier by his quilted Siberian parka and his festoonings of equipment—moving fast downhill through the fog perhaps 50 yards above me. The object in his fist looked like a machine pistol, wicked, efficient.

When he stopped and lifted it to aim I flung myself behind a boulder and heard the ricocheting bullets shriek over my head.

I crawled madly—infuriated to a white-hot rage; fear saps a man of his dignity and that's a hateful plight.

"Shemya. Charlie Dark calling Shemya. For Pete's sake come in Shemya."

Nothing. Static. I was in a dead-radio pocket.

I caromed off the walls of a Japanese trench, bouncing off the slippery sides, running as best I could—shambling, really; the mud sucked at my boots. I made random turns in the maze every time I came to a fork. The Japanese had dug miles of trenches.

Finally I stopped and attempted to control my breathing. I'd been making too much racket. Use your head, Charlie—keep your wits because that clown intends to kill you to get his hands on the code box in your pocket.

I moved on, bent low and trying to walk without sound. It was difficult; the boots squished in the muck.

The wind moaned; mist rolled and curled in unpredictable tendrils—one moment I was socked in, blind, and the next I could see blue sky. I kept stopping to listen. At first I heard him

banging around up there, running from trench to trench, searching. Then the clamor stopped and I knew he was moving as I was—softly, waiting for me to give myself away.

He was the hunter. It put the burden on him. Realizing that, I knew my best chance was to stop.

The boulder had been too huge to shift, so they had curled the trench around it, undercutting its belly. I wouldn't find better cover. I crouched under the overhanging rock and took out the survival carbine, cocked it, and waited.

I thought of trying the radio again but that was no good. They couldn't help me in the fog—and he might hear my voice.

I heard the suck of bog around his boots.

He was up high on the mountain side somewhere above the trench. The rock above my head prevented me from seeing him—and prevented him from seeing me as well. Maybe I had a chance.

He was still searching for me and that meant it was more than mere curiosity. He knew I had the code box; otherwise he'd have been satisfied to run me off the search area. Possibly he'd found the abandoned metal-detector and drawn his conclusions from that; or maybe he'd seen my tracks at the foot of the cliff where I'd recovered the CCT. A man adept at reading tracks could have—

Tracks. The realization grenaded into me. I'd left huge tracks in the muddy trench. Not being an outdoorsman I hadn't even thought of it before.

My tracks led to this spot. They didn't lead away from it.

Too late now to think about sweeping mud over them. All I could do was pray he didn't see my spoor.

But he found it.

The trench walls were nine or ten feet high. If the Japanese had used ladders they had long since rotted away. The only way to get down was to jump; the only alternative was to travel along the trench to a distant point where the walls were lower.

I listened to him come. He was near the boulder, just above me. He went back and forth a couple of times. I could see what he saw—tracks on one side, no tracks on the other.

I heard the harsh metal clack when he worked the mechanism

of the machine pistol.

Then unaccountably his boots moved away.

It took me a moment to understand. Then I realized. The trench was too wide for him to leap across it. And he couldn't jump down in plain view of me. He was heading along the trench to jump into it beyond the bend and come at me carefully on a level.

While I listened to his footsteps recede I knew I couldn't stay here. Some primitive impulse drove me out of my shelter—back the way I'd come, sliding my feet into the tracks I'd already made.

I approached the bend and stopped, my back to the wall, searching the rim above me. Then I heard him again—he was past the bend; something clanked.

I slid along the wall, coating the parka with muck. I was in time to see him jump right down into my view.

The muck betrayed him. His feet slid out from under him and he sprawled. The machine pistol slid out of his hand and lay there with its handle protruding from the mud at an angle.

I took a pace toward him and spoke in Russian, "Be still."

He froze. His face came around—a big flat Mongol face, the face of a Siberian Tatar Cossack.

I trained the carbine on him. "Take it easy, Tovarich." But my heart pounded. His face was preternatural, terrifying. His dark eyes burned at me. Then they flicked toward the machine pistol just beyond the reach of his long powerful arms.

Sure, I thought. They'd picked a Mongol for the job because they wanted someone expendable and someone expert at out-door maneuver—a man who could read the earth like an Apache Indian and find an object that American eyes had missed. An animalistic soldier who could move across an enemy island without being trapped by the enemy.

In short, he was formidable. Primitive but clever; simple but expert—a fighter, a survivor, a killer.

All this I understood with one look at him. And something else: he wasn't programmed to surrender.

He came to his feet with slow menacing care. He kept looking from me to his machine pistol and back. Judging his chances.

His eyes lingered a moment on my survival carbine. It was a high-velocity .22, very small and light. He was thinking he could absorb one or two of those and still live to kill me.

He wasn't a technological sophisticate. There was something I knew that he didn't know. I had an edge that had nothing to do with the gun in my hands. But just the same I faced a terrible dilemma.

I said in English, "I won't kill you in cold blood. It's not my style."

I could see by the slight squint of his eyes that he didn't understand my English. I went on, talking in a calm voice as you might talk to a skittish animal to calm it. "I can't just walk away. You'd come after me. I can't tie you up—if I get that close to you, you'll find some way to get the better of me. I can try to take you down to the beach at gunpoint but that doesn't have much appeal either. In this fog? You'd have too many chances to escape or jump me. Look, I want to get out of this alive."

He only stood there, facing me, adamant.

I said in Russian, "Don't try to reach your gun."

He made no reply but from the flash of his eyes I knew he'd understood that. Stubborn, willful, he watched me with single-minded intensity.

I said reasonably, "You might kill me and get the box. But you can't get off the island. We've driven your submarine away. You're stranded here. Your only choice is to go back with me. I won't hurt you if you don't force me to."

With one hand I held the gun on him, with the other I wormed the radio out of its bag. I spoke into the mouthpiece in English.

"Shemya, this is Charlie Dark. I doubt you can hear me. But if you can, send a squad over here to help me out. I've got my hands full with a Mongolian Tatar who wants my guts for lunch." I waited for a reply, got none, switched it off, and fumbled to put it away.

He was motionless; his very stillness was menacing. His quick determined mind was racing visibly and I knew I'd never get him to the beach.

I spoke to him in English. "It's splitting hairs and I'm going to hate myself for a hypocrite, but I don't see any other way to do this. You're too healthy for me to contend with."

He didn't even blink.

I switched to Russian: "We're going to walk down the valley to the beach. You first."

Then I turned my head as if to locate something in my pack.

I was the break he'd waited for. He pounced on the machine pistol, willing to take his chances, figuring he could survive my first shot or two, figuring my reaction time would be slow—an old fat soft American.

The weapon rode up in his grasp and in that broken instant of time I wondered if I'd guessed wrong. But it didn't matter now. I didn't bother to try to lift my carbine; it would have been a useless gesture. I saw the grim stubborn satisfaction in his eyes; a trace of puzzlement flicked across him but he was already committed. He pulled the trigger.

The explosion rang in my ears. Pieces of heavy steel whacked into the walls of the trench. The Mongol wheeled back with a wail, blood streaming from his right hand in a gout. He sank to his knees and folded himself protectively over the shattered hand, grunting his agony.

I found the first-aid kit in my pack and tossed it to him. "Here. Bind it. We've got a long hike ahead of us."

And hike we did. He was docile enough now; the injury had blown the fight out of him.

The chopper collected us at noon on Massacre Beach.

The base commander drove me to the plane. When I got out of the car we shook hands. He said, "Thanks for bringing him in alive. We'll milk him for every drop. But I still don't understand how you brought it off."

"I guess I didn't play fair with him. I could have told him not to try to shoot that machine pistol. You can't fire a weapon that's got mud jammed up its muzzle. It won't shoot—it'll only explode."

CHALLENGE FOR CHARLIE

by Brian Garfield

This took place several years ago; I must make that clear.
Normally Helsinki is one of my favorite towns, but this
time I was reluctant to return there because the job was the
toughest one Rice had yet put into my ample lap, and the
adversary was Mikhail Yaskov, who was—bar none—the best in
the business.

Yaskov and I had crossed paths obliquely several times down
through the Cold War decades, but I had never been sent head-
to-head against him before, and the truth is I was not eager to
face this assignment, although—vanity being what it is—I be-
lieved I probably could best him. "Probably" is not a word that
gets much of a workout in my lexicon; usually I know I can win
before I start playing the game; but with Yaskov I'd be dead if I
became overconfident.

The job was simple on the face of it: straightforward. As usual
the assignment had come to our section because of the odd
politics of international espionage which sometimes can cause
simple jobs to become sensitive ones. If it's a job that would
embarrass anybody, then it usually gets shoveled into our de-
partment.

In this case I was America's friendly right hand, extended to a
country that needed assistance not because of any lack of skill or
courage (the Finns excel in cleverness and toughness), but be-
cause of a fine delicacy of politics.

Finland is virtually the only country to have fought a war with
Russia in modern times and not lost it. Finland is the only
country in Europe that fought against the Red Army in World
War II and did not get occupied by the Russians as a result.
Finland is the only country in Europe that has repaid, to the
penny, the postwar reconstruction loans proffered by the West-
ern powers. Yes, I like the Finns.

They share a border with the Soviet Union. The world being
what it is, they make a few concessions to the Russians by way
of trade agreements and the like. Soviet-made cars are sold in

Finland, for example, although few Finns choose to drive them; the Finns don't admit it loudly in public but they loathe the Russians, and if you want a clout in the face, a good way to earn one is to state within a Finn's earshot that Finland is within the Soviet sphere of influence.

It emphatically is not; Finland is neither a Communist country nor an intimidated one. It is, however, a nation of realists and while it does not bow obsequiously to the Soviets, neither does it go out of its way rudely to offend them. It treads a middle ground between hostility and friendship, the object being the preservation of Finnish independence rather than the influencing of power blocs. Finland practices true and admirable neutrality.

Mikhail Yaskov was an old-fashioned master spy. He had run strings of agents everywhere in the West—usually with brilliant success. The only American agents I knew of who'd come level against him were Miles Kendig, who was said to be dead now, and my colleague Joe Cutter, who by then was running our operations out in the Far East. I was the only one left in Langley who had a prayer of besting Yaskov, so I was the one picked to fly to Finland.

The KGB had sent Yaskov into Helsinki because of chronic failures in the Soviet espionage network there. The Finns were too shrewd for most of the Russian colonels who showed up at the Soviet Embassy disguised as chauffeurs or Second Secretaries or Trade Mission delegates. The apparatus was a shambles and the Organs in Moscow had dispatched Yaskov to take charge in Helsinki, as if the KGB network were a musical comedy having trouble in New Haven and Yaskov were Abe Burrows sent in to doctor it up.

Yaskov was too sharp to put his foot in anything and there was no likelihood of his giving the Finns sufficient legitimate reason to deport him. If they declared him *persona non grata* in the absence of clear evidence of his perfidy, it would provoke Moscow's wrath; this Helsinki preferred to avoid.

Therefore as a gesture of good will I was flown to Helsinki to find a way to get Yaskov out of the country and keep him out—without involving the Finnish government.

It was a bloody impossible job against a bloody brilliant

opponent. But I wasn't really worried. I'm really the best, bar none.

In my time I have pulled off a number of cute and sometimes complicated capers and I suppose, given my physique (corpulent) and age (well past retirement schedules), I could aptly be called a confidence man rather than a man of action. But Yaskov was not susceptible to con games. He wasn't a man to be fooled by elaborate tricks—he knew them all; in fact, he'd invented most of them.

There really was only one way to attack him—head-on and straight up. And I had only two weapons to employ against him—his own vanity and his awareness of mortality.

I made the call from a public coin phone in the cavernous Stockmann department store.

Comrade Yaskov could not come to the telephone immediately. Could the caller please leave a number to be called back?

No, I could not. I would phone again in an hour. Please tell Comrade Mikhail Aleksandrovitch to expect my call. Thank you.

When I called again Yaskov came to the phone and chuckled at me in his suave avuncular fashion. He had a rich deep voice and spoke excellent English with an Oxford inflection. "How good to hear your voice, Charlie. I do hope we can get together and exchange notes about the Lapland scenery. Two foreigners in a strange land and all that. Perhaps we can meet informally."

"By all means."

It was elementary code, designed to set up a meeting without witnesses or seconds.

I said, "Do you happen to know a fellow named Tower?"

"The Senator from Texas?"

"No. Here in Finland."

"I see. Yes, I know of him."

"Perhaps we could meet him tomorrow."

"Where?"

"I don't mind, Mikhail. You pick a spot."

"Would Tavern Number Four suit you?"

"Fine. I'll see you there." I smiled and cradled the phone.

There was a place called the Tavern Number Four, but we wouldn't be there. The conversation had been designed to mislead anyone who might be eavesdropping on the call—one could depend on the Soviet Embassy's lines being tapped, possibly by several different organizations. The fellow named Tower was a place—the town of Lahti, within fair commuting distance of Helsinki; the town was known for its landmark, a great high water tower that loomed on stilts above the piney landscape. The number four established the time for the meeting.

I was there at three, an hour ahead of schedule, to inspect the area and insure it hadn't been primed with spies or ambushers. My eyes don't miss much; after forty minutes I felt secure and awaited Yaskov openly in the parking lot.

It was a pleasant sunny day with a touch of autumn chill creeping south from Lapland: Lahti is hardly 100 kilometres north of Helsinki, but the forest cools the air.

Precisely at four Yaskov arrived. It might have been seemly and sensible for him to drive himself, in a Soviet-built Moskvitch or Pobeda, but Yaskov was fond of his comforts and he sailed elegantly into view in the back seat of a chauffeur-driven silver Mercedes limousine. Like me he was a man who stood out in crowds—he was not the sort of executive who dwelt in anonymity—and I believe the Organs must have put up with his ostentatious eccentricities on account of the excellence of his performances.

The chauffeur was, so far as I could tell, simply a chauffeur; his face did not flash any mug photos against the screen of my mind. He could have been a recent recruit or an agent whose face had not been put on file in the West, but I doubted it because if the man were of any importance Yaskov would not have exposed his face to me. The chauffeur trotted around to open the limousine's back door and Yaskov emerged smiling, uncoiling himself joint by joint, a very tall lean handsome figure in Savile Row pinstripes, a Homburg tipped askew across his silver hair. No baggy Moscow serge for him.

His pale intense blue eyes, illuminated from within, were at once the shrewdest and kindest eyes I'd ever known and I had always attributed part of his success to those extraordinary eyes: I suspected they had inspired more candor from his victims than had all the drugs and torture apparatus in the Arbat and

Lubianka. Yaskov could charm the Sphinx out of its secrets.

As always he carried a cane. He owned an extensive collection of them. This one was a malacca, suitably gnarled and gleaming. The excuse was an old leg injury of some kind, but he walked as gracefully as an athlete and the cane was a prop, an affectation and, if necessary, a weapon.

He transferred it to his left hand and gave me his quick firm handshake. "Such a pleasure to see you again. When was our last meeting, do you recall?"

"Paris, 'seventy-four. When we were all chasing Kendig." He remembered it as well as I did but it was a harmless amenity and we both smiled. I said, "Why don't we take my car?"—drawling it with grave insouciance: I didn't want the chauffeur around.

"Why not indeed," Yaskov said carelessly. He made a vague sign to the gray-uniformed man, instructing him to wait by the limo, and followed me to my hired Volvo.

We drove out of town along a country road that curled gently through the forest. I made a right here, a left there. After twenty minutes—small talk between us—I pulled onto the verge and we walked across a carpet of pine needles to the edge of a crystal blue lake. Central Finland has thousands of such lakes, each as postcard-beautiful as the next; with a suitable net you can scoop up your supper from the bottom—fresh-water crayfish.

There was a log, strategically placed, and I sat down on one end of it. "I'm not bugged."

"Nor am I. Shall we go through the wretched tedium of searching each other?"

"We're both a bit long in the tooth for that kind of nonsense."

"I aggree."

We trusted each other to that extent mainly because we were such fossils. We antedated the computer boys with their electronic gadgetry; we were the last of the tool-making men: we'd had to polish our wits rather than our mathematical aptitudes. In our decrepitude we still preferred to walk without the crutches of microphones, long lenses, and calculator-ciphers. To use those would have been a confession of weakness.

He said, "You seem heavier than you were."

"May be. I rarely weight myself."

"Don't they have physical requirements in Rice's section?"

"For everybody but me." I said it with a measure of pride and

he picked it up; his warm eyes laughed at me.

Then he said, "I too. You know I have a serious heart condition."

"Yes, I know that."

"I'd have been astonished if you didn't. It is a secret only from some of my own superiors." He laughed again, silently, and settled on the log next to me, prodding the earth with his cane.

I studied the toes of his polished cordovan shoes. "This is a bit dicey, Mikhail. You may have guessed why I've been posted here."

"May I assume the Company wishes me out of the Finns' hair?"

"You may."

"Well then." He smiled gently.

I said, "You've got a villa on the Black Sea, I hear."

"For my retirement."

"Nice place?"

"One of the largest of them. Magnificent view. Every room is wired with quadraphonic speakers for my collection of concert recordings. It's quite an imposing place. It belonged to a Romanov."

"It's a wonder to me how your bourgeois conceits haven't got you in trouble with your superiors in the classless state."

"A man is rewarded for his worth, I suppose."

"You should have been born to an aristocracy."

"I was. My father was a duke."

"Oh, yes. I'd forgotten." I hadn't forgotten, of course; I was simply endeavoring to prime the pump.

On the far side of the lake a rowboat appeared from an inlet and proceeded slowly right to left, a young couple laughing. I heard the faint slap of the oars. I said, "I hope you'll be able to enjoy the villa."

"Why shouldn't I, Charlie?"

"You might die in harness."

He chuckled avuncularly.

I said, "It would be a waste of all those quadraphonic speakers."

"I've often thought it would." he agreed with grave humor.

"I don't have a villa," I said.

"No. I suppose you don't."

"I've got nothing squirreled away. I spend everything I earn. I have four-star tastes. If they retired me right now, I'd be out in the street with a tin cup."

"What, no pension?"

"Sure. Enough to live on if you can survive in a mobile home in Florida."

"Of course that wouldn't do." He squinted at me suspiciously. "Are you asking me for money? Is that it? Are you proposing to sell out?"

"I guess not."

"I'm relieved. I would accept your defection, of course, but I wouldn't enjoy it. I prefer to see my judgments vindicated—I've always respected you. It would be an awful blow if you were to disappoint me. In any case," and he smiled beautifully, "I wouldn't have believed it for a moment."

"The trouble with Charlie Dark," I said, "I have champagne tastes and a beer income. I'm way past retirement age. I can't fend them off forever. I'm older than you are, you know—"

"Only by a year or two."

"—and they're eager to put me out to pasture. I'm an eyesore. My presence embarrasses them. They think we all should look like Robert Redford."

"How boring that would be."

I said, "This time they're offering me an inducement. A whopping bonus if I pull this last job off."

"Am I to be your last job?"

"Charlie's last case. A fitting climax to a brilliant career."

He laughed. "How much am I worth, then?"

"If I told you it would only inflate your conceit even more. Let's just say I'll be able to put up at Brown's and the Ritz for the rest of my life if I take a notion to."

"I don't believe very much of this, Charlie."

"That's too bad. I was hoping you would. It would have made this easier for both of us."

I took the pistol out of my pocket.

Yaskov regarded it without fear. One side of his lip bent upward and his eyebrow lifted. Across the lake the young couple in the rowboat had disappeared past a forested tongue of land; we were alone in the world.

I said, "It's only a twenty-five caliber and I don't know much

about these things, but at this range it hardly matters. With your heart condition your system won't withstand the shock."

"It's a tiresome bluff, Charlie."

"That's the problem, don't you see? I don't want to shoot you. But you're not going to leave me any choice. I can't think of any way short of shooting you to convince you that I'm not bluffing."

He poked at the pine needles with his cane. I gave him a look. "Can you think of any?"

"Not offhand." He gestured toward my pistol with the head of the malacca. "You'd better go ahead."

"We've got plenty of time. Maybe if we put our heads together we can think of an alternative."

"I doubt it. You're quite right, Charlie—I don't believe you'll do it. I believe it's an empty threat."

I studied the pistol, and unfamiliar object in my hand. "At least I know where the safety catch is. I think of this thing as a nuclear arsenal—a deterrent force. If you ever actually have to use it, it's too late."

"Yes, quite."

"But that doesn't make it impotent. The nukes are real, you know. This thing's loaded."

"I'm sure it is. But a loaded gun is no danger to anyone until there's a finger willing to pull the trigger."

I said, "It's a fascinating dilemma. I guess it comes down to a comparison of relative values. Which is more important to you—your life or your self-respect? Which is more important to me—the conceit of never resorting to violence or the promise of luxury for the rest of my life?"

"It's no good, Charlie. You'll have to kill me. There's no alternative at all. Look here, suppose I agreed to leave Finland and never return. Would that satisfy you?"

"Yes."

He said, "It would be easy for me to agree to that. Here: I promise you I'll leave Finland tomorrow and never return. How's that?"

"Fine. We can go now." I smiled but didn't stir.

"You see it's no good. I have only to break my word. My people would begin the hunt for you immediately. And it would be you, not I, who would end with a bullet in him."

"Ah, but if you kill me, then they'll send the whole Langley Agency after you and they won't sleep until they've nailed you. They've got their pride too, you know. No, Mikhail, you can't do it that way."

"Not to be terribly rude, old boy, but I really doubt they'd care that much. They're trying to get rid of you anyway. I might be doing them a favor." He spread his hands to the sides, the cane against one palm. "Charlie. it's no good, that's all. You've never killed a man in cold blood. In fact, you've never killed a man at all, have you?"

"No. But obviously I'm not a pacifist or I'd be in some other line of work. I believe in protecting oneself and one's interests."

The rowboat reappeared, heading home. I put the gun away in my pocket to hide its telltale gleam from the young lovers, but I kept my hand on it and kept the muzzle pointed in Mikhail's direction. I said, "Your running dogs aren't good enough to sniff me out. You know that. While they were looking for me I'd be looking for you. Sooner or later I'd reach you. You know as well as I do that there's no way on earth to prevent a determined adversary from killing a man."

"There's one. Kill the adversary first. Unlike you I have no compunctions about that."

"Thing is, Mikhail, right now I'm the one with the gun. There's also the fact that I'm only a replaceable component. If I'm taken out they'll just send someone else to finish the job."

"Joe Cutter, no doubt?"

"Probably. And Joe isn't as peaceable as I am."

"On the other hand he's not quite as good as you are, Charlie. I could best him. I'm not sure I could best you—not if you were actually determined to kill me."

"And the next one after him, and the next after that?"

"Oh, they'd grow weary of it; they'd cut their losses."

"If nothing else, I think your heart wouldn't stand the strain."

The smile drifted from his gaunt handsome face; he regarded me gloomily. "Do you know what I'm thinking about?"

"I guess so. You're thinking about the comforts of those quadraphonic rooms and the untidiness of trying to operate in a country where the enemy superpower wants you out. You're thinking I'm never going to give you any peace. You're thinking how you like me as much as I like you, and you don't want to

kill me any more than I want to kill you. You're thinking there's got to be a way out of this impasse."

"Quite."

"The rowboat was gone again. I heard the lazy buzz of a light plane in the distance. Yaskov drew doodles in the earth with his cane.

I said, "You can leave any time you want. You write your own ticket. You volunteered for this post, I imagine, and you can volunteer out . No loss of face. The climate doesn't agree with your heart condition."

He smiled again, shaking his head, and I took the pistol out of my pocket. "I want that bonus. I want it a lot, Mikhail. It's my last chance at it."

He only brooded at me, shaking his head a bit, and I lifted the pistol. I aimed it just past his face. I said, "If I pull the trigger it won't hit you. You'll get a powder burn maybe. The first time I shoot you'll flinch but you'll sit there and smile bravely. The second time my hand will start to tremble because I'm not used to this kind of thing. I'll get nervous and that'll make you get nervous. I'll shoot again and you'll have a harder time hanging onto that cute defiant smile. And so on until your heart can't stand it any more. When they find your body, of course they'll do an autopsy and they'll find out you died from a heart attack. My conscience will be a bit stained but I'll live with it. *I want that bonus.*"

He sighed, studying my face with an impassive scrutiny; after a long time he made up his mind. "Then I suppose you shall get it," he said, and I knew I'd won.

Yaskov left Finland at the end of the week and I returned to Virginia and other assignments. As I said, these events took place several years ago. Recently I had a call from an acquaintance in the Soviet trade delegation in Washington and I met her for drinks at a bar in Georgetown.

She said, "Comrade Yaskov sends his regards."

"Tell Mikhail Aleksandrovitch I hope he's enjoying his villa."

"He's dying, Mr. Dark."

"I'm very sorry."

"I know the question. Tell him the answer is no—I was not bluffing."

I thought of it as a last gift from me to Mikhail. In truth the whole play had been a bluff; I would not have killed him under any circumstances. I lied to him at the end because it would have been churlish and petty to puncture his self-esteem on his death-bed. Far better to let him die believing he had sized me up correctly. It meant he would think less of me, for compromising my principles, but I guessed I could live with that. It was a small enough price to pay. You see, I really did like him.

Still, I suspect he may have had the last laugh. It has been several months since the lady and I had drinks in Georgetown. To the best of my knowledge Yaskov is still very much alive; now and then an evidence of his fine hand shows up in one operation or another. I suspect he's still pulling strings from his Black Sea villa—directing operations from his concert-hall surroundings.

It leads me to believe he was simply growing tired of field work, tired of pulling inept Soviet colonels' chestnuts out of fires, tired of living in dilapidated embassies with enemies breathing down his collar. He was looking for an excuse to return home and I gave him an excellent one.

As the years go by I become increasingly uncertain as to which of us was the real winner.

CHARLIE'S VIGORISH

by Brian Garfield

When I saw the phone's red message-light flashing I had a premonition—it had to be Rice; no one else knew I was in New York.

I rang the switchboard. "This is Mr. Dark in 1511. There's a message light." I tossed the folded Playbill on the coffee table and jerked my tie loose.

"Yes, sir, here it is. Please call Mr. Rice. He didn't leave a number, sir."

"That's all right, I know the number. Thanks." I cradled it before I emitted an oath. Childishly I found ways to postpone making the call: stripped, showered, counted my travelers' cheques, switched the television on and went around the dial, and switched it off. Finally I made a face and rang through to Rice's home number in Georgetown.

"Charlie?"

I said, "I'm on vacation. I didn't want to hear from you."

"How was the play?"

"Dreary. Why don't they write plays with real people in them any more?"

"Charlie, those *are* real peopl. You're out of touch."

"Thank God. What do you want?" I made it cold and rude.

"Oh, I just thought you might be lonesome for my voice."

"Has hell frozen over?" He's my boss but I will not call him my superior; I loathe him as much as he does me. I said, "If it's an assignment you can shove it somewhere with a hot poker. You've already postponed my vacation once this year."

"Actually I've been thinking of posting you to Reykjavik to spend a few years monitoring Russian submarine signals. You're designed for the climate—all that blubber insulation."

"The difference between us," I told him, "my blubber's not between my ears. You called me in the middle of my vacation to throw stale insults at me?"

"Actually I wish there were some terrible crisis because it might give me the pleasure of shipping you off to some Godforsaken desert to get stung by sandflies and machine-gun slugs, but the fact is I'm only passing on a message out of the kindness

of my heart. Your sister-in-law telephoned the company this afternoon. Something's happened to your brother. It sounded a bit urgent. I said I'd pass the word to you."

"All right." Then I added grudgingly, "Thanks." And rang off. I looked at the time—short of midnight—and because of the time zones it was only about nine in Arizona, so I looked up the number and rang it.

When Margaret came on the line her voice seemed calm enough. "Hi, Charlie, thanks for calling."

"What's happened?"

"Eddie's hurt."

"How bad?"

She cleared her throat. "He was on the critical list earlier but they've taken him off. Demoted him to 'serious.' " Her abrupt laugh was off-key. I suspected they might have doped her with something to calm her down. She said, "He was beaten. Deliberately. Nearly beaten to death."

Eddie isn't as fat as I am, or as old—by six years—but he's a big man with chins and a belly; his hair, unlike mine, is still cordovan but then unlike me he's going bald on top. The last time I'd seen him—a quick airport drink four years earlier, between planes—the capillaries in his nose had given evidence of his increasing devotion to Kentucky bourbon. His predilection was for booze while mine was for cuisine.

This time his nose and part of his skull were concealed under neat white bandages and both his legs were in plaster casts. He was breathing in short bursts because they'd taped him tight to protect the cracked ribs. They were still running test to find out if any of his internal organs had been injured.

He looked a sorry sight on the hospital bed and did not attempt to smile. Margaret, plump and worried, hovered by him. He seemed more angry than pained—his eyes flashed bitterly. His voice was stuffed up as if he had a terrible head cold; that was the result of the broken nose.

He said, "Been a long time since I asked you for anything."

"Ask away."

"I want you to get the guy who did this."

"What's wrong with the cops?"

"They can't touch him."

The hospital room had a nice view of the Santa Catalina mountains and the desert foothills. There was only one chair; Margaret seemed disinclined to use it, so I sat down. "Who did it?"

"Three guys. Border toughs. The cops have them—they were stupid enough to let me see their car when they cornered me and I had the presence of mind to get the license number. They don't matter—they've been arraigned and I'll testify. They're just buttons."

"Hired?"

"Ten-cent toughs. You can rent them by the hour. Somebody briefed them on my habits—they knew I'd stop at Paco's bar on my way home. They were waiting for me in the parking lot."

Margaret said, "They're in custody but of course they claim they don't know who hired them."

"They probably don't," Eddie said. "A voice on the phone, a few hundred dollars in cash in an unmarked envelope. That's the way it's usually done. It makes certain the cops can't trace back to the guy who hired them."

I said, "The Mob."

"Sure."

"You know who he is, then?"

"Sure. I know." Then his lids drooped.

Margaret said, "You're a sort of cop, Charlie. We thought you might tell us how to handle it."

"I'm not a cop." Around the fourth floor in Langley they call us loose stringers, meaning we're nomadic troubleshooters—no fixed territorial station—but I'm by no means any kind of cop. Margaret and Eddie didn't know my actual occupation; they knew I worked for the government and they assumed I was with the C.I.A. but for all they knew I was a message clerk. I found their faith touching but misplaced.

Eddie said, "If you were a cop you couldn't do me any good. I don't want somebody to read the scum his rights—I want somebody to nail him."

"I'm not a hit man, Eddie. I don't kill people."

"I don't want him killed. He didn't kill me, did he?" His eyes glittered. "I just want him to hurt."

"Who is he?"

"Calls himself Clay Foran. I doubt it's the name he was born with. What he does, he lends money to people who can't get it from the bank."

"Loan shark."

"Yeah."

"Eddie, Eddie." I shook my head at him. "You haven't grown up at all."

"Okay, I can't move, I'm a captive audience if you want to deliver yourself of a lecture."

"No lecture. What happened?"

"An apartment-house construction deal. I ran into cost over-rides—rising prices on building materials. I had to come up with another fifty thousand or forfeit to the bank that holds the construction mortgage. I figured to clear a four hundred kay profit if I could complete the job and sell it for the capital gain, and of course there's a whopping tax-shelter deduction in that kind of construction. So I figured I could afford to borrow the fifty thousand even if the interest rate was exorbitant."

"Vigorish."

"Yeah. Usury. Whatever. Trouble is, I was already stretched past my limit with the banks and the building-and-loans. Hell, I was kiting checks over the weekend as it was, but I was in too deep to quit. I had to get the building completed so I could sell it. Otherwise the bank was set to foreclose. So I asked around. Sooner or later somebody steered me to Clay Foran."

"And?"

"Very respectable businessman, Foran. Calls himself an in-vestment broker. Of course he's connected with the Mob. Arizo-na's crawling with them nowadays, they all moved out here. For their health," he added drily.

"How big is he?"

"Compared to what?"

"Nickel and dime, or million-dollar loans?"

"In the middle. It didn't pinch his coffers to come up with my fifty kay but he only did it after I offered him a little extra vigorish on the side. Mostly I imagine he spreads it around, five thousand here, ten thousand there—you know, minimize the risks. But hell, those guys get five percent a week; he's rich enough."

"Two hundred and sixty percent annual interest?"

"You got it. I know, I know. But I was in a bind, Charlie, I had nowhere else to turn. And I figured to sell the project inside of a month. I figured I could handle it—ten grand interest."

"But?"

"You see what they did to me. Obviously I came up short. It wasn't my fault. The building next door caught fire. My building didn't burn but the heat set off the automatic sprinkler system and it ruined the place. Seventy thousand damage—carpets, paint, doors, the works. The insurance barely covered half of it, and the damage set me back more than two months behind schedule. I had to bail out, Charlie. What choice did I have? My construction company went into Chapter Eleven.

"It's not my first bankruptcy and maybe it won't be my last—you know me—but I'd have paid them back. I tried to keep up the payments. I was a few days late a couple of times and we got threatening phone calls, so forth—you know how it goes. Then it wasn't a week any more, it was three weeks, and you see what happened. They took out their vigorish in blood. I guess they wrote me off as a bad debt but they figure to leave me crippled as an example to other borrowers who think about welshing. Nothing personal, you understand." His lip curled.

Margaret took his hand between hers. Margaret was always there to cushion Eddie's falls: good-humored, fun-loving, careless of her appearance. She had endured all his failures; she loved the real Eddie, not the man he ought to have been. If I ever find a woman like Margaret I'll have won the grand prize.

Eddie said, "I know the ropes, I had my eyes open. I'm not naive. But they've crippled me for life, Charlie. Both kneecaps. They'll be replaced with plastic prosthetics but I'll spend the rest of my life walking like a marionette. Two canes. I almost died. Maybe I still will. We don't know what's bleeding inside me."

"You knew those guys played rough, Eddie. You knew it going in."

It sounded lame and self-righteous even as I said it. Eddie's eyes only smiled at me. He knew I'd pick up the baton.

My long-distance call to Rice was lengthy and exasperating. He kept coming back to the same sore point. "You're asking me

to commit Agency facilities to your private vengeance scheme. I can't do it."

"The Agency's got no use for it. Never will have. The press blew its cover in 1969 and it's been sitting there ever since, gathering dust. They're carrying it on the books as a dead loss—they'll be tickled to unload and get some money out of it. From your end it's a legitimate transaction and the profit ought to look pretty good on your efficiency report.

"And one other thing. If you don't authorize it I'll have to apply for a leave of absence to help my brother out. The Agency will grant it with pleasure—you know how eager they are to get rid of me. And of course that would leave you without anybody to pull your chestnuts out. You haven't got anybody else in the division who can handle the dirty jobs. You'd get fired, you know."

"You damn fat—" I didn't hear the rest.

Foran was slight and neat. The word dapper is out of fashion but it fits. He had wavy black hair and a swimming-pool tan and the look of a night-club maitre-d' who'd made good.

It took me a week to get the appointment with him, a week of meeting people and letting a word drop here and a hint there, softly and with discretion. I'm good at establishing the bona fides of a phony-cover identity and in this case it was dead easy because the only untruth in the cover story was my name: I didn't want him to know I had any family relationship with Eddie.

His office on the top floor of a nine-story high-rise had a lot of expensive wood, chrome, and leather. The picture windows gave views of the city like aerial postcard photographs. It was cool inside—the air-conditioning thrummed gently—but you could see heat waves shimmering in the thin smog above the flat sprawling city: the stuff thinned out the view of the towering mountain ranges to the north and east. I felt a bit wilted, having come in from that.

Foran had a polished desk a bit smaller than the deck of an escort carrier; it had a litter of papers and an assortment of gewgaws made of ebony and petrified wood. He stood up and came affably around this display to shake my hand. His smile was cool, professional; behind it was a ruthlessness he didn't

bother to conceal.

He had a deep confident voice. "Tell me about the proposition."

"I'm looking to borrow some money. I'm not offering a prospectus."

"If my firm authorizes a loan we have to know what it's being used for." He settled into his swivel chair and waited.

"What you want to know," I said, "is whether you'll get your money back and whether I'll make the interest payments on time."

"I don't know you, Mr. Ballantyne. Why should I lend you money?"

"I'm not being cute," I said. "If I lay out the details to you, what's to keep you from buying into the deal in my place while I'm still out scrounging for capital?"

"That's a risk you have to take. You'd take the same chance with anybody else, unless you've got a rich uncle. At least give me the outlines of the deal—it'll give us a basis for discussion."

I brooded at him as if making up my mind. I gave it a little time before I spoke. "All right. Let's assume the government owns a small private company with certain tangible assets that are of limited value to any domestic buyer, but might be of enormous value to certain foreign buyers to whom the present owner is not empowered to sell. You get my drift?"

"An arms deal?"

"In a way. Not guns, nothing that bald. The way this is set up, I'll be breaking no laws."

"Go on."

"You've had a few days to check me out," I said. "I assume you know I work for the government?"

"Yes."

"I'm about to retire. This deal will set me up for it. I need money to swing it, and it's got to come from somebody like you. But let me make it clear that if you try any odd footwork on me you'll find yourself in more trouble than you want to deal with."

His smile was as cold as Rice's. "Did you come here to threaten me or to borrow money?"

I sat back. "The C.I.A. founded, or bought, a number of private aviation companies fifteen or twenty years ago. They were used for various purposes. Cover fronts for all sorts of operations.

They used some of them to supply revolutionary forces, some of them to run bombing missions against unfriendly countries, some of them to train Cuban exiles, and that sort of thing. It was broken by the press several years ago, so you know the story."

"Yes."

"All right. A few of those companies happened to be here in Arizona. I'm interested in one of those. Ostensibly it was a private air service, one of those shoestring jobs that did everything from private executive charters to cropdusting. After the C.I.A. bought it the facilities were expanded to accommodate air-crew training for student pilots and gunners from Cuba, Haiti, South Vietnam, and a couple of African countries. Then the lid blew off and the Agency got a black eye because we're not supposed to run covert operations inside the United States. After the publicity we were forced to close down the operation."

"Go on." He was interested.

I said, "The facility's still there. Planes, ammunition, bombs, radar, Link Trainers, the whole battery of military training equipment."

"And?"

"And it's on the market. Been on the amrket for seven or eight years. So far, no buyers. Because the only people who have a use for those facilities are governments that we can't be seen dealing with. Some of those governments would pay through the nose for the equipment—far above its actual value."

"You figure to be a go-between?"

"I know those countries. I've got the contacts. And I've recently chartered a little shell corporation in Nassau that I set up for this deal. The way it goes, I buy the Arizona Charter Air Company and its assets from the government. I turn around and sell it to the Nassau shell corporation. The shell corporation sells the stuff wherever it wants—it's in the Bahamas, it's outside the jurisdiction of American laws.

"When we make the sale, the shell corporation crates up the assets in Arizona and ships them out of the country on a Bahamian bill of lading, and then they're re-shipped out of Nassau on a new ticket so that there's no evidence in this country of the final destination. As I said, the buyers are lined up—they'll be bidding against one another and I'll take the high bid."

He was flicking his upper lip with his fingernail. He looked deceptively sleepy. With quiet brevity he said, "How much?"

"To buy the aviation company and pay the packing and shipping and incidental costs I figure one million nine hundred thousand. I'd rather call it two million in case I run into a snag somewhere—it's better to have a cushion. It's a bargain actually—the government paid upwards of fifteen million for that stuff."

"Maybe. But what condition is it in now? It could be rusty or obsolete or both."

"Obsolete for the U.S. Air Force, maybe, but not for a South American country. And it's all serviceable. It needs a good dusting, that's all. I've had it checked out."

"How much profit do you expect to realize?"

"That's classified. Let's just say I intend to put a floor under the bidding of three million five."

"Suppose you can't get that much? Suppose you don't get any bids at all?"

"I'm not going into this as a speculation. I've already made the contacts. The deal's ready to go down. All I have to do is name the time and place for the auction—but I've got to own the facilities before I can deliver them."

"Suppose we made you a loan, Mr. Ballantyne. And suppose you put the money in your pocket and skipped out to Tahiti."

"All right. Suppose we draw up contracts. If I don't pay the interest and principal you foreclose the company. The assets will remain right here in Arizona until I've sold them and received the cash down-payment, which will be enough to repay your loan. If I skip out with the money you'll have the assets—and with them a list of the interested governments. Fair enough?"

"We'll see. Two million is a great deal of money."

"Did I ask you for two million? I've got my own sources of private capital who want to buy in for small shares. I've raised six hundred thousand on my own. The loan I need is for one million four." That was elementary psychology: scare him with a big amount, then reduce it attractively.

Then I dropped the clincher on him. I said, "I'll need the money for no more than six weeks. I'll pay one percent a day, no

holidays, for six weeks. That works out to just short of six hundred thousand dollars interest. You lend me one million four, you get back two million."

"I'll have to check this out first."

I knew I had him.

Margaret looked tired but she covered the strain with her smile. She set out cheese and biscuits in the living room while I mixed the drinks.

She said, "They haven't found any internal bleeding. He's going to be all right." She cut me a wedge of cheddar. "He's a foolish man sometimes but he didn't deserve this. Money's only money. Eddie—he's like a kid playing games. The money's just a counter, it's the way you keep score. If you lose a game you don't kill your opponent—you just set up the board and start another game."

"Foran doesn't play by those rules, Margaret. Eddie knew that."

She drank; I heard the ice cubes click against her teeth. "Did Foran go for it?"

"I won't know for a while. He's checking things out. But I think he'll buy it. He's too greedy to pass it up. The easiest mark for a con man is another crook."

"If he's checking things out, is there anything for him to find?"

"I doubt it. Most of what I told him was true. My boss set up the Nassau shell corporation for me. It'll be there when Foran looks for it. The Arizona Charter Air Company exists, it's on the government's books just as I told him it was, and the assets and facilities are exactly as I described them to him."

"If you pull it off, Charlie, they'll come after you."

"I don't think they'll find me. And I don't think I'll lose any sleep over it." I smiled to reassure her. People have been trying to kill me for more than 30 years and many of them are far more adept at it than the brand of thugs that Foran and his kind employ.

I knew one thing. If Foran didn't fall for this scam I'd just get at him another way. In any case Foran was finished. Eddie and Margaret didn't know it, but they had pitted the most formid-

able antagonist of all against Foran. I'm Charlie Dark. I'm the best there is.

The results of his investigations seemed to satisfy Foran. His lawyers drew up the most ironclad contracts I'd ever seen. Not a single item of Arizona Charter Air Company equipment was to be moved off its present airfield location until every penny of the loan had been paid back. The only thing the contract didn't include was the vigorish—the actual usurious interest rate; on paper we had an aboveboard agreement at 12% annual interest with a foreclosure date six weeks from the date of signatures.

The money was in the form of a bank cashier's check and I endorsed it over to the government in exchange for the deed to all outstanding stock in the Arizona Charter Air Company. I flew back from Washington to Tucson with the deed and stock certificates in an attaché case chained to my wrist. Twelve hours later they were in a safe-deposit box to which Foran had the second key, so that if I skipped out without paying, he would have possession of the documents and stock certificates. If I didn't repay him within 42 days he would be the legal owner of the company and all its assets.

We shook hands at the bank and I departed for the airport, whence I flew to Phoenix and rented a car. By midnight I was on the desert airfield that belonged to me. I dismissed the night watchman and took over the premises. As soon as I was alone I began setting the demolition charges.

There was nobody to prevent my destroying the equipment. I had canceled all the insurance policies the day before, so that I was perpetrating no fraud. It was my own property; I was free to do whatever I pleased with it.

The explosions would have thrilled any 12-year-old war movie fan. When the debris settled I drove to the hospital to say goodbye to Eddie and Margaret.

Eddie's eyes twinkled. "Mainly I regret he'll never know I had anything to do with it."

"Keep it that way. If he ever found out he'd finish you."

"I know. I'm not that much of a twit—not any more."

Margaret said, "What will happen to Foran?"

"Nothing pleasant," I said. "It can't have been his own money, not all of it. He's not that rich. He must have laid off a

good part of the loan on his Mob associates. At least a million dollars, I'd guess. When he doesn't pay them back they'll go after Foran the way he went after Eddie."

Then I smiled. "And that, you know, is what they call justice."

CHECKPOINT CHARLIE

by Brian Garfield

I always mistrust Rice but never more so than on those occasions when he pulls me off a job that's only half done and drags me back all the way from Beirut or Helsinki or Sydney to hand me a new assignment. Usually it means he's at his wits' end and needs me to bail him out.

This time it was a short trip back to Langley. I'd been in Montreal and consequently managed to arrive at Rice's lair without the usual jet lag; my only complaint was hunger— there'd been nothing but a light snack on the plane.

It was two in the morning but Rice keeps odd hours and I knew he'd still be in his fourth-floor office. I trampled the U.S. Government Seal into the tiles and the security guard ran my card through the scanner and admitted me to the elevator. The fourth-floor hall rang with my footsteps—eeire, hollow like my innards: I was short-tempered with hunger.

"You're even fatter," Rice greeted me. "I didn't believe it was possible. Where do you buy those suits, Charlie, a tent shop?"

I hate him too.

I sat down. "It's late, you're rude, and I'm, hungry. Can we get down to it without half an hour of the usual sparring?"

"I guess we'd better."

I was astonished. "It's serious then."

"Desperate, actually. You've been following the Quito hijack?"

"Just the headlines."

"We're in a bind."

I smiled and he scowled at my smile. "Stop leering at me. One of these days—"

"One of these days you'll ask me to do one of your impossible jobs and I'll refuse. And you'll get fired," I said. "Until then you need me, so I'll leer if I feel like it."

"I need you no more than you need me, Charlie. How long can you survive without my protection? If I stop making excuses for you upstairs it'll take the computer lads about seventeen seconds to program you into inglorious retirement. You're eight years and a hundred and umpteen pounds past retirement stan-

dards for field-duty executives. Now let's have no more let-me-do-you-a-favor nonsense, all right?"

The one thing he never admits is the key to the whole matter—the reason why he needs me. It's simple. I'm the best he's got, the best there is, and I'm the only capable executive in the company who'll work for Rice.

Old, fat, and conceited—he hates me for all three reasons. But above all I'm the best.

The kids with computer print-outs and space-age gadgets and martial-arts black belts can't keep up with fat old Charlie Dark when the job calls for guts and wits. The blood line has thinned; they don't make them like me any more. Rice never admits this to my face but he knows it.

I, on the other hand, am candid enough to admit my side of the bargain. I loathe Rice but I'd rather work for him than go into an old folks' home and those are the alternatives.

I said, "What about the hijacking?"

Rice's smile displays a keyboard of teeth reminiscent of an alligator. He rarely employs it to indicate amusement; he uses it mainly when he is anticipating the acute discomfort of someone other than himself.

For a while he smiled without speaking. Then, after he felt he'd struck terror deep into my heart, he spoke.

"The hijackers have nearly one hundred hostages, a Boeing Seven-twenty-seven, and a variety of explosives and small arms. They have a number of ransom demands as well. They've communicated the demands to the world via the plane's radio equipment."

"Does anybody know where they are yet?"

"Sure. We've known their location from the beginning. Radio triangulation, radar, so forth. It's a field the Ecuadorians built a few years ago to give their air force a base against the Tuparamos guerrillas. It's been in disuse since March of last year but the runway was sufficient for the Seven-twenty-seven, which is a relatively short-roll aircraft. They couldn't have done it with a jumbo. But they seem to know what they're doing; undoubtedly they took all these factors into account. We're not dealing with idiots."

"Access by road?"

"Forget it, Charlie. It's not an Entebbe situation. We can't go

in after them. Our hands are tied."

"Why?"

"International politics. Organization of American States et cetera. Just take my word for it."

"Then what's the scam?"

"The hijackers have demanded the release of seventeen so-called political prisoners who are incarcerated in various countries on charges of terrorism, murder, espionage, so forth. What the liberation people think of as victims of political persecution. Actually most of them are vermin, guilty of the vilest crimes."

"Plus they're doubtless asking for a few million dollars and a free ride to Libya or Uganda."

"Yes, of course. Disregard all that, Charlie. The problem is something altogether different."

"Then why bore me with inessentials?"

"Bear with me. Twelve of the seventeen so-called political prisoners are Ché guerrillas who're incarcerated in various South American jails. Four in Ecuador, seven in Bolivia, one in Venezuela. Four more are in prison in Mexico."

"That adds up to sixteen. Where's the seventeenth?"

"Here. Leavenworth."

"Who is he?"

"Emil Stossel." And he grinned at me. Because I was the one who'd put Stossel in prison.

I didn't give him the satisfaction of rising to the bait; I merely said, "So?"

"So the Latin Americans have elected to accede to the terrorists' demands temporarily, figuring to nail them after the hostages have been freed. The plane has several high-ranking Latin American dignitaries on board. The OAS doesn't want to risk their lives any more than it has to."

I snorted. "They're already at risk."

"It's not for us to decide. The various governments have agreed to turn the sixteen guerrillas loose and give them safe passage to Havana. They're asking us to cooperate by handing Stossel over to the East Germans in Berlin."

"Why not Havana? It's closer."

"He's not Cuban. The Cubans would have little reason to grant him asylum—he'd be an embarrassment to them. He's German. Anyhow that's the demand and we've got to live with

it." Rice glanced at the clock above the official photograph of the President. "In two hours we're putting him on a plane in Kansas. It will connect with an international flight at Dulles. He'll be in Berlin tomorrow night."

Then Rice made a face. "It's asinine, I agree—you don't make deals with terrorists. These governments are fools. But we've got no choice. If we held out—refused to release Stossel—you can imagine the black eye we'd get if the hijackers started murdering hostages one at a time."

"All right," I said. "We've got our national tail in a crack. We have to turn him over to the DDR. I don't like turning mass murderers loose any more than you do but I still don't see what it's got to do with me."

Rice smiled again. I fought the impulse to flinch. "How's your broken-field running these days, fat man?"

I saw it coming. His smugness made me gag. He said, "You're going to intercept the pass, Charlie."

"Before or after he crosses the wall?"

"After."

"Lovely."

"We can't recapture him until after the hijack has been dealt with, can we. The hostages have to be turned loose before we can lay a finger on Stossel."

"In other words you want to deliver him to the East Germans and wait for the hijack to end and then afterward you expect me to get him back and put him back in Leavenworth to finish out his sentence."

"Right. After all, we can't have the world think we've gone soft, can we. We've got to prove they can't get away with it. Carry a big stick and all that."

"We could kill him," I said. "It's a lot easier to assassinate him in East Germany than it is to bring him out alive. No, never mind, don't say it. I know. We won't be stampeded into committing public murder, especially on hostile soil. We have to bring him back alive because that's the best way to rub their noses in it."

"You have the picture, I'm happy to see."

I said, "It's impossible."

"Of course it is. They'll be expecting it. They'll leave no openings at all."

He smiled slowly, deliciously. "Charlie, it's the kind of job you do best. You get bored with anything less."

"Ever since that caper with von Schnee I've been persona non grata in the Eastern sector. If they catch me on their side of the wall they'll lock me up for a hundred and fifty years. In thumbscrews. On German peasant food."

"Yes. I know. Adds a bit of spice to the challenge, doesn't it."

And he smiled more broadly than ever.

Emil Stossel had cut his eyeteeth on Abwehr duplicity and he'd run a string of successful agents in the United States for the Eastern bloc intelligence services. The FBI hadn't been able to crack him and I'd been assigned to him about twelve years ago before we all got dumped into a fishbowl where we were no longer permitted to do that sort of thing domestically. It took time and patience but in the end we were ready to go in after him. His HQ was in Arlington not far from the Pentagon— Stossel had nerve and a sense of humor.

The actual bust was an FBI caper and as usual they miffed it. Stossel got away long enough to barricade himself in the nearby high school and before it was finished he'd killed several of his teen-age hostages. It had led to five life sentences, to be served consecutively, and even the Red diplomats had been wise enough not to put up more than token objection.

But Stossel remained one of the cleverest operatives the DDR had ever fielded. He was an embarrassment to them but they wouldn't mind having him back; he could be of use to them: they'd use his skills. He'd soon be directing clandestine operations again for them, I had no doubt of it; they'd keep him out of sight but they'd use him and we'd feel the results before long. It was another excellent reason to get him back.

Stossel's callous annihilation of the teen-age innocents in the high school naturally had endeared him to the verminous terrorists who infested the world of "liberation" movements. He was a hero to them; it didn't matter whether he was a professional or an asinine leftist incompetent—it was his brutality that made him a hero to the Quito hijackers. At the same time the East Germans, to whom Stossel was undoubtedly a public embarrassment, could not disown him now without offending their Marxist disciples in Latin America. They would have no choice but to

grant him asylum; and once having done so, as I say, they would use him.

Of course that wouldn't do.

I managed to arrive at Templehof ahead of him by arranging for his plane to undergo a refueling delay at Gatwick. It gave me time for a brief meeting at Templehof with an American Air Force colonel (Intelligence) who was dubious about cooperating until I put him on a scrambler line to Washington. The colonel grunted into the phone, stiffened to attention, said, "Yes, sir," and cradled the receiver with awe. Then he gave me the item I'd requested.

I'd had time on the plane, between meals and extra meals, to work out something approximating a plan. It is what distinguishes me from the computer lads: flexibility, preparedness, the ability to improvise quickly and precisely—ingenuity guided by experience. It's why I am the best.

The plan had to account for a number of factors such as, for example, the undesirability of my having to set foot physically on their side of the Wall. Much better if I could pull off the caper with long strings, manipulating my puppets from afar. Also there was the fact that Stossel undoubtedly would have several days' grace inside East Germany before the hijackers released their hostages and the Quito caper came to its conclusion; it would give Stossel time to bury himself far beyond my reach and I had to counter that effect with preparations designed to bring him to the surface at the end of the going-to-ground period.

The scheme was, I must admit, one of the cleverest of my long, devious, and successful career . . .

I waited for Stossel in a private cubicle at the airport— somebody's office; it was well furnished, the appointments complete right down to a thoroughly stocked bar and an adjoining full bath. Through the double-paned windows I had a sound-proofed view of the busy runways.

Two armed plainclothes guards brought him into the room and examined my credentials carefully before they retreated to the far side of the room and left me to talk with him. We spoke in German.

I said, "You remember me."

"Yes. I remember you." He'd had twelve years in prison to

think about me and there was a great deal of hate in his voice.

"I was doing my job," I said, "just as you were doing yours." I wanted to soften him up a bit and Stossel's German soul would understand the common concept of duty: he was, above all else, a co-professional. I was leaning on that.

I said, "I've got another job now. My orders are to make sure you get across to your own country in safety. You've still got enemies here,"

It made him smile a bit at the irony of it and I was pleased because it was the reaction I needed from him. I went around behind the bar. "A drink? It'll be a little while before our transportation arrives. We want the streets empty when we drive you through West Berlin."

He looked dubious. I poured myself a bourbon and stepped away from the bar. "Help yourself," I said off-handedly, and wandered toward the windows.

A Viscount was landing, with puffs of smoke as the wheels touched. In the reflection of the glass I saw him make his choice. He poured himself two fingers of Polish vodka from a bottle that had a stalk of grass in it; he brought the drink around toward me and I turned to face him. "Prosit." I elevated my glass in toast, and drank. "What's it feel like to be going home?"

"It feels good. Doubly good because it must annoy you so much to watch me walk away." He made an elegant and ironic gesture with the glass and tossed it back Russian style, one gulp, and I watched his eyes close with the pleasure of it—it was the first drink of first-class home-style booze he'd had in a dozen years.

I said, "Did you ever find out what led me to you in Arlington in the first place?"

"Does it matter?"

"It was a trivial error."

"Humans make them."

"Yes. But I have the feeling you'll make the same mistake again—the same weakness will trip you up next time." I smiled. "In fact, I'm sure of it."

"Would you care to bet on it, Dark?"

"Sure."

"How much, then?"

"Your freedom," I said.

He was amused. "We'll never meet again, unless it's in an East German prison—you inside, me outside."

"I'll take the bet, Stossel." I turned to watch the Viscount taxi toward the terminal. "I'd like you to memorize a telephone number. It's here in the Western sector."

"What for?"

"You may want to get in touch with me." I gave him the number: I repeated it three times and knew he wouldn't forget it—he had an excellent memory for numbers.

He laughed. "I can't conceive of—"

The phone rang, interrupting him. I went to the bar to answer it. Listened, spoke, then turned to Stossel. "The car's here."

"I'm ready."

"Then let's go."

I stood on the safe side of Checkpoint Charlie with my hatbrim down and my collar up against the fine night drizzle and watched the big Opel slide through the barriers. The Wall loomed grotesquely. Stossel emerged from the car at the DDR booth and I saw him shake hands with the raincoated delegation of East German officials. They were minor functionaries, police types, Vopos in the background in their uniforms; near me stood an American TV crew with a portable camera, filming the scene for tomorrow's news.

It was all bleak and foreign-intriguish; I hoped they were using black-and-white. The East Germans bundled Stossel into a dark Zis limousine and when it disappeared I walked back to Davidson's Volkswagen and squeezed into the passenger seat.

Davidson put it in gear. "Where to?"

"Bristol Kempinski."

On the way to the hotel he tried to pump me about my plans. Davidson is chief of the Berlin station; Rice hadn't had any choice but to brief him on my mission because there'd have been a flap otherwise—jurisdictional jealousies are rampant in the company and never more ferocious than on the ultra-active stations like Berlin. Rice had been forced to reveal my mission to Davidson, if only to reassure him that I wasn't horning in on any of his own works-in-progress. But he knew none of the tactical details and he was seething to find out.

I had to fend him off without putting his nose too far out of

joint. I didn't enjoy it; I'm no good at it—I'm an accomplished liar but that sort of diplomatic deceit is not quite lying and I lack the patience for it. In any case I was tired from the long flight and from the adrenalin that had shot through me during the crucial stage of the set-up. If it had gone wrong at that moment . . . But it hadn't and I was still on course and running.

In the hotel room I ordered a huge dinner sent up. Davidson had eaten earlier but he stubbornly hovered, still prying for information, watching with amazement and ill-concealed disgust while I demolished the enormous meal. He shared the wine with me; it was a fair Moselle.

"What did you want from that Air Force colonel who met you at the airport?"

"Look, Arthur, I don't mean to be obstructionist, I know it's your bailiwick but the details on this operation are classified on a need-to-know basis and if you can get authorization from Langley, then I'll be happy to fill you in on the tedious details. Right now my hands are tied. I ask you to understand and sympathize."

Finally he went away after making it clear he intended to file a complaint. I was relieved to see his back. I tumbled into the luxurious bed and was instantly asleep.

There wasn't much I could do but wait for the phone call. I had to spend the time in the hotel room: some discreet machinations had taken place, through Davidson's offices, to get the private phone line installed on short notice. I might have been in prison for all the freedom of movement I had; it made me think of Stossel with irony. At least I had a comfortable cell; it was why I'd picked the Bristol Kempinski—Old World elegance, hot and cold running everything.

I caught up on reading, watched some soporifically slow German television programs, enticed Davidson and some others into a sixteen-hour poker game that cost them, collectively, some $400, and growled at the phone frequently in an effort to will it to ring.

The television brought me news of the hijack story in South America. All their other demands having been met, the hijackers forced the aircrew to fly them to Buenos Aires on the first leg of a journey to North Africa. While the plane was refueling at Buenos Aires a gang of Argentinian commandos got aboard in

maintenance coveralls, isolated the hijackers neatly, and brought the caper to its end; passengers and crew were released unharmed; two hijackers dead, three wounded and captured. Case closed.

About that time I had a blistering phone call from Rice. "Are you still sitting on your four-acre duff? You're free to go in and get him now."

"I've still got jet lag. Maybe tomorrow."

"Damn you—"

"You want it done properly, don't you?"

"The pressure's on me."

"Live with it." I rang off, amused and pleased. I hadn't revealed my plan to him. Let him stew. I summoned a whopping great lunch from room service.

Between me and Rice lies the unspoken understanding that he has half his hopes pinned on my accomplishing the objective and the other half pinned on my falling flat on my big face. I'm uncertain which of the prospects gives him the greater anticipatory thrill.

By the fourth day Rice's phone calls were nearly apoplectic and I was rested, replete and recumbent. Today would be the most likely day for things to break according to the science of the situation.

Rice was issuing ultimata. "I know you're scared of going over into the Eastern zone. Well, it's just too bad, Charlie. If you're still in that hotel at midnight I'm throwing you to the wolves."

I rang off without replying. I was able to contain my anxiety— if he threw me to the wolves prematurely and then my plan came off successfully, it would make him doubly the fool and he wasn't going to risk that. The threat was empty for the moment. But he might go around the bend at some point, throw self-preservation to the winds in his rage against me. I couldn't do much about that except hope it held off long enough to let things sort themselves out.

The real anxiety had to do with Stossel. Suppose he couldn't get to a phone? If they were still holding him in Debriefing he might not have access to an outside phone. But they'd had him nearly a week now; surely they'd have administered pentathol by now and learned he was still loyal to them.

I knew one thing. Rice or no Rice, I wasn't going over that

Wall. No one-way trips for old Charlie Dark. However it topped out, this was going to remain a remote-control job. I'd already pulled the strings and there was nothing left now except to wait and hope the puppet danced.

Davidson kept dropping in when he had nothing better to do. He came to me from oblique angles and doubtless thought himself clever. That afternoon he was pumping me slyly about Stossel. "How did you nail him in the first place?"

"The job was to find him—we didn't know where he was holed up. He ran his network through a Byzantine series of cut-outs and blind drops. Nobody had ever been able to trace him back to his lair. We knew he was in the Arlington-Alexandria area but that was the sum of our knowledge. I had to ask myself how somebody might find Charlie Dark if *he* were hiding out, and I answered myself that all you'd have to do would be to find the best Italian food in town and wait for Charlie Dark to show up there.

"It worked the same way with Stossel. Everybody has preferences, colas or a brand of cigarettes or whatever. It takes a lot of manpower to work that kind of lead but we had no choice. We had the dossier on him, we knew his quirks. He's half Polish, you know. Always had a taste for the best Polish vodka—the kind that's sold with a stalk of buffalo grass in the bottle."

"I've tried that stuff. Once. Tastes foul."

"Not to Stossel," I said. "Or a lot of other people. Most fair-sized liquor stores in the States carry the stuff. It took manpower and legwork—that was FBI work, of course. They staked out dozens of stores and in the end it led us to Stossel. He was tripped up by his preference for Polish vodka. I told him it was a weakness that would betray him again."

"Has it?"

I was about to answer him when the phone rang. It galvanized me.

"Herr Dark?"

"Speaking."

"My people—the doctors—they tell me there is no antidote."

"They're wrong," I told him. "We've developed one."

"I see." There was no emotion in Stossel's voice.

"West side, Checkpoint Charlie," I said, "any time you're

ready. We'll be waiting. Come alone, of course." I smiled when I cradled the phone.

The smile wasn't for Stossel; it was for Rice.

Stossel came out at 11:40 that night. It was twenty minutes short of the deadline Rice had given me. There was a satisfying symmetry in that.

Davidson put the handcuffs on him. Stossel was stoic. "How long do I have?"

"You'll be all right now." We rode toward the airport with Stossel squeezed between us in the Opel's back seat. It was safe to tell him now. I said, "It's a benign poison. It has all the attributes and early symptoms of Luminous Poisoning but actually it's the reverse."

"Our doctors told me it was incurable. I had terrible cramps."

"I didn't give you the poison, Stossel. I gave you the antidote. Like a serum. It contains similar properties."

"You bluffed me." He brooded on his handcuffs. "Of course it was in the vodka."

"Where else? I told you the weakness would trip you up."

When I boarded the plane with Stossel I was savagely happy anticipating Rice's rage. On the ten-hour flight I ate five dinners.

CHARLIE IN MOSCOW

by Brian Garfield

The plane delivered me to Sheremetevo at eleven Tuesday morning but it was past three by the time the attaché's car brought me to the embassy: the Soviets get their jollies from subjecting known American agents to bureaucratic harassment.

After my interminable session with insulting civil servants and the infuriating immigration apparatus I was dour and irritable and, overriding everything else, hungry.

As we drove in I had a look at the embassy and saw the smudges above the top-story windows where the fire had licked out and charred the stonework. I made a face.

I introduced myself at the desk and there was a flurry of phoning and bootlicking. I was directed to the third floor and managed to persuade one of the secretaries to send down for a portable lunch. Predictably I was kept waiting in Dennis Sneden's outer office and I ate the sandwiches there, after which—20 minutes having passed—I stood up on the pretext of dropping the lunch debris in the blonde receptionist's wastebasket.

When she looked up, startled, I said, "Tell him he's kept me cooling my heels long enough."

"I beg your pardon?"

"I know you all resent my coming. But making me sore won't help any of us. Punch up the intercom and tell him I'm coming in." I strode past her desk to the door.

"Sir, you can't—"

"Don't worry, I know the way."

Sneden was on the phone. He looked up at me, no visible break of expression on his pale features, and said into the mouthpiece, "Hang on a minute." He covered it with his palm. "Sit down, Charlie, I'll only be a minute."

The blonde was behind me, possibly trying to decide how to eject me by force. It would have been a neat feat in view of the fact that I outweighed her by two-and-a-half to one. After Sneden had addressed me with civility she changed her mind,

made an apologetic gesture of exasperation to Sneden, and withdrew.

He said into the phone, "Nothing we can do until we know more about it. Listen, Charlie Dark's here, he just walked into the office. I'll have to call you back—we should have an update later . . . Right. Catch you." He cradled it and tried to smile at me.

The chair was narrow; I had to perch. Through the high window I had a distant glimpse of the Kremlin's crenelated onion towers.

Sneden looked pasty, his flat puffy face resembling the crust of a pie; I attributed the sickly look to chagrin over what had happened and fear for his job. I said, "I'm not necessarily here to embarrass you."

"No?"

"The Security Executive—Rice—wants a first-hand report. And I'm to lend a hand if it seems desirable."

"Desirable to whom?"

"Me."

"That's what I thought." He lit a cigarette. His fingers didn't tremble visibly. "It was a freak."

"Was it set? Arson?"

"We don't know yet. It's being investigated."

"But there were Russian firemen inside the building."

"Moscow fire department. We had to. But not on the top floor. We handled that ourselves with portable extinguishers. It never got too bad up there—we caught it before it spread that far."

"You know for a fact there's no possibility any of them got up to the top floor, no matter how briefly?"

"No possibility. None. Our people were at the head of the stairs to cordon it."

"I'll accept that, then."

"Thank you," Dennis said. "I'm in charge of security here. I do my job." But his eyes drifted when he said it; then he sighed. "Most of the time. As you know, there's one point of uncertainty."

"The safe on the third floor."

"Yeah."

"Tell me about it."

"It was all in my report through the bag."

"Go over it again for me."

"Charlie, what's the point? I doubt anybody got into the safe. There's no sign anything's been disturbed. But there's a one-in-a-thousand chance that it happened and we have to be guided by that—we have to assume the safe was compromised."

"Hell of an expensive assumption, Dennis."

"I know. I can't help it."

"Files covering six current covert operations."

"Ongoing operations, right."

"Including the identities of at least eleven of our agents."

"Yes. But everything's in code."

"Never was a cowboy that couldn't be throwed, never was a horse that couldn't be rode. Dennis, there never was a code that couldn't be broke."

"I know. But each operational file is kept in a different code. The Control on each operation has access only to his own codes."

"Who assigns the codes?"

"I do. Part of my job."

"Then nobody else can decipher more than one case-officer's files without access to your code books?"

"Well, they're not code books any more, they're computer programs. But in essence you're correct. Nobody can decode more than a few of those files at a time."

"Unless they manage to break all the codes simultaneously," I said. "If they breached those files with a camera we have to write off six current operations and eleven crucially valuable agents."

"Not to put too fine a point on it, Charlie, but only two of them are crucially valuable. The other nine are just nice to have but in the cruel impersonal terms of modern espionage they're expendable." He was fiddling with his windproof cigarette lighter, flicking the lid open and shut. "We've already taken preliminary steps to shut down the capers and cover our tracks."

"Good."

"The safe was unlocked—before, during, and after the fire. In the excitement it didn't occur to anybody to lock it. I guess that's my fault; it's my job to maintain security."

"Your loyalty to your subordinates is commendable, Dennis, but it doesn't solve the problem."

Dennis tapped ash ferociously from his cigarette, missed the ashtray, and bent down to blow the ashes off the desk. I said, "Did the Comrades or did they not photograph the contents of the safe?"

"There's no way to find out. Not for a while until we start getting feedback from them."

"That could be too late. I'll need to have a look at those files."

I spent most of the night with the files and a brown bagful of cooling hamburgers from the cafeteria downstairs. By the end of it, I realized why Rice had picked me for this one. He hates me—no more than I hate him—and whenever a job comes along that requires both ingenuity and mortal risk he likes to throw it at me because, whatever the outcome, he can't lose. If I come a cropper, then my embarrassment, injury, incarceration, or demise will provide Rice with perverse satisfaction; if I succeed in bringing off the impossible, then the success will reflect on Rice and he will climb higher in the favor of the Langley executives. It's no wonder he keeps me on, even though I'm too fat to pass the physical and considerably past the standard civil-service retirement age.

The files offered me a half a dozen covert capers-in-progress to select from. All of them were espionage operations involving hired Russians who had been subverted by the American station operatives, usually for money, less often by means of blackmail or other shady coercions. None of them was selling his country out for ideological reasons; spies seldom do except in movies.

The eleven agents listed in the coded files from the embassy's safe were unimportant people for the most part: two of them were charwomen with access to certain wastebaskets; others were clerks, countermen, a typist, a telephone repairman, a minor commissar's chauffeur, a computer technician, and a laboratory assistant.

I found possibilities in two of the six operations although the risks in both cases would be high: one misstep and I could find myself in the Lubianka dungeons with electrodes affixed to my tender parts. There were several KGB executives who would delight in getting me into such a plight.

Dennis was stil nervous. "I could be in bad trouble."

"Take it easy. The worst you'll suffer may be early retirement. You've only got ten months left anyway."

"Just the same—"

"Don't ask me to cover up anything, Dennis. I'm not in the whitewash trade."

"I wouldn't do that. What do you take me for? We've known each other too long for you to say that to me, Charlie." But he said it too fast and I focused my gaze on the summary sheets so that I wouldn't compound his guilt by witnessing it.

He annoyed me, putting his petty career ahead of the job at hand, but it was understandable. A black mark on his service record this late in his career would hurt his chances to get a top job in civilian security; it could make the difference between prestige positions in aerospace corporate counterespionage and routine jobs with the security departments of small banks.

I took out one of the summary sheets. "We'll concentrate on this one. It's our best shot. The MIG-32 designs."

"Why?"

"If they've learned about the leak they'll plug it—start feeding us phony information." I tapped the document and it made the flimsy flashpaper rattle. "You've got two people inside the MIG-32 program feeding us data on aircraft development and weapons systems. If the KGB got a copy of this file from our safe they'll put surveillance on these two agents."

"Maybe not. They may try to fool us by leaving the two alone."

"Any of the other capers, yes. But this one's too sensitive. They can't afford *not* to plug a leak in the MIG-32 program. It's the most advanced fighter-bomber design in the world. If they get it into production within the next few years they'll be a dozen years ahead of us—unless we can build countermeasures around our stolen copies of their designs. With that much at stake they can't play cute games with our intelligence people. If they know these two guys are working for us they'll either double them or transfer them to a less sensitive sector to get them away from access to top-secret data."

"Well, if the two guys get transferred we'll know about it."

"Yeah."

"But how will we know if they're doubled?"

"Why, we'll ask one of them, Dennis."

I gave it two days because I wanted to be sure the KGB had time to make their move if they were going to make one. Thursday after dark Sneden and I left the embassy in an official limousine and led the Russian shadow-cars around the city a while. Then near the old Ekaterinburg Station we pulled around a corner far enough ahead to be out of their sight just long enough for the two of us to get out of the car and hide in the shadows; then our driver went on toward the British embassy where he would enter the underground garage, wait three hours, then return along the same route to pick us up.

Free of the tail we walked four blocks along poorly lit streets to an unexceptional third-story flat that belonged to a French journalist who was away covering a trade fair in Riga. We'd had the flat swept for bugs that afternoon and in any case I carried a jammer in my briefcase.

Dennis made a drink and left me alone with it; he didn't want Poltov to see his face. Poltov had been recruited by another Control and was run by a cut-out, all standard procedure, and Poltov had no idea who his real boss was. It didn't matter if he saw my face; I'd be out of the country soon anyway; but Dennis had to be protected—he was embassy staff.

Poltov arrived at half-past eleven. He was a neat small fellow with carefully combed gray hair and the conceited self-confidence of a Cockney bookmaker. He had something to do with computers—a fact that made him a great prize to Dennis Sneden's department because it gave Poltov access to every question, answer, and program that went through the computer banks on the MIG-32 project.

He introduced himself and shook my hand; he seemed amused by my corpulence. He made himself a drink without comment. Cognac, I noticed—none of the domestic trash for him. He'd be much more comfortable in sharkskin than in the drab Moscow serge he wore; he had ambitions to be dapper. One day, with the money we were paying him, he'd find his way to Austria or Denmark and set himself up in luxury.

When he had tasted the cognac he smiled at me. He spoke a hard Kharkov Russian that I had a little trouble following. "May I ask who you are?"

"Call me Tovarich Ivanovitch if you like," I said.

"Your accent is atrociously American."

"I'm not much of a linguist. They gave me the eight-week course at the Army school in Monterey. Sit down, Tovarich, and tell me what unusual things have happened to you in the past forty-eight hours."

"Unusual? Yes, there's been one thing."

"What was it?"

"The summons to this meeting." He smiled again, enjoying his little joke.

"Other than that, nothing out of the ordinary?"

"No."

"No break in routine? No phone calls from strangers? No odd encounters? No questions?"

"Nothing."

"You've had security briefing? You know how to disclose a tail?"

"Yes. I know if I'm being watched. I'm often watched, it's part of the job. They're clumsy idiots, most of them. I was tailed Monday when I left the computer building. Three men, one car. They shadowed me to the GUM store and then to my flat. I went to bed and in the morning they were gone. It was a routine check on my movements—it happens once or twice a week to all of us. May I ask the reason for these questions?"

"What would you say if I told you that some of the information you've been selling us is false?"

"I would say you are misinformed."

"Poltov, if they've doubled you and you're feeding us false information for them, we'll have you terminated with extreme prejudice. You know the term?"

"Yes. I understand you have the responsibility to do that. But only if I have betrayed you. And I haven't."

"You're too calm about it to suit me," I said. "What, no indignation at the unjust accusation?"

Poltov smiled gently. "We're accustomed to such charges here. Indignation is not a useful response. I am well paid for what I sell to you. My Swiss account grows nicely. I've never sold you false information. If I ever do, I shall expect you to terminate me." Beneath the fatalistic surface his smile was bright and ingenuous.

Dennis was cautious. "Why should you believe him?"

"Partly intuition—he's a game player, he enjoys the danger,

but he's not devious enough to play both ends against the middle. If he were crossing us he'd be nervous about it."

"I still don't see how—"

"If they saw the files they know he's workiig for us. And if they know he's working for us they can't afford knowingly to let him go on releasing accurate data to us. The project's too vital to their security. Either they'll falsify the information he acquires or they'll force him to discontinue delivering it. Either way we'll know it's blown."

He managed a sickly smile. "I hope it turns out he's clean."

"Because if he's clean then your record's clean?"

"Charlie, I'm only human."

"I'm sorry," I said. "The security lapse was there whether or not the Russians managed to take advantage of it."

Brief anger flashed from him but then he slumped behind the desk. "I guess I knew that anyway. Listen, no hard feelings. I know you've been fair." He flicked his windproof lighter open, ignited it, and poked his cigarette into the flame.

The phone buzzed. He picked it up, spoke, and listened; I watched his face change in a violent exhalation of smoke. When he cradled it he looked angry, then crushed. "Damn them! Begorenko committed suicide this morning."

"Begorenko?"

"One of our agents in the GRU. One of the names in the safe. Charlie, I think it must mean they got into the safe."

It called for a council of war. Reinforcements were summoned from the Security Executive—young Leonard Ross flew in from Paris and then we were favored with the presence of Joe Cutter who arrived handsome and alert from Tokyo; finally on Saturday, Rice himself flew in over the Pole from Langley and we had a quorum. In the embassy's conference room the jammers were running and the blinds drawn.

First Sneden reported, bringing it up to date. "We lost another one last night. Rastovic jumped off the roof of a block of flats in Leningrad. Less than forty-eight hours after Begorenko's death. Of course we don't know it they killed themselves or if they were suicided by the Organs, but it means the same thing either way—we're blown. Six operations, eleven operatives. Including the MIG-32 program."

Ross: "Are we sure of that? It couldn't be coincidence?"

Cutter: "Two dead out of eleven? Not a chance."

Sneden: "I'm afraid Joe's right. I feel miserable about this. It's my fault—I was too lax in my guidelines for third-floor security. The safe should never have been left unlocked."

Cutter: "Why wasn't it locked?"

Sneden: "Ease of access. We had five different Controls in and out of it all the time. Plus myself and occasionally the First Secretary. If we had to unlock the damn thing every time ... "

Rice: "All right, all right. Let's hear from Mr. Dark."

Me: "A couple of curious items. See what you make of them. Item one—evidence of arson. Traces of lighter fluid residue in the wastebasket where the fire started. Any comments?"

Cutter: "The fire had to be set by somebody inside. It was burning before the Russian firemen arrived. Elementary conclusion: a saboteur among us. Elementary question: to what purpose?"

Me: "Elementary answer: to cover something up and/or provide a distraction. Agreed?"

Rice: "Go on, Charlie."

Me: "Item two. As far as we know, the computer information coming through from agent Poltov is still clean. If not accurate it's at least plausible to our scientists who've been analyzing it as it comes through. As of last night, when I had my third interview with Poltov, he claimed he'd been neither harassed nor approached."

Ross: "How do we know he's not lying about that? How do we know he hasn't been doubled?"

Rice: "Intuition, Charlie?"

Me: "No. Logic. If they knew he was feeding us they'd stop him or falsify the data. They've done neither. Therefore they don't know he's ours."

Cutter: "Fascinating."

Me: "I knew you'd be the first one to see the point, Joe. Your mind's always six steps ahead of everybody else's. Next to me you're the best."

Cutter: "I might put it the other way around, there, Charlie."

Me: "You'd be wrong. Your talent's equal to mine but I still have the edge in experience."

Ross: "Well, maybe they only managed to break the codes that dealt with Begorenko and Rastovic. Isn't that possible? Maybe

they're still working on the rest of the codes over at Cryptanalysis in the Arbat. Suppose they don't break Poltov's code until next week after we've cleared him? Then what?"

Me: "No. The Russians haven't broken any of our codes at all. They haven't had time. The fire was set Monday. Begorenko died Thursday night late, or if you prefer Friday morning. It takes longer than that to break a top-class code, even with the aid of the best computers. Unless you've got help from somebody on the other side."

Cutter: "The two suicides, Begorenko and Rastovic—let me get absolutely clear on this. They were on different capers? They had nothing to do with each other? They didn't even know of each other's existence? They had separate Controls, separate cut-outs, separate and distinct codes?"

Sneden: "Correct. Total strangers to each other. One in Moscow, one in Leningrad."

Rice: "But they were both blown. And the only thing they had in common was that both their names were in the safe on the third floor."

Ross: "Leaving us no choice. We've got to shut down all the operations. Including Poltov."

Sneden: "Hell no! Charlie's just got through saying Poltov's secure. How can we shut him down? It would be a disaster for us when we're this close to getting the final data on the MIG-32. Nobody wants to close Poltov down. He's the most valuable agent we've got anywhere in the world at this moment in time."

Me: "I agree with Dennis. Poltov's secure. I vote we let him continue running."

Rice: "I don't follow your reasoning at all. How can we let him run? If it's only a matter of time before they break the code on his file too—"

Me: "I told you. They don't have Poltov's file. They don't have *any* files."

Cutter: "Charlie's right."

Rice: "Somebody please tell me what's going on here."

Me: "Dennis, you can tell him or I will."

Cutter: "I think the cat's got Dennis' tongue. I guess you've got the floor to yourself, Charlie."

Me: "All right. Not without regret. The Russians never got near the safe; if they had, Poltov would have been transferred,

killed, or doubled by now. Therefore the information on Begorenko and Rastovic was given selectively to the KGB by someone who didn't mind betraying inessential information but balked at selling the hard stuff. It had to be someone inside this embassy, of course—someone who set the fire so as to make it look as if the safe had been compromised. That way we wouldn't look for a spy in our own ranks; we'd look for a spy in a Russian fireman's uniform instead. That gets our culprit off the hook, covers his tracks. That's what the distraction was for."

Sneden: "That could have been anybody."

Cutter: "Dennis, you're the only one who had access to both codes—the two governing Begorenko and Rastovic."

Me: "And you use that old-fashioned lighter, Dennis. Most of the other smokers here use matches or butane disposables. They don't own lighter fluid. You do."

Cutter: "How much did they pay you, Dennis?"

Dennis Sneden was ash-white but he held his tongue and refused to meet anyone's eyes. Misery wafted off him like the smell of decay.

I said, "Most of the files are routine information-gathering capers. We buy information whether it's important or not. It all goes into the hopper. Most of it, individually, isn't important to our security. Begorenko sold us statistical data on collective farm output and miscellaneous agricultural information. Rastovic kept us posted on personnel shifts in administrative commissariats in Leningrad. I guess Dennis felt he could sell those without bruising his conscience too badly. He knew his professional future was dim. He wanted a cushion—money for his retirement. A little supplement to the pension. What was it, Dennis? A few hundred thousand in a Swiss bank account?"

He didn't answer.

Cutter said, "But he's still loyal enough to protect the vital mission. He couldn't sell Poltov to them."

I said, "That was his mistake. Dennis, you really should have blown Poltov. We might never have found you out."

Sneden said quietly, "What do you take me for?"

None of us needed to answer that. After a moment Sneden crushed out his cigarette. "Do I get killed or what?"

Rice smiled at me. "Charlie broke the case—we'll leave the

disposition to him." He got up and wandered out of the room, having lost interest in the proceedings. Damn him! He wanted to force me to order an execution—he knows I don't kill people. He thinks it's because I'm squeamish—it doesn't occur to him that it might be a matter of moral scruple.

I looked at Joe Cutter and Leonard Ross. Neither of them was at all amused. Cutter said, "He's a class-A wonder, Rice is."

Ross, who is young and collegiate and manages to retain a flavor of naivete despite several years in the service, brooded at Dennis. "Why the hell did you do it?"

Dennis sat listlessly, with smoke trickling from his nostrils. He stared bleakly at the tabletop; he neither stirred nor responded to Ross's question.

I said, "I don't see any need for blood. Dennis, are you ready to sign a confession?"

Do I have a choice?"

Joe Cutter said, "You could commit suicide."

"Not me."

"Then you haven't got a choice."

"What if I deny the charges?"

I only stared him down and he understood. If he didn't cooperate he'd he terminated—if not by me then by somebody else working under Rice's instructions.

"If I sign a confession what happens then?"

I said, "You go to prison. It's the best we can do. We can't have you getting bitter and selling the rest of your inside knowledge to the Comrades. In a few years you'll get out on parole—after the information in your head has become obsolete."

Cutter said, "Take the deal, Dennis. It's a better offer than you'd get anywhere else."

Dennis took the deal.

I drove out to the airport with Joe Cutter. When we queued for our flight he said, "One of these days Rice is going to force you to kill somebody, or get killed yourself."

"He keeps trying to," I agreed. "He's perverse."

"Why don't you get out, then? God knows you're old enough to quit."

"And do what?"

I walked away toward the plane.

THE SPY AT THE END OF THE RAINBOW

by Edward D. Hoch

R and was in Cairo looking for Leila Gaad when he first heard about the End of the Rainbow. It had been nearly two years since they had fled the city together by helicopter with half the Egyptian Air Force in pursuit, but a great many things had changed in those two years. Most important, the Russians were gone. Only a few stragglers remained behind from the thousands of technicians and military advisers who had crowded the city back in those days.

Rand liked the city better without the Russians, though he was the first to admit that their departure had done little to ease tensions in the Middle East. There were still the terrorists and the almost weekly incidents, still the killings and the threats of war from both sides. In a world mainly at peace, Cairo was still a city where a spy could find work.

He'd come searching for Leila partly because he simply wanted to see her again, but mainly because one of her fellow archeologists at Cairo University had suddenly become a matter of deep concern to British Intelligence. It was not, at this point, a case for the Department of Concealed Communications, but Hastings had been quick to enlist Rand's help when it became obvious that his old friend Leila Gaad might have useful information.

So he was in Cairo on a warm April day. Unfortunately, Leila Gaad was not in Cairo. Rand had visited the University to ask about her, and been told by a smiling Greek professor, "Leila has gone to the End of the Rainbow."

"The end of the rainbow?" Rand asked, his mind conjuring up visions of pots of gold.

"The new resort hotel down on Foul Bay. There's a worldwide meeting of archeologists in progress, and two of our people are taking part."

It seemed too much to hope for, but Rand asked the question anyway. "Would the person accompanying Leila be Herbert

Fanger, by any chance?"

The Greek's smile widened. "You know Professor Fanger, too?"

"Only by reputation."

"Yes, they are down there together, representing Cairo University. With the meeting in our country we could hardly ignore it."

"Are the Russians represented, too?"

"The Russians, the Americans, the British, the French, and the Chinese. It's a truly international event."

Rand took out his notebook. "I just think I might drop in on that meeting. Could you tell me how to get to the End of the Rainbow?"

Foul Bay was an inlet of the Red Sea, perched on its western shore in the southeastern corner of Egypt. (For Rand the ancient land would always be Egypt. He could never bring himself to call it the United Arab Republic.) It was located just north of the Sudanese border in an arid, rocky region that all but straddled the Tropic of Cancer. Rand thought it was probably the last place on earth that anyone would ever build a resort hotel.

But that was before his hired car turned off the main road and he saw the lush irrigated oasis, before he caught a glimpse of the sprawling group of white buildings overlooking the bay. He passed under a multihued sign announcing *The End of the Rainbow*, and was immediately on a rainbow-colored pavement that led directly to the largest of the buildings.

The first person he encountered after parking the car was an armed security guard. Rand wondered at the need for a guard in such a remote area, but he followed the man into the administrative area. A small Englishman wearing a knit summer suit rose from behind a large white desk to greet him. "What have we here?"

Rand presented his credentials. "It's important that I speak to Miss Leila Gaad. I understand she is a guest at this resort."

The man bowed slightly. "I am Felix Bollinger, manager of the End of the Rainbow. We're always pleased to have visitors, even from British Intelligence."

"I haven't seen all of it, but it's quite a place. Who owns it?"

"A London-based corporation. We're still under construction,

really. This conference of archeologists is something of a test run for us."

"You did all this irrigation work, too?"

The small man nodded. "That was the most expensive part—that and cleaning up the bay. Now I'm petitioning the government to change the name from Foul Bay to Rainbow Bay. Foul Bay is hardly a designation to attract tourists."

"I wish you luck." Rand was looking out at the water, which still seemed a bit scummy to him.

"But you wanted to see Miss Gaad. According to the schedule of events, this is a free hour. I suspect you'll find her down at the pool with the others." He pointed to a door. "Out that way."

"Thank you."

"Ask her to show you around. You've never seen any place quite like the End of the Rainbow."

"I've decided that already."

Rand went out the door indicated and strolled down another rainbow-colored path to the pool area. A half-dozen people were splashing in the water, and it took him only a moment to pick out the bikini-clad figure of Leila Gaad. She was small and dark-haired, but with a swimmer's perfect body that glistened as she pulled herself from the pool.

"Hello again," he said, offering her a towel. "Remember me?"

She looked up at him, squinting against the sunlight. "It's Mr. Rand, isn't it?"

"You're still so formal."

Her face seemed even more youthful than he remembered, with high cheekbones and deep dark eyes that always seemed to be mocking him. "I'm afraid to ask what brings you here," she said.

"As usual, business." He glanced at the others in the pool. Four men, mostly middle-aged, and one woman who might have been Leila's age or a little older—perhaps 30. One man was obviously Oriental. The others, in bathing trunks, revealed no national traits that Rand could recognize. "Where could we talk?" he asked.

"Down by the bay?" She slipped a terrycloth jacket over her shoulders.

"Bollinger said you might show me around the place. How about that?"

"Fine." She led him back up the walk toward the main building where they encountered another man who looked younger than the others.

"Not leaving me already, are you?" he asked Leila.

"Just showing an old friend around. Mr. Rand, from London— this is Harvey Northgate, from Columbia University in the United States. He's here for the conference."

They shook hands and the American said , "Take good care of her, Rand. There are only two women in the place." He continued down the walk to the pool.

"Seems friendly enough," Rand observed.

"They're all friendly. It's the most fun I've ever had at one of these conferences." Glancing sideways at him, she asked, "But how did you manage to get back into the country? Did they drop you by parachute?"

"Hardly. You're back, aren't you?"

"But not without the University pulling strings. Then of course the Russians left and that eased things considerably." She had led him to a center court with white buildings on all sides. "Each building has nine large suites of rooms, and you can see there are nine buildings in the cluster, plus the administrative complex. Those eight are still being finished, though. Only the one we're occupying has been completed."

"That's only eighty-one units in all," Rand observed.

"Enough, at the rates they plan to charge! The rumor is that Bollinger's company wants to show a profit and then sell the whole thing to Hilton." They turned off the main path and she pointed to the colored stripes. "See? The colors of the rainbow show you where you're going. Follow the blue to the pool, the yellow to the lounge."

The completed building, like the others, was two stories high. There were four suites on the first floor and five on the floor above. "How are you able to afford all this?" Rand asked.

"There's a special rate for the conference because they're not fully open yet. And the University's paying for Professor Fanger and me." She led him down the hall of the building. "Each of these nine suties has a different color scheme—the seven colors of the spectrum, plus black and white. Here's mine—the orange suite. The walls, drapes, bedspreads, shower curtain—even the ashtrays and telephone—are all orange." She opened a ceramic

orange cigarette box. "See, even orange cigarettes! Professor Fanger has yellow ones, and he doesn't even smoke."

"Who's in the black suite?"

"The American, Harvey Northgate. He was upset when he heard it, but the rooms are really quite nice. All the black is trimmed with white. I like all the suites, except maybe the purple. I told Bollinger he should make that one pink instead."

"You say Professor Fanger is in yellow?"

"Yes. It's so bright and cheerful!"

"I came out from London to check on the possibility that he might be a former Russian agent we've been hunting for years. We arrested a man in Liverpool last week and he listed Fanger as one of his former contacts."

Leila Gaad chuckled. "Have you ever met Herbert Fanger?"

"No yet," he admitted.

"He's the most unlikely-looking spy imaginable."

"They make the best kind."

"No, really! He's fat and over forty, but he still imagines himself a ladies' man. He wears outlandish clothes, with loud colors most men wouldn't be caught dead in, even these days. He's hardly my idea of an unobtrusive secret agent."

"From what we hear, he's retired. He used the code name Sphinx while he was gathering information and passing it to Russia."

"If he's retired, why do you want to talk to him?"

"Because he knows a great deal, especially about the agents with whom he used to work. Some of those are retired now too, but others are still active, spying for one country or another."

"Where do I come in?" she asked suspiciously. "I've already swum the Nile and climbed the Great Pyramid for you, but I'm not going to betray Herbert Fanger to British Intelligence. He's a funny little man but I like him. What he was ten years ago is over and done with."

"At least you can introduce me, can't you?"

"I suppose so," she agreed reluctantly.

"Was he one of those at the pool?"

"Heavens, no! He'd never show up in bathing trunks. I imagine he's in the lounge watching television."

"Television, this far from Cairo?"

"It's closed-circuit, just for the resort. They show old movies."

Herbert Fanger was in the lounge as she'd predicted, but he wasn't watching old movies on television. He was deep in conversation with Bollinger, the resort manager. They separated when Rand and Leila entered the large room, and Bollinger said, "Well, Mr. Rand! Has she been showing you our place?"

"I'm doubly impressed now that I've seen it."

"Come back in the autumn when we're fully open. Then you'll really see something!"

"Could I get a room for tonight? It's a long drive back to Cairo."

"Bollinger frowned and consulted his memory. "Let me see . . . The indigo suite is still vacant, if you'd like that."

"Fine."

"I'll get you the key. You can have the special rate, even though you're not part of the conference."

As he hurried away, Leila introduced Fanger. "Professor Herbert Fanger, perhaps the world's leading authority on Cleopatra and her era."

"Pleased to meet you," Rand said.

Fanger was wearing a bright-red sports shirt and checkered pants that did nothing to hide his protruding stomach. Seeing him, Rand had to admit he made a most unlikely-looking spy. "We were just talking about the place," he told Rand. "What do you think it cost?"

"I couldn't begin to guess."

"Tell them, Felix," he said as the manager returned with Rand's key.

Bollinger answered with a trace of pride. "With the irrigation and landscaping, plus cleaning up the bay, it will come close to seven million dollars. The highest cost per unit of any resort hotel."

Rand was impressed. But after a few more moments of chatting he remembered the reason for his trip. "Could I speak to you in private, Professor, about some research I'm doing?"

"Regarding Cleopatra?"

"Regarding the Sphinx."

There was a flicker of something in Fanger's eyes. He excused himself and went with Rand. When they were out of earshot he said, "You're British Intelligence, aren't you? Bollinger told me."

"Concealed communications, to be exact. I know this coun-

try, so they sent me to talk with you."

"I've been retired since the mid-sixties."

"We know that. It took us that long to track you down. We're not after you, but you must have a great many names in your mind. We'd be willing to make a deal for those names."

Fanger's eyes flickered again. "I might be interested. I don't know. Coming here and talking to me openly could have been a mistake."

"You mean there's someone here who—"

"Look, Rand, I'm forty-seven years old and about that many pounds overweight. I retired before I got myself killed, and I don't know that I want to take any risks now. Espionage is a young man's game, always was. Your own Somerset Maugham quit it after World War One to write books. I quit it to chase women."

"Having any luck?"

"Here?" he snorted. "I think Leila's a twenty-eight-year-old virgin and the French one is pure bitch. Not much choice."

"Exactly what is the purpose of this conference?"

"Simply to discuss recent advances in archeology. Each of five nations sent a representative, and of course the University thought Leila and I should attend, too. There's nothing sinister about it—of that I can assure you!" But his eyes weren't quite so certain.

"Then why the armed guards patrolling the grounds?"

"You'd have to ask Bollinger—though I imagine he'd tell you there are occasional thieving nomads in the region. Without guards this place would be too tempting."

"How far is it to the nearest town?"

"More than a hundred miles overland to Aswan—nothing closer except native villages and lots of sand."

"An odd place to hold a conference. An odder place to build a plush resort."

"Once the Suez Canal is back in full operation, Bollinger expects to get most of his clientele by boat—wealthy yachtsmen and the like. Who knows? He might make a go of it. Once it's cleaned up, Foul Bay could make a natural anchorage."

They had strolled out of the building and around the cluster of white structures still in various stages of completion. Rand realized the trend of the conversation had got away from him.

He'd not traveled all the way from London to discuss a resort hotel with Herbert Fanger. But then suddenly Leila reappeared with another of the male conferees—a distinguished white-haired man with a neatly trimmed Vandyke beard. Rand remembered seeing him lounging by the pool. Now he reached out to shake hands as Leila introduced him.

"Oh, Mr. Rand, here's a countryman of yours. Dr. Wayne Evans, from Oxford."

The bearded Dr. Evans grinned cheerfully. "Pleased to meet you, Rand. I always have to explain that I'm not a medical doctor and I'm not with the University. I simply live in Oxford and write books on various aspects of archeology."

"A pleasure to meet you in any event," Rand said. He saw that Fanger had taken advantage of the interruption to get away, but there would be time for him later. "I've been trying to get a straight answer as to what this conference is all about, but everyone seems rather vague about it."

Dr. Evans chuckled. "The best way to explain it is for you to sit in at our morning session. You may find it deadly dull, but at least you'll know as much as the rest of us."

"I'd enjoy it," Rand said. He watched Evans go down the walk, taking the path that led to the pool and then changing his mind and heading for the lounge. Then Rand turned his attention to Leila, who'd remained at his side.

"As long as you're here you can escort me to dinner tonight," she said. "Then your long drive won't have been a total waste."

He reacted to her impish smile with a grin of his own. "How do you know it's been a waste so far?"

"Because I've known Herbert Fanger for three years and never gotten a straight answer out of him yet. I don't imagine you did much better."

"You're quite correct," he admitted. "Come on, let's eat."

He checked in at the indigo suite he'd been assigned and found it not nearly as depressing as he'd expected from the color. Like the black suite, the dominant color had been liberally bordered in white, and the effect proved to be quite pleasant. He was beginning to think that the End of the Rainbow might catch on, if anyone could afford to stay there.

Over dinner Leila introduced him to the other conferees he hadn't met—Jeanne Bisset from France, Dr. Tao Liang from the

People's Republic of China, and Ivan Rusanov from Russia. With Fanger and Northgate and Evans, whom he'd met previously, that made six attending the conference, not counting Leila herself.

"Dr. Tao should really be in the yellow suite," Rand observed quietly to Leila. "He would be if Bollinger had any imagination."

"And I suppose you'd have Rusanov in red?"

"Of course!"

"Well, he is, for your information. But Dr. Tao is green."

"That must leave the Frenchwoman, Jeanne Bisset, in violet."

"Wrong! She's white. Bollinger left indigo and violet empty, though now you have indigo."

"He implied that was the only suite empty. I wonder what's going on in violet."

"Nameless orgies, no doubt—with all you Englishmen on the premises."

"I should resent that," he said with a smile. She put him at ease, and he very much enjoyed her company.

After dinner the others split into various groups. Rand saw the Chinese and the Russian chatting, and the American, Harvey Northgate, walking off by himself. "With those other suites free, why do you think Bollinger insisted on giving the black one to the American?" Rand asked Leila as they strolled dong the edge of the bay.

"Perhaps he's anti-American, who knows?"

"You don't take the whole thing very seriously."

"Should I, Mr. Rand?"

"Can't you find something else to call me?"

"I never knew your first name."

"C. Jeffery Rand, and I don't tell anyone what the C. stands for."

"You don't look like a Jeffery," she decided, cocking her head to gaze up at him. "You look more like a Winston."

"I may be Prime Minister someday."

She took his arm and steered him back toward the cluster of lighted buildings. "When you are, I'll walk along the water with you. Till then, we stay far away from it. The last time I was near water with you, I ended up swimming across the Nile to spy on a Russian houseboat!"

"It was fun, wasn't it?"

"Sure. So was climbing that pyramid in the middle of the night. My legs ached for days."

It was late by the time they returned to their building. Some people were still in the lounge, but the lights in most suites were out. "We grow tired early here," she said. "I suppose it's all the fresh air and exercise."

"I know what you mean. It was a long drive down this morning." He glanced at his watch and saw that it was already after ten. They'd strolled and chatted longer than he'd realized. "One thing first. I'd like to continue my conversation with Fanger if he's still up."

"Want me to come along?" she suggested. "Then we can both hear him say nothing."

"Come on. He might surprise you."

Fanger's yellow suite was at the rear of the first floor, near a fire exit. He didn't answer Rand's knock, and they were about to check the lounge when Rand noticed a drop of fresh orange paint on the carpet under the door. "This is odd."

"What?"

"Paint, and still wet."

"The door's unlocked, Rand."

They pushed it open and snapped on the overhead light. What they saw was unbelievable. The entire room—ceiling, walls, floor—had been splashed with paint of every color. There was red and blue and green and black and white and violet and orange—all haphazardly smeared over every surface in the room. Over it all, ashtrays and towels meant for other suites had been dumped and scattered. Fanger's yellow cigarette box was smashed on the floor, with blue and yellow cigarettes, green and indigo towels, even and orange ashtray, scattered around it. The suite was a surrealistic dream, as if at the end of the rainbow all the colors of the spectrum had been jumbled with white and black.

And crumpled in one corner, half hidden by a chair, was the body of Herbert Fanger. The red of his blood was almost indistinguishable from the paint that stained the yellow wall behind him. He'd been stabbed several times in the chest and abdomen.

"My God," Leila breathed. "It's a scene from hell!"

"Let's phone the nearest police," Rand said. "We need help here."

But as they turned to leave, a voice from the hall said, "I'm afraid that will be impossible, Mr. Rand. There will be no telephoning by anyone." Felix Bollinger stood there with one of his armed security guards, and the guard was pointing a pistol at them both.

Rand raised his hands reluctantly above his head, and at his side Leila Gaad said with a sigh, "You've done it to me again, haven't you, Rand?"

They were ushered into Bollinger's private office and the door was locked behind them. Only then did the security guard holster his revolver. He stood with his back to the door as Bollinger took a seat behind the desk.

"You must realize, Mr. Rand, that I cannot afford to have the End of the Rainbow implicated in a police investigation at this time."

"I'm beginning to realize it."

"You and Miss Gaad will be held here in my office until that room can be cleaned up and some disposition made of Herbert Fanger's body."

"And you expect me to keep silent about that?" Rand asked. "I'm here on an official mission concerning Herbert Fanger. His murder is a matter of great interest to the British government."

"This is no longer British soil, Mr. Rand. It has not been for some decades."

"But you are a British citizen."

"Only when it pleases me to be."

"What's going on here? Why the armed guards? Why was Fanger murdered?"

"It does not concern you, Mr. Rand."

"Did you kill him?"

"Hardly!"

Rand shifted in his chair. "Then the killer is one of the others. Turn me loose and I might be able to find him for you."

Bollinger's eyes narrowed. "Just how would you do that?"

"With all that paint splashed around, the killer must have gotten some on him. There was a spot of orange paint on the carpet outside the door, for instance, as if it had come off the bottom of a shoe. Let me examine everyone's clothing and I'll identify the murderer."

The manager was a man who reached quick decisions. "Very

well, if I have your word you'll make no attempt to get in touch with the authorities."

"They have to be told sooner or later."

"Let's make it later. If we have the killer to hand over, it might not look quite so bad." Rand got to his feet. "I'll want another look at Fanger's room. Put a guard on the door and don't do any cleaning up."

"What about the body?"

"It can stay there for now," Rand decided. "If we find the killer, it'll be in the next hour or so."

Leila followed him out of the office, still amazed. "How did you manage that? He had a gun on us ten minutes ago, and you talked your way out of it!"

"Not completely. Not yet. His security people will be watching us. Look, suppose you wake everyone up and get them down by the pool."

"All right," she agreed. "But what for?"

"We're going to look for paint spots."

The American, Harvey Northgate, refused to be examined at first. And the Russian demanded to call his Embassy in Cairo. But after Rand explained what it was all about, they seemed to calm down. The only trouble was, Rand and Leila could find no paint on any of them. It seemed impossible, but it was true. Rand's hope of reaching a quick solution to the mystery burst like an over-inflated balloon.

It was Bollinger himself who provided an explanation, when the others had been allowed to return to their beds. "I discovered where the paint cans and the rest of it came from. Look, the side exit from this building is only a few steps away from the side exit to that building still under construction. Just inside the door are paint cans, boxes of towels and ashtrays, and even a pair of painter's coveralls."

"Show me," Rand said. He looked around for Leila but she was gone. Perhaps the day really had tired her out.

The resort manager led Rand to the unfinished building. Looking at the piles of paint cans, Rand had little doubt that this was the source of the vandal's supplies. He opened a box of red bath towels, and a carton of blue ashtrays. "Anything else here?" he asked.

"Just drapes. Apparently he didn't have time for those."

"What about the carpeting? And soap and cigarettes?"

"They're stored in one of the other buildings. He just took what was close at hand. And he wore a painter's coveralls over his own clothes."

"I suppose so," Rand agreed. The splotches of paint seemed fresh, still tacky to his touch. "What I'd like to know is why— why risk discovery by going after that paint and the other things? He had to make at least two trips, one with the paint cans and the second to return the coveralls and probably gather up a few other things to throw around the room. Who knew these things were here?"

"They all did. I took them on a tour of the place the first day and showed them in here."

"Coveralls," Rand mused, "but no shoes. The shoes with the orange paint might still turn up."

"Or might not. He could have tossed them into the bay."

"All right," Rand conceded. "I'm at a dead end. We'll have to call in the authorities."

"No."

"What do you mean, no?"

"Just what I said. The people here don't want publicity. Nor do I."

"They're not archeologists, are they?"

"Not exactly," Bollinger admitted.

"Then what were Leila and Fanger doing here?"

"A mistake. Cairo University believed our cover story and sent them down for the conference. Fanger, a retired agent himself, knew something was wrong from the beginning. Then you came, and it scared one of them enough to commit murder."

"You have to tell me what's going on here," Rand said.

"A conference."

"Britain, America, France, Russia, and China. A secret conference in the middle of nowhere, policed by armed guards." He remembered something. "And what about the violet room? Who's in there?"

"You ask too many questions. Here's a list of all our guests."

Rand accepted the paper and scanned it quickly, refreshing his memory:

First Floor: Red—Ivan Rusanov (Russia)

Orange—Leila Gaad (Egypt)

Yellow—Herbert Fanger (Egypt)

Green—Dr. Tao Liang (China)
Second Floor: Blue—Dr. Wayne Evans (Britain)
Indigo—Rand
Violet—
White—Jeanne Bisset (France)
Black—Harvey Northgate (U.S.)

"The violet suite is empty?" Rand questioned.

"It is empty."

Rand pocketed the list. "I'm going to look around."

"We've cut the telephone service. It will do you no good to try phoning out. Only the hotel extensions are still in operation."

"Thanks for saving me the effort." He had another thought. "You know, this list doesn't include some very good suspects— yourself and your employees."

"I would never have created that havoc. And my guards would have used a gun rather than a knife."

"What about the cooks and maids? The painters working on the other buildings?"

"Question them if you wish," he sid. "You'll discover nothing."

Rand left him and cut through the lounge to the stairway. He was anxious to check out that violet suite. It was now after midnight, and there was no sign of the others, though he hardly believed they were all in their beds.

He paused before the violet door and tried the knob. It was unlocked, and he wondered if he'd find another body. Fanger's door had been left unlocked so that the killer could return with the paint cans. He wondered why this one was unlocked. But he didn't wonder long.

"Felix? Is that you?" a woman's voice called from the bedroom. It was the French-woman, Jeanne Bisset.

"No, just me," Rand said, snapping on the overhead light.

She sat up in bed, startled. "What are you doing here?"

"It's as much my room as yours. I'm sorry Felix Bollinger was delayed. It's been a busy night."

"I . . . "

"You don't have to explain. I was wondering why he kept this suite vacant, and now I know." He glanced around at the violet furnishings, deciding it was the least attractive of those he'd seen.

"Have you found the killer?" she asked, recovering her com-

posure. She was a handsome woman, older than Leila, and Rand wondered if she and Bollinger had known each other before this week.

"Not yet," he admitted. "It might help if you were frank with me."

She blinked her eyes. "About what?"

"The purpose of this conference."

"She thought about that. Finally she said, "Hand me a cigarette from my purse and I'll tell you what I know."

He reached in, found a case full of white cigarettes ringed in black, and passed her one. "Is the house brand any good?" he asked. "I used to smoke American cigarettes all the time, but I managed to give them up."

"They're free and available,"she said, lighting one. "Something like Felix Bollinger himself."

"You were going to talk about the conference," he reminded her.

"Yes, the conference. A gathering of do-gooders trying to change the world. But the world cannot be changed, can it?"

"That all depends. You're not archeologists, then?"

"No. Although the Russian, Rusanov, knew enough about it to fake a few lectures after Fanger and Miss Gaad turned up. No, Mr. Rand, in truth we're nothing more than peace activists. Our five nations—America, France, Britain, China, Russia—are the only ones who have perfected nuclear weapons."

"Of course! I should have realize that!"

"We are meeting here—with funds provided by peace groups and ban-the-bomb committees in our homelands—to work out some coordinated effort. As you can see, we're no young hippies but sincere middle-aged idealists."

"But why only the five of you? And why out here in the middle of nowhere?"

"A larger meeting would have attracted the press—which would have been especially dangerous for Dr. Tao and Ivan when they returned home. We heard of this place, just being built, and it seemed perfect for our purpose."

"Do you remember who actually suggested it?"

She blushed prettily. "As a matter of fact, I did. I'd met Felix Bollinger in Paris last year, and—"

"I understand," Rand said. "You sent out some sort of

announcement to the press to cover yourselves, and Cairo University believed it."

"Exactly."

"Which one of you did Fanger recognize?"

She looked blank. "He didn't admit to knowing any of us."

"All right," Rand said with a sigh. "Thanks for the information."

He left and went in search of Leila Gaad.

He found her finally in her room—the last place he thought of looking. The orange walls and drapes assaulted his eyes, but she seemed to enjoy the decor. "I think I've found our murderer," she announced. "And I've also found a concealed comunication for you to ponder."

"I thought this was going to be one case without it. First tell me who the killer is."

"The American—Northgate! I found this pair of shoes in the rubbish by the incinerator. See—orange paint on the bottom! And they're American-made shoes!"

"Hardly conclusive evidence. But interesting. What about the concealed communication?"

She held a little notebook aloft triumphantly. "I went back to Professor Fanger's room and found this among his things. He was always writing in it, and I thought it might give us a clue. Look here—on the very last page, in his handwriting. *Invite to room, confirm tritan.*"

"Tritan? What's that?"

"Well, he spelled it wrong, I guess, but Triton is a mythological creature having the body of a man and the tail of a fish—sort of male version of a mermaid. That would imply a good swimmer, wouldn't it? And seeing them all around the pool, I can tell you Northgate is the best swimmer of the lot."

"Fanger was going to confirm this in his room? How—by flooding the place?"

"Well ..." She paused uncertainly. "What else could it mean?"

Rand didn't answer. Instead he said, "Come on. Let's go see Northgate."

The American answered the door with sleepy eyes and a growling voice. "Don't you know it's the middle of the night?"

Rand held out the shoes for him to see, and he fell silent.

"Going to let us in?"

"All right," he said grudgingly, stepping aside.

"These are your shoes, aren't they?"

There was little point in denying it. "Yes, they're mine."

"And you were in the room after Fanger was murdered?"

"I was there, but I didn't kill him. He was already dead. He'd invited me up for a nightcap. The door was unlocked and when I went in I found him dead and the room a terrible mess. I was afraid I'd be implicated so I left, but I discovered later I'd stepped in some orange paint. When you got us all out by the pool to search for paint spots I panicked and threw the shoes away."

Rand tended to believe him. The real murderer would have done a better job of disposing of the incriminating shoes. "All right," he said. "Now let's talk about the conference. Jeanne Bisset has already told me its real purpose—to work for nuclear disarmament in your five nations. Did Fanger have any idea of this?"

"I think he was onto something," the American admitted. "That's why he wanted to see me. He wanted to ask me about one of the others in the group—someone he thought he knew."

"Which one?"

"He was dead before he could tell me."

"What damage could a spy do at this conference?" Rand asked.

Northgate thought about it. "Not very much. I suppose if he was in the pay of the Russians or Chinese he could report the names of Rusanov and Dr. Tao to their governments, but that would be about all."

"I may have more questions for you later," Rand said.

"He was probably killed by one of the Arab employees," Northgate suggested as Rand and Leila headed for the door.

Back downstairs, Leila said, "Maybe he's right. Maybe it was just a robbery killing."

"Then why go to such lengths with the paint and the other things? There was a reason for it, and the only sane reason had to be to hide the killer's identity."

Leila took out one of her orange cigarettes. "Splashing paint around a hotel room to hid a killer's identity? How?"

"That's what I don't know." He produced the dead man's notebook again and stared at the final message: *Invite to room,*

confirm tritan. It wasn't Triton misspelled. A professor at Cairo University wouldn't make a mistake like that.

His eyes wandered to Leila's cigarette, and suddenly he knew.

Dr. Wayne Evans opened the door for them. His hair and beard were neatly in place, and it was obvious he hadn't been sleeping. "Well, what's this?" he asked. "More investigation?"

"The final one, Dr. Evans," Rand said, glancing about the blue suite. "You killed Professor Fanger."

"Oh, come now!" Evans glanced at Leila to see if she believed it.

"You killed him because he recognized you as a spy he used to deal with. He invited you to his suite to confirm it, and when he confronted you with it there was a struggle and you killed him. I suppose it was the beard that made him uncertain of your identity at first."

"Is this any way to talk to a fellow countryman, Rand? I'm here on an important mission."

"I can guess you mission—to sabotage this conference."

Evans took a step backward. He seemed to be weighing the possibilities. "You think I killed him and messed up the room like that?"

"Yes. The room was painted like a rainbow, and strewn with towels and things from the next building. But just a little while ago I remembered there were cigarettes strewn on that floor too, next to the broken ceramic box they were in. There were no cigarettes stored in the next building. I think while you were struggling with Fanger he ripped your pocket. The cigarettes from your suite tumbled out, just as the table was overturned and his own cigarette box smashed. Your cigarettes and his cigarettes mingled on the floor. And that was the reason for the entire thing—the reason the room had to be splashed with paint and all the rest of it. To hide the presence of those blue cigarettes."

"Dr. Wayne Evans snorted. "A likely story! I could have just picked up the blue ones, you know."

"But you couldn't have," Rand said. "Because you're colorblind."

That was when Evans moved. He grabbed Leila and had her before Rand could react. The knife in his hand had appeared as if

by magic, pressed against her throat. "All right, Rand," he said very quietly. "Out of my way or the girl dies. Another killing won't matter to me."

Rand cursed himself for being caught off guard, cursed himself again for having Leila there in the first place. "Rand," she gasped as the blade of the knife pressed harder against her flesh.

"All right," he said. "Let her go."

"Call Bollinger. Tell him I want a car with a full petrol tank and an extra emergency can. I want it out in front in ten minutes or the girl dies."

Rand obeyed, speaking in clipped tones to the manager. When he'd hung up, Evans backed against the door, still holding Leila. "Can't we talk about this?" Rand suggested. "I didn't come to this place looking for you. It was only chance—what happened, I mean."

"How'd you know I am color-blind?"

"Fanger left a notation in his notebook. *Invite to room, confirm tritan.* He was simply abbreviating tritanopia—a vision defect in which the retina fails to respond to the colors blue and yellow. It's not as common as red-green blindness, and when Fanger thought he recognized you he knew he could confirm it by having you up to his yellow room. By a quirk of fate you'd been placed in the blue suite yourself. And when you dropped the cigarettes during the struggle, you had only two choices— pick up *all* the cigarettes, blue and yellow alike, or leave them all and somehow disguise their presence."

"Make it short," Evans said. "I'm leaving in three minutes."

"If you took all the cigarettes you risked having them found on you before you could dispose of them. Even if you flushed them down the toilet, a problem remained. Fanger was a known nonsmoker. The broken cigarette box would call attention to the missing cigarettes, and the police would wonder why the killer took them away. If your color blindness became known, someone might even guess the truth. But splashing the room with paint, using every color you could find, not only camouflaged the cigarettes but also directed attention, in a very subtle manner, *away* from a color-blind person."

Evans reached behind him to open the door. "You're too smart, Rand."

"Not really. Once I suspected your color blindness, I remem-

bered your momentary confusion on those rainbow-colored paths yesterday, when you started down the blue path to the pool and then changed your mind and took the yellow one to the lounge. Of course both colors only looked gray to your eyes."

"Walk backward," Evans told Leila. "You're coming with me."

"Who paid you to spy on the conference?" Rand asked. "What country?"

"Country?" Evans snorted. "I worked for countries when Fanger knew me. Now I work where the real money is."

He moved down the hall, dragging Leila with him, and Rand followed. Felix Bollinger was standing by the door, holding it open, the perfect manager directing a departing guest to his waiting car.

"Out of my way," Evans told him.

"I hope your stay was a pleasant one," Bollinger said. Then he brought a gun from behind his back and shot Evans once in the head . . .

Leila Gaad downed a stiff shot of Scotch and said to Rand, "You would have let him go, just to save me! I must say that wasn't very professional of you."

"I have my weaknesses," Rand admitted.

Felix Bollinger downed his own drink and reached again for the bottle he'd supplied. "A terrible opening for my resort. The home office won't be pleased."

"Who was paying Evans?" Leila asked. "And paying him for what?"

"We'll have to check on him," Rand said. "But I suppose there are various pressures in today's world working against disarmament. In American sometimes they're called things like the military-industrial complex. In other nations they have other names. But they have money, and perhaps they're taking over where some of the governments leave off. When we find out who was paying Evans, it might well be a company building rockets in America, or submarines in Russia, or fighter planes in France."

"Is there no place left to escape?" Leila asked.

And Felix Bollinger supplied the answer. "No, my dear, there is not. Not even here, at the End of the Rainbow."

THE SPY IN THE PYRAMID

by Edward D. Hoch

"Do you remember Miss Leila Gaad? Hastings asked, leaning forward across the desk. "The young archeologist from Cairo University who helped you in the Nile Mermaid affair?"

Rand nodded. "Of course. She was of great assistance." He still remembered her soft voice and blushing face, and the fleeting kiss she'd given him at one point in their adventure. "What about her?"

"She's part of a scientific party studying the Great Pyramid of Cheops. We think something's happening there, something that interests the Russians. A Red agent recently left London to join them in Egypt."

Rand perked up at this. "Do you know who?"

Hastings shook his head. "Our informant could only say that Moscow requested an Englishman who could pass himself off as an archeologist. We don't know who they sent, but if Russia has a man there, we should look into it too. When I heard Leila Gaad was a member of the party, you seemed the right man for the job."

"What about Double-C?"

Hastings smiled. "Concealed Communications can get along without you, at least for the short time you'll be away. That's one of the penalties you pay for building up such a fine staff."

Rand gave him no argument. The London weather was turning bad, and a few days in the company of Leila Gaad just might be fun.

Cairo in October was almost as hot and dry as Cairo in June, and the political climate had also changed little since Rand's last visit. He still saw Russians everywhere in the Egyptian capital—technicians and businessmen and occasional airforce officers—brought in to help the buildup against Israel. War seemed very close.

On the morning after his arrival Rand rented a car for the ten-mile drive to the Giza plateau west of the city. Crossing the Nile at the Giza Bridge he could already see the twin pyramids of

Cheops and Kephren looming large on the horizon, and as he drew closer Mykerinos and the other smaller pyramids came into view.

Cheops was the largest pyramid in Egypt, a prize of ancient grave robbers and modern scientists. Looking now over the plateau on which the pyramids rested, Rand could see a group of native Egyptians toiling at its base. There was a scattering of tourists too, and off to one side a camp of canvas tents and desert vehicles that marked the party he sought. Rand stopped the first Englishman he encountered and asked, "Is Leila Gaad around? I'm an old friend."

The man was tall and slim, with the stony-faced look of an army officer. He studied Rand for a moment and then replied, "She's over by the Sphinx with some people."

There was something bizarrely casual about the way Rand crossed the stretch of sand to the classic statue of the lion-woman. Large as it was, the Sphinx seemed dwarfed by the nearby pyramids. Three people stood in its shadow, studying the great stone face with its broken nose. He recognized Leila at once, a small dark-haired girl with the pleasing high-cheekboned features he remembered so well.

"Hello there. Sorry to interrupt, but I thought I saw a familiar face."

She turned to him, smiling, and when she spoke it was the soft familiar voice he'd known more than once in his dreams. "Mr. Rand! So good to see you again!"

"I'm in Cairo for a few days, and the University said I could find you out here."

"Yes, we're hard at work. This is Sir Stafford Jones, a countryman of yours who's financing our project, and his wife Melinda."

Sir Stafford was a wispy middle-aged man who seemed worn out in contrast with the youthful vigor of his wife. Melinda was Leila's age, still under 30, and it developed they'd known each other slightly at Cairo University. She was Sir Stafford's second wife, and the marriage was new enough so that apparently he had not yet learned to cope with her youthful high spirits.

"Girl drags me over here to look at the Sphinx, Mr. Rand, and what does it mean? All I see is a lion with the head of a woman. What *does* it mean?"

Leila smiled. "The most likely explanation is that the Sphinx is half lion and half virgin, symbolizing the junction of the constellations Leo and Virgo in the fourth millennium B.C."

Melinda joined in, agreeing. "The Egyptians knew a great deal about the stars. Some say the Great Pyramid itself was a sort of observatory."

"That's one of the theories," Leila agreed, "though not one I favor."

"Just what is your work here?" Rand asked.

"Professor Danado is in charge. He's trying to continue the experiments of Dr. Luis Alvarez, the Nobel Prize winner, in recording the passage of cosmic rays through the pyramids. By the use of a computer to analyze the recorded tapes it's possible to discover the location of any unknown chambers."

"Interesting," Rand admitted.

"The threat of war put a stop to Dr. Alvarez's work, but Professor Danado obtained permission from the government to carry on. He's a fascinating man. You'll have to meet him."

When they'd returned together to the road Sir Stafford said, "Melinda and I must be getting back to our hotel."

Leila seemed disappointed. "So soon?"

"We'll be out again tomorrow," Melinda promised. "Good meeting you, Mr. Rand."

"Odd couple," Rand commented as they drove away.

"Mismatched," Leila agreed. "But he's paying the bills so I have to be nice to him. Now tell me how you are, Rand—you look simply smashing!"

"For a man past forty I'm holding up pretty well," he grinned. "Have you been swimming in the Nile lately?"

She made a face. "How did I ever let you talk me into that?"

"I have a way with pretty Scotch-Egyptian girls."

"You remembered!"

"My business is remembering. When can I meet your Professor Danado?"

"Right now. Come on."

"He's not the thin Englishman with the stone face, is he?"

"No, that's Roger Pullman, our foreman. He handles the native labor we use to string wires and such. You should see them climbing the side of that pyramid!"

She led Rand across the sand to the base of the Great Pyramid. Close up, he could see that the individual tiers of stone were of irregular height. But some were three feet or more, making a climb to the top a more difficult task than he'd imagined. "There are two hundred and one stepped tiers in all," Leila explained. "Want to try climbing?"

"No, thanks. It's really quite ugly close up, isn't it?"

"It wasn't always. The original covering was a full mantle of polished limestone, which must have been dazzling in the sunlight. But following some earthquakes in the Thirteenth and Fourteenth Centuries, the Arabs stripped off the mantle and used the precious limestone to rebuild their cities and construct a number of mosques in Cairo. Without the limestone the core masonry has gradually weathered."

"You know a great deal."

She grinned at him. "My business is remembering, too. Come on, I'll take you inside and introduce you to Professor Danado."

He followed her up the side of the pyramid until he thought his legs would give out. She had actually gone up only 50 feet when they reached the entrance, but it was high enough for Rand. "You expect me to crawl through there?" he asked.

"It widens out farther along. Be careful, though. The descending passage has a slope of twenty-six degrees."

Somehow Rand managed to follow her down and then up, climbing like a monkey through the low narrow passageway. At one point there was a screech and fluttering of wings as something flew by his face. "What was that?"

"Just a bat," Leila reassured him. "These passages used to be full of them."

"Look," Rand gasped, "what are you doing to me?"

She held up her flashlight and smiled back at him. "Nobody comes to see me because they just happen to be passing by a pyramid, Rand. I know what your business is, remember? I'm the girl who swam the Nile and almost got herself killed for you. We've had some strange things going on here, and now you turn up. I want to know why."

"What sort of strange things?"

"Oh, an odd little Egyptian named Hassad showed up looking for a job with the work crew. We didn't need any more men so

we sent him away. The very next day a stone fell on a workman and almost killed him. Hassad returned in less than an hour and got his job."

"Coincidence," Rand suggested. "Unless someone here wanted Hassad hired badly enough to drop the stone on the other man."

"Is that why you came? Is there an enemy here among us?"

"Enemy is a relative term. An enemy of what?"

They had emerged from the narrow ascending passage into the pyramid's Grand Gallery. It was still a steep climb, but now Rand could stand upright, admiring the high-ceilinged passageway lit by battery-operated torches. When they reached the King's Chamber at the top, two men were waiting for them. Leila made the introductions. "Professor Danado of Cairo University and another countryman of yours, Graham Larkey."

Larkey was a nondescript Englishman who would have looked more at home with a bowler hat and a cane. But it was Danado who focused Rand's attention. He was a tall bearded man who gave the impression of age and wisdom while seeming to hide a ripple of muscles that would have put most athletes to shame. Rand guessed him to be still in his thirties, and in perfect physical condition.

"Always glad to have visitors," Danado said, shaking Rand's hand with a firm grip. "We've been running wires here for weeks, but we're almost ready to begin."

"Just what are you doing?"

"We have a spark chamber in the lower vault, beneath the pyramid. It will record cosmic rays from outer space as they penetrate the pyramid walls. Computer analysis should pinpoint any unknown rooms or passages. Dr. Alvarez has been quite successful with the technique on other pyramids."

"It's a big place," Rand said, understating the obvious.

Graham Larkey coughed. "Big is hardly the word! There are two and a half million blocks of limestone and granite in this pyramid—enough to build a wall around France, as Napoleon once observed, or to construct all the churches in England."

Professor Danado nodded. "Whatever its original use, as observatory, tomb, or temple of initiation, the builders performed an incredible task."

"It must have taken centuries," Rand decided.

"Only twenty years, according to Herodotus. But the man-power would have been fantastic."

After another hour inspecting the Queen's Chamber and the lower vault, Rand was eager for fresh air and daylight. They climbed down to the ground, with Larkey in the lead, and headed for the grouping of tents some hundred yards away. "Almost time for cocktails," the Englishman explained. "We must observe the amenities, you know."

The stone-faced man whom Rand had met earlier appeared from somewhere to talk in low tones with Professor Danado. After a moment Larkey joined them, leaving Rand alone with Leila Gaad. "When did Roger Pullman join your group?" he asked.

"We've only been here two weeks. Everyone came at the same time. I believe Pullman and Larkey arrived from England together. Do you think one of them—?" She was interrupted by Danado's return.

"Pullman says there's trouble with the work crew. I'll have to check on it. Meantime, Graham will furnish you with some fine London gin in his tent."

Graham Larkey prepared drinks for them, keeping up a con-stant flow of conversation about the pyramid. He even had a small wooden model, about a foot high, that he handed Rand for inspection. "Of course you can't tell too much from this," he said. "But the proportions and angles are correct."

"You really think there are more secret chambers?"

Larkey shrugged. "Danado is convinced of it." There was a growing roar from the sky above the tent, and Rand looked out to see a pair of Russian-built Egyptian jets streak by overhead, bound for the Cairo airport. "Don't mind the noise, Mr. Rand. We've got used to it."

"Of course you'll be staying the night," Leila said.

"I hadn't planned to," Rand replied.

"Nonsense! We have plenty of room. I've urged Sir Stafford and Melinda to stay too, but they must have their running water and other conveniences."

There was more talk while Larkey poured another batch of drinks, and presently Rand decided to stay the night. He was not unhappy at the prospect. Leila had managed to point out a dusky Egyptian workman who was the mysterious Hassad, and Rand

decided it might be wise to keep an eye on him. If Hassad was an enemy agent he'd been placed there by somebody already present—most likely Pullman or Larkey, the only Englishmen on the scene.

Leila saw him to his tent at ten o'clock. "It's been a hard day. Sometimes we drive into Cairo for the evening, but after all that climbing you'd probably rather turn in."

"I think so" Rand agreed. "But I'll keep an eye open."

"Do you have a gun?"

"Will I need one?" he countered, not wanting to admit to the firm bulge under his armpit.

"I hope not."

"You mentioned strange happenings. What, besides the stone falling?"

She hesitated, then said, "All this wire strung up and down the pyramid. Dr. Alvarez's technique doesn't need that much wire."

"Have you asked Professor Danado about it?"

"No. I'm sure he has his reasons."

Rand nodded. "I'll see you in the morning."

He settled down to read a book about the pyramids by the light of his battery-powered lamp, but within an hour Leila was back at the flap of his tent. "It's Hassad," she whispered. "I saw him sneaking around. I think he's heading for Cairo."

Moving fast, Rand slipped a loose-fitting shirt over his holster and hurried across the sandy darkness. There was enough moonlight for him to make out the shadowy figure of Hassad some 50 feet ahead, moving toward the road. It seemed a simple task to trial the man, but suddenly the figure ahead of him vanished from view. Startled, Rand stopped dead, scanning the ground. Nothing moved. He went forward slowly.

Suddenly, a snakelike arm shot out, tackling him around the ankles, and Rand went down. Before he could free his gun the Egyptian was on him, tumbling him into a shallow excavation below the surface of the plateau. Rand saw the silver flicker of moonlight on a dagger's blade and jerked to one side as it descended.

He felt the steel slice through his shirt sleeve, then he got an arm free for a judo chop at his assailant's neck. Hassad grunted

and dropped. Rand pulled himself free and stood up. When Hassad didn't move, he bent down to roll him over. The man was dead. He'd fallen on his own knife.

Rand's first thought, in a business where no one could be trusted, was that Leila Gaad had lured him into a trap. He was still nursing that suspicion as he went quickly through Hassad's pockets. Then his probing fingers encountered a tube, a cigarette holder with something inside it. He dropped it into his pocket and headed back to the tents.

Leila was waiting for him. "What happened?"

"A little trouble. Hassad's dead."

"You killed him?"

"An accident. He came at me with a knife."

"Should we tell the others?"

Rand thought about it. "Better not. I don't particularly want to get hung up with the local police." He took out the metal cigarette holder and saw that it had a piece of paper rolled inside.

"What's that?" Leila asked.

"I found it on him."

He unrolled the paper and revealed a message, apparently in cipher: PMION CTRAD INGCA YDWEA LARTO IROAR RORSS EWERC EAAIR AKCCR EOVER BASES.

"Can you read it?"

"With time and a little luck. That's my business."

"What do you want me to do?"

"Go back to your tent and get some sleep. And try to act surprised when they find Hassad's body in the morning."

When he was alone, Rand set to work on the cipher message before him. It appeared to be broken down into five-letter groups for transmission—a common practice—and the very fact that Hassad had been carrying it told him a great deal. The Egyptian was a courier, taking the message from someone at the pyramid to his superiors in Cairo, where it would no doubt be transmitted to Moscow. Hassad had tried to protect the message with his knife.

Rand stared down at the twelve groups of five letters each. Sixty letters in all. He checked the letter frequency first, and came up with 10 r's, 9 a's, 7 e's. But in such a short message,

letter frequencies could be misleading. More interesting was the end of the message, where the words *over bases* appeared together. Coincidence?

After an hour's work Rand put the paper carefully away and went to bed. It was not as easy a job as he'd hoped.

He awoke before dawn and went back to work on the message, but still it would not yield its secret. When he heard the others moving about he joined them for breakfast, waiting for the workmen to discover Hassad's body. Over coffee and eggs Professor Danado was expounding some of the theories of pyramidology, including the somewhat far-fetched ideas of Menzies and Smyth. They were dining in Larkey's tent, and Danado said, "Hand me that pyramid model, Rand, and I'll show you what I mean."

Rand passed the wooden pyramid to him and Danado continued, "They believed that each of the passages, and the very dimensions of the pyramid, contained a chronological history of mankind. Some even claimed the Great Pyramid predicted the Second Coming of the Lord, and the end of the world."

"Rubbish!" Roger Pullman exclaimed, and Larkey nodded agreement.

As Rand listened to the talk Leila slipped into the seat at his side. She'd gone for a fresh pot of coffee and now she leaned over to whisper, "Hassad's body is gone."

Rand nodded, hoping she hadn't been overheard. Someone had decided to hide the body, for reasons of his own. He glanced down at the fingers of his left hand and saw a find film of white dust. Sniffing, he was reminded of a schoolroom. He wondered why there'd been chalk dust on the side of Larkey's model pyramid.

Sir Stafford Jones and Melinda arrived promptly at 10:00 for what seemed to be their daily inspection of progress. While Danado showed them around, Rand prowled the campsite, seeking a likely place where Hassad's body might have been hidden. Finally he climbed up the side of the pyramid, resting every few tiers, and inspected the wires that Danado's crew had been stringing. The place would be perfect for transmitting short-wave radio broadcasts, but then so would the tall buildings in Cairo. It seemed unlikely that spies would wire the Great

Pyramid simply to use it for a transmitting tower.

"Hello there—out for a stroll?"

He glanced down and saw Melinda Jones, fetching in a yellow pants suit, clambering over the stones below him. Rand held out a hand. "This is a tough climb."

She paused beside him, panting for breath. "Are you going all the way to the top?"

"Hardly! I'm just about done in."

"I can't imagine why my husband is so interested in a pile of stones!" She opened a fresh pack of cigarettes and lit one.

"Perhaps because it's the largest pile of stones in the world."

"You may be right. Stafford has always been attracted to superlatives."

"Even in women," Rand observed gallantly.

"Thank you, sir!" She dipped in a little bow.

"But yesterday you also seemed quite interested in this pile of stones, speculating on its use as an observatory and such."

"Oh, I'm interested in everything Stafford does. I wouldn't have married him otherwise. But he has a great deal of money and I only hope he's spending it wisely here."

They climbed higher, looking out across the sands at the buildings and mosques of Cairo. "A marvelous view," he said.

"Perhaps the ancient Egyptians thought they could see the whole world from the peak of the Great Pyramid."

After a time they went back down and found Professor Danado deep in conversation with Sir Stafford. They broke apart when Melinda and Rand approached, and the talk shifted to lighter topics. Whatever was going on here, Sir Stafford obviously did not want his wife involved. Rand said a few words and then drifted off to find Leila.

He found her checking measurements at the base of the pyramid, aided by an Egyptian workman. "I saw you up there with Melinda," she said.

"Nice girl. Wonder why she married Sir Stafford."

"Money and power. In college Melinda always wanted both."

Rand was inspecting some of the graffiti left by tourists along the base of the pyramid. "They write anywhere, don't they?"

"Graffiti has a long and honorable history here. Most of the early explorers left their names on the walls of the pyramid. Even Mercator, the mapmaker, carved his name in one of the

inner chambers."

Rand waited until the workman had moved off and then asked, "Leila, what do you think is going on here?"

"I have no idea, except that it's unlike any other project I've ever been on. Professor Danado seems to assign me tasks like this just to keep me out of the way."

"What about Pullman and Larkey?"

"Pullman works with him, but not Larkey so much."

"Have you ever seen Larkey marking up his model pyramid with chalk?"

"No. Why?"

Just wondered. There was chalk dust on it this morning."

He glanced toward the main tent and saw that Melinda and Sir Stafford were leaving. "Let's say goodbye to them," he suggested.

"Fine progress," Sir Stafford was saying. "Fine, fine!"

"I do hope it's finished soon," Melinda complained. "I can't wait to get back to London. My body just isn't suited to this heat." She turned to Roger Pullman. "Mr. Pullman, do you have a cigarette? I need something to revive me after climbing halfway up that pyramid."

"Certainly," he said, handing her one. But even Melinda's charms couldn't change the stony expression on his face.

"We'll be out again tomorrow," Sir Stafford assured them.

Danado nodded. "I should be just about ready then."

Rand watched them walk across the plateau to their waiting car. Melinda was talking to her husband , gesturing with the unlit cigarette, perhaps repeating her wish to return to London soon.

That evening, after an agreeable dinner with Danado and Leila and the two Englishmen, it was decided that Rand would spend another night with them. He knew he couldn't remain indefinitely without attracting even more suspicion than he already had, but he hoped that one more night would give him the time needed to crack the cipher message. In his tent he spread the paper out flat and scanned it once again: PMION CTRAD INGCA YDWEA LARTO IROAR RORSS EWERC EAAIR AKCCR EOVER BASES.

Sixty letters. He started writing them in columns, and after a moment a slow smile began to spread over his face.

"Rand!" Leila burst into his tent. "They've found Hassad's

body. It was buried in the sand near one of the smaller pyramids."

"It doesn't matter now. My job is about finished."

"The cipher?"

He nodded. "Let's go see Professor Danado, Pullman, and Larkey."

They met in Danado's tent, where the lamps had been lit as dusk settled over the area. There was a new urgency about the professor, and his bearded face betrayed the hint of a troubled man.

"What do you know of Hassad's murder?" he asked Rand.

"It wasn't murder. He fell on his own knife while trying to kill me last night."

"And you hid the

"Someone else did that." Rand glanced toward Graham Larkey.

"Just what is your business here, Mr. Rand?"

"This." He laid the slip of paper down on the table before them.

Danado's eyelids shot up. "You can read this?"

"Yes."

"What does it say?"

Rand turned to Leila. "Could you get me the model pyramid out of Larkey's tent, please?"

The Englishman bristled. "What do you want my pyramid for?"

"To unscramble this message, the same way it was originally scrambled. You see, this is a transposition cipher rather than a substitution one. The letters retain their true identities but are merely mixed up. The chalk dust on the wooden sides of that model pyramid tipped me off that the model served as the device for enciphering the message. In most transposition ciphers the message is written in a square grid, and the letters are then read vertically instead of horizontally. Here the four sides of the pyramid were used—like this."

Rand began chalking the message on the side of the pyramid:

P
M I
O N C
T R A D
I N G C A

He turned the pyramid and did the same on the second side:

```
      Y
     D W
    E A L
   A R T O
  I R O A R
```

The third side:

```
      R
     O R
    S S E
   W E R C
  E A A I R
```

And the fourth:

```
      A
     K C
    C R E
   O V E R
  B A S E S
```

"Now, we read it a line at a time, starting with the top letter *on each side*—P,Y,R,A. Then to the second line *on each side*—M,I,D,W,O,R,K,C. And so on. When all sixty letters are written in their correct order, and separated into the obvious words, we have a message that reads: *Pyramid work conceals secret radar tower covering Cairo area air bases.*"

"Very interesting," Professor Danado said quietly. His hand came from beneath the table, and it was holding a gun. "Now will you please raise your hands?"

Rand took a step backward and obeyed. He'd learned never to argue with a gun. "All right. You seem to have the upper hand."

Danado shifted the gun an inch to include Graham Larkey. "You too, Graham. Put up your hands."

"What is this?"

"Did you send this message?"

"I don't know a thing about it! What's this business about a radar tower?"

"A very clever plan," Rand interjected. "The Great Pyramid is, in a sense, a building more than forty stories high, towering over the city of Cairo. From this position radar could cover the movement of all aircraft, the firing of all missiles. Any radar in Israel is restricted, of course, by the natural curvature of the

earth. Low-flying planes are safe from detection, except by radar units mounted on other aircraft. But a secret radar station hidden in the Great Pyramid would be an important weapon for Israel—the ultimate in espionage."

Larkey's mouth hung open. "Does he mean, Professor, that you're an Israeli agent?"

"I'm doing what has to be done. And what about you, Larkey? Did you write that message?"

"Hell, no! Pullman borrowed the model last night. Said he wanted to figure something out."

"Pullman?"

They suddenly realized that Pullman was no longer with them. He'd slipped out at the very beginning of Rand's explanation. "Put that gun away," Rand told Danado. "I may not be with you, but I'm certainly not against you. If Pullman is the spy—"

He was interrupted by the blaring of an auto horn from somewhere on the road. Danado hesitated only an instant before pocketing the gun. "No tricks, Rand! Let's see what's happening."

Outside, in the hazy twilight close to night, they saw two figures running from the road. Rand recognized Sir Stafford and Melinda. "Take cover!" Sir Stafford shouted. "The Egyptians know everything! Army units are right behind us!"

As if to punctuate his words, a line of fast-moving troop carriers came into view on the road, their spotlights scanning the desert plateau. From one of the other tents a figure appeared, and Rand saw that it was Roger Pullman. He carried an army .45 automatic and there was a look of triumph on his usually stony face. "Stay right there!" he shouted. "You're prisoners of the Egyptian government."

Professor Danado, stepping behind Rand, pulled his gun from his pocket. He fired twice as Pullman's first shot went wild, and dropped the Englishman in his tracks.

"Good shooting!" Sir Stafford exclaimed.

"But I don't like being used as a shield," Rand grumbled.

Melinda ran over to the body. "He's dead. Was he a spy?"

"You should keep your wife better informed," Danado told Sir Stafford.

"The less she knew, the better. Sorry, dear." He glanced over

his shoulder. "Those army units seems to be surrounding us. Any suggestions, Professor?"

Danado debated only an instant. "To the pyramid! We'll be safe in there from small-arms fire and they wouldn't dare use artillery on it."

They ran toward the towering pyramid, Melinda and Leila in front, followed by Graham Larkey. Rand, Sir Stafford, and Danado were bunched together at the rear, as if none wanted to present his back to the others.

"That was good work on the cipher," Danado admitted as they reached the pyramid and started the climb to the entrance. "Too bad you didn't come up with it sooner, before Pullman sent it."

"I stopped Hassad from delivering the first message," Rand said. "But there must have been a second one."

They stared down from the pyramid at the line of troop carriers and half-tracks taking up positions around them. An amplified voice cut suddenly through the night. "The Egyptian government calls upon you to surrender at once as enemies of the state!"

"Now what?" Sir Stafford asked Danado.

The bearded professor did not answer. Instead he knelt on a slab of stone and took careful aim with his pistol. He fired at the nearest spotlight and hit it squarely. As the light died there was an answering burst of small-arms fire from below. A bullet zinged off the rocks above Rand's head. Then there was a barked command from below and the firing ceased.

"They'll send troops up the other sides to encircle us," Danado decided. "We can go inside, but we've no way out."

"Al-Mamun's passage," Larkey suggested. "That's below us."

"They know about that. They're Egyptians, remember? This is their thing." Danado took aim and hit another spotlight. This time there was no answering fire.

"There's one way out," Rand said. "Get on that radio."

Danado frowned. "What radio?"

"This is no time for games. You must have short-wave contact with Israel. Otherwise what good would a secret radar station be?"

"You're right, of course," Danado admitted.

"Tell them we need help."

"What can they do? Start a war just to save us?"

"Remember that commando raid by helicopter last year? They carried off a whole Egyptian radar station from Shadwan Island. Maybe they can get us out."

"Rand, we're ten miles west of Cairo!" Danado protested.

"It's that or spend a few years rotting in an Egyptian jail."

Danado drew in his breath and nodded. "Take this," he said, handing Rand the gun. "Use it if they start up this side of the pyramid, toward us or al-Mamun's passage. I'll be back." He retreated down the shaft into the heart of the pyramid.

"I'm scared," Melinda said. "How in the world did I get involved in this?"

"All my fault," Sir Stafford said. "I've been financing this project on behalf of Israel. But I couldn't let you know. It had to look like a scientific project, to keep the Egyptians from getting suspicious."

"What about Pullman?" Larkey asked. "Who was he?"

"A spy in the pay of the Russians," Rand explained. "That's what brought me here."

"But what made the Russians suspicious in the first place? The radar station isn't even in use yet."

"That's a very interesting question," Rand admitted.

There was a crackling from below and then another call on the loudspeaker for their surrender. Rand fired a shot in the air, just to keep them on their toes. He hoped they'd wait till daylight to storm the pyramid, but he knew it was a dim hope.

Suddenly Danado was back, panting for breath. "They'll do what they can," he said. "We're to climb to the top."

"All the way?"

"All the way. We'd better get started."

It was a difficult climb in the dark, made even more difficult with the women along. Before they had gone halfway they could hear the first soldiers starting up after them. Rand was beginning to sweat, helping Leila over the tiers of stone while the others helped Melinda. "How much farther?" he gasped to Danado after they'd been climbing nearly an hour.

"My count makes this the one hundred and seventy-eighth tier, and there are two hundred and one in all. Let's rest here and then go on to the top."

Behind them, still far down, there was a scrambling over stone. "They think they've got us cornered," Larkey said.

"If those helicopters don't come they'll be right." Sir Stafford scanned the eastern sky, but there were no lights visible.

"You mean we're going to have to go up rope ladders or something after a climb like this?" Melinda moaned.

"I only hope we get the chance," Danado replied. "Egyptian jails can be unpleasant. Come on, rest period's over."

Slowed down by the effects of the climb it took them nearly half an hour more to reach the top. Then, standing on what seemed the roof of the world, Rand felt more helpless than ever. The climbing below them seemed to have stopped, but now new and more powerful searchlights had arrived and were sweeping their beams across the face of the pyramid.

Then suddenly a sound of sirens reached their ears, coming from the direction of Cairo. "Air raid," Danado said. "This may be it!"

As they stood waiting, four men and two womena atop the Great Pyramid of Cheops, Rand heard at last the whirling of blades above their heads. "Helicopters coming in!"

Two large troop-carrying copters emerged from the night and hovered above them, rotors chopping at the air. There were a few shots from the ground, but they were high enough to be out of accurate range. A light shone down from the nearest copter, and a rope ladder snaked down.

"We're going up," Danado said. "Ladies first."

The troops on the ground had stopped firing, but only because jet interceptors were already taking off from the nearby air base. Rand could see their fiery tails as his turn came to climb the rope ladder. He wondered if this would be his end, hanging here in the sky above a pyramid.

But he made it to the shelter off the helicopter along with the others and stretched out panting on the floor. "Good show," an Israeli with a British accent told them. "Didn't think you'd make it."

"We haven't made it yet," Sir Stafford advised him. "Those are Egyptian jets out the side window."

The jets moved in close, but did not open fire. They seeemed to be waiting for something. Rand pulled Leila close and whis-

pered in her ear. He was taking a chance, and he hoped he was right.

Suddenly, as the helicopters turned northeast toward home, Melinda Jones made her move. She yanked open the door of the pilot's compartment and pointed a tiny gun. "We're not going back to Israel," she announced. "We're landing at Cairo airport."

"Melinda! What in hell is this?" Sir Stafford took a step forward and she turned the gun on him. In that moment, her face grim with determination, Rand really believed she would shoot her husband.

But then Leila pounced on her back, fists flying, knocking the gun aside and forcing Melinda to the copter's floor. Rand moved in to scoop up the gun.

"Tell them you're landing," he ordered the pilot. "But when the jets start down, reverse yourself and take off, straight up. At their speed they won't be able to turn quickly enough to follow."

The man obeyed instructions, and the craft shot suddenly upward with the second helicopter following. A burst of antiaircraft fire hit near enough to jar them, but then suddenly the skies seemed quiet.

"What about Melinda?" Sir Stafford asked. "I can't believe it!"

"I think you'll find she was planted by the Russians, sir. If you'll pardon me, you were just the right age to be lookijng for a young wife. With you reputation for financing causes she must have been suspicious of this pyramid thing. She needed an agent on the inside, actually part of the group, so she asked the Russians for help and they sent Pullman. He, in turn, arranged for Hassad to carry messages to Melinda in Cairo. The cipher message was meant for her, after Pullman had learned about the secret radar station."

"How did you know?" Danado asked. "You warned Leila to jump her when she pulled the gun."

"When the firing stopped I figured it meant one of their people was aboard. That meant she'd try to force us to land. As for it being Melinda, consider the facts. Someone told the Russians to send Pullman. Someone got Pullman's second message and told the Egyptians tonight. But how did Pullman deliver the message after Hassad died and Pullman hid the body?"

"Well, Hassad had the first message rolled up in a cigarette

holder. Pullman simply varied the technique slightly and rolled the second message in a cigarette. You'll remember that Melinda asked him for a cigarette today at the pyramid, even though I'd seen her just open a fresh pack of her own. *And then she didn't light it!* She carried it unlit in her hand. That had to contain the second message."

"Smart," Melinda said from the floor. "But you're not out of it yet."

"Yes, we are," Danado corrected her. "We've just crossed Suez. We're safe now."

"But you didn't win!" she spat. "You didn't get yor damned radar station!"

"Neither side won," Danado agreed. "Another draw decision in a long and fruitless war."

Rand walked to the front of the copter where Leila sat. "Are you all right?"

"I guess so. This time was worse than swimming the Nile."

"Sorry about that."

"And they probably won't let me back into Egypt."

"We have some fine old ruins in England," he said, "if you want to try them sometime."

She smiled up at him. "I just might do that."

THE SPY IN THE TOY BUSINESS

by Edward D. Hoch

As soon as he heard the door chimes, Ravic picked up his Luger and walked quickly to the window. From it he had a good view of the quiet London street and the steps leading up to his front door. He could see a young woman standing on the top step, holding a small child by the hand. They seemed harmless enough, but he kept the Luger in hand behind his back as he went to open the door.

"Yes?"

She was a pretty blonde still in her twenties, and it was obvious from the tight fit of her jeans and sweater that she carried no weapon. "Is this the flat that's for rent?" she asked, acting just a bit vague.

"No, not here," he replied, starting to close the door.

"Oh, dear, I must have the wrong address. What'll we do, Suan?"

The little girl looked up at her with a wondering expression and lutched a curly-haired doll to her chest. "I'm tired of walking," she said.

The blonde woman said to Ravic, "Do you have a telephone I could use, to check on the address?"

He glanced beyond her at the empty street, fearing a trick of some sort. But she seemed to be alone. His grip on the Luger tightened, but he kept it hidden behind his back. "I suppose so. Come on in." The child helped ease his suspicions. They wouldn't send a child along if there was to be gunplay. Still, he was ready if the woman made a single false move.

She smiled at him and walked directly to the phone he indicated, dialing a number obviously familiar to her. When a voice came on the other end she said, "Mum? Could you look at the ad in the paper and give me the address again? I think I wrote it down wrong."

Ravic smiled down at the child. "How are you, little girl?"

"Tired." She clutched the doll tighter.

"Thanks, Mum," the blonde woman said. "We'll be home as

soon as we look at it." She hung up and turned to Ravic with a smile. "Thank you so much. Can I pay you for the call?"

"No, no. Glad to be of service."

"Come on, Susan."

"Do you have the right address now?" he asked.

"It's 865 instead of 665. Don't know how I made such a mistake. My eyes must be failing me."

He showed them to the door, still holding the gun behind his back. "Good luck."

"Thank you."

He watched as they went down the steps to the empty street and then closed the door firmly behind them. All right, he decided, putting down the Luger at last. A false alarm this time, but one couldn't be too careful.

Turning back toward the telephone he saw the curly-haired doll lying on a chair. The child had put it down and forgotten it.

Well, he wasn't going to run after them.

He picked it up . . .

The explosion blew out the windows facing the quiet street and brought people running from their homes. But the blonde woman and the child were already in a car far away.

Rand's first days of retirement after returning with Leila from their honeymoon in Jerusalem were spent in a sort of abstract stocktaking. He busied himself with the task of moving into their new home on the outskirts of London, arranging books and sorting through reminders of his past life. He'd be 50 years old on his next birthday, and it seemed as good a time as any to re-examine things.

"You miss it, don't you?" Leila asked one day, coming upon him as he flipped through the pages of a fat volume on codes and ciphers.

"Not at all. Glad to be out of it."

In January Leila would start teaching again, a course in archeology at one of the better small universities. And Rand would get to work on the book he's always wanted to write. They'd be doing what they liked, with time off to enjoy life and each other.

Still, Rand was curiously interested when he received the letter from Amos Chessman that first week in December.

"Here's a man offering me a job," he told Leila. "Maybe I should go see him."

She came up to read over his shoulder. "He's certainly vague about it. Speaks of something in your field."

"I never heard of Amos Chessman, but I'm curious about it." He smiled at her. "That's one of the advantages of being retired—time to satisfy your curiosity."

He rang up Amos Chessman and made an appointment to see him in a few days. Chessman was president of ABC Toys, a computerized company turning out everything from the traditional stuffed animals, dolls and games to more sophisticated playthings and even teaching machines for classroom use. The meeting took place in Chessman's office atop one of London's newer buildings overlooking the Thames. From its windows Rand could see his old office across the river from Parliament.

"Rand?" Amos Chessman asked. "Is that the only name you have?" He was an overstuffed little man, much like his office furniture.

"It's Jeffery Rand."

"Names can be important. Full names. Even middle names can be important." He smiled at some secret joke.

"I see my old home over there," Rand said, sinking into a chair. "With a pair of binoculars you could look right in our windows."

Amos Chessman chuckled. "Did you keep government secrets tacked up on the bulletin boards?"

"Hardly. But then you don't have any toys on display either."

"Frankly, I didn't write to enlist you in the toy business. I'd heard that a Mr. Rand just retired from the cipher section of British Intelligence and I have an opening very much in your line." He was interrupted by his secretary, a white-haired woman named Mrs. Terry, who had some letters to be signed.

When they were alone again, Rand asked, "What sort of opening?"

Amos Chessman leaned back in his chair. "As you may know, ABC Toys has a subsidiary involved in the manufacture of teaching machines. For the past year we've been experimenting with a machine somewhat like those used in stockbrokers' offices which could relay information quickly to various locations via a computer hookup. It would save a great deal of time

in the business world. There's just one drawback, of course. As in most computer operations, it would be possible for an unauthorized person using one of our desktop terminals to tap into the data bank and intercept messages meant for others. What we need is some sort of cipher for sending the messages, a cipher which could be promptly unscrambled by a machine at the other end. In that way an individual company's messages would be free of interception."

"You want a cipher machine that ties in to a computer and operates automatically."

"Exactly. Can you do it for us?"

Rand thought about it. "I spent a good many years in Concealed Communications working with cipher machines, but I'd hate to have to build one. My main problem, though, is security. You must know, Mr. Chessman, that members of government intelligence agencies like Double-C and the American CIA sign a contract at the beginning of their term of employment. We promise not to enter into a compromising business arrangement which might somehow divulge secret information."

"I'm not asking you to divulge secret information."

"Nevertheless, I don't see how I could undertake the job without using the knowledge gained with Concealed Communications. In designing a cipher machine for your use, I'd naturally be drawing on secrets contained in the most advanced British machines."

Amos Chessman was not pleased. "It seems I got you down here for nothing."

"Not at all. Perhaps I could act in some sort of limited advisory capacity."

Chessman thought about that, toying with a pencil that he tapped on the edge of the desk. "Tell you what, Mr. Rand, I'd like you to see my son Richard. He's heading up the Robot Reading division. They've been doing most of the preliminary work because of their experience with teaching machines. It might well be that you can give Richard a hand with some other aspect of the program that doesn't compromise your position." He rose to shake hands, then asked his secretary to ring Richard Chessman.

By this time Rand was becoming increasingly sorry he'd even bothered to follow up the older Chessman's letter. He was

certain there was no way he could supply them with information, even in an advisory capacity. He was only wasting their time and his.

But he agreed to see Amos Chessman's son.

Richard's office was on a lower floor of the same building, down a corridor lined with stuffed animals and colorful toys. Where the father's domain had been barren of company products, the son's office was piled high with children's games, model airplanes, talking dolls, and electric trains. There were even a number of typewriter-sized devices that Rand guessed to be Robot Readers.

"Pleased to meet you," Richard Chessman said, extending a hand. He was taller and thinner than his father, but with the same sort of aggressive face and deep-set eyes.

"As I was telling your father, I don't really know that there's much I can help you with."

"Official Secrets Act? That sort of thing?"

"More or less."

He cleared a pile of packaged puzzles from a chair so Rand could sit. "Excuse the looks of this place. It always happens toward Christmas. The other divisions feel my work comes in the pre-school months and that I have nothing to do come autumn. So they load me down with traffic aassignments—seeing to it that a shop in Manchester gets two gross of dolls or a toy store in Liverpool receives its allotment of Teddy bears."

"Your father tells me you're working on a new project—some sort of information machine for offices."

"That's right." He indicated one of the Robot Reading machines on a side table. Apparently it had been modified for the new information system. "You see, our need is for some sort of cipher machine attachment to keep the system secure against industrial espionage."

"There is a way in which I might help," Rand said. "As I told your father, I couldn't be involved in designing or building a cipher machine for you, but there's another solution to your problem. I gathered the information retrieved from the computer would be displayed on this screen much the way teaching machines normally function."

"That's correct."

"Well, rather than trying to encipher the words and figures at

their source, why don't you use a scrambling device for the picture itself? A number of devices are on the market in America, for use with pay television systems. I'm sure one could be adapted to your needs. That way, any unauthorized person cutting in on your transmission would get only a shredded picture impossible to read."

"I like that," Richard Chessman admitted. "Could you work with us on it?"

"You don't really need me. I'd feel guilty taking a fee for such basic advice. Any electronics engineer could have told you the same thing."

"Still you've been a big help already and I'm sure you could do more for us on this project. I—"

He was interrupted by the arrival of a blonde-haired young woman wearing a short fur jacket over a blue pants suit. "Are you taking me to lunch, Richard?" she asked from the doorway, ignoring Rand's presence.

For just an instant he seemed embarrassed. Then he turned to Rand. "This is my sister, Atlanta."

Rand smiled and took the hand she coolly extended. "An unusual name—after the American city?"

She returned the smile. "No—the ocean."

"I'll be ready in just a moment, Atlanta. Mr. Rand here is giving me some advice on the new information system."

She eyed Rand up and down. "Good for him."

"I don't really think there's anything more I can tell you right now," Rand said. "Why don't you hop off to lunch and you can phone me if any questions come up."

"I'll do just that," Richard Chessman promised. "My father was right about you. I think you can help us a great deal."

Rand left them and rode down in the elevator with a group of giggling secretaries discussing some office gossip.

He was just getting into his car in the parking garage a block from the Chessman Building when he saw a familiar figure approaching between the vehicles. It was Hastings, his immediate superior when Rand was head of Concealed Communications.

"Well, Hastings. How've you been? What—?"

"Let me slip into your back seat, Rand. I'll crouch down while

you drive out. We shouldn't be seen together."

The idea of old Hastings crouched in the back seat of his little car amused Rand. "What is all this? I'm out of the business, you know—or had you forgotten?"

"Just drive out of here and head for Hyde Park. We can talk there."

Five minutes later, parked on one of the roads adjoining the Serpentine, Rand said, "Now what's this all about?"

Hastings straightened up but remained in the back seat. "We have someone watching the offices of ABC Toys. You can imagine my surprise an hour ago when I received word that you were calling on Amos Chessman."

"I see," Rand said, though he didn't see at all. "ABC Toys is a nest of spies, is it? Sending secret messages to the—who? Russians?—inside stuffed pandas?"

But Hastings wasn't in a mood for joke. "What's your connection with them, Rand?"

"Amos Chessman tried to hire me as an advisor on a project one of their divisions has in the works. Some sort of information hookup for offices using modified teaching machines. I don't think it's much of an idea, but they didn't want my opinion. They wanted my skill at designing cipher machines."

"I see."

"Good. Then suppose you explain it all to me."

"You're no longer one of us, Rand."

"Then don't explain it. Just get out of my car."

"No need to get testy. I suppose I can trust you if I can trust anyone, after all we've been through over the years."

"I appreciate that," Rand replied with a trace of sarcasm.

"We have information that ABC Toys is a front for a private espionage network, gathering diplomatic and weapons information for the highest bidder—which at present would be certain Middle Eastern oil nations."

"Amos Chessman is behind it?"

"Yes, and probably his son as well."

"I'll admit it helps explain why he approached me. The story about those information machines was pretty thin. How did you stumble onto them?"

He was watching Hastings' face in the mirror and saw the man hesitate visibly before replying. "A Slav named Ravic contacted

us a few months back and offered to sell us information. His story was that he worked for Chessman as a cipher expert. He was no friend of England or NATO, but he decided we might pay better than Chessman."

"Where is he now?"

"We hid him in a flat in Chelsea. Unfortunately he went against our orders and contacted a former co-worker at ABC Toys. We think that enabled them to locate him. In any event, three days ago he was blown apart by a bomb. That's a messy way to end your life, being killed by a bomb."

"A bomb!" During the past few months Rand's life had been tied to the sudden deadly blast of bombs. His old enemy Taz had died of a bomb in Switzerland, and more recently terrorist bombings in London had served as a cover for two killings while he was addressing a meeting of crime writers. It was a manner of killing he especially detested, catching all too often the innocents along with the intended victim.

"Perhaps you read about it in the press, though the polie have been keeping mum on details. There are no clues at all, and no hint as to how the killer got close enough to him to plant the bomb in the first place. It didn't come in the mail, and I know Ravic would never have let anyone into his flat. He had a gun and knew how to use it."

"You didn't have a man with him?"

"No," Hastings snapped out. It sounded like an answer he'd been called on to give too many times in recent days. "We have informers and double agents all over England—all over Europe. We can't keep a man on every one of them."

"What do you want me to do about all this?"

"I can't ask you to do anything. You're no longer one of us."

"What do you want me to do?" Rand repeated.

The next day he went to work for ABC Toys.

He was assigned to an office next to Richard Chessman's crowded den at the end of the corridor, and almost at once he found himself working closely with the young man. Chessman had an eye for detail, spotting poor workmanship on a plastic boat as quickly as he put the finger on the reason for a delay in shipments to Scotland.

"A few more days and this hectic pace will be over," he

assured Rand. "We don't accept Christmas orders after the tenth because it's too late to fill them."

"Then you'll get to work on the information system again?"

"Exactly. Meantime, you can be reading over this background data." He pulled out a loose-leaf binder and handed it to Rand. "That should tell you everything you need to know."

But a half hour alone with the pages of feasibility studies and engineering reports convinced Rand it was nothing but a smokescreen. They didn't want his advice on an information system that would probably never be marketed. They wanted him for something much more immediate.

"How do you like it here?" Atlanta Chessman asked him one day when she came up to have lunch with her brother.

"Fine, so far."

She was often around the office, but as near as he could determine she held no official position with any of the divisions of ABC Toys. She was more in the nature of an unpaid advisor to the family business. If she knew anything about the private espionage network maintained within the Chessman organization, she gave no hint of that knowledge.

That day after he'd returned from lunch Rand asked about Atlanta. "Your sister is a very attractive young woman, Richard. Is she married?"

"Not getting ideas, are you?"

"Hardly. I'm just newly married myself."

"Atlanta is divorced. Married a real bounder when she was fresh out of the university. He went off to the south of France somewhere."

"Sorry. I can't imagine anyone deserting her. She seems quite charming."

"Atlanta's all right, for a sister. We're the only children and we've always been quite close. Mother died when we were very young. And of course father was always busy at the office."

"Toys have been profitable for him."

"Toys and other things."

"Like what?"

"Oh, the teaching machine and this latest scheme of his."

"Does ABC Toys have much of an overseas business?"

"Sure—we sell in France and Italy, and some in West Germany. The Common Market, you know."

"What about the Middle East?" Rand asked casually. "I see Arabs on the streets of London buying everything else these days."

"No, we don't deal with the Middle East," Richard answered, perhaps a little to quickly.

Later that day Rand found an excuse to visit the personnel office on the eighth floor. He asked about an acquaintance named Ravic who'd worked for the company. The girl behind the desk frowned at his question and asked, "Is that the same man Mr. Chessman was asking about last week?"

"Yes, it is."

"Well, as I told him, Mr. Ravic left our employ a few weeks ago. We have only his original address. He gave us no forwarding address after he moved."

"I see."

"I saw you with Mr. Chessman in the lift. You work with him, don't you?"

He suddenly realized she was talking about Richard rather than his father. "Yes, the next office. When did you say Richard Chessman asked you about Ravic?"

"Oh, it must have been the middle of last week sometime. I know it wasn't Friday because I took that day off."

Rand thanked her and went back to his office. Richard Chessman had been seeking Ravic's address just a few days before the man was killed. That was interesting. It could mean something. He thought about getting a picture of Richard and showing it around to the neighbors near the Ravic apartment. It was the sort of thing Hastings would never think of because it smacked too much of Scotland Yard routine.

Richard kept a picture of himself and Atlanta in a frame on a side table in his office. The next day, while young Chessman was at lunch, Rand removed the picture long enough to copy it on the office Xerox. The copy was far from perfect but it would serve for identification purposes.

On the next day, Saturday, Rand drove out to the address Hastings had given him and started talking to the neighbors. It was just a week after the explosion that had killed Ravic and they all had their own stories about what they'd been doing at the time of the blast. But all of them seemed unable to identify Richard Chessman as anyone they'd ever seen before.

He was ready to give up when he reached the last house on the block. A stout middle-aged woman in a flowered apron came to the door and listened to what he said. "Never saw the man, didn't even know he lived there," she muttered, already starting to shut the door in his face.

"But you did hear the explosion last Saturday?"

"Sure I heard it. Near knocked the mister outa his chair!"

"Let me show you this picture. I want to know if you saw this person on the street the day of the blast."

She studied it carefull. "Not much of a picture."

"It's a copy. What do you think?"

She handed it back to him. "Hard to tell from that, but I think so. I was out in front just before the explosion and I noticed her—"

"*Her*?"

"That's right. She was with a little girl—her daughter, I suppose—and they were hurrying along. I remember because the child was saying she'd left her doll somewhere. I never thought to connect them with the explosion, though. They didn't seem suspicious."

"Thank you," Rand said. "You've been a great help."

Driving back toward the center of London, he tried to sort out the pieces. If Atlanta had visited Ravic at his hideaway, was it prearranged? Did he know her from her visits to Richard's office, or had Ravic's job kept him out of sight?

He knew Richard and some of the others would be working this Saturday, getting out the last of the Christmas orders. And Richard might have some answers for him.

He pulled into the car park across the street from ABC Toys, surprised to see a number of vehicles in front of the building. Several of them were police cars. Amos Chessman's secretary, the white-haired Mrs. Terry, stood near the main entrance, and he saw that she'd been crying.

"What is it, Mrs. Terry? What happened?"

"Someone shot Amos," she said, her eyes brimming with tears. "He's dead! He's been murdered!"

It was true. Amos Chessman had been shot through the head while he sat at his desk, apparently by someone using a silenced weapon since no sound had been heard outside his office. Mrs.

Terry swore no one had passed her desk, but there was a private entrance Chessman used to avoid the reception area. The assassin—the word Mrs. Terry used—must have entered that way, with or without Amos Chessman's invitation.

Rand avoided the police and Scotland yard men who were questioning employees and went directly to his office. He wasn't surprised to find Richard in the hall with his sister. Both were grim but there were no tears visible. "A terrible thing," Rand said. "You have my deepest sympathy."

"Who'd want to do that to Daddy?" Atlanta asked of no one in particular. "He never harmed a living person, never said an unkind word."

The thought crossed Rand's mind that she might not know the true extent of Amos Chessman's activities. But then he remembered the woman who'd identified the picture. Atlanta Chessman had been on the street where Ravic was hiding just minutes before the explosion. She was no innocent.

"Of course this changes everything," Richard told Rand. "It's even uncertain whether or not we'll proceed with the information system. If we do, there'd surely be a delay of many months. I'll be busy taking over the reins of the company."

"So you won't be needing me."

"Well, you understand, don't you?"

"Certainly."

Richard went off to see about the funeral arrangements, leaving Rand to pick up his few papers while Atlanta hovered in the doorway. "Sorry you weren't with us longer," she said.

"I'm sorry it had to end this way. But I imagine Richard will carry on your father's work."

"The toy business, you mean?"

"That and other things." Rand finished packing his briefcase. "I understand you have a child."

She nodded. "A daughter. That was all my former husband left me with."

Rand decided to drop his bombshell. "You were seen at Ravic's flat."

"I beg your pardon?" The color had drained from her face.

"Ravic—the man who got blown up last week. I understand he once worked here."

"If he did, I never knew him. I know nothing about it."

"But you were there, with your little girl."

"Just who are you, Mr. Rand?"

"I thought you knew. I'm exactly who you hired me to be."

"I didn't hire you—remember?"

"But your father and your brother did. I was to take Ravic's place in the organization, wasn't I? The new house expert on codes and ciphers."

"I told you I don't know Ravic."

"But you went to see him."

"I—I was doing a favor for my brother. He showed me a picture and asked me to see if the man was staying at that flat. I got in on a pretext, established that he was the man, and left. That's all there was to it."

"You could have left a bomb there."

"I could have, but I didn't."

"Do you know what Richard and your father have been doing here?"

"I don't meddle in company matters."

"ABC Toys is a front for an extensive private espionage network, financed at present by Arab oil money."

"I don't believe that!"

Rand headed for the door. "Ask your brother about it. Tell him what I told you."

The police were still questioning people as he left the building, but no one stopped him.

Lelia told him that Hastings had been trying to reach him. Rand put in a call to Hastings' private number and heard the man say, "We should meet again. The same place in the park?"

"Right."

"Leave your car and walk down by the Serpentine. I'll be sitting on a bench there."

Though the city was experiencing some rare December sunshine that Saturday afternoon, the chill air had kept all but the most hearty from strolling in the park. He saw a woman walking her dog, and a young man jogging along one of the paths, but otherwise Rand encountered no one until he reached the bench near the water where Hastings was waiting.

"Aren't you afraid someone might notice us?" Rand asked, half in jest.

"It was safer than coming around to your place. They might be watching that."

"More likely they're lying low after Amos Chessman's killing."

"What do you know about that, Rand?"

"Nothing. I was out checking Ravic's apartment when it happened."

"Ravic's—"

"Amos Chessman's daughter, Atlanta, was at Ravic's flat just before the bomb went off. A neighbor identified her."

"Interesting."

"Damned interesting. Says her brother asked her to go there, to confirm it was Ravic. Apparently Atlanta and Ravic didn't know each other."

"Ravic was kept pretty much under cover in the organization. He had little contact with others. Do you think she planted the bomb?"

"It's certainly possible." Rand studied hsi former superior's face. "It's possible you planted it too."

"Are you serious, Rand?"

"There have been times in the past. Remember Colonel Nelson?"

"That was years ago. And if he lied to you it was certainly without departmental sanction. Those days are over, Rand. We don't assassinate our enemies any more. At least not in this country."

"But you lied to me about one thing. I was watching your face in the rearview mirror when I asked about having a man on Ravic. I know enough about operations to realize you wouldn't let him hide out on his own."

Hastings gave a sigh and tossed a pebble at the water. "All right, we did have a man on him. The man's gone, vanished. His name was Cray and he was fairly new. I suppose they might have bought him. That would explain how they knew where Ravic was stashed."

"Why didn't you tell me the other day?"

"Because you'd have suspected exactly what you've come to suspect now—that we played a part in Ravic's death."

"Perhaps."

"Look here, we didn't kill Ravic and we didn't kill Amos

Chessman. Whoever did it had their own motives."

"That's just the trouble," Rand said. "I don't see how the same motive could figure in both deaths. Ravic was killed to protect the organization. Chessman was killed to destroy it."

"Or to take it over."

"Yes, there's that possibility too."

Hastings got to his feet. "Will you still be working there?"

"No. Richard said they no longer needed me, and I made certain my ties were broken by telling Atlanta Chessman what I knew about the espionage organization."

"That was a mistake."

"It could force them out into the open."

Rand nodded. "That too."

"You're newly married man. You have responsibilities now."

"I'll try to be careful." But as he started to leave he thought of something else. "The woman who identified Atlanta Chessman said something about a doll. The child had left a doll at Ravic's flat."

"That explains it, then. We found a doll, badly scorched by the blast. I wondered about it."

"I'll keep in touch," Rand said.

"Be careful."

Rand still possessed his key to the offices of ABC Toys, and he went back there Saturday evening, after he was reasonably certain the Scotland Yard people had completed their business. He could not reach the executive floor where Amos Chessman's office had been, but that was not his goal. He went instead to the floor housing the firm's computer operations center. In some earlier day the secrets would have been hidden in a safe behind a picture, or in the false bottom of a desk drawer. Now it was more likely they were on a roll of magnetic tape in some bank of computers.

He reached the glass-enclosed computer room without any clear idea of how he could gain access to the information he sought. The access code might well have died with Amos Chessman, though he doubted it. After a few moments' work unlocking the door he entered the windowless room and snapped on the lights. He sat down at the nearest computer keyboard and stared at it for inspiration.

There was an ABC doll on one corner of the desk, probably left there by one of the women programmers. The company's toys were everywhere in the building, used as decorative talismans by many of the female employees.

He stared at the label.

ABC Toys.

Amos Chessman had mentioned his name once, in that first conversation when Rand answered the invitation about the job. He'd said full names were important, even middle names could be important.

What was Amos Chessman's middle name?

ABC Toys.

Amos B. Chessman.

But what did the B stand for? Blake, Bradley, Black, Benchley . . .

Suddenly the lights went out.

Rand half rose from his seat, knowing he was not alone in the big room. Someone else had entered, seen him, and plunged the computer center into darkness. There was the sharp ping of something hitting metal and Rand dove to the floor. A silenced pistol, and a bullet not far off its mark.

He slid along the floor toward the door, aiming for the light switch. But the other had already realized his error in turning off the lights, and they came back on with Rand halfway to his goal.

He heard the cough of the pistol and rolled to one side, still seeking his assailant.

Then he saw the flash of the weapon from behind a bank of computers. "Come on!" he called out. "We're both after the same thing. Let's talk!"

There was a moment's silence and then a voice called back, "What are you doing here?"

Rand took a chance and stood up in full view. "Looking for the access code to the computer. I suppose that's why you're here too."

The other person stepped out from behind the metal cabinet. He was a tall man with steel-gray hair and a rugged appearance. Rand had never seen him before. "Please don't do anything with your hands," he said, "or I'll be forced to kill you."

"The way you killed Chessman?"

The cold eyes sharpened a bit. "What do you know about that?"

"You needed his records—a notebook or whatever—to gain access to the computer. You wouldn't be here so soon if you didn't have them."

He patted his breast pocket. "Oh, I have them. All the proper codes to reveal Chessman's secrets." He raised the gun a trifle. "Now just who are you?"

"The man sent ot stop you," Rand said.

"Sent by Richard Chessman?"

"No. By British Intelligence."

"Those fools!"

Rand moved a step closer, back to the computer console where he'd started. "They're fools, but I'm not. I'll bet your little notebook doesn't contain the access code word necessary to make the rest of it work, does it? Because Amost Chessman would have no need to write it down."

"Why not?"

"I think the code word was his middle name. It enabled him to gain access to a wealth of secret espionage records stored here while keeping them perfectly safe from inspection by any of ABC Toys' regular employees."

"His middle name . . . " The man with the gun thought about that. "And what is it?"

Rand looked at the silenced pistol. He knew he'd be a dead man as soon as he told. "We have to try it first, to see it I'm right. But ABC Toys suggests that Amos Chessman's middle name started with a B. Suppose his father had a sense of humor and gave him the name of an actual chessman. Not pawn or rook or—"

"Bishop!"

Rand nodded. "Amos Bishop Chessman. Let's try it." He took a step toward the keyboard.

"Hold it! Keep back and I'll try it." The gun never wavered. He sat down at the typewriter keyboard and flipped the *On* switch. Then he tapped out the letters with his left hand while holding the pistol in his right. "B-i-s-h-o-p! Let's see what—"

The machine paused for just an instant, then sprang to life with renewed chatter. The man shifted his eyes to look at the

message being typed and Rand hurled the doll that had been standing on the edge of the desk.

"Damn!" The doll hit the man's hand as he fired, wide of the mark, and Rand was on him before he could aim again. They tumbled onto the floor, toppling the metal chair with a crash. Rand landed on top, but only for an instant. The other man was no younger, but he was stronger.

Rand felt his grip weakening. He felt himself rolling off the top. The gun was swinging around when suddenly the door to the computer room burst open.

"Hold it!" a voice shouted, and he recognized it as Hastings'.

There was a shot, two shots, and the man toppled forward onto him.

"My God!" Hastings said.

"A bit of a surprise for you, I daresay."

"Do you know who this is, Rand?"

"I've got a pretty good idea it's the supposedly blown-up Mr. Ravic. Am I right?"

Later, up in Richard Chessman's office, they talked about it while they waited for Amos' son to arrive. "You had the right access code, Rand. The computer is disgorging its secrets—payments from Arab countries, information delivered, everything! How'd you know the word?"

"A lucky guess," Rand answered truthfully. "After all those years trying to break codes and ciphers at Double-C, I guess I was entitled to a lucky guess. But what about Ravic?"

"This time he's dead for good. The pistol is no doubt the same one he used on Chessman."

"You had a man on me, didn't you, Hastings?"

"Well, Rand, you know—"

"I know."

"When he phoned to say you'd gone into this building I decided to come down. I was prowling around when I heard the chair fall over."

"I suppose I should thank you."

"You can thank me by telling me about Ravic. If he didn't die in that explosion, who did?"

"I assume it was your man Cray, who vanished so completely. You said the body was blown apart, so positive identification

would have been difficult. Atlanta went there with her daughter on some pretext, to make sure Ravic was hiding there. We know the daughter left her doll—and I thought at one point the doll might have held a bomb. But then it would have been blown apart, not become badly scorched as you described it.

"I think Ravic saw the doll after they'd left and picked it up. When he recognized it as an ABC doll he must have suspected or feared that his hiding place was discovered. He realized his life wasn't safe for long so he decided to end it on his own terms. After all, he owed nothing to you. So he slugged your man Cray, changed clothes with him, and set off a bomb he'd had with him all the time. Cray was dead in his place and he was free to go after ABC Toys. Earlier today he got up to Chessman's office and killed him to get the access code to the computerized records. He'd decided they'd be more profitable in his hands than delivered to you."

"We have them now anyway, and when Richard and his sister arrive I'll tell them they're out of the espionage business for good."

"If they're smart they're on a plane to Paris or Rome by now." Hastings smiled. "Think you might meet them again one day?"

Rand shook his head. "Not me—you! I'm retired, remember? And Leila is waiting for me at home."

As it happened, Rand did meet them again one day.

But that's another story.

THE SPY WHO TRAVELED WITH A COFFIN

by Edward D. Hoch

The man in the black raincoat was an assassin. He was, actually, quite skilled at his job, and he was employed only by the most important governments. He liked the work, especially the frequent travel that went with it. This day he was even enjoying Tokyo in the rain.

Harumi-Dori is a street that runs up from Tokyo Harbor to the grounds of the Imperial Palace. Crossed at two points by the new expressway, it perhaps symbolizes modern Japan as well as any other street in the capital. At least that was what the man in the black raincoat was thinking as he walked along it, past the Nishi Honganji Temple and the famous Kabuki-Za Theatre. The old Japan and the new—Kabuki and expressways.

He paused at the corner, decided that the rain had almost stopped, and turned down the collar of his raincoat. Then he crossed the busy street and entered the offices of the Japan News Agency. The newsroom was on the third floor, and he found it without difficulty. It was a crowded, bustling place of clattering teletype machines and chattering Japanese voices. Very much like a newsroom anywhere else.

But then he paused. The desks were set in neat rows, and there was no identification on any of them. Thirty-six men occupied the room, seated at thirty-six desks, and he had no way of identifying the man he sought. He pondered a moment, deciding on the best tactic. His knowledge of Japanese was limited, and he could not simply ask for the man he sought without attracting attention to himself and warning his prey.

There was a pay telephone in the hallway outside the newsroom. He dropped in the necessary coins and dialed the number of the news agency itself. When the operator answered, he spoke the name of the man he sought.

"Shoju Etan."

She made the connection and he heard a phone in the newsroom begin to ring. One among many, but the only one to start ringing at exactly that instant. He let the receiver hang free and

stepped back into the newsroom. The man was at the head of the center row of desks, as befitted his position. A dull, middle-aged Japanese speaking now into the silent phone, questioning, waiting.

The man in the black raincoat stepped quickly to the desk and fired one shot from the Llama .32 in his hand . He needed only one shot. The man at the desk slumped over dead, and the phone receiver clattered to the floor.

Then there were screaming and shouting, the turmoil so familar to his way of life, and death. The man in the raincoat twisted his lip in a sort of smile as he backed through the door and headed for the fire stairs. A copy boy was blocking his path, and the man swung the Llama automatic in a wide arc, catching the youth on the temple. Then he was through the door, running quickly down the stairs to the safety of the street . . .

When Rand stepped off the big jet airline at Tokyo Airport two days later, the sun was shining brightly. The time change during the flight form London had tired him, and he should have been sleeping, but the sights of the strange and exotic city freshened his mind.

"Your first visit to Tokyo, Mr. Rand?" a voice asked. It belonged to a dark-haired American with fashionable sideburns and badly capped front teeth.

"Yes, it is," Rand replied. "But not my first to the Orient. I visited Hong Kong some years back." He moved into line at the Customs counter. "You must be Lanning."

"That's right," the American said. "My car is outside."

Ten minutes later, seated in the back of an American limousine far too large to pass unnoticed on Tokyo's crowded streets, Samuel Lanning produced his identification. Rand inspected the plastic-sealed I.D. card from the Central Intelligence Agency. He'd seen them before, and if they weren't quite as colorfully printed as the Americans' Secret Service identification, they were still impressive.

"You fellows should get your Treasury to print these." Rand commented. "The Secret Service ones look like miniature money."

Sam Lanning blinked and slipped the wallet back in his pocket. "You've been to America? The Secret Service rarely gets

to London, I know."

"Oh, yes, New York, Washington, other places. I spent some months there just last year."

Lanning nodded. He spoke a few words in Japanese to the driver and then settled back. "Your department is Concealed Communications, isn't it?" he asked. "Codes and things?"

Rand smiled. "Codes and things. I must say I'm impressed with your car. I didn't realize the CIA payed so well."

The American snorted. "The car belongs to the Embassy, and they don't pay that well. I started at $8000 a year, about what I could have made as a high-school teacher, and a good deal less than I might have earned as an actor."

Rand nodded. The man was interesting, even by the usual standards of the trade. "You were an actor?"

"I did a little Shakespeare after college."

"Hamlet?"

"No, but I did Iago once in a semiprofessional production of *Othello*. That's the longest role Shakespeare ever wrote."

The sedan took an expressway that looped around the Imperial Palace and then left it to wind through the narrow streets of the city. Lanning explained that they were in the Bunkyo-Ku section in the northern part of the city. The car passed the Kodokan Judo Hall and slowed to a stop before a middle-class apartment house. The streets here were filled with young people, and Rand asked about them.

"Tokyo University is only a few blocks away," Lanning said. "Things are normal there now. It's almost time for the summer vacation."

"Who will we be seeing here?" Rand gestured toward the apartment house. "Mrs. Belgrave?"

"Yes. And the other."

Rand frowned at the CIA man. "A replacement for Shoju? I assume someone replaced him after the killing on Monday."

Lanning smiled, as if proud of his little secret. "No one could replace Shoju in this operation, but happily we don't have to. Shoju Etan is alive."

"Alive?" Rand could not conceal his surprise. "But the papers said—"

"Someone else was sitting at his desk. We decided to play along and throw the assassin off the track temporarily." He opened the door. "Shall we go up now?"

Shoju Etan was a short balding Japanese of indeterminate age, with twinkling eyes that seemed always friendly. Rand had met him in London some years earlier, when he was once honored by a journalism group.

"Shoju! I'm so glad to see you alive!" Rand hurried to shake his hand.

"Ah, the Double-C man!" The slanted eyes took on their familiar twinkle. "I am indeed alive. I could hardly depart this earth without having written that interview we talked of in London."

"The reports in the paper—"

"Ah! We never believe what we read, do we, Mr. Rand? I was writing a series on the Tokyo zoo, and went out for further information. Another man was using my desk, and unfortunately he was mistaken for me."

Rand became aware of the woman who sat in one corner of the pleasant room, her face hidden in shadow. "You must be Mrs. Belgrave."

She stood up and offered her hand. Seeing her face, he was a bit surprised by its obvious youthful beauty. Somehow he'd expected Gordon Belgrave's wife to be close to his age—a woman in her fifties. But Mrs. Belgrave could have been no more than 35, and her flashing red hair contrasted strikingly with the pale skin of her face.

"How do you do, Mr. Rand," she said, speaking with a slight British accent, as of one who has lived most of her life far from her homeland. "I do hope you can help free my husband."

"I'll do what I can, of course," Rand assured her. Then, to Lanning, "Suppose you run over the situation for me. I must admit this attempt to kill Shoju here was more than I'd bargained for."

Lanning cleared his throat, a little like a lecturer. "Sure. Glad to, Rand. As you know, Gordon Belgrave is the American representative of a book publishers' council who was sent to Moscow to negotiate an agreement with the Russians on book royalties. The Reds had been pirating American books for years without paying anything, and lately there's been some reverse pirating by U.S. publishers. Mrs. Belgrave accompanied her husband, and perhaps she should take up the story at this point."

They turned toward the red-haired woman, and in that moment her pale drawn face revealed more of her ordeal than any

words she might utter. Finally she pulled herself together and began. "We'd been there about two weeks, and Gordon had met with various minor government officals, when one night without any warning we were arrested as we were leaving the hotel for dinner. They said my husband was an American spy, and they—they took us away to jail. I was questioned several times and so was my husband. Finally this man Taz said that I was being released because I was British. He said Gordon had confessed to being an American spy, and would have to stand trial."

Rand interrupted. "Taz is my opposite number in Moscow. His field is codes and ciphers. He wouldn't be involved in a routine espionage case."

"We know about Taz," Lanning said. "That's why you're here, Rand. I understand you've met the man."

"We've met twice, in East Berlin and in Paris, and I think we respect each other's work. It goes no further than that."

"But you're the man to talk to him, to reason with him. He has some coded messages that Gordon Belgrave is supposed to have sent."

"Did Belgrave really confess?"

Lanning motioned to the Japanese reporter. "Shoju can best answer that. He was there."

"I was," Shoju Etan admitted. "I was in Moscow on this series of articles I mentioned, and when I heard of the arrest I hurried to the Kremlin. After some time I managed to see Taz, and he took me with him while he interviewed the prisoner. He said he wanted to avoid the sort of publicity that spy arrests usually received in the Western press. He wanted to show me that Belgrave had not been tortured or brainwashed or otherwise coerced into making a confession."

"And Belgrave did actually confess?"

"He did," the Japanese reporter confirmed. "He said he had sent telegraphic messages to Allied agents in London using something called a SYKO cipher. Taz had the evidence of the messages themselves."

"What information was he supposed to have sent?"

Shoju stirred uneasily. "I did not include this in my published articles on the matter, but the Russians are working on a new form of SUM missile—surface to underwater missile—for use against America's Polaris submarines. I believe Taz suspects

that Mrs. Belgrave's husband was spying on this activity."

"I see," Rand commented. "But how can I help?"

Mrs. Belgrave stood up. "My husband is innocent, Mr. Rand. Completely innocent. He's —not well. He had a nervous breakdown about a year ago, and has been under treatment since then. I believe the Russians have done something to his mind."

"I'm sure the book publishers' council wouldn't have sent him to Moscow if he were seriously ill."

"Oh, it wasn't anything he couldn't control," she insisted. "In fact, he'd been much better since the shock treatments at the hospital. But I can't help feeling that his confession was the result somehow of his mental condition."

Rand turned to Lanning. "What about it, Lanning? Was he working for you?" He knew it was a foolish question, which could only bring a negative reply.

"Absolutely not," the CIA man insisted. "Belgrave was an Army Air Corps Intelligence officer during the Second World War, but he'd been completely separated from any sort of government service ever since. He has absolutely no connection with the CIA, NSA, or any other agency."

"I'm inclined to believe you," Rand said with a smile. Then, to Shoju, "You're returning to Moscow?"

The Japanese nodded. "I said in my last article that I would return this week with Mrs. Belgrave to try and free her husband."

"You think that's why they tried to kill you?"

Shoju shrugged. "I do not know."

"All right," Rand decided. "I'll go with you to Moscow. Since the British government sent me all this distance to help, I hardly think they'd want me to quit now. When is the next plane?"

"There is only one flight each week from Tokyo to Moscow," Shoju informed them. "Every Thursday on Japan Air Lines."

"Tomorrow." Rand considered for a moment. "All right, tomorrow it is."

On the way back to his hotel, alone with Lanning in the back of the limousine, Rand asked the question again. "Is he one of your men, Lanning?"

"No. That's the truth, Rand."

"All right. Next question. Who tried to kill Shoju at his office?"

"We believe it was a Turkish assassin named Sivas. He arrived in Tokyo three days ago and promptly dropped out of sight."

"Who's he working for?"

Lanning spread his hands. "That we don't know. He generally takes assignments from governments rather than from individuals. In recent years he's been quite active in the Middle East and the Balkans."

"Albania?"

"Perhaps."

"Would he work for Moscow?"

"Certainly, if they paid him."

"What does he look like?"

"Medium, dark. His appearance has a way of changing."

"I see," Rand said. He saw, but he didn't like it.

They gathered at the airport the following day—Rand, Lanning, Mrs. Belgrave, and Shoju Etan. An oddly mixed group, by any standard. Rand looked over his fellow passengers and wondered for the first time what he was doing there. Would he really have any influence with Taz on the Russian's home ground?

The flight was only about half full, with the rest of the passenger list consisting of an assortment of Oriental businessmen and traveling diplomats. There were only two women on board—Mrs. Belgrave and the lady with the coffin.

Rand noticed her at once, but he could hardly credit that to acute powers of observation. She was a striking brunette of perhaps 35—about Mrs. Belgrave's age—and her vaguely Oriental features seemed a perfect blending of the East and West that the flight itself symbolized. Her dress was Oriental, but when she spoke to her traveling companion it was in an English that could only have been learned in India or Hong Kong or some other outpost of the faded Empire.

Her companion was a grumbling man with a sinister face that seemed perpetually twisted into a frown. Lanning took one look at him and whispered to Rand, "Now that fellow could pass for a Turkish assassin any day of the week!"

But it was the coffin more than anything else which attracted attention to the odd pair. A series of adjoining seats had been removed from the rear of the plane's passenger compartment, and six stocky baggage handlers helped carry a full-sized coffin on board. There was a noticeable stir among the passengers, and

one man was even about to leave the plane. The pert young stewardess moved up and down the aisle, assuring everyone that the coffin did not really contain a body.

Rand glanced out the window at the morning mists that drifted across the field. Then, as he watched, the big jet engines came to life and the plane began to move. He glanced at his watch. It was 8:20 a.m., Japan time. They were right on schedule.

When they had reached their cruising altitude, Rand unbuckled his seatbelt and moved across the aisle to speak to the handsome brunette with the coffin.

"Excuse me," he said, "but I must admit that my curiosity has the better of me. If there's no body inside, what is in it?"

She smiled up at him. "Sit down. Join us. It's been so long since I've heard a real British accent."

"Thank you."

She introduced the sinister, grumbly man by the window. "This is Dr. Hardan, my associate. I am Yota Twain."

"My name is Rand. This is my first trip in the Far East, and I'm not accustomed to coffins sharing the passenger quarters on an airline."

She laughed, a musical blending of two cultures. "It is rare, and we had to obtain special permission."

"You still haven't told me what's inside that couldn't be trusted to the baggage compartment."

"And I'm afraid I can't." She made a pretty face. "It's a secret!"

"Classified material," the frowning Dr. Hardan said. "Can't talk."

"I think it's a body after all," Rand said, smiling.

"Perhaps it is," she agreed. "Perhaps I'm a witch, Mr. Rand, and it is the body of something very old, very dangerous. A monster of sorts." she was smiling as the spoke, but somehow her words were not humorous. Rand felt a chill down his spine.

"You're British?" he asked, changing the subject.

"Half, on my father's side. The other side—well, a mixture of things. The dark ways of the Orient. I've never been to England. Is it damp and dreary?"

"Not really. Though there's usually a time every winter when all your friends have colds. I'm used to it, I suppose. I like it."

"What are you doing on a flight to Moscow?"

"Asking questions of ladies with coffins."

"A journalist?"

"Of sorts." He motioned toward the back of Shoju's head. "My friend over there is a real one. I'll bet he could find out what's in your coffin."

She smiled agian. "You can see for yourself at Customs. We'll have to open it then."

"The great unveiling."

"Yes." She glanced at her watch, an expensive timepiece with a jeweled face. "This is a very long flight."

"Exactly four thousand six hundred and sixty-three airline miles." Rand liked to impress smiling ladies with his knowledge. "Even nonstop like this it takes over ten hours. It'll be one o'clock this afternoon when we land in Moscow, counting the six hours we gain."

"A walking timetable!"

"A sitting one right now, but I do have to to get back to my own seat. I'll talk to you later. Nice to have met you, and Dr. Hardan." The frowning man nodded slightly.

Rand resumed his seat next to Mrs. Belgrave. Lanning and Shoju were in the seats behind them. "Did you have an interesting chat, Mr. Rand?" asked Mrs. Belgrave. "Didn't learn a thing." he reported. "She says there's a monster in the coffin, and that she's a witch."

"She said that?"

"More or less. Why?"

Mrs. Belgrave pursed her lips. "I was watching that coffin when we took off. I could have sworn it moved."

"Vibrations."

"No. More than that. And six men to carry it on! It must weigh three hundred pounds!"

"Maybe it's a body after all."

"A live body, Mr. Rand. Do you suppose they're Russian agents, kidnaping someone and taking him back to Moscow against his will?"

"I doubt that."

"I would have doubted that Gordon could be arrested as a spy."

"That's a bit different."

"Do we really know these Russians, Mr. Rand? Do we know

what they want, what they're up to?"

"Perhaps they're only afraid," he said. "Like us."

It was a long trip, without even the time-killing relaxation of the in-flight movies provided on trans-Atlantic flights. By the time nine hours had passed, Rand and the others had pulled down the window shades against the noonday sun and were dozing fitfully. Rand was aware of Mrs. Belgrave leaving her seat at one point, making her way toward the rest rooms at the rear of the aircraft.

It was a sound like a cough that awakened him finally, and even then he did not know what had caused it. He glanced around, saw Mrs. Belgrave making her way back down the aisle, saw Shoju and Lanning both dozing in the seats behind him. He got up to stretch his legs and speak to Yota Twain again, but she was not in her seat. Dr, Hardan was alone, his face buried in a Russian-language newspaper.

He found Yota in the rear of the plane, bent over the coffin like some daytime vampire, and once more he felt the chill on his spine. "Checking body temperature?" he asked.

"It would be quite low," she replied smiling. Then, standing up, she added, "Our journey is almost over."

"None too soon."

"Have you looked out the window? At the snow? It's quite a sight with the sun on it."

"Even in the summer Siberia holds little interest for me."

"This is the Urals. We're passing over them now."

"I'll look," he promised.

"Rand!" He turned and saw that Lanning was motioning to him. Something was wrong—Lanning had lost his coolness.

"What is it?" Rand asked, hurrying up the aisle.

Lanning turned open the jacket of Shoju's suit, showing the widening circle of blood. "Rand—he's been wounded somehow! I think—"

Rand bent to feel Shoju's pulse, then lifted one eyelid. "He's dead," he said simply. "He's been murdered."

Lanning stared hard at the body in the seat next to him, as if unable to comprehend Rand's words. "But—I was right here all the time! How could he have been murdered?"

Rand avoided the most obvious answer and examined the

wound more closely. "It looks like a bullet," he said. "Did you hear a shot?"

"Nothing! I was dozing, but a shot would certainly have awakened me."

"Maybe not," Rand said, remembering now the quiet cough which had awakened him. A silenced pistol, perhaps further muffled by a pillow. With the passengers dozing and the stewardesses busy, no one had noticed. "Have a stewardess report it to the pilot. He should radio ahead and have police waiting at Moscow airport. The gun must still be on the plane."

"What is it?" Mrs. Belgrave wanted to know. She had returned to her seat without realizing anything was amiss.

"There's been some trouble. Shoju is dead."

"*No!*" Her hand flew to her mouth. "What will happen to Gordon now?"

"I don't think it will make his situation worse," Rand told her.

"But why kill Shoju just because he heard Gordon's confession?"

"I don't know. But somebody was certainly intent on getting Shoju out of the way. When the killer failed at the office, he followed Shoju aboard the plane."

Lanning glanced up and down the rows of seats at their fellow passengers. "The Turkish assassin—Sivas?"

"Maybe," Rand agreed. "Mrs. Belgrave, did you notice anyone else in the aisle when you went to the rest room?"

"Only that woman, back there with her coffin."

Some of the other passengers were beginning to group around them now, and a stewardess had arrived. Dr. Hardan came across the aisle to look, and Rand asked him, "Are you a medical doctor?"

"I—no. What has happened?"

"A man's been killed." He saw Yota hurrying up to join them, and he moved down the aisle past her. While they were busy looking at the body he'd have a few minutes alone with the mysterious coffin.

Rand dropped to his knees beside the polished wooden box and pressed his ear against it. There might have been a sound from inside, but he couldn't be sure. He took a deep breath and began to unscrew the bolts that held the lid in place.

"No! *Keep away from there!*" Yota Twain flew down the aisle at him, her little fists clenched. "Don't open that!"

"I'm sorry," Rand said, trying to fight her off. "I have to open it. A man's been murdered. The weapon may have been hidden in here."

"There's no weapon! Don't open it!"

"Lanning! Keep her off me, will you?"

The CIA man had appeared behind Yota, and now he grabbed her arms, pinning them to her side. "Calm down, Miss."

"You don't understand! If you lift that lid—"

Rand twirled the last bolt free and began to raise the lid, slowly, mindful of a bomb or booby trap.

But the thing that faced him as he lifted the lid was much older than a bomb, and perhaps more dangerous. Their eyes met for just an instant, and then the ancient scaly jaws began to open slowly.

The thing in the coffin was a crocodile.

"I wish you'd listened to me,"

Yota told him when the lid had been screwed down again. "It upsets him to have it opened like that."

"It upset me a bit too." Rand agreed. "Suppose you explain."

"It's not at all that unusual, Mr. Rand. Crocodiles are sometimes shipped between zoos in coffins, simply because it's such a perfect container for them. This particular specimen is a Philippine crocodile, almost fully grown. We're transferring him from the Tokyo zoo to the Moscow zoo, for mating with a female they have there."

"You couldn't tell us this before, Miss Twain?"

She smiled. "My real name is Dr. Yota Nobea, professor of zoology at Tokyo University. I have close ties with the zoo. And no, we couldn't tell you this, Mr. Rand. Passengers would have been just as disturbed flying with a live crocodile as with a dead body, I'm afraid."

Rand glanced back at Shoju's seat. "Now they have both, I'm afraid. I suppose Dr. Hardan is a zoologist too."

"That's correct. He's worked closely with me on the crocodile-mating project."

"Why would anyone want to mate crocodiles?"

She shrugged. "It is an occupation much preferred to the

killing of people, Mr. Rand."

Lanning came up from the front of the plane, carrying a Llama automatic wrapped in a handkerchief. "We found the murder weapon, Rand. It was stuffed into an empty seat. Anyone could have put it there during the excitement just now. Here's the silencer, too."

"Could this be the gun that killed the man in Shoju's office?"

"Same caliber. Yes, it could be."

"Then Sivas is on this plane?"

"Sivas or someone else." Lanning tried to grin. "I don't go much for mysterious Turkish assassins myself. Sometimes life is a lot simpler."

Rand stepped away so that Yota could not hear his answer. "Someone doesn't want Belgrave freed. Could it be his wife?"

"I'll buy anything at this point, Rand, if you can come up with a motive and evidence."

The plane was beginning its descent. A voice on the intercom instructed the passengers to fasten their seatbelts. In a few moments they would be on the ground at Moscow airport.

Rand had been waiting for the better part of two hours in the high-ceilinged Kremlin office before Taz made his appearance. He was as Rand remembered him from Paris—middle-aged, with a thin face, pointed jaw, and deep blue eyes. His graying hair swept back from his forehead, and his thin fingers played nervously with the metal buttons of his jacket.

"Ah, my friend Rand!" He extended his hand in greeting, speaking the same accented English that Rand remembered from their previous meetings. "I am so sorry to keep you waiting like this, but your flight from Tokyo has complicated our lives. The murder of a news reporter is not to be taken lightly."

"I'm glad to hear that." Rand wished he had a cigarette.

"But the killing is out of my hands. You come to discuss the arrest of the spy Belgrave, no?"

"No Belgrave's no spy and you know it, Taz."

"I do *not* know it, my friend. He has confessed, and we have the evidence."

"I'd like to see that evidence."

Taz smiled slightly and untied a folder he'd been carrying. "I like to anticipate you. I especially like it when we are decipher-

ing your messages."

Rand frowned. This was, in some ways, a new Taz—a man supremely confident. "We're pretty good at anticipating too," he countered lamely. "Now, let's see this evidence."

Taz spread the telegraph forms on the desk between them. There were six in all, made up of familiar five-character cipher groups. Rand scanned one at random: 3H9J4 WBRD1 SQ25F MILT7 6G8RP. "You've deciphered it?" he asked Taz.

"In essence. After he confessed, Belgrave read the rest for us. A SYKO cipher, of course. I suspected as much when I saw the mixture of numerals and letters."

"Were these actually sent?"

"Of course not!" Taz chuckled at the very thought of it. "Russian telegraph offices could hardly be expected to transmit enciphered messages."

"Exactly!" Rand pointed out. "So what did Belgrave hope to gain by trying to send them? If he'd discovered any secrets it would have been much safer to carry them back to America inside his head."

"The fact remains that he confessed. And without torture."

"The only witness to that is dead now."

"The Japanese?" Taz dismissed him with a wave of the hand. "*I* was a witness to it. Do you not accept my word?"

Rand looked into the deep blue eyes. "I do," he said at last.

"Then what else is there to discuss? The man was caught trying to send enciphered messages, and he confessed to being an American spy."

"Spying on what? On your new SUM missile?"

"The particular nature of his espionage is not important."

"I think it's damned important," Rand barked, learning forward until his face was only inches from Taz's. "There's nothing in these messages about the SUM and you know it!"

"Do I?"

"Because if there was you wouldn't be so free in showing them to me. I could have them memorized already, for all you know. It's not too difficult a feat."

"All right." Taz leaned back, breaking the contact of their eyes. "The messages did not mention SUM. They seemed to be about aircraft reconnaissance. They did not, admittedly, make a great deal of sense."

"I wouldn't think so."

Taz frowned at him now. "Why not?"

"Because the SYKO cipher was a widely used Allied air-ground system during World War II. It hasn't been used since then. Gordon Belgrave was an Air Corps Intelligence officer during the war. He was confessing to acts of espionage committed twenty-five years ago."

Taz turned from the desk and walked over to the high broad window that reached almost to the ceiling. He stood for a moment gazing out at the lights of the Moscow evening; then at last he turned to face Rand.

"You can prove what you say?"

"Belgrave had a nervous breakdown last year. He received shock treatments. Your medical men will tell you that such shock treatments sometimes cause age regression. Belgrave came here to meet with Russian publishers, but suddenly imagined himself in the world of twenty-five years ago. He tried to send messages in the old SYKO cipher, and when you arrested him he confessed to espionage."

"It's possible," Taz admitted somewhat reluctantly. "It would explain the oddness of the messages."

"It's more than possible—it happened. I want the man released at once, Taz."

"That is beyond my authority."

"Like hell it is! What do you hope to gain by holding him?"

Taz motioned him to the window. "Forget about the American for a moment and look down on all this. We are in one of Moscow's tallest buildings—not tall by American standards, but it compares favorably with London, no?"

"Get to the point, Taz. The American is innocent. What do you want in exchange for him?"

The blue eyes blinked. "What do I want? Why, I want you, my friend. And it appears that I have you."

"What new game is this?" Rand felt his blood run cold. Had he been outwitted somehow?

"I could press that button on the desk and have you arrested for murder, Mr. Rand."

"Murder!"

"The murder of one Shoju Etan on a Japanese airliner over

Russian territory."

"You're crazy, my friend."

"I could produce three witnesses who would swear they saw you shoot him."

"You had Shoju killed just to frame me for his murder?"

"Hardly. But it *is* convenient, is it not? I could keep you here, remove you forever from the Department of Concealed Communications."

"If that's what you want you could have me killed back in London any day of the week. I'm really quite vulnerable, as I told you once before."

Taz shook his head. "I do not want you dead, my friend. I want only to make you an offer."

"In return for my freedom?"

"In return for the freedom of Gordon Belgrave."

"He means nothing to me."

Taz shrugged. "Very well, then. Who else must I seize? The American CIA man—Lanning?"

"Leave him out of it." Rand realized that his palms were sweating. He'd come here as the cat and now suddenly he felt like the mouse. "What is your offer?"

Taz smiled, motioning toward the walls with their proletarian adornment. "I can assure you there are no listening devices in this room."

"I accept your assurance."

"Very well. Let us get to business. My offer is simply this— that we, you and I, join forces for our own betterment. That we, shall I say, exchange certain key pieces of information regarding our codes and ciphers."

Rand leaned forward, not certain that he'd heard correctly. "You can't be serious!"

"I'm deadly serious, my friend. Neither of us grows younger. The espionage business is a dying one, replaced by satellites in the sky and old men around a conference table. Would it not be to our advantage to work together, to try and gather a—what is it called?—yes, a nest egg for the days of our enforced retirement. What I am suggesting, after all, is no more than Major Batjuschin suggested to Captain Redl in 1902."

This brought a smile from Rand. "You mean Captain Redl, the archtraitor?"

"Yes or no, my friend?"

"I suppose, Taz, that what you're suggesting is the only sensible course for practical men to follow. And I suppose I'm both foolish and old-fashioned in turning you down."

"What is it—patriotism?"

"Nothing so nebulous as that. I suppose, quite simply, it's just that I don't quite trust you, my friend."

The Russian's face froze. "Very well. Then Gordon Belgrave remains with us."

Rand held up a hand. "Not so fast. Now it's my turn to propose a deal. Do I have your word that the Russians are not responsible for Shoju Etan's murder?"

"You have it."

"What about a man named Sivas?"

"A hired killer, employed by the Albanians, and sometimes by their friends the Chinese."

"I suspected as much."

"Is Sivas here, in Moscow?" asked Taz curiously.

"If you'll release Belgrave, I'll deliver Sivas—and more besides."

"More?"

"Now it's your turn to trust me."

Taz nodded slowly. "Show me Sivas. Where is he?"

"Let's look for him together. At the Moscow zoo."

Dr. Yota Nobea glanced up as they entered, neglecting for a moment the languid crocodile in its shallow pool of water. "The zoo is closed till morning," she said automatically. "It's almost eleven o'clock."

"You've forgotten me already?" Rand asked. "After only ten hours?"

"Mr. Rand! What brings you to the zoo at night? And who is that with you?"

"My name is Taz," the Russian said softly.

"You really must excuse me. I'm getting my crocodile settled in his new quarters."

"We don't want the crocodile," Rand said. "We want the coffin he came in."

"The coffin! It's out on the truck. But why do you want it?"

"Because, Dr. Nobea, six big men had to struggle to get that coffin on board. A full-grown Philippine crocodile weighs less

than an average person, and you said this one wasn't yet full-grown. I want what's hidden in the bottom of that coffin."

"There's nothing," she said, but her eyes darted with fright.

"No Customs man would search further after you showed him the crocodile, would he? And no Customs man would question the total weight of the coffin, at least not when it arrived in the care of Professor Nobea of Tokyo University. Which brings us to the question: what happened to the real Professor Nobea?"

Yota's mouth twisted. "I am Nobea."

Rand shook his head. "Shoju Etan was doing a series of articles on the Tokyo zoo, which included research in Moscow. He must have known about the crocodile-mating project. He must have met the real Nobea. That was why Shoju Etan had to die, wasn't it? Not because of Gordon Belgrave's confession, but because of Shoju's zoo articles. Not because the newspaperman might recognize you on the plane, but because he *wouldn't* recognize you! When that coffin was opened at Customs and you identified yourself as Dr. Nobea, Shoju would have been there to call you a liar."

"The first attempt on Shoju was made at his office," Taz objected. "How would they know that soon whether he would be on the same flight?"

"Shoju wrote in his Belgrave story that he'd be returning to Moscow this week, and there's only one flight from Tokyo to Moscow each week. Yota knew he'd be on that plane, and so he had to die. When they failed to kill him earlier, they had to do it before the plane landed. I had a tip when Yota admitted using a false name early in the flight. There was no reason for it—except to keep her assumed identity a secret from Shoju till he was dead."

There was a wound behind them, and Rand saw Dr. Hardan in the doorway. He was wearing a black raincoat and he held a Llama automatic in his hand. A spare in his baggage, of course. All experienced assassins carry two.

Yota screamed something in Chinese and leaped to the side of the crocodile pond. Taz turned, his reactions just a bit too slow, and saw the assassin's gun trained on him. Rand had only a second to consider the alternatives. Then he fired through the pocket of his jacket and caught Hardan in the chest.

"You were armed," Taz muttered, recovering himself enough

to get a firm grip on the woman.

"No one searched me," Rand replied with a smiled. "I always visit Russians with a gun in my pocket." He walked over and nudged the body on the concrete floor. "This is Dr. Hardan, or if you prefer, Sivas, late Turkish assassin. Funny, Lanning said he even looked like one. The CIA can't be all bad."

"What is in the bottom of the coffin?" Taz asked.

"Something Chinese agents were anxious to smuggle into Moscow. You take it from there."

"I will, my friend," Taz said.

The following morning a Russian military transport was waiting at Moscow airport. Rand and Taz watched while Mrs. Belgrave led her husband to the plane, and then Rand said, "Thanks for the transportation. It saves us a wait."

"Thank *you*, Mr. Rand." The Russian seemed in good spirits.

"The coffin?"

"It's not my department, but I understand it's very critical. Pieces of metal, and much wiring. The more melodramatic of our people suspect they may be components of a small Chinese atomic bomb."

Rand whistled. "You'd better watch out for the rest of it."

"We will." Taz paused. "And Rand, if you ever decide to accept my offer—"

"Don't count on it. In this business we all end up poor. There's no beating the system, Taz." He remembered Lanning's complaint about his low pay, and saw the CIA man walking toward them. "I'd better go now."

The Russian nodded and waved as they parted. Then Rand fell into step with Lanning and they walked to the waiting jet. "You did a good job, Rand," the American observed. "We just heard from Tokyo that they've located the real Dr. Nobea. She was drugged but unharmed."

"It was a good job," Rand agreed. "I helped Taz and I freed Belgrave. Sorry you couldn't get the plan for the SUM missie while we were at it."

Lanning started up the steps of the plane, then turned back toward Rand with a little smile. "What makes you think we didn't get it?" he whispered.

THE SPY AND THE CATS OF ROME

by Edward D. Hoch

Rand felt vaguely uneasy sitting in the familiar chair in Hastings' office at British Intelligence. He'd sat there on a thousand prior occasions over the years, but this time was different. He'd retired from the Department of Concealed Communications the previous autumn, and though he'd been involved in one or two cases since then, this was his first visit back to the old building.

"Good to see you again, Rand," Hastings said. "How's your wife?"

"Leila's fine. Teaching archeology at Reading University."

"You live out that way now, don't you?"

"That's right. We have a house west of London, about halfway to Reading. It's an easy drive for her."

"And yourself?"

"Rand shrugged. "Writing a book. What everyone does when they retire from here, I suppose."

"I wanted you to know how much I appreciated your help on that Chessman toy business a few months back."

"You told me so at the time," Rand reminded him. "What is it now?"

"Does it always have to be something?"

"You're too busy a man to invite me down for a mere chat. What is it?"

At that instant Hastings seemed old and bleak. "The sins of our youth catching up with us, Rand. It's Colonel Nelson."

Rand stiffened. That had been—how many years ago?—ten at the very least. Colonel Nelson had been in charge of certain international operations for British Intelligence. He'd lied to Rand about the nature of a Swiss assignment, and some good people had died. Shortly afterward Colonel Nelson suffered a nervous breakdown and was retired from the service. Even after ten years Rand had never forgotten the man and what he did. He'd thrown it up to Hastings in moments of anger, and had cited the affair to younger members of Double-C as a glaring

example of what could go wrong if an overseas agent was not in possession of all the facts.

"What about him?" Rand asked.

"We have reports from Rome that he's stirring things up, recruiting white mercenaries to fight in Africa."

"Not on behalf of British Intelligence, surely!"

"No, no, of course not. And I doubt if he's working for the Americans, either. Frankly, we don't know what his game is. But it's most embarrassing at this time."

"Where do I come in?"

"Could you fly down to Rome for a day or two? Just see what mischief he's up to?"

"Oh, come on now, Hastings! I'm out of the service. I helped you on that toy business because—"

"I know, I know. But I don't want to send anyone officially. You know Colonel Nelson. You'd recognize him, even after ten years."

"And he'd recognize me."

"That might be enough to scare him off what he's doing, or at least make him assume a lower profile. You'd be strictly unofficial, but he'd get the message."

"I don't want to be away—" Rand began, still resisting.

"Two nights at most. Certainly your bride could spare you that long."

Perhaps it was the enforced bleakness of the winter months, or the simple need for activity. Perhaps it was a gnawing sense of unfinished business with Colonel Nelson. Ten years earlier Rand had wanted to kill him. Now, perhaps if he saw the man, he could write a finish to it, finally forget it.

"All right," he said, "I'll go."

Hastings smiled. "I thought you would. I have your plane ticket here."

Rand phoned Leila at the university and explained, as best he could, that he'd been summoned to Rome for two days. "Back at it, aren't you?" she asked accusingly.

"Not really. It's some unfinished business. A fellow I used to work with."

"Be careful, Jeffery."

"Don't worry. I'm through taking chances."

He gathered up some things into an overnight bag and flew to Rome that evening. It was a city he'd visited only briefly in the past, and perhaps his impresssions of it were different from most. To him it was not so much a city of churches as a city of fountains and cats.

This night, having settled into a hotel room not far from the Spanish Steps, he took a taxi to a restaurant near the Forum, where the cobblestoned street was cluttered with cats of all sizes waiting to be fed the scraps from the kitchen. Some said the cats had been there since the Fifth Century B.C., when they were imported from cat-worshipping Egypt. They ran wild in many parts of the city, often simply sitting and watching a passerby with a regal indifference that made one believe they might well have inhabited the city for 2500 years.

The restaurant itself was unspectacular. It was called Sabato—Saturday—and perhaps that was the only night it did any business. Certainly on this Thursday night there were plenty of empty tables. Rand saw a few men at the bar—young Italian toughs of the sort that might make good mercenary material. If Colonel Nelson did his recruiting here, business might be good.

A young woman wearing a tight satin skirt and scoop-necked blouse appeared from somewhere to show him to a table. She asked him something in Italian and he answered in English, "I'm sorry. My Italian is a bit rusty."

"Do you wish a menu?" she asked, speaking English almost as good as his.

"Thank you, no. My name is Rand. I've come in search of a friend. I understood I could find him here."

"What is his name?"

"Colonel Nelson."

"Ah! The man with the cats!"

"Cats?"

"He feeds them. They trail him down the street when he leaves."

"Does he come here every night?"

"Usually, but you have missed him. He's been and gone."

"I see. You wouldn't happen to know where he lives, would you?"

She shrugged. "Ah, no."

Rand glanced at the line of men standing by the bar. "Any of

his friends around?"

"Colonel Nelson's friends are the cats."

"But if he comes in here he must drink with somebody."

"Ask them," she answered, indicating the men at the bar.

"Thank you, Miss—"

"Anna."

"Thank you, Anna."

The first man Rand approached spoke only Italian, but his companion had a knowledge of English. He also had a knowledge of Colonel Nelson. "I take you to him if you want. He lives not far from here."

"Fine. Does he work around here?"

"No, no, he's an old man. He feeds the cats, that is all."

Rand figured Colonel Nelson to be in his early sixties, but the effects of the nervous breakdown might have aged him. Still, it seemed odd that a neighborhood character who fed the stray cats of Rome would be seriously recruiting mercenaries to fight in Africa.

"All right, take me to him."

The man gestured with his hands. "I must pay for the drinks I have."

Rand took the hint and put down a couple of Italian bills. The man smiled, pocketed one of them, and left the other for the bartender. Then he led the way outside, heading down a dim alley lit only by the curtained glow from the restaurant windows.

"How far is it?" Rand asked.

"Not far from here," the man said, repeating his earlier words, and Rand wondered it he was being set up for a trap. But presently they reached a seedy stone building that obviously contained small apartments, and the man motioned him inside. "I leave you. Sometimes he does not like visitors."

Rand checked the mailboxes—some standing open with their hinges broken—and found one for *Col. A. X. Nelson*. Ambrose Xavier Nelson. Rand hadn't thought of the full name in a decade. He glanced around to thank the man who'd brought him, but the man had already vanished into the night.

The apartment was on the third floor and Rand went up the dim steps with care. The place smelled of decay. Not all that quiet, either, he decided, hearing the noise of a family quarrel

from one of the second-floor apartments as he passed it. There was a man's body sprawled on the third-floor landing, and he thought for an instant it was Coloonel Nelson, cut down by enemy agents. But it was only a drunk, wine bottle empty at his side, who opened his month and snored when Rand turned him over.

He knocked at the door of Colonel Nelson's apartment and waited.

Nothing happened. After a moment he knocked again, harder this time.

Finally a voice reached him from inside. "Who is it?"

"An old friend, Colonel Nelson. I'm in Rome and thought I'd look you up."

The door did not open. "Who is it?" the question was repeated.

"Jeffery Rand, from London."

"Rand. Rand?"

"That's right. Open the door."

He heard latches being undone and bolts pulled back. The heavy oak door opened a crack and a white kitten squeezed out. Then it opened farther, revealing a wrinkled face and balding head. Tired eyes peered at Rand through thick glasses. "I'm Colonel Nelson," the man said. "Why did you come here?"

"To see you. May I come in?"

"All right. The place is a mess."

Two more cats came into view, running across the floor in Rand's path. He lifted a pile of newspapers from a chair and sat down. The place was indeed a mess. "Do you remember me?" Rand asked.

The man opposite him waved his hand. "The memory comes and goes. The old days are clouded sometimes. But I think I remember you, yes."

"That surprises me," Rand said, almost casually, "because I've never laid eyes on you before. You're not Colonel Nelson."

The old man smiled then, showing a missing tooth. "Didn't think I could fool you, but I had to give it a try, right?"

"Who are you, anyway? Where's Nelson?"

"He's away. Hired me to take care of his cats and things. My name's Sam Shawburn."

"You're English."

"Sure am! There's a great many of us in Rome, you know. I was with the British Embassy in my younger days. That's how I met old Nelson."

"But this place—!"

"Isn't very tidy, is it? He's fallen on bad times, Colonel Nelson has. Gets a small pension, you know, but not enough to live on."

"Yet he can afford to pay you to stay here while he goes off traveling. That doesn't make sense."

"He was called away on business. He expects to make scads of money and then he says he's going to move to a better place. Maybe take me with him, too."

"I see. Are the cats his?"

"Sure are! They're not mine, I can tell you that. He feeds them in alleys and sometimes they follow him home. He's got close to a dozen around here, maybe more."

"I really would like to see him while I'm in Rome. When's he due back?"

"Who knows? He's been gone a week now."

"I understand he has business connections in Africa."

Sam Shawburn's eyes narrowed. "Where'd you hear that?"

"The word gets around. I heard he was recruiting mercenaries to fight in Africa."

"Old Nelson's a sly one. I wouldn't want to say what he's up to. But I never heard anything about Africa."

"All right," Rand said. "Good talking to you, anyhow. And be sure to tell him I was asking for him."

"Sure will!" the old man said.

Rand left the apartment and went back downstairs. The drunk was gone from the landing now, and he wondered what that meant. Was Colonel Nelson's apartment being watched, and if so by whom? Rand hadn't noticed a telephone in the shabby quarters and once he reached the street he decided to wait a few minutes and see what happened. If anything.

Luck was with him. Within five minutes Sam Shawburn left the building and headed down the street, followed by a couple of cats. He might have been taking them for a walk, but Rand was willing to bet he was headed for a telephone.

The streets in that section of the city were all but deserted at night, and it was difficult for Rand to follow too closely. Once or

twice he thought he'd lost the trail, but finally he saw Shawburn enter a little tobacco store and make for a telephone in the rear. The cats waited outside, scanning the street for some unseen prey.

He waited until the old man emerged from the shop and stared back down the street. Then Rand crossed quickly to intercept him. "Hello again, Mr. Shawburn."

"What?"

"It's Rand. I wonder if you've been touch with Colonel Nelson."

The old man took a step backward, as if frightened by the sudden encounter. "No, no, I haven't talked to him."

"Who'd you just call now?"

"When?"

"Just now, in the tobacco store."

"My daughter. I called my daughter."

"Here in Rome?"

"Yes. No—I mean, near here."

"You phoned Colonel Nelson, didn't you?"

The old man's head sagged. "I sent him a telegraph message. I thought he'd want to know."

"Where did you send it?"

"Moscow."

"Colonel Nelson is in Moscow?"

"Yes."

Rand cursed silently. What in hell had he got himself into? The brief favor for Hastings was opening before him like an uncharted swamp. "What's he doing there?"

"I don't know. Business, I guess."

"Where's he staying?"

"I don't know."

"You had to send the telegram somewhere."

Shawburn seemed to sag a bit. "The Ukraine," he replied at last. "He's staying at the Ukraine Hotel in Moscow."

There was never any doubt in Rand's mind that he'd be going to Moscow. He phoned Hastings in London to tell him the news and then made arrangements to catch a flight the following morning. As Hastings had quickly pointed out, the possibility of establishing a link between the Russians and the recruiting of

African mercenaries was too good an opportunity to be passed over.

Rand had been in Moscow before, in 1970, and he was surprised to see the fresh coats of paint on buildings that had long been neglected. The city was spruced up; it was more modern and lively than he remembered it, and riding down Kalinin Prospekt in the taxi from the airport he might have been in any large city of western Europe. He could see the Gothic spires of the Ukraine Hotel in the distance, looking like some sort of medieval anachronism, contrasting sharply with the modern offices and apartment buildings that lined the thoroughfare. And he couldn't help wondering if his chances of finding Colonel Nelson were any better in a grand Moscow hotel than in the cat-filled alleys of Rome.

The desk clerk at the Ukraine spoke some English, and he knew of Colonel Nelson. "I think he is in the dining room," he told Rand.

The difference in time between Rome and Moscow had made it the dinner hour without Rand's realizing it. He thanked the room clerk and entered the dining room. It was long and fairly wide with a raised bandstand at the far end and balconies running the length of either side. A huge chandelier hung from the center of the ceiling, adding a surprisingly ornate touch. Most of the side tables were set for large parties, but at one of the small center tables he found Colonel Nelson dining alone. This time there could be no mistake, even after a decade.

"Hello, Colonel."

The old smile greeted him, though the face around it had aged and the eyes above it had taken on a slightly wild look. "Well, Rand—good to see you! I trust your flight from Rome was a pleasant one."

"So Shawburn sent a second telegram."

"Of course! Did you think he wouldn't? The old man is quite faithful."

"Mind if I join you?" Rand asked, already pulling out a chair.

"Not at all!"

"How's the food here?"

"Predictable. And the service is slow, as in all Moscow restaurants. But I can recommend the soup. It's so thick your fork will stand in it unsupported."

"I'll try some," Rand said with a smile. "What brings you to Moscow, Colonel?"

"Business prospects. Nothing of interest to Concealed Communications, I shouldn't think."

"Oh, I'm retired from there," Rand said casually.

"Are you, now? Then why are you tracking me across Europe?"

"I was in Rome and thought I'd look you up, see how you're doing. I'll admit when I heard you were in Moscow my curiosity got the better of me. Not changing sides after all these years, are you?"

Colonel Nelson glanced around nervously, as if fearing they'd be overheard. "I have no side in London any more. Surely you remember how I was booted out of the service."

"I remember how you lied to me about that Swiss assignment and caused the death of several people."

"We are in the business of lying, Rand. You know that. Didn't Hastings ever lie to you?"

"Not to my knowledge."

"Ah, the good gray Hastings! A knight in shining armor! But he's the only one of the old crowd left, isn't he? You and I are out of it—and I hear that even some of the Russians like Taz are gone."

"Taz was blown up in a car shortly before I retired. He made the mistake of coming out of retirement."

Colonel Nelson smiled. "I hope you don't make the same mistake."

Rand leaned forward. "What are you doing here, Colonel?"

"A business matter."

"You're playing a dangerous game. Your apartment in Rome is being watched."

"No doubt by British Intelligence."

Rand decided to lay his cards on the table. "They know you're recruiting mercenaries," he said quietly. A small combo was tuning up on the bandstand, and he doubted if even a directional microphone could have picked up his words.

Colonel Nelson merely shrugged. "There is very little for an aging man to do in my line of work. One must make a living."

"Are the Russians paying you?"

Nelson thought about the question for a moment, then said,

"Look here, Rand, come with me tomorrow morning and see for yourself. It will save you the trouble of following me all day."

"Tomorrow morning?"

"At ten, in the lobby. We're going to Gorky Park. It's the first warm weekend of spring and there's certain to be a crowd there."

He'd been right in his weather prediction, at least. The temperature had climbed to 22 degrees on the Celsius scale, and the park was crowded with strollers. Gorky Amusement Park was located on the Moscow River, a few miles south of the central city. Rand had never been there before, and somehow the sight of the giant Ferris wheel startled him.

"They come here in the winter to ride the ice slide," Colonel Nelson said, "and in the summer to sun-bathe on the hillside. It is a park for all seasons."

"A good place for a meeting," Rand agreed. "Especially on a mild spring weekend."

"The man I'm to meet is named Gregor. Make a note of it if you wish, for Hastings."

"That won't be necessary."

They strolled deeper into the park, past the amusement area to the bank of the river. There were people resting on its grassy shore, and Colonel Nelson said, "It's too cold for swimming except in mid-summer, but they like to wade."

"You know a great deal about Moscow."

"After so many trips it's like London or Rome to me. But come, there's Gregor now."

Gregor was a heavy-set Russian wearing a dull gray suit that seemed too heavy for the weather. Rand's unexpected presence made him nervous, and after a few words in Russian the two of them moved off out of earshot. "You understand, old chap," Colonel Nelson said.

Rand found a bench and sat down, watching some children at play with a fat yellow cat. He couldn't help thinking that the cats of Moscow seemed better fed than those of the Rome alleys. Presently he saw the two men part and Colonel Nelson joined him on the bench. He bent to pet the cat, then sneezed suddenly and sent the creature scurrying into the bushes. "That was simple," he said. "My business in Moscow is finished."

"You handed him an envelope."

"Down payment. In three weeks' time he will deliver five hundred Russian and East German weapons, mainly automatic rifles."

"You're buying arms here?"

"Of course! What else would bring me to Moscow?"

"For your African mercenaries?"

"Yes," Colonel Nelson answered smugly. "Then if the arms are captured it appears the Russians supplied them."

"Who really supplies them?"

"You know as well as I do, Rand. The British are footing the bill, perhaps with the C.I.A.'s help. I'm still with British Intelligence, you see. I never really left."

"I can't believe—"

"Can't believe what? That Hastings didn't tell you? Good clean Hastings who's always so aboveboard? Hastings knows what I'm doing, all right. He sent you on a fool's errand, going through the motions in the event anyone asked questions later on. I'm working for the British, supplying guns and men to various African factions. You might as well accept it, Rand, because it's true."

Rand was stunned by the words. He didn't want to believe them, didn't want to believe that Hastings had lied to him just as Colonel Nelson had done a decade earlier.

But before he could speak, a man wearing a black raincoat detached himself from the nearby strollers and headed toward them. Rand's first thought was that the man looked vaguely familiar. Then he saw the gun come into view and he thought they were under arrest.

But the gun was a 9mm German Luger, and it was pointed at Nelson's chest. "Volta, Colonel Nelson!" the man shouted, and fired three quick shots.

Rand saw it all as if in slow motion. He saw Nelson topple backward as the bullets tore into his chest. saw the assassin drop the weapon at Rand's feet and disappear into the bushes.

Then Rand was running—knocking screaming women and frightened men from his path, running after the gunman who'd already melted into the crowd on the next footpath. It was impossible to find him, and to most witnesses Rand must have looked like the killer himself. He saw a policeman coming his

way, guided by the pointing fingers of the crowd.

He ducked behind a signboard as the officer approached, and quickly bought a ticket on the Ferris wheel. As soon as he began his ascent, he spotted the policeman still searching the crowd for him. And higher up, with a view of the entire park, he could see the crowd gathered around the spot where Colonel Nelson's body lay. It was hard for him to believe that the tiny figure at the center of that crowd was Nelson, who'd survived a dozen intrigues to die like this in a Moscow amusement park.

He thought about that, and about Hastings back in London.

Had Hastings really lied to him? Was Colonel Nelson working for British Intelligence all this time, financing his African venture with money from England and possibly from America?

And had the killing of Colonel Nelson been part of the ultimate double-cross?

Rand left the Ferris wheel after three more trips around. The view hadn't answered any of the questions for him, but at least he'd seen Colonel Nelson's body being carried off and he knew the police had stopped searching the immediate area. He took a taxi back to his hotel and was just entering the lobby when he noticed the two men in belted black raincoats talking with the room clerk. This time there could be no mistake. These really were Russian police.

He went back out the revolving door without pausing.

They were looking for him and they knew where to find him.

He was being nicely framed for the murder of Colonel Nelson.

As Rand saw it, there were only two courses of action open to him. He could attempt to leave the country by the first available airliner—and no doubt be stopped and arrested at the gate. Or he could go to the British Embassy and try to get help there. The embassy seemed the better bet. Once inside a Russian prison, he knew he'd be a long time getting out.

He was only a few blocks from the embassy building, and he went on foot. The entrance seemed clear as he approached, but almost immediately two Russian detectives emerged from a parked car to intercept him. "Could you state your business, please?" one of them asked in good English.

"My business is with the British Embassy."

"Could we see your passport?"

"I've lost it. That's why I've come to the Embassy."

"You must understand we are looking for a British citizen wanted in connection with a murder. We must ask for identification."

"Are you denying me entrance to my own Embassy?"

The Russian shrugged sadly. "Only until you produce identification. You are still on Russian soil here." He pointed to the ground at his feet, as if daring Rand to step past him.

"All right. I have some identification in my car. I'll go get it." He held his breath as he turned, wondering if the Russians would follow. But their instructions had been to remain at the Embassy entrance, and they only followed him with their eyes. He walked down to the next cross street, where a small Moskvich automobile sat at the curb, its front end hidden from the Russians by a projecting building. Rand bent and pretended to try unlocking the door, then straightened up, shrugged, and made as if to walk around the front of the vehicle to the other side.

As soon as he was out of sight of the Russians he started running, heading down a narrow alley between buildings. He didn't think they'd desert their post to follow him too far, but he wasn't taking any chances.

Finally, panting for breath and fearful of attracting attention, he slowed to a walk as he emerged onto a busy avenue. No one stopped him. For the moment he was safe.

But what should he do now?

Hunted in a strange country for a murder he didn't commit, unable to leave the city or reach the British Embassy, knowing very little of the language, it seemed only a matter of time before he was taken into custody.

He descended into one of the ornate Moscow subways with its gilded chandeliers and sculptured archways and rode to a point not far from the American Embassy. But as he approached he saw a familiar-lookng car with two men inside. He kept on walking, wondering how many embassies in Moscow had teams of police watching their doors.

Next he entered a small shop and asked for a public telephone. When he finally made his message clear, the woman behind the conter led him to a telephone—but there was no phone book. He remembered reading somewhere that telephone numbers were

hard to come by in Moscow. With some difficulty he might reach the British or American Embassy by phone, but then what? They would hardly risk an international incident by coming into the street to rescue an accused killer. The best they'd offer would be a visit to his prison cell after he was arrested.

And what if he was arrested? Even his friends back in London might half believe the charge against him. He'd hated Colonel Nelson for ten years, and that hate might have boiled over into a murderous attack. And though several strollers must have seen the real killer in Gorky Park, Rand was not deceiving himself into believing that any of them would dare come forward to testify. If the government said he was guilty, he was guilty.

He wondered about the man who had really shot Colonel Nelson. Was he in the pay of the Russian, Gregor, who'd accepted his down payment for the weapons and promptly ordered Nelson killed? Or was it a more complex plot than that?

Someone had told the Russians his name, and only Hastings in London had known he was going on to Moscow. Was it possible that Hastings was in on it after all, as Colonel Nelson had insisted?

No. Rand refused to believe that.

The British hadn't been financing Nelson for all these years. He'd bet his life on it.

In fact, he'd bet his life on Hastings.

He took a trolleybus to the Central Telegraph Building and addressed a message to a cover address Hastings maintained in London: *Negotiating early landing shipment of new diesel engines at desirable seaport. Eastern nations don't pose any serious supply problem or route trouble.* He signed it *L. Gaad* and indicated a reply should be sent to him at the Central Telegraph Building.

Rand was certain Hastings would recognize Mrs. Rand's maiden name signed to the wire. And he was betting Hastings could read the very simple steganographic message hidden in it.

But he knew it would be morning before he could expect a reply.

A hotel would ask to see his passport and might even want to keep it. He couldn't sleep in the subway because they closed for maintenance from one to six in the morning. And he knew from

his last visit to Moscow that the streets would be empty by ten o'clock. After that there'd be no crowds in which to hide.

Finally, as night was falling, he took the subway out to the end of the line, beyond Gorky Park, and went to sleep on a part bench.

In the morning, hoping his overnight beard wasn't too noticeable, he returned to the Central Telegraph Building. Yes, the woman clerk informed him, there was a reply for Mister L. Gaad. She handed over the form and Rand read, with rising spirits: *News of our negotiations received. Every dealer should quote under amount received elsewhere.* It was signed with Hastings' code name.

Rand almost shouted. Hastings had come through. The passport was on its way. He would meet the man and—

Unless it was a trap.

Unless Hastings was setting him up for the Russian police, or for the man who had shot Colonel Nelson.

It was a chance he'd have to take.

The message from Hastings had instructed him to be in Red Square at noon, so he assumed the agent bringing him the fake passport would know him by sight. Red Square at noon, with its lines of tourists waiting to visit Lenin's tomb, could be a very busy place.

There would have been time for an overnight flight from London, Rand knew—or the agent meeting him could be someone from the British Embassy. In any event, they would have to find each other in the crowd.

He reached Red Square a little before noon, wandering aimlessly along the fringes of the crowd waiting at Lenin's tomb. Though he kept his head down, his eyes were alert, scanning the faces he passed, looking for someone familiar.

At ten minutes after twelve he was still looking.

Perhaps Hastings had meant noon of the following day. Perhaps—

"Jeffery," a soft voice said at his shoulder.

He spun around, trying not to appear too startled, and looked into the face of his wife, Leila. "What are you—?"

"Hastings sent me. He knew it had to be someone you trusted. I have a passport in the name of Lawrence Gaad for you. And

tickets on an evening flight to London."

"My God, he thought of everything!"

She smiled up at him, and at that moment they might have been the only people in the center of Red Square. "He said to tell you he expected something better from the former head of Double-C than a steganograph with the first letters of each word spelling out the message."

"Sometimes the simple things are the easiest to sneak by. And I had to have something that could be read almost at once. But I don't like the idea of his sending you here."

"Jeffery, I once swam the Nile to a boatload of Russian spies! A midnight flight to Moscow is really nothing."

He rubbed the stubble on his face. "Come on. If you don't mind dining with someone who needs a shave, I'll buy you lunch."

They arrived at Sheremetyevo International Airport in the late afternoon to find the usual scene of confusion and delayed flights. Rand asked Leila to check the departure time while he went off to do some checking of his own. He was remembering the words of Colonel Nelson's assassin: "Volta, Colonel Nelson!" It had sounded half Russian then, but he now realized it could have been Italian. *Time, Colonel Nelson!* A time to die.

And if the assassin was Italian—someone who had followed Nelson here from Rome—might not he be returning to Rome?

He confirmed at the information booth that the flight to Rome was six hours late in departing. There was just a chance that—

And then he saw the man.

There was no mistaking him, leaning aganst the wall smoking a cigarette. He even wore the same black raincoat.

Rand slipped a retractable ballpoiint pen from his inner pocket and walked up to the man. Quickly, before he was noticed, he pressed the pen against the skin of the man's neck. "Don't move! Do you understand English? There's needle in here that could poison you in an instant. You could be dead within a minute. Understand?"

The man was frozen in terror. "Yes. I understand."

"Why did you shoot Colonel Nelson?"

"I—"

Rand pressed harder. "Why?"

"I was paid to."

"By whom? The British?"

Suddenly Rand felt something hard jab him in the ribs, and he realized his mistake. There'd been two of them booked on the flight to Rome. "Let him go, Rand, or you're a dead man," a familiar voice said. "Turn arround slowly and drop that pen."

He turned and stared into the deadly eyes of old Sam Shawburn.

It was then Rand remembered where he'd seen the gunman before. "He was the drunk on the landing outside your apartment!"

Sam Shawburn smiled. "Tony here? Yes, that's right. He was just leaving when he heard you climbing the stairs, so he went into his act. We work well together."

"And you had Colonel Nelson killed."

"A matter of necessity. The African business was becoming too complex—and too profitable to share with a partner. One of us had to go, and I simply acted first, before he got the notion of killing me. I thought murdering him in Moscow was a stroke of genius. It presented so many more possible suspects, including yourself, than did Rome."

"I should have known. Someone tipped off the Russian police and I thought of Hastings. But you knew I'd come to Moscow too—you'd even warned Colonel Nelson of my arrival. You followed me here, had Tony shoot Nelson, and gave the Russians my name. It was easy for them to locate my hotel and to place guards at the embassies."

"Very good!"

"And that wasn't Colonel Nelson's apartment. Those weren't his cats," Rand said, remembering the sneezing in Gorky Park. "Colonel Nelson was allergic to cats."

"True."

"You fed the cats and you recruited the mercenaries for Africa, using Nelson's name."

"His business was buying the guns in Moscow, but I found it safer to use his name for the entire operation."

"How will you get the guns now?"

"Gregor will still deliver. He has contacts and he likes money."

Rand had to know one more thing. "The British? Are they

financing the operation?"

"The British?" Shawburn laughed. "Not a chance! Did Nelson tell you that? It was his daydream that he still worked for British Intelligence. He couldn't face that he was living a grubby existence in the back streets of Rome. We were in it on our own."

"What now? Will you try shooting me within earshot of five hundred people?"

"Outside," Shawburn decided. "Walk between Tony and me. No tricks now!"

They were almost to the outer doors, walking fast, when Leila was suddenly upon them. There were two burly Russian policemen with her and she was yelling, "Stop those men! They're kidnaping my husband!"

Shawburn tried to pull the pistol from his pocket but he was old and slow. The Russians were on them, and it was over.

Rand and Leila didn't catch the London plane that evening.

It took two days and several telephone calls to London, plus visit by the British ambassador, to free them from the endless rounds of questioning. By that time the Russians had found Gregor's address in Sam Shawburn's wallet and learned all about the illegal arms deal. They seemed more interested in that aspect of the case than in the murder of Colonel Nelson, but it was enough to insure that Shawburn and Tony would be spending a long time in Russian prisons.

Finally, flying back to London, Rand said, "You saved me twice in one day. I'm beginning to think I should have had you around all my life."

Leila smiled and leaned her head back on the seat. "if you're going to doing little favors for Hastings, you'll need me around."

THE SPY IN THE LABYRINTH

by Edward D. Hoch

The first thing a traveler usually noticed about Egyptian belly dancers was that they wore body stockings—a holdover from the puritanical rule of President Nasser. At least that was the first thing Scotty Jung noticed as he lounged at the bar of Sahara City, a night club exotically located in a giant tent just beyond the Pyramids. Seeing Sahara City and remembering his own Pyramid adventures of some years back, Jeffery Rand would have been startled and just a bit dismayed. Scotty Jung had no such problem. He was only 26 years old and this was his first visit to Egypt. He accepted the tented night club in the desert just as he accepted the Pyramids themselves.

Scotty had become something of a world traveler since he'd fled from the United States in the closing days of the war protests. He'd got in deeper than he'd ever planned when he set a bomb in a Florida draft board that killed the building's janitor. The fact that Scotty hadn't meant to kill anyone, that he'd been physically ill for three days after realizing what he'd done, would have carried little weight with the authorities. He was a fugitive now, a hero among the underground groups, though with the coming of peace and the resignation of Nixon the general public had almost forgotten his name.

Some others had forgotten too, like Linda, the girl he'd been living with at the time. When he fled to Canada and then on to the Middle East, she promised to join him. He waited a whole year believing that promise until someone in the underground sent him a newspaper clipping announcing her marriage to a young systems engineer at IBM.

This past year, first in Turkey and then in Jerusalem, Scotty had managed to live by his wits. He'd stayed out of Turkish prisons and had spent several months living with a charming young typist who was quite willing to support him. When that broked up he'd drifted to Cairo. He had no doubt that the next adventure was no farther away than the pretty blonde now sitting at the bar.

"Your first time here?" she asked suddenly, perhaps aware that his eyes were on her.

"Yes. I've only been in Cairo a few days."

"Oh, you're American!"

"And you're British. I guess there's no hiding it."

They laughed and he offered to buy her a drink. She seemed about his age and said her name was Atlanta Chessman. She also said yes to the drink.

"Atlanta. Back in the States I lived in northern Florida not far from Atlanta."

"I was named after the ocean," she said with a smile, "not the city."

"Are you here alone?" A tent in the middle of the desert hardly seemed a likely singles bar.

"I'm traveling with my brother. We had a toy business back in England, but we fell on hard times."

"Happens to everyone," he assured her. "What sort of toys?"

"Dolls, games—almost anything."

After a second drink he asked, "Can I drive you home from here? I have a rented car outside."

She threw back her head and laughed. "Only Americans would be foolish enough to rent a car in Cairo! It's almost suicidal, the way Egyptians drive. For a few extra dollars you could hire a car and driver."

"I didn't know that. But the offer's still open."

Her eyes seemed to be searching the crowd. Suddenly she said, "There's my brother—come meet him."

Richard Chessman was tall and slim, with deep-set eyes that gave his face an aggressive appearance. Scotty Jung disliked him almost at once, though Richard was pleasant enough to him. "Enjoying the belly dancers?" Richard asked as they shook hands. "Of course they're better in Beirut."

"And in Istanbul," Scotty agreed. "These are a bit hefty for my taste."

"You men!" Atlanta complained, leading him away. "Have you seen the sound-and-light show at the Pyramids yet?"

"I haven't seen anything, but I'd certainly like a guide."

"Very well," she agreed willingly. "Come on, then. We should be just in time for the English language commentary. They do it in English, French, German, and Arabic each night."

Scotty followed her outside and then stood for a minute watching the lights playing on the nearby Pyramids. "It's still a bit far to walk," he decided. "Let's take the car."

But when they were inside she stayed his hand on the ignition. "Let's just watch the lights for a while. We've got time."

"Sure. Whatever you say."

She turned her lips to his and kissing her he thought about driving her back to his room near Ramses Square. The Pyramids could wait for another night.

Suddenly the door opened and Richard Chessman slid into the car with them. "There's something we want you to do for us, Scotty," he said quietly.

For the first time since Rand's retirement from Concealed Communications, he and Leila were having his former superior, Hastings, to dinner. Thinking back to their telephone conversation, Rand couldn't quite remember how it had come about, but he had half a suspicion that somehow Hastings had managed to invite himself.

"Lovely place you have here," the intelligence chief said over coffee, "and the dinner was delicious. I should visit you more often."

Leila and Rand exchanged glances. "We're so far out in the country," she said. "I'm afraid we're losing touch with all our London friends. With my teaching and Jeffery's writing—"

"Ah, yes—how is the book coming, Rand? Giving away all our secrets?"

"Hardly." Rand shifted uneasily in his chair, knowing that the real reason for Hastings' visit was about to be revealed.

"There are two weeks yet before the autumn term begins. You two should get away somewhere."

"Oh?" Leila perked up. "And where would you suggest, Mr. Hastings? Moscow again?"

"No, no! That Moscow business was unfortunate. I was thinking of Cairo. You haven't been back since your marriage, have you, Leila?"

Rand saw the flicker of pleasure mixed with suspicion cross her face. He knew she'd half regretted not going to Cairo on their honeymoon, and they'd talked casually about making the trip earlier this summer. The damp autumn weather had set in

sooner than was expected this year, which was another reason for Leila to wish for the warm sands of her homeland. And yet—

"Give it to us straight," Rand said, voicing her suspicions. "What's in Cairo?"

"It's *who*, not what."

"Then who's in Cairo?"

"Richard Chessman and his sister. Remember that business with the toy company last winter?"

"How could I forget!" Rand poured some more coffee. "They got away from you that time. What are they up to now?"

"That's just it—we don't know! I can't send anyone officially, but you're in a unique position to help us, Rand."

"They both know me."

"But they don't know Leila."

"Let's keep it that way. You seem to forget that when we married I retired from Double-C—she didn't join up."

Hastings sighed and took a sip of coffee. "Just once more, Rand, and I won't bother you again. You'll both get a free trip to Cairo."

Rand turned to his wife. "It's up to you, Leila. What do you think?"

She looked into his eyes, found her answer there, and said, "I'd like to see Cairo again."

"Good!" Hastings exclaimed. "How soon can you leave? Tomorrow?"

Rand smiled and shook his head. "Still the same old Hastings, aren't you? Give us forty-eight hours at least."

"Thirty-six. I can get you on a plane Thursday morning. And you'll be back in plenty of time for the autumn term, Leila."

"I hope so. I'll admit it will impress my archeology students to tell them I'm just back from the Pyramids."

"Where will we find Chessman and his sister?" Rand asked.

"She's been seen with an American fugitive named Scotty Jung, wanted back in the States for a terrorist bombing. He has a room off Ramses Square and it seems they're living there together."

"Why don't the Americans have him arrested?"

"Extradition is always difficult from those Middle-Eastern countries, even when they recognize it by treaty. Besides, we're more interested in the Chessman connection just now. They're

up to something."

"We'll see," Rand said. His thoughts were already in Egypt, where he and Leila first met years ago.

Scotty Jung awakened and opened his eyes, immediately aware that he was alone in the bed. Though it was barely daylight, Atlanta was up preparing breakfast. He listened to her moving around the tiny kitchen, imaging how she looked in the sheer silk kaftan he'd bought her with his advance from Richard. Thinking of Richard, he suddenly remembered what day it was. "How's it going?" he asked, coming out to the kitchen.

She glanced up from the toast she was buttering. "Good morning. I didn't want to disturb you, but I must be on my way. I'm meeting Richard at eight."

"When will you be back?"

She hesitated. "I'm not certain. Tonight or tomorrow."

After breakfast she was gone and he had the whole day ahead of him. He decided to spend it at the Pyramids again. They'd gone to the sound-and-light show twice in the week he'd known Atlanta, sitting through all four performances with successive narrations in English, French, German, and Arabic. This was because Richard had told Atlanta he wanted Scotty to spy on a certain Ali Zamal, who presented the nightly taped commentaries and sometimes gave special talks in Arabic. Zamal was a short swarthy man who wore a business suit and a red fez. Scotty might never have looked at him twice had not Atlanta pointed him out. "That is Zamal," she whispered on the first night at the show. "He's a dangerous man."

He considered his situation often in the days that had followed. Richard and Atlanta had recognized him from some old news paper photos and arranged to meet him. They knew he'd killed a man back home, and knew they could use him for their own purposes. There was little danger of Scotty turning them in to the police, even after Atlanta told him they wanted him to kill Zamal. But he still looked forward to his eventual return to America at some time when past events would have drifted into the forgotten pages of history. Now Richard wanted him to kill a man, and he wasn't at all certain he could do it.

He spent most of the afternoon wandering around the Pyramids, watching groups of American tourists being photo-

graphed. Some climbed bravely onto the back of a tired-looking camel while the camera clicked, and Scotty felt a special fondness for them. Foolishly dressed in their garish sports shirts and bulging pants suits, they were still his countrymen.

"That camel looks mean," a young woman at his side remarked.

"He looks more tired than mean," Scotty said. "You know when they're mean."

She tossed the dark hair out of her eyes and smiled at him. "I see you're a camel expert. And an American too."

"Does it show?" Somehow this reminded him of his meeting with Atlanta Chessman only a week before. He studied the young woman intently. She was older than Atlanta, perhaps around 30, and certainly not British. Egyptian, he guessed.

"I like Americans," she replied. "Is this your first time in our country?"

"It is. And you're Egyptian?"

"Partly. I teach at the university." She held out her hand. "I'm Leila Gaad."

He accepted the hand, finding it soft but strong. "Scotty Jung," he said, certain the name would mean nothing to her. "What brings a native out here on a hot afternoon?"

"Archeology is my subject. I like to come here for a bit of a refresher every few months."

He smiled at her. "Speaking of refreshers, Sahara City's just down the road and their bar is open. Can I buy you a drink?"

She consulted her watch, hesitated, then said, "That would be lovely."

The restaurant beneath the huge tent was crowded for the cocktail hour, with tourists mingling freely among a scattering of local residents. Leila Gaad said, "I don't usually drink this early in the day, to say nothing of drinking with a stranger."

He smiled. "We introduced ourselves, didn't we?"

But there was something about the woman that made him uneasy. He'd picked up girls in bars and on street corners all through the Middle East, and he knew the way it was supposed to go. This wasn't going right. He was sorry he'd told her his real name.

After a half hour of aimless chatter she excused herself. "I have to make a phone call but I'll be right back. Don't go away."

"I won't."

He watched her cross the empty dance floor and thread her way between the tables. Whoever she was going to call, he had a hunch it wouldn't be good for him. He paid the bill and started for the opposite entrance. Ali Zamal, the man in the red fez, was standing there watching him. Scotty glanced the other way as he walked past. He drove back toward the city, going over in his mind the instructions for that evening which he'd received from Richard. It took him an hour to accomplish what he had to do.

It was dark by the time he returned to his apartment, having made his way through the city's back alleys to shake off any possible followers. He went quickly up the steps and unlocked the door. Inside, he realized he was not alone. There was a sob from a darkened corner of the room. Scotty froze, wishing he had a weapon.

"Who's there?" he asked softly.

The sob came again, and as his eyes became accustomed to the dark he saw Atlanta Chessman hunched in a corner. He ran to her and knelt down. "What is it? What are you doing here, Atlanta? I thought you were away."

She clung to him, her face terrified and tear-streaked. "They've shot Richard," she sobbed out at last. "I think he's dead."

"Where is he?"

"Downstairs—in the car. I was afraid to stay with him. They're after us both."

"Who is?"

"Ali Zamal's people."

"Stay here. I'll go down and have a look."

Scotty went down the back stairs, moving cautiously when he reached the street. The little car was in the place she always left it, and he went to it at once. Richard Chessman was crumpled on the floor of the back seat, his shirt soaked with blood. He was more dead than alive and Scotty drew back helplessly, not knowing what to do.

Suddenly a man he'd never seen before was at his elbow, shoving him aside. Scotty wanted to run, but if the man was a police officer he knew it was too late for that. "Chessman!" the man said, bending over the crumpled figure on the car floor. "Can you hear me?"

Scotty saw the dying eyes flicker open. "What ... ? Rand, is that you? Am I back in London?"

"You're in Cairo, Chessman, and you're dying. Who shot you?"

Chessman gasped and tried to speak again, but his mouth filled with blood. The words wouldn't come. With a final gesture he tapped the breast pocket of his shirt, then sagged back as if crushed by a great weight.

"He's dead," the man named Rand said. Already he was reaching for the pocket that Richard had indicated. He took out a folded piece of paper, glanced at it in the dim light, and pocketed it.

"Who are you?" Scotty asked. "Police?"

"I knew Chessman in London. I think we'd better talk. You could be in big trouble."

Rand had gone searching for Scotty Jung as soon as Leila reported losing him. Finally he's staked out the apartment near Ramses Square. He hadn't seen Atlanta go in the back door, but when Scotty arrived he saw that. He'd been checking out the rear parking area when Scotty emerged again and went to the car. Rand knew it was some sort of luck that had brought him to the dying Chessman, but he didn't know if it was good luck or bad.

Atlanta faced him now in the upstairs apartment, her face puffy and tear-streaked. "You again! Was it you who shot Richard?"

"Hardly."

"What is all this?" Scotty demanded. "Who is this guy?"

When Atlanta didn't answer, Rand replied for her. "Their father operated a private intelligence-gathering organization in London until he was killed. I'm retired from British Intelligence and they hired me for a time as a cipher expert."

"What are you doing here?"

"On holiday with my wife."

"And doing a littel snooping for British Intelligence?" Atlanta asked, beginning to recover herself.

Scotty Jung interrupted. "He's after me. He came to my apartment.

"I'm not after anyone," Rand tried to convince them. "I just want to know what's happened. Who killed your brother, Atlanta?"

"Probably one of Ali Zamal's men. He was shot by a sniper as he was getting into our car at the airport parking lot. We'd just flown back from a meeting—" She broke off suddenly, aware that she was saying too much.

"You have to tell me," Rand urged. "Richard is dead downstairs. You could be next."

"I can't say any more."

"You and Richard are still working for the highest bidder, aren't you? Who is it this time—the Arabs or Israel? And who is Ali Zamal?"

"He works at the Pyramid sound-and-light show," Scotty answered.

"That's enough, Scotty," she warned.

"You should know," Rand told her, "that the Egyptian police can be very hard on murder suspects—especially when espionage is suspected."

"Do you think I killed my own brother?"

"They might ask why you drove arouund while he bled to death in the back seat."

"I was terrified, hysterical! I was afraid to stay at the airport and afraid to drive to a hospital. I came here to find Scotty."

"Where had the two of you been?" Rand asked.

"We flew to Amman," she said at last. "To meet a man named Rangoon." Turning toward Jung she added, "I wasn't sure when Richard planned to come back. I thought he might want to stay overnight."

"But when you did return this evening a sniper was waiting at the airport?"

"Yes. I believe he meant to kill us both."

"Tell me about Rangoon."

She shrugged. "He's paying us a great deal of money."

"For what?"

Another hesitation, and a glance at Scotty Jung. "To kill Ali Zamal. That's where Scotty fits in. We told him first that it was only a spying job, but then we told him the rest of it."

"I see." Rand felt tired. There was always someone new, someone young like Scotty, who could be hired to do the killing. "Where will it all end now, Atlanta?"

"With Ali Zamal. I won't need Scotty. I'll kill him myself."

Rand remembered the piece of paper he'd taken from

Richard's pocket. He opened it and studied it again in better light. On it were four lines enclosed in a maze-like frame:

LABYRINTH
LABYRINTHE
LABYRINTH
82

"Any idea what it means?" Rand asked her. "Richard was indicating it when he died."

"It's only doodling," she replied. "It means nothing."

"What is the labyrinth?"

"I don't know."

"What does 82 mean?"

"If it means anything he didn't tell me."

Rand turned over the slip of stiff paper. The message was on the back of Richard's airline boarding pass, but that told him nothing. "All right. Call the police and tell them about your brother. I don't care what sort of story you make up, but leave me out of it. And stay away from Ali Zamal for now—both of you."

Scotty Jung nodded, but Atlanta only turned away.

Rand returned to their hotel room to find Leila on the sofa. "I'm such a failure, Jeffery. Were you able to locate him?"

He poured them both a drink and told her about it. "He and Atlanta were at his apartment. Richard's there too, but he's dead."

"Dead!"

"Someone shot him at the airport. Atlanta let him bleed to death in the back of their car. I found him just in time to get this before he died."

He showed her the slip of paper. "Some memo or note in his pocket. He pointed to it just before he died. Know any labyrinths around here?"

"Of course," she replied, surprising him. "The labyrinth at Arsinoe is just south of here." She studied the paper and smiled. "About 82 kilometers south of here, in fact."

"Interesting. Do archeologists do their digging there?"

"Not any more. Only the foundations survive. The most interesting fact about it is that the ancient name for Arsinoe was Crocodilopolis. Isn't that a wonderful name for a city?"

"Not exactly the sort civic boosters would suggest."

"It was probably the most famous labyrinth of antiquity. Herodotus said it contained twelve courts and 3000 chambers, half of them below ground for the tombs of kings and the sacred crocodiles. It was most likely built as a tomb, though some historians believe it may have served as a secret meeting place for political leaders."

"If we decided to drive there could you find it in the dark?"

She smiled at the question. "Unless it's moved after 4300 years. It's about an hour's drive from here."

"Richard was trying to tell me something about the labyrinth. But what? You say nothing's left of it but the foundations."

She picked up the slip of paper again. "Why did he write the word three times—and once with an *e* on the end? And the 82 at the bottom. It all must mean something."

"You told me that was the distance to the labyrinth."

"Yes, but why did he write it at the bottom like—" Her frown gave way to a slow smile. "Oh, Jeffery, it's wonderful! I should have worked with you at Concealed Communications!"

"You mean you see something that I'm missing?"

"Of course! He's written the word *labyrinth* in three languages—English, French, and German. It's nearly identical in all three."

Rand still didn't get it. "And the number?"

"He wrote down the number—the distance to Arsinoe—because he didn't know the Arabic word for labyrinth. Don't you see? It's an *Arabic* number, like all our numbers! Four lines, four languages—English, French, German, and Arabic. And what does that bring to mind?"

"The sound-and-light show at the Pyramids!"

"Exactly."

"Come on," Rand said. "There's still time to catch the end of tonight's performance."

The order of the multi-lingual narrations was changed nightly and they arrived to find that the French commentary was just ending. The spotlights that played on the Pyramids were dimmed and the audience was filing out. A short man in a red fez was changing the lettering on the announcement board, indicating that the German commentary would be coming next.

"Let's go in," Rand said.

They took their seats amid a scattering of tourist. He noticed two Japanese gentlemen in the row ahead and wondered if they understood German. Presently the man in the fez took his place at the microphone and turned on some soothing Eastern music. Then he began to speak rapidly in German.

"Something's wrong here," Leila whispered in his ear. "They usually just play a tape of the lecture in the appropriate language."

"Can you understand what he's saying?" Rand asked, but even he had caught the word *labyrinth*.

The two Japanese men sitting ahead of them suddenly rose and headed up the aisle toward the rear exit. "What do you think is happening, Jeffery?"

"This show is being used as a staging area for some purpose. The spoken narration before the tape recording tips them off as to where they're going next—in this case, the labyrinth at Arsinoe. That was the meaning of Richard's memo. He'd noticed the word *labyrinth* used by the speaker in all three languages he understood."

They left their seats and moved up the darkened aisle after the two Japanese men. But by the time they reached the parking area it was only to see a little car disappearing down the highway. "We'll never catch them at night," Leila said. "They could turn off anywhere."

"Is that the road to the labyrinth?"

"They could go that way, yes. It lies near the city of Al-Fayyum."

Rand was aware that the voice of the German narrator had changed, but it didn't occur to him that the tape was now playing until he saw the short man in the red fez coming up behind Leila. "You departed from my show with great haste," he said. "We should speak of this."

He held out his hand as if to shake Rand's in greeting, and too late Rand saw the spring knife shoot from his sleeve. It moved toward him like an adder, striking for the kill, when suddenly another shadowy figure appeared form the darkness and collided with the man in the fez. There was a brief tussle as they hit the ground together, then stillness. As the light show began, Rand saw the face of his rescuer in the reflected glow from the great

Pyramid. It was Scotty Jung.

"Good to see you again, Scotty." He glanced down at the ground. "Did you kill him?"

"No, only knocked him out." Jung turned and recognized Leila at once. "I should have known you were with him."

"She's my wife. Now suppose you tell us who this fellow is."

"Ali Zamal, the man they wanted me to kill."

"I see."

"I guess I'm not much at killing—at least not with my bare hands. Let's get out of here."

Rand made a quick decision. Whichever side Jung was on, it was better to keep him in sight. "Come with us," he urged. "We're driving to the labyrinth at Arsinoe."

"Tonight? What for?"

"To find out, among other things, why Ali Zamal tried to kill me just now."

Leila drove, because she knew the roads, while Rand and Jung sat in the back seat where they could crouch down out of sight quickly if another car overtook them. "Where is Atlanta?" Rand asked when they'd been on their way about ten minutes.

"She took the car somewhere, with her brother's body."

"To the police, I hope."

"I don't know."

"How do you fit into this whole picture?"

The American leaned back and closed his eyes. "Sometimes I wonder about that myself. I killed a man back in the States, with a bomb. It was part of an anit-war protest and I didn't mean to injure anyone, but that didn't matter. I've been running ever since, living by my wits, taking on a few dirty jobs just to stay alive. Cairo seemed as good a city as any, until I met Atlanta. Oh, she was fine but her brother was trouble. Right away he tried to recruit me for some dirty work. He wanted me to spy on Ali Zamal and find out what he was up to. Then Atlanta asked me to kill him for them."

"Did you agree?"

"Not at first, but Atlanta was wearing me down. They knew all about my background—they'd recognized me from a photo—and knew I couldn't turn them in. It was a kind of blackmail, I suppose."

"What about this trip to see a man named Rangoon?"

"Rangoon is the C.I.A.'s chief undercover agent in the Middle East. He was supposed to return to Cairo with the Chessmans tonight but he changed his plans."

"I see. Then Atlanta and Richard were workiing for the C.I.A.?"

"For whoever paid them the most. Richard told me sometimes they worked for both sides at the same time."

As they drove on through the darkness, heading south across the desert toward Al-Fayyum and the ruins of Crocodilopolis, Rand imagined another car with Atlanta Chessman at the wheel, bearing her dead brother toward some unmarked grave. Sudden death was a hazard of the game, Rand knew, but that didn't make the danger any more acceptable.

"Soon," Leila said presently. "We're at the outskirts of Al-Fayyum now."

Rand could see little but darkness out the car windows, broken now and then by lamplight from some house they passed. Presently the houses became more numerous, but Leila avoided the center of town to take them a little to the west. It was almost midnight when she finally parked the car and announced, "The ruins are just over the next rise. I'd suggest we go the rest of the way on foot if you expect to spy on anyone without being seen."

Rand and Jung followed her advice, leaving the car and trailing behind her on foot as she led the way up a sand dune. The moon was almost full, and from the top of the dune they could look down at a stretch of palm trees lit by the moon's silver glow. "The ruins of the labyrinth are just beyond the trees. You are standing now in the ancient city of Crocodilopolis."

"Where were the crocodiles?" Rand asked. "Are we close to the Nile?"

"The Nile is nearly forty kilometers to the east, but several streams and a canal flow through here, connecting the river with Lake Moeris to the north. Yes, there were sacred crocodiles in the lake at one time. There still are, occasionally, though the Aswan Dam has pretty much ended the seasonal flooding of the Nile at this point."

"Crocodilopolis, " Scotty Jung said, speaking the name softly. "The city of Crocodiles."

Suddenly Leila's hand was on Rand's shoulder. "Look there, in the moonlight!"

He followed her gaze and saw two men moving among the trees. One of them carried what might have been a rifle. "You two stay here," he said. "I'm going down."

Before Leila could protest he was gone, slipping along the sand to the shelter of the palm trees. As he drew closer the moonlight revealed a low man-made structure, half buried in the ground. He could see a sign by an entrance, printed in the usual four languages. With some difficulty he read the lines in English, using a match to augment the moonlight: *Opening soon—a modern reconstruction of a portion of the labyrinth at Arsinoe. Made possible by funds from the Egyptian State Tourist Administration.*

The match flame singed Rand's fingers and he let it drop. Almost at once a voice behind him said, "We meet again, Mr. Rand. But this time I have a gun instead of a knife."

Rand turned slowly to face Ali Zamal and the sten gun he held steadily in one hand. There was no arguing with it. "I thought I left you back in Cairo."

"The journey is very swift by helicopter. Now please raise your hands and step inside ahead of me. You'll find a friend of yours already present."

Rand opened the door and stepped down into the reconstructed maze. The place was a long, dimly lit corridor with passages and rooms going off on either side. Glancing in as they passed, he could see more doorways, more passages, leading in all directions. They passed a niche where a realistic stuffed crocodile waited to greet tourists with its gaping jaws.

"To the left," Ali Zamal instructed as they reached a corner. "Then to the right."

"You know your way through here."

"I helped design the reconstruction. In here now."

Rand entered and found two other Arabs standing beside a chair. Atlanta Chessman sat in it, tied hand and foot. She raised her eyes when she saw him. "Rand."

"Atlanta! How did you—?"

Ali Zamal snorted. "She tried to kill me because she thinks I shot her brother. I brought her along in the helicopter."

"What is all this?" Rand asked. "What's gong on here?"

It was Atlanta who answered. "A meeting—a meeting of terrorist leaders from around the world. Germans, Japanese, Irish, Palestinians. All the bombers and plane hijackers and assassins. He wants to unite them into a worldwide terrorist network."

Ali Zamal stared down at her. "Shut up," he said quietly.

"That's why Rangoon was coming—to try and break it up. But something happened at the last minute. He was tipped off there'd be an assassin waiting. There was—only he killed my brother instead."

Ali Zamal slapped her across the face with his open palm. "You've said enough. As for your brother, you'll soon be joining him."

Rand took a step forward and one of the Arab guards raised his weapon. That was when they heard the first explosion.

Ali Zamal wheeled and shouted something in Arabic. The guards took off, running. There was the clatter of machine-gun fire, echoing through the labyrinth's corridors, and then another explosion.

Suddenly Scotty Jung appeared with a sack of grenades over one shoulder and a sten gun in his hands. "Let's get out of here!" he shouted to Rand. Ali Zamal raised his own weapon but he was too slow for the American. The sten gun's bullets cut through his middle and he toppled against the chair where Atlanta was tied.

Rand knelt to cut her free, and then they were running with Scotty, making their way back through the maze. "How can we find our way out?" Atlanta gasped.

"I left a trail of sand. We're following it now," Scotty told her.

"Where'd you get the gun and grenades? Rand asked.

"Your wife and I found a helicopter behind the dune. The stuff was in there, and I figured you might need help."

"You figured correctly."

Atlanta twisted her ankle and fell. Rand paused to help her up just as a Japanese rounded the corner behind them. Scotty fired a short burst from his weapon. "You two go on," he said. "I'd better stay here."

"You can't—"

"There are probably twenty of them in this maze. It's better if none of them gets out. Go on now! Leila's waiting outside."

Rand put his arm around Atlanta and helped her the rest of the way. The last he saw of Scotty Jung the American was hurling another grenade into the depths of the labyrinth. They just made it into the moonlit night when a quick series of explosions seemed to rip the place apart, throwing them to the sand.

Leila found them a few seconds later. "Jeffery! Are you all right?"

"Good enough, I guess. Atlanta twisted her ankle, but she's all right."

Atlanta Chessman stood up uncertainly, gazing back at the smoke and fire so close behind them. "Scotty."

"I'm sorry," Rand said. "He didn't make it. Let's get back in case there are more explosions."

They went a little farther but then she dropped to her knees in the sand, sobbing for Scotty as she had for her brother.

"He said to give you this," Leila told Rand. "It was a note he wrote just before he went in after you. I don't think he planned to come out."

"No," Rand said. "He wouldn't have."

"Aren't you going to read it?"

"I think I know what it says, Leila. Richard Chessman knew about the labyrinth—remember the writing on his boarding pass?—so there was no reason for him to want Scotty to spy on Zamal, then to kill him. It was only a cover story so his sister wouldn't know the truth—that he was working for both sides. He knew about the labyrinth and the messages in the sound-and-light show because Zamal told him. And what about Scotty? He supposedly didn't know when Richard and Atlanta were getting back from Amman—but in the back seat tonight he told me the C.I.A. man named Rangoon was supposed to return to Cairo with them this evening. Don't you see? Rangoon got lucky, and Richard died instead, probably thinking Zamal killed him."

"What do you mean, Jeffery?"

He unfolded Scotty's last note and they read it together by the light from the burning labyrinth.

Rand—You're a good guy, so I'm leaving you this. Richard hired me to assassinate Rangoon, the C.I.A. man, at the airport tonight. Ali Zamal was paying for it, but Richard didn't want

Atlanta to know. He wanted me to do it instead of some hopped-up Arab who might hit her with a stray bullet. Only I was the wrong guy for it. I don't really know if I would have shot Rangoon or not. The longer I waited there with the rifle, the more Richard became the real villain in my mind. When they went to the car, Rangoon wasn't with them and I shot Richard instead.

THE SPY AND THE SNOWMAN

by Edward D. Hoch

Hilda Nelson was a tweedy young woman who might have been pretty if she wore her hair differently and chose glasses more suited to the shape of her face. As it was, she was the sort men passed on the street every day without noticing, the sort one would have a hard time describing at a later date. When Rand met her in the lobby of London's Dorchester Hotel, his first thought was to wonder if this appearance was deliberate on her part. After all, her father had been a spy.

"Good afternoon, Mr. Rand." She smiled and extended a delicate hand. "So good of you to come."

"I'm surprised you remembered me," he said with a smile. "You must have been all of nine years old the last time I saw you."

"I'm twenty-two now," she told him, making an announcement of the fact.

Rand glanced beyond her shoulder and saw the waiters serving tea and sandwiches in the inner lobby. "Let's go in there," he suggested. "It looks comfortable."

When they'd removed their coats and settled onto the nearest sofa, Hilda Nelson said, "I'm really most appreciative of your coming into London to meet me in such terrible weather."

"It's been a bad winter," he agreed, "but a little snow doesn't bother me." In truth it was the snowiest January in many years, blanketing much of England with depths of over a foot. In a country where the winter weather was more likely to consist of rain and fog, the change was a bit startling.

"I telephoned you, Mr. Rand, because there's something strange going on which I think you ought to know about. It could be a national-security problem."

"I'm retired from Concealed Communications, you know. Have been for several years."

"I know. But I have to tell someone. Father always had a liking for you."

That information came as a surprise to Rand. Colonel Nelson

had left British Intelligence in disgrace, much to Rand's satisfaction, and become involved with Russian agents in Rome. Two years ago, when Rand attempted to estahblish contact with him in a Russian amusement park, he'd been murdered before Rand's eyes. "I was there when your father died, you know," he said quietly.

"I know. Hastings was kind enough to tell me all about it."

"In a way I might have contributed to his death."

"But you also brought his killer to justice." Her face seemed to soften a bit. "I hold no grudge against you, Mr. Rand. My father left mother and me some years ago. I can barely remember him now."

"How is your mother?"

"She died too, this past summer."

"I'm sorry."

"Anyway, I have a place of my own now—a very comfortable gardener's house on the old Swindon estate."

"Swindon! Isn't that where the NATO foreign ministers' conference is being held this week?"

"Exactly. The government wanted a secure location away from London, so they leased the estate. It's quite well guarded already, and they don't arrive for the conference till tomorrow. My little house is just outside the gates, so I'm not affected directly."

"Do you work there?"

"In the nearby town. I help out at the library. But I never quite finished my stuidies and I'm planning to return to Reading for my final year."

"A good University. My wife teaches there."

"Hastings told me you were married. He said your wife actually went to Moscow to help you at the time my father was killed."

"Yes. It was a sticky few days. But tell me about your problem."

"From my bedroom window I can see over the wall to the grounds of the estate. The night before last, as I was preparing for bed, I happened to look out the window and the moon was full. I could see the grounds quite clearly and I observed that someone had built a snowman about a hundred yards from the main house."

"Are there children on the grounds?"

"Not that I'm aware of. There's a caretaker, but the government moved its own team in to prepare for the NATO meeting."

"Please go on."

"There's very little more to tell. When I awakened yesterday morning and looked out, the snowman was gone."

"Melted?"

"The temperature hovered around freezing all night. There was certainly no thaw."

"Interesting," Rand agreed.

"Mr. Rand, the same thing happened again last night!"

"The snowman?"

"Yes."

"And it was gone this morning?"

"Yes."

"Why didn't you report it to the authorities?"

"I suppose because they'd laugh at me. But I felt I should tell someone."

"As I said, I'm retired."

"But couldn't you come out to Swindon with me? If the snowman appears again tonight you'd know what to do."

He thought about that. "I'm afraid it's impossible for tonight. But I'll tell you what I'll do. I'll drive out to see you first thing in the morning. Keep an eye out tonight and let me know if anything unusual happens."

"Thank you, Mr. Rand."

"Now relax and let's have some tea."

He chatted with her a bit longer and then left her to catch the late afternoon train home. His wife Leila was waiting for him at the station.

He trudged across the snow-covered parking lot and climbed into the car, giving her a kiss.

"How was your meeting with Colonel Nelson's daughter?" she asked as she started the motor.

"Odd. She wants me to come out there. Something about a snowman spying on the NATO conference."

"Are you serious?"

"I am. I don't know about her."

"What do you mean?" Leila asked.

"Damn it, do you suppose she really does blame me for her

father's disgrace and death? Do you suppose she'd try to lure me into a trap of some sort with a wild story she knew would intrigue me?"

Leila couldn't answer that. And neither could Rand.

In the morning, before he left home, Rand phoned Hastings at the unlisted office number. The duty officer came on to inform him that Hastings hadn't yet come in, but Rand knew better. He'd worked with Hastings long enough to know every quirk of his former superior's routine. "It's after eight. If he's not in his office on something urgent, he's in the canteen having coffee. Get him, will you? Tell him it's Rand."

He waited five minutes before the familiar voice came on the line. "My God, Rand, have the Russians invaded us? What prompts a call from you?"

"Remember Colonel Nelson's daughter?"

"Vaguely. Gilda? Hilda?"

"Hilda. She's living at the former gardener's cottage just outside the walls of the Swindon estate, where the NATO conference starts tonight. Know anything about the security setup there?"

"We have a man named Hartz on the scene handling security. The conference was planned for London but they decided last month to move it because an isolated country estate is less vulnerable to electronic eavesdropping. You know, Rand, they have a device now whereby a laser beam aimed at a window from outside can pick up the vibrations caused by voices inside the room. Some offices in Washington are actually equipped with speakers over the windows to curtain them with the sound of rock music and prevent this sort of eavesdropping."

"We live in a marvelous age," Rand agreed. "You think the Russians are after something at the conference?"

"With the world situation what it is, I imagine they're after whatever they can get. Do you think Nelson's daughter could be involved with them?"

"I can't be sure. I'm going out there this morning."

"We can't give you any special clearance, Rand."

"I know. I'm retired. On the shelf, except when I can be useful to you."

Hastings may have detected a note of bitterness. "What does

Hilda Nelson mean to you, Rand?"

"Not a thing. Last time I saw her she was nine years old."

"You can't blame yourself for her father's death."

"I don't. The way he died was brought on by the way he'd lived. But his daughter came to me for help, and I'm not sure exactly what sort of help she needs. She's seen some odd things around the estate, or claims she has, anyway."

"You say you're going over there today?"

"Yes."

"Keep me informed, will you? If you run onto anything we should know about—"

"Don't worry, I'll let you know."

Rand said goodbye to Leila as she was leaving for her classes, and then headed the car west toward the Swindon estate. It was just under an hour's drive from his house, along country roads made narrow by the unusual snowfall. As he approached the estate, a uniformed constable appeared in the road to stop his car.

"Can't go through here, sir. You'll have to turn back and detour through the town."

"I'm calling on Miss Hilda Nelson. I believe she lives in that cottage outside the gate."

"What would your name be, sir?"

"Jeffery Rand."

"Oh, yes, Mr. Rand. Miss Nelson told us you'd be coming. Drive right on through."

Rand thanked the constable and went on to the cottage, pulling the car off the road into alarmingly deep snow. Hilda must have seen his arrival, for she was waiting by the open front door as he approached. "Come in, Mr. Rand. I'm so glad you could make it."

He entered the small cottage, and was surprised to encounter a slim young man wearing a turtleneck sweater and a leather jacket. He got to his feet and offered a hand. "Mr. Rand, I'm Charlie Fanet, a friend of Hilda's. Nice to meet you."

"Charlie came here last month to do some research for a paper on British archeological sites, but the snow has put a chill on his studies." Hilda opened two beers and held one out to Rand. She gave the other to Charlie and got one more for herself. "This place certainly is a hive of activity with the conference starting today."

"They stopped me on the road," Rand said, feeling uneasy at the presence of Fanet.

"Mr. Rand used to work with my father," Hilda explained to the young man. "They were boring civil servants together."

Fanet sipped his beer. "Were you in the foreign office too?"

"I traveled a great deal," Rand answered vaguely.

"Well, I really should be on my way, Hilda. The snowfall hasn't affected the libraries and I have a great deal of bookwork to catch up on."

"Will I see you for dinner?"

"Of course," he said with a smile. "I've heard there's a charming little inn over near Wantage. And not too expensive either. I'll pick you up at seven."

"Fine." She walked him to the door and Rand watched them exchange brief goodbye kisses.

When Hilda returned she was all business. "Sorry about that. I didn't know he'd come by this morning."

"Seems like a nice young chap," Rand remarked. "Is it serious?"

She shrugged. "I've only known him since Christmas. I may have mentioned I have a part-time job at the local library. That's where we met."

"What about the snowman? Did you see it again last night?"

"No, but it was overcast and there was no moonlight. It might have been there in the shadows."

"Could we see the area from this window?"

"The upstairs bedroom is better. Follow me."

The cottage was small, with only a single bedroom upstairs under the eaves. From its window Rand could see over the wall to the grounds of the estate. It was about 200 yards to the mansion itself and the week-old snow was crisscrossed by trails of footprints in every direction. "The snowman was about halfway up," Hilda said. "Not far from that big chestnut tree."

Rand raised the window and leaned out as far as he could. "I wish I could see the area just inside the wall."

"Why is that?"

"You can see from the lines of footprints that the grounds are patrolled. A snowman that appeared and disappeared would be far too noticeable. But one that was there all the time, and only moved a bit at night, might escape detection."

"Then you agree with my thinking that there has to be someone inside the snowman?"

"It's certainly possible," he admitted.

"But why? What could they hope to see that they can't see from here?"

Rand looked at her oddly. There was something about her remark— "It may not be a matter of seeing, but of hearing. There are certain types of listening devices which can be implanted in walls and actually transmit sounds for short distances. No wires are necessary. But the walls of that old place are quite thick, I imagine. That would cut down considerably on the range of the transmitter."

"So someone hidden in the snowman could move close enough to pick up the signals on a radio receiver."

"Exactly." Rand closed the window. "But this is pure speculation. I haven't even seen the snowman yet."

"The conference doesn't start till tonight. Why would the snowman have appeared so early?"

"Testing the equipment, of course. And picking up information on the arrival of the delegates."

"What are you going to do now?" she asked as Rand reached for his coat.

"Take a look through that gate and see if I can spot our snowman."

Hilda waited in the cottage while he strolled down to the gate where another constable stood guard.

"Not allowed in here, sir," the man told him. "The grounds are closed by government order."

"I know. The NATO conference. Has everyone been moved or is the caretaker's family still on the grounds?"

"I couldn't say, sir."

"If the children are here they'd have built a snowman in this weather."

"Well, I did notice a snowman down along the far wall, but I haven't seen any children about."

Rand thanked the constable and went back to the cottage where Hilda Nelson was waiting. He saw the question in her eyes and answered it before she asked. "Your snowman is there, all right."

"I wasn't sure you believed me."

"I wasn't sure I did either."

"What will you do now?"

"I need to get onto the grounds, and for that I must call Hastings in London."

He dialed the special number and identified himself. "Yes, Rand," Hastings said. "What is it?"

"I want you to arrange my admission to the Swindon estate."

"That would be difficult. The foreign ministers are arriving already."

"There could be a serious security leak."

Hastings hesitated. "How much time do you have?"

"I want to be in there by nightfall."

"I'll drive out myself."

"You don't need to—"

"I'd better come. This NATO meeting is an extremely delicate affair."

"Very well." Rand gave directions to Hilda's house.

When he'd hung up she asked, "Is Hastings coming?"

"Yes."

"You'll want something to eat, while you're waiting."

Cars were arriving in a steady stream now—big black limousines from London that pulled up to the gate before being admitted to the estate. Hilda watched them in fascination as the afternoon passed, talking all the while to Rand about growing up and the memory of her father.

"He was a bad man, wasn't he?" she asked at one point.

"Who am I to judge?"

"I think even when I was very young I knew that he was bad. And after he left British Intelligence to live in Rome I knew something terrible had happened to his life. Mother never spoke much about it, but I remember once when I was old enough to realize she was going out for the evening with a man who wasn't my father, she said to me, 'He's kind and gentle and open. When he says something I can believe it. With your father I was never sure. Whatever you do, Hilda, never fall in love with a spy. Deception seems to come too easy to them.' "

Rand thought of Leila, and wondered if he could ever consciously deceive her. "Generalizations like that are usually wrong," he observed. "Still, it's not a good life for a family man. I

retired from Concealed Communications when I married."

Hastings came in the late afternoon, when the slim traces of winter sun had already given way to darkness. Activity at the estate had stepped up as the last of the foreign ministers arrived for a dinner that evening which would open three days of talks. Hilda Nelson greeted Hastings a bit coolly, and Rand could see he was uncomfortable in her presence.

"We'd better be getting over there," he said, "and check out this idea of yours."

"It's Hilda's idea, really," Rand said.

Hastings regarded her uncertainly. "I'm sure you'll receive whatever credit is due, Miss."

They entered the gates of the estate in Hastings' car and drove up to the house itself. Now that the conference was about to begin the area close to the house itself was floodlit from the roof to prevent anyone from sneaking up unseen. Far out against the wall, just at the edge of the lighted area, Rand could see a chubby round snowman about six feet in height. "There it is," he said, and proceeded to tell Hastings what little he knew.

"You got me all the way out here because of a snowman that moves around at night? I don't think retirement has treated you too kindly, Rand."

"Radio transmitters implanted in the walls could carry as far as that snowman. Soomeone hidden inside could listen in and even record conversations."

"Far-fetched at best," Hastings decided. "What would happen if there was a thaw and the snow melted?"

"I assume the Russians can tune in the long-range forecasts as easily as we can. The below-freezing or near-freezing temperatures are supposed to hang on till the weekend."

A tall athletic-looking man approached the car and gave a sort of half-salute to Hastings. "The gate guard told me you were here, sir."

"Hello, Hartz. Rand, this is George Hartz, our chief of security for the NATO conference. I think he's new since your days."

"Is there some trouble?" Hartz asked.

"Have your people checked out that snowman down by the wall?"

Hartz looked startled. "Snowman? You want me to search him for weapons?"

"See what I mean, Rand?" Hastings said with a sigh. Then, to Hartz, "You could break it apart to make sure it's really all snow."

The tall man grunted. "I'd have no cause to do a thing like that. We get little enough snow in England. I say if someone builds a snowman let them enjoy it."

"That's right—you're the skier, aren't you? Skied in the Olympics, didn't you?"

Hartz drew himself up with a touch of pride. "Silver medal in the biathlon, sir."

"Well, we don't need skiers here. We need snowman inspectors." He glanced sideways at Rand. "You want to walk down and take a look?"

Rand thought about it and knew the time had come to put his vague fear into words. "I think we'd better wait, Hastings."

"What for?"

"If Hilda Nelson is telling the truth that snowman will start to move sometime this evening. Possibly about the time dinner gets under way inside. When that happens, we'll know."

"*If* she's telling the truth? Why should she lie?"

"We have to consider the possibility she made up the whole story to lure me out here. And you too, perhaps. Don't you see, Hastings? She might hold us responsible for what happened to her father. What if we walked over to that snowman and started kicking it apart and the whole thing blew up in our faces?"

"Pleasant thought," Hastings remarked distastefully.

"Should I call the bomb squad?" George Hartz asked.

Rand waved away the suggestion. "No, no. I was just considering all the possibilities. Let's park around the back of the house, out of sight, and see what happens."

Hartz returned to his patrol duties and Hastings drove the car into the parking area, stopping next to a black Rolls-Royce. "Now what?" he asked.

"We wait," Rand said. "Do you have binoculars in the car?"

Hastings produced a pair from the glove compartment. Rand focused them and studied the snowman standing in the shadows near the wall of the estate. It was tall and quite bulky—easily large enough to contain a medium-sized man and a miniature radio receiver. For arms there was a broom handle stuck through it, just below the head, with an old glove on either end. Antenna

wires could easily run along the broom handle too, Rand decided.

They'd been there about 30 minutes when Rand suddenly tensed. "Someone's coming over the wall," he said. "See there? Just above the snowman?"

Hastings took the binoculars. "You're right. Let's go get him."

"Hold on. I want to see exactly what he's up to."

The figure, dressed in white to blend with the snow, dropped to the ground behind the snowman and did not move for several minutes. Then suddenly the snowman seemed to rise up about two feet in the air. "He's lifting it!" Hastings said.

"And getting inside."

The snowman settled back to the ground and remained motionless. Finally, after another five minutes of waiting, they detected some movement—ever so slight—toward the house.

"How far away would you say he is?" Rand asked.

"About a hundred yards and coming closer."

"Let's get him close enough so we can beat him to the wall if he tries to run for it," Rand suggested.

"Should I signal to Hartz?"

"Not yet. I think we can take him ourselves."

The snowman stopped moving, and they waited some more. Then it edged forward across the snow again, only to pause as one of Hartz's security men rounded the corner of the house. "Why doesn't he notice that it has moved?" Hastings wondered.

"It's still not that far from the wall, and there's no landmark except for the chestnut tree. Besides, people don't think about snowmen moving."

Once the guard was out of sight the snowman edged forward again. When it was almost to the tree, Rand said, "Let's go. That's where Hilda said she saw it and I don't think it'll come any closer."

It was still more than 60 yards from the house when Rand and Hastings broke into a trot, spreading out to approach the snowman from two directions. It came up a bit and wavered, as if the man inside had seen them and didn't know quite what to do. Then the snowman settled down and was still. By the time Rand reached it Hastings had his gun out. "Lift it up," he told Rand. "I'll cover you."

The snowman was cold to the touch, which surprised Rand.

He'd expected it to be made of plastic or cotton, but on the outside at least it really was snow. It was very light, though, and couldn't have weighed more than ten or twelve pounds. As he raised it they saw the figure underneath, and Hastings warned, "Don't move! I have a gun!"

The man was kneeling inside the snowman, and now he toppled forward on his face, arms outstretched toward the wall as if in a final effort to escape. There was a bloody wound in the back of his neck and a blood-covered knife spotted the snow at his side.

"What—?" Hastings lowered his weapon in amazement. "What happened to him?"

Rand bent to feel for a pulse. "He's been stabbed. I think he's dead."

Hartz felt it was important to conduct the investigation as much as possible without disturbing the NATO foreign ministers who were just settling down to dinner inside the house. Hastings was quick to agree. "Let's wrap it up and tell them about it later. That all right, Rand?"

Rand grunted and peered again at the inside of the snowman. The body of a man he'd never seen before interested him not nearly as much as the equipment he'd brought with him. The snowman itself was a shaped mold of thin white plastic, already showing a few tears and holes, onto which had been packed a layer of snow. The broom handle that formed the arms passed through the inside, enabling the whole thing to be easily lifted and carried from within. There was no antenna as Rand had first suspected, but clipped to the dead man's belt had been a miniature radio receiver and tape recorder.

Rand switched it on now and heard the voices from within the house: '*Let me propose a toast to western unity*," someone was saying. The reception was weak and crackly, but understandable. To test his theory Rand walked back toward the wall with the receiver. After a few yards the crackling overwhelmed the voice. He had to advance almost to the position of the body before the voice could be understood again.

"A wall mike," he told Hastings. "Not too powerful, which is probably why Hargz's electronic sweep of the house missed it. You might check to see if there's been any recent repair work in there—especially plastering of the walls."

"Where are you going?"

"Back to Hilda Nelson's place, to tell her what's happened."

"What *has* happened?" Hastings wanted to know. "You realize no one could have stabbed him. We were watching this snowman at all times. No one came anywhere near it."

"Doesn't seem like it," Rand admitted.

"And no one commits suicide by stabbing himself in the back of the neck."

"This one must have. There's no other explanation."

"I've got a call in for the local medical examiner. We'll see what he thinks."

Rand walked through the ring of security men and returned to his car. He drove the short distance to the cottage outside the walls and was met at the door by Hilda. "What's going on over there? I could see all the men standing around the snowman."

She had some logs burning in the little fireplace and Rand sat down to warm himself. "There was a spy in the snowman, as we suspected. The man apparently killed himself as Hastings and I tried to capture him."

"Apparently?"

"He's dead and there's no other explanation. He was recording conversations from the house. They must have a transmitter in the walls somewhere. Probably more than one, in fact."

Hilda tried to keep her voice casual. "Was the dead man anyone you knew?

Rand studied her expression. "Never saw him before."

The bell sounded and she went to answer the door. Rand saw Charlie Fanet come in, shivering from the cold. "What's all the excitement at the estate?" he asked. "There are lights and men all over the place."

"Mr. Rand was just telling me about it. They caught a spy."

"I wouldn't say we caught him," Rand corrected. "He's dead."

"Dead?"

"Either suicide or a damned strange murder. We don't know which yet."

"Such excitement for this little town! Was he a Russian?"

"We don't know that either. Not yet."

"Can I get us a drink?" Hilda asked them.

"That would taste good," Fanet said. "It's really turning cold out there."

Rand excused himself to go upstairs and peer out the bedroom

window once more. He could see that the body had been re-
moved and the security guards were searching the area around
the snowman for clues. He knew Hastings would arrive at the
cottage shortly.

When he went back downstairs Fanet was standing with his
arm around Hilda. He removed it when he heard Rand and said,
"What's so almighty important about that NATO conference
anyway?"

"The Russians have been acting up lately, as you must know.
This conference is to plan certain countermoves by the western
powers. Naturally anything the Russians can learn about what is
discussed—"

His words were cut short by the bell again. This time it was
Hastings, and he acknowledged Fanet with a brief handshake
before turning to Rand. "We were lucky on identification. Found
the dead man's car parked down the road. He's Gregor Pechora,
an under-secretary at the Russian Embassy in London. We have
a file on him."

Rand nodded. "What did the doctor say?"

"Funny thing. The knife wound is crude and bloody, but not
really deep enough to have caused death. They're doing an
autopsy."

"Interesting."

"At least it solves part of the mystery for us. The wound could
have been inflicted before he climbed over the wall and got
inside the snowman."

Rand disagreed. "Not a chance, Hastings. I examined the
snow. There wasn't a trace of blood anywhere except where we
found the body. The knife wound was inflicted there."

"By an invisible man?"

"Even invisible men leave footprints. Remember that old
movie? There were a great many prints in the snow, but none
close enough to the scene—except the prints Gregor made as he
moved the snowman along."

"Do you think he had a partner who killed him?" Hilda asked.

"That's exactly what we think," Hastings responded.

Rand was silent. When he finally spoke it was with a request
for Hastings. "I'm going to stay here a while. Could you phone
me as soon as you learn anything more from the doctor?"

"Of course. But what—?"

"Give me some time, Hasting" he said quietly. "I have to ask the right questions."

When Hastings had gone, young Charlie Fanet settled down as if he intended to stay the night. Rand got Hilda aside and suggested, "Send him out for beer or something. I want to talk with you privately."

She frowned, questioning his words, but said nothing. Instead she walked back to the fireplace where Fanet was relaxing and told him, "Run up to the store, Charlie, and get me some things, will you? A quart of milk and some beer?"

"We don't need beer."

"Mr. Rand would like some."

He shot a glance at Rand and stood up. "All right. I'll be back in a few minutes."

When they were alone, Rand turned to Hilda Nelson. "Why did you come to me with this? Why did you want me up here?"

"I—"

"My first thought was that it was some sort of trap, that you blamed me for what happened to your father."

"No, no!"

"But now I think it was something else. The NATO conference was only moved here last month, and something else happened at about the same time, didn't it? Charlie Fanet came here, supposedly on his archeology project. You told me he came around Christmas. And he came here, didn't he? It wasn't you that was important to him, but this house."

The strength seemed to go out of her and she stared at the fireplace. "It's what I've been afraid of," she admitted quietly.

"Because of your father?"

She nodded. "I lived with that deception all the while I was growing up. My mother lived with it too. Sometimes I think it helped to kill her. I don't think I could ever love a man like that."

"Do you love Charlie?"

"How can anyone be sure after a single month? He told me he loved me at first sight, but you see what I look like. How can I believe him?" Her voice was filled with desperation.

"Has he seemed suspicious?"

"You'll remember I said something earlier—about what a spy could hope to see from that snowman that he couldn't see from

here. The same goes for listening. Maybe he wanted my house to pick up those radio transmissions. When he couldn't, he was forced to use the snowman."

"Try to calm down," Rand urged her. "You're not unattractive, Hilda, regardless of what you might think. A man doesn't have to be lying if he says he's in love with you."

The phone rang and she went to answer it. Then she held it out for Rand. Hastings was on the line. "The autopsy confirms that the knife wound didn't kill him. There were simply three or four gouges in the skin, not more than half an ich deep."

"If that didn't kill him, what did?"

"The doctor suspects a quick-acting poison. Some form of cyanide. He'll need more time for tests, but it looks as if we're back to the suicide theory. He swallowed a pill when he saw us coming."

"And then tried to stab himself too?" Rand wasn't buying it. "I think he was murdered, Hastings."

"Then tell me how."

"The Russians are experts when it comes to devious devices. Remember last year when a defector was killed by the injection of bacteria through an umbrella tip?"

"You're trying to tell me the snowman was poisoned?"

"No, this man Pechora was only killed when it became obvious we would capture him." He was thinking of the upstairs window again. "A tiny poisoned dart fired from a powerful air rifle could have—Of course, Hastings! That's it—a poisoned dart! Pechora felt it hit him in the back of the neck and he knew what it was! He was trying to dig it out with his knife, to cut away the skin as one does with a snakebite, when he died."

Hilda Nelson had come up beside him as he spoke. He glanced at her pale face as he heard Hastings protesting, "But we didn't find any dart."

"It was a tiny thing, and it fell in the snow after Pechora cut it out. It's probably still there somewhere. When I examined the inside of that snowman I noticed one or two holes in the plastic. And the thin layer of snow on the outside of the plastic wouldn't have stopped the dart."

"I'll have Hartz shovel up that snow and melt it down."

"Tell him to be careful. The dart will be sharp and still quite lethal."

He hung up as Hilda said, "You think it was fired from my window, dont't you?"

He answered with a question of his own. "Was Fanet here at the time?"

"I don't know when the time was. He came about a half hour before you did." She turned suddenly, hearing a sound at the front door. "He's back!"

She ran toward the front door before Rand could stop her, and suddenly he remembered the body of the dead Russian as it sprawled in the snow at his feet. Lying on its face, arms outstretched toward the wall.

Face to the wall meant back of the neck toward the big house, away from Hilda's cottage. If it was a poisoned dart, it couldn't have been fired from the upstairs window.

"Hilda!"

She backed into the room and Rand saw the security chief, George Hartz, come through the door. Hartz was holding a revolver in his hand as if he intended to use it.

Rand stood perfectly still, then slowly raised his hands as Hartz motioned with the gun. "Of course," Rand said as if thinking aloud. "You would have had this cottage bugged too. Did we sound as if we were getting too close to the truth?"

Hartz raised the pistol an inch. "I'm sorry I have to do this," he said. "No one was meant to die."

"Why would you kill us?" Hilda demanded. "I don't even know who you are!"

"Let me introduce you," Rand offered, allowing himself a slight smile. "This is George Hartz, in charge of security for the NATO conference next door. Of course the Russians needed an insider to plant the listening devices in the walls. Hartz was on duty and could hardly handle the listening-in chores, but he could manage to overlook a fake snowman on the grounds of the estate."

"Then it wasn't Charlie after all?"

Rand shook his head. "Fanet wouldn't have had access to the estate. And Fanet wouldn't have found it necessary to murder his accomplice to prevent his talking. After all, Fanet was a nobody. He could simply drop out of sight. But Hartz has a position to protect. He couldn't risk Pechora talking. It was worth a shot with an air rifle, sending a tiny poisoned dart into a

snowman sixty yards away."

George Hartz smiled. "You'll admit it was a good shot."

"But not a difficult one for somebody who won the Olympic silver medal in the biathlon. That's a cross-country ski race with target shooting along the course. I believe the shooting is with a rifle at fifty meters—nearly as far as sixty yards."

"That's enough talk," Hartz said. "When you're both dead Fanet will be blamed for the whole thing."

"No, he won't," Rand insisted. "The Russian was shot in the back of the neck while facing away from the big house. Only someone up there could have killed him. Someone whose security position would allow him to keep an air rifle hidden in his car."

"No one will think of that. They don't all have your brains." The gun moved up an inch more just as the front door opened and Charlie Fanet returned with the groceries. Hartz started to run and Rand was on him in an instant.

It was over very quickly.

"I'm glad Charlie had his own key," Rand said from his position on top of Hartz. "Now you'd better telephone to Hastings."

Hilda blushed and looked at Charlie. "I had the most terrible suspicions about you."

"What sort of suspicions?" he asked, puzzled.

"She didn't believe in love at first sight," Rand told him, "until now."

He drove home that night feeling just a bit like Cupid.

THE SPY WHO DIDN'T DEFECT

by Edward D. Hoch

"I can't believe we've been married four years," Leila said as they were driving toward London.

"It seems like yesterday," Rand agreed with a chuckle. A night of dinner and the theater in London was something he usually tried to avoid, but on their anniversary he'd left it to Leila to plan the night's festivities. She'd suggested dining at the Café Royal on Regent Street, followed by a visit to a nearby music hall.

As it turned out, the very pleasant dinner ran late and they emerged from the Café Royal to find a gentle November rain chilling the air. The music hall was a few blocks away and neither them had thought to bring an umbrella. "We don't have our tickets yet anyhow, so why don't we just forget it?" Leila suggested sensibly.

Rand quickly agreed and they ducked down a narrow side street off Regent. That was how they happened to find Ibis Books, one of those quaint second-hand shops that are generally open during the early evening hours. "Let's duck in here," he suggested, "just till the rain lets up.

There were no other customers in the shop, and the gray-haired man behind the counter frowned as they entered, giving the impression he was about to close. While Leila went in search of books on Egyptology, Rand browsed over the used-fiction table. It was not until he glanced up, catching a glimpse of the clerk's profile, that he recognized him.

Rand edged over to Leila and said, "I think I know that man. His name is Rodney Cork and he's supposed to be in Russia."

"Perhaps you're mistaken."

"We'll see." Rand walked up to the counter and said, "You're Rodney Cork, aren't you? We worked together in the government."

The pale eyes turned blank. "I'm afraid you're mistaken, sir. My name is Withers."

Rand smiled at him. "Sorry. You look a great deal like him."

"I'm always being mistaken for people. Found anything you want?"

"Not, not yet."

"I'm going to be closing in fiive minutes."

Rand nodded, taking the hint. "We'll be going, then. Leila, are you ready?"

As they left the shop Mr. Withers turned out the light on his sign and pulled down a shade on the door. "We were keeping him," Leila said. "I suppose it's nearly nine."

"Leila, I'm certain that man is Rodney Cork."

"He denied it?"

"He denied it, but I remember the way Rodney's eyes would go blank when someone questioned him about an unpleasant subject. This man Withers did the same thing."

"You said he's supposed to be in Russia."

"There was a scandal about five years ago, shortly before I retired from the Department of Concealed Communications. Rodney was in the Asian section and they discovered he was a double agent. I remember they took him off somewhere and questioned him for a whole week."

"Torture?"

"Who knows what they did? The story was that they finally released him because they had no hard evidence. Somehow he got out of the country and defected to Russia. We kept waiting for Moscow to present him at one of their fancy news conferences but they never did. After a time everyone just forgot about him."

"And now he's back?"

"If he ever went away."

She could see that he was troubled. Even the continuing drizzle passed unnoticed as they reached Regent Street again. "What are you going to do?"

"Do you want to cross over and wait for me in the lobby of the Piccadilly Hotel? I won't be long, but I want to have another try at talking to him."

"All right, but remember it's our anniversary."

"I won't be long." he said again, and retraced his steps down the little side street. The bookshop was in darkness now, and for an instant he feared he was too late. Then he saw the door open and the man named Withers emerged. He turned up the collar of

his coat against the drizzle and headed down the street in the opposite direction from Rand.

He walked rapidly through the night, as if to discourage interception by the occasional streetwalkeers Rand saw waiting in doorways. Finally, just as Rand was about to overtake him, he turned into a darkened entrance and inserted his key in a lock. "Rodney," Rand called out softly behind him.

The man whirled, crouching slightly as if expecting an attack. Then he straightened. recognizing Rand. "Oh, it's you again."

"Rodney, I want to talk with you."

"I said I wasn't—"

"I'm not here to harm you. I just want to talk. What happened to you, Rodney? They said you went to Russia."

He snorted then and turned the key in the lock. "My room is upstairs. If you want to talk, we'll talk there."

Rand followed him up the creaking stairs to a second-floor apartment whose windows looked out on the gaudy marquee of a strip club around the corner. Withers turned on a single lamp and by its dull glow Rand became aware of how much the years had aged the man. He couldn't have been much older than Rand himself, somewhere in his mid-fifties, but the gray hair and tired eyes suggested someone a decade further along.

"Your apartment is close to work," Rand said, trying to open the conversation. "Do you like the bookshop?"

Withers shrugged. "I've been at it nearly a year now, and I get along well with the owner. The pay's not much, but they'll take care of me when I retire. There's a home called Bookrest for old book people. That's more than there is for retired spies."

"Then you never went to Russia?" Rand asked, certain now that this was Rodney Cork.

A vague chuckle. "No, I never went to Russia." Cork's eyes seemed to blur for an instant, as he brought his mind to focus on the words. "I remember you, Rand. I recognized you the minute you entered Ibis Books. The years have been kinder to you than to me."

Rand edged forward. "Do you want to talk about it?"

"I'd have thought you knew the story. The internal security people said I was a double agent, working with Moscow. They took me away for questioning. The man in charge was someone named Grunning. I never saw him—his underlings worked on

me. You knew Grunning, didn't you?"

"Only by name. I never met him."

"You can thank God for that! The man must be a devil! They took me to an abandoned mill on the Nene River and kept me there a week, trying to get information."

Rand's mouth was dry. "Did they torture you?"

"Not physically. With drugs. I was near crazy by the end of the week, seeing things that weren't there. At the end one of Grunning's men said he had orders to kill me. He pointed a gun at my head and pulled the trigger. It wasn't loaded, but that was the final—" His voice broke and his face twisted in terror at the memory. After a moment he continued, "I don't remember any more, not really. Only faceless questioners asking me the same things over and over, the same faceless people who'd tormented me all week. When I came to my senses a long time later, I was in a mental hospital. They spread the story I'd defected to Russia and kept me locked up for four years. When they let me out Ibis Books offered me a job. It was like a pension, I suppose."

"But were you working for the Russians?" Rand asked, wanting some reassurance that Rodney Cork had not been a completely innocent victim.

"To tell you the truth, I don't know. Somebody gave me some money once, and I delivered a few innocent documents on trade statistics. The sort of thing one finds in almanacs, you know. Maybe he was with the Russians. I never asked. Figured if he was foolish enough to part with his money, I was smart enough to take it."

"Why do you think they said you defected?"

Rodney Cork shrugged. "To make me look more important, I suppose. To explain my disappearance. To keep me from suing them, perhaps."

"But didn't you have a family that asked questions? A wife?"

"Sure, I had a wife then."

"Didn't she ask about you?"

Cork smiled sadly. "My wife is the one who turned me in."

Rand had been gone longer than he'd planned, and he could see Leila was upset. "I've been sitting here for a half hour," she said.

"I'm sorry. He wanted to talk."

"On our anniversary night?"

"Can I make it up to you with a drink before we start for home?"

They went down a few steps to a little bar off the hotel lobby and ordered after-dinner drinks. Leila settled back and started to relax. "Honestly, Jeffery, I was getting some pretty strange looks in that lobby. What was so important that you had to go off with this Cork person?"

"I was simply surprised to see him. I wondered if he'd come back from Russia, but it developed he'd never gone in the first place. He told me a bit of a horror story about our boys drugging him and threatening to kill him, and then locking him away in a mental hospital for four years. Fellow named Grunning was behind it."

"Felix Grunning? You told me something about him once, something unpleasant. I remember the name."

"There was a great deal unpleasant about Grunning. I wonder whatever happened to him."

She reached out to press his hand. "You're getting that look in your eyes again. Stay away from it, Jeffery."

"There's nothing to say away from. Just a tired old man working in a bookshop. But I might take a run into town later in the week and see Hastings."

"Why?"

"Oh, I don't know. Maybe it's just that Cork's story is such a sad one. He took some money from a man he hardly knew, and his wife betrayed him to the authorities. Then our friend Grunning had his men spend a week shattering Cork's mind with drugs and threats. And to top it off they told the press he'd defected. An unjust story. I'd like to know if it's a true story."

Leila wasn't happy about it, but Rand took the morning train to London on Friday, having phoned Hastings in advance to suggest they lunch together. Hastings had been his superior during all those years Rand served as Director of Concealed Communications, and he still called on Rand occasionally for favors. Rand felt he deserved a bit of information in return.

They dined expensively at Hastings' private club on St. James's Street.

"This is like old times, Rand," Hastings said, lighting a cigar

as they finished eating.

"Hardly. You never took me to your club in the old days."

"Didn't I?" His smile faded a bit. "What was it you wanted to talk about?"

"Rodney Cork. Remember him?"

"Cork? Went off to Russia, didn't he?"

"No," Rand said. "He's a clerk at Ibis Books, a shop off Regent Street."

"Is that so?"

"I had a chat with him the other night. He has an alarming story to tell. It's a wonder he doesn't bring a lawsuit against the government."

"Oh, I don't think he could do that."

"Tell me, is Felix Grunning still in the service?"

"Grunning? Not any more. He did contract work for counter-intelligence. Mainly internal security checks. But he was a bad customer, a real sadist. I don't know what happened to him."

"They used him on Cork. Grunning's men drove Cork out of his mind with drugs and psychological torture. He was in a mental hospital all the time the papers were saying he'd defected to Russia."

"That was out of my department. They said he defected and I believed them. I didn't ask questions."

"Come on, Hastings! You always knew everything that was going on! And what about Cork's wife?"

"What about her?"

"Did she know the truth of what happened to him?"

"She didn't care, Rand—it was she who turned him in. Probably easier in her mind than going through a divorce."

"But they're divorced now?"

"Oh, yes. I understand Mrs. Cork has remarried."

"I think I'd like to see her."

"What in God's name for? Why dredge up this old business?"

"The man was done an injustice, Hastings, and you know it. Whatever he did, he didn't defect to Russia. I think it's time we corrected the records."

"You want to rewrite history?"

"If it's wrong, yes."

"Who cares if it's wrong, Rand? Five years is a lifetime in our game. The public doesn't even remember Rodney Cork or what

he did. You stir things up and you may get a Sunday feature in the *Telegraph*, but then it'll all be forgotten again and Cork will still be working in the bookshop. He probably won't thank you for it, either. He's anonymous now and I'll wager he'd like to stay that way."

"We'll see," Rand said. "I'll ask him."

After lunch he walked up St. James's to Piccadilly and then cut through Swallow to Regent Street. It was only a few minutes' walk to Ibis Books and he hoped he would find Rodney Cork in the shop. But a tall man wearing thick glasses was behind the counter instead. "Can I help you?" he asked.

"I'm looking for Withers," Rand said.

"He's off this afternoon. I'm Mr. Ibis."

Rand smiled. "I didn't realize there was a Mr. Ibis. My wife thought the name had an Egyptian connotation."

"We do try to stock Egyptian books," Ibis said. "Did she look in the basement?"

"No. We'll catch up next time."

Rand left the shop and walked down the side street toward Rodney Cork's apartment. He pressed the buzzer under the name *Withers* and after a moment the outside door was released. Upstairs he found Cork waiting in the doorway. "Oh. It's you again," he said without emotion.

If Cork was not surprised to see him, Rand had a surprise as he stepped into the room. The gray-haired man was not alone. A woman of about thirty, heavily made up and dressed somewhat like the streetwalkers in the doorways, stood by the window. "And who's this?" she asked.

"Mr. Rand," Cork said. "We were together in the government."

"Pleased to meet you." The woman extended her carefully manicured hand. "I'm Milly Martin. I work across the street."

"Across—?" Then Rand remembered the strip club he'd seen from the window. "Oh, of course."

"Does he know?" she asked Cork.

"He knows."

She turned back to Rand. "Rodney told me what they did to him. I want him to go to the press about it."

"I agree something should be done," Rand murmured.

"This person Grunning—he must have been a beast! To think our government employs people like that is more than I can stomach."

"How long have you known Rodney?"

It was Cork who answered. "A few months, but I just told her my story the other night, after you were here."

They seemed such an unlikely pair that Rand had trouble accepting the evidence of his eyes. Perhaps she really felt sorry for him. "I told Rodney I'm writing a letter," she said. "I'm going to stir things up."

"That might not be such a good idea," Rand cautioned. "I'm sure they can find a clause in the Official Secrets Act to shut you up." Then he remembered the reason for his visit. "Rodney, I wonder if I might call on your former wife."

"What for?"

"I'd like to get her view of what happened to you. After all, she was the one who reported you to the authorities."

"I haven't seen her since I came back to London. Haven't seen her since any of it happened, in fact. She's remarried now."

"What's her new name?"

"Teresa Spann. She wrote me at the hospital after they were married, but I never replied."

"Do you remember her address?"

"Somewhere on Addison Road, if that's any help."

"Kensington?"

"Farther up. Probably Notting Hill."

"I'll find it," Rand said. "Pleased to meet you, Miss Martin."

She gave him a tired smile. "Come see my show some night. I go on at ten."

"I'll do that."

He could hear them talking again as he closed the door and went downstairs.

It did not take Rand long to find the address on Addison Road. The short dumpy woman who answered his ring stared at him suspiciously before admitting, "Yes, I was Teresa Cork, but that was a long time age. I'm divorced now, and remarried."

"Who is it, Teresa?" a male voice called from inside. It hadn't occurred to Rand that her husband might be at home.

"Some man looking for Teresa Cork," she called back.

That was enough to bring him forward. He was as tall as Rand

and ruggedly handsome, perhaps a bit younger than Teresa though Rand couldn't be sure. Like Rodney and Milly, they made an odd couple. "I'm Walter Spann, the lady's husband. Can I help you?"

Rand introduced himself. "I once worked with Rondey Cork and I ran into him the other day."

"Here in London? That's impossible," his former wife exclaimed.

"I think you know better, Mrs. Spann. May I come in and talk for a few minutes?"

She glanced at her husband and then stepped aside to let Rand pass. "It can't be long. We're going out."

Rand sat down facing them. The living room was well furnished and he wondered what Spann did for a living. "I'll be as brief as I can, Mrs. Spann. I don't believe your first husband was a conscious Russian agent. And he certainly never defected to Moscow as the papers said. He was right here in England all the time, recovering from a really terrible week of drug-induced mental torture. But I think you know most of this already, don't you?"

Her face had hardened, but now with the indoor shadows across it Rand could see that she'd been pretty once. Perhaps as recently as five years ago she'd been pretty enough to attract a man like Walter Spann. "I know nothing," she said. "Nothing but what the newspapers said."

"Come, Mrs. Spann! After he accepted money for delivering those documents, it was you who notified the authorities."

"I was frightened I'd be arrested as an accessory. In America Rosenberg's wife went to the electric chair with him."

"We don't have an electric chair in England, Mrs. Spann. We don't even have capital punishment at the present time." All we have, he thought silently, is a week at the old mill with Felix Grunning and his henchmen.

"My wife has nothing to say about it," Walter Spann said. "You'd better go now."

But Rand wasn't giving up that easily. "You knew he was in a mental hospital, didn't you, Mrs. Spann? He said you wrote him there to tell him you'd remarried."

"It's not my responsibility," she insisted. "What is it you want, anyhow?"

"The truth," Rand said. "Only the truth. The man deserves

that much after all he's been through."

"I can't help you," she said firmly.

"Do you know a man named Felix Grunning?"

She hesitated only a second. "No, why should I?"

"He was responsible for your husband's torture, Mrs. Spann."

"Things like that don't happen in England," her husband insisted.

"No? Ask some of the people arrested in Northern Ireland. Ask some of the Americans who had similar experiences with their own intelligence services. Things like that can happen anywhere so long as no one speaks out against them."

"What is it you want?" Teresa Spann asked again.

"When the time comes, will you tell what you know about Rodney Cork's case?"

She took a deep breath. "I don't know, Mr. Rand. I really don't know."

He brooded about Cork over the weekend, puttering purposelessly about the house and barking at Leila when she suggested they drive into Reading for dinner one night. "Is it still that business with Rodney Cork?" she asked him finally.

"I'm afraid so," he admitted.

"It isn't really your affair, is it?"

"Leila, the man was branded a defector, when in truth he was drugged out of his mind and locked away in a mental hospital. Our government used a ruthless, sadistic man named Grunning to try, convict, and punish a man who might well have been innocent—or at least an innocent pawn."

"He took money, didn't he?"

"Yes," Rand admitted.

"He should have realized the consequences of his act."

"Do people always stop to realize the consequences of the things they do? Did I realize the consequences of following Rodney Cork to his room last week?"

Leila had no answer for that.

On Monday afternoon Hastings phoned from London, taking Rand away from his typewriter. The voice on the phone was cool and formal, and came right to the point.

"Rand, a woman named Milly Martin has been writing letters. Do you know of her?"

"I met her once, last week. She's employed at a strip club

round the corner from Rodney Cork's flat. I gather they've become friends."

"Where is that?"

"On the edge of Soho, east of Regent Street. I'm sure you have Cork's address in your files, if not on the desk in front of you."

Hastings sighed. "You may not believe this, Rand, but the entire Cork matter was handled elsewhere. I knew as little as you did at the time. When I learned what happened it was long after the fact."

"But you're uncomfortable now that Milly Martin and I are stirring things up."

"Of course I'm uncomfortable! The thing happened five years age, Rand. It's dead and buried!"

"Rodney Cork isn't dead and buried. He's very much alive, and in need of fair play for once."

"They were a bit rough with him, I'll admit that. But consider the alternative, Rand. A long messy trial for treason, his name dragged through the press—"

"Almost as bad as being branded a defector."

"Look, Rand, call off this Martin woman."

"Is that an order?"

Hastings hesitated. "You're not in a position where I can give you orders. It's a request from a friend."

"What about Grunning?"

"What about him? We don't employ him any more. I don't know where he is."

"Then why are you protecting him?"

"I'm not, Rand. I'm protecting the department."

"And I'm protecting Rodney Cork."

"Call her off. When things quiet down maybe we can arrange some sort of pension for him."

"Nice of you."

"Rand, for God's sake—"

"All right, I'll have a talk with her."

Rand took the evening train into London, over Leila's objections, and then hailed a taxi for the strip club where Milly Martin performed.

He remembered she'd said she went on at ten o'clock, and it was nearly that when he reached the place. There was a dim

light burning in Rodney Cork's window, but Rand went straight to the club, finding a place at the bar from which he could watch the performance. He'd bought a temporary membership at the door, complying with the fiction that this was a private club.

There were two girls on before Milly, and Rand found their performances boring and unsexy. They seemed tired and anxious to be done with it. When Milly Martin took the stage, with a suitable fanfare of drums, there was some improvement. But Rand couldn't help noting the lines of age beginning to show on her body. Pink lights and powder couldn't quite hide them.

When she went off he paid for his drink and followed her backstage. The corridor was narrow and badly lit, and it took him a few minutes to locate her dressing room. The door was partly open and when she didn't reply to his knock he stepped inside. What he saw there made him shut the door quickly behind him.

Milly Martin was sprawled on the floor between her chair and the dressing table, with her neck at an angle that told Rand it was broken. He'd seen people killed like that before—it was a trick the British government had taught commandoes during the war, and secret agents ever since.

The dressing-room window was open, and he saw at once that it faced an alley. The killer had simply waited until she walked into the room after her act. Then he'd gone out the window.

Someone hadn't waited for Rand to talk with her. It might have been any number of people employed by Hastings, but somehow Rand doubted it. He'd known Hastings for half of a lifetime, and he trusted him.

It seemed far more likely that Felix Grunning was back in town.

Rand exited by the alley window, dropping silently to the ground and making his way quickly back to Regent Street. He didn't want to see Rodney Cork now, not with this latest tragedy still unknown to him. Instead, he took a taxi to Paddington Station and caught the last train home. Leila was already in bed, just dozing off, and he delayed telling her what had happened.

In the morning as they were finishing breakfast, Hastings arrived. This time he hadn't bothered to telephone first. "I drove here directly from home," he told Rand. "That woman Milly

Martin was murdered last evening at the strip club where she worked."

Rand decided to keep quiet about finding the body, at least for the present. "Any idea who did it?" he asked.

"A damn good idea. The police found a pay voucher from Ibis Books under the body. It was made out in the name of Withers."

"That's the name Cork uses. You can't believe he killed her!"

"He knew her. They might even have been lovers. He'd been seen backstage and in her dressing room on any number of occasions. The blow that killed her is one that Cork would have learned while in our service."

"Felix Grunning would have learned it too," Rand pointed out.

"Why would Grunning want to kill her?"

"Because she was raking over old coals, threatening to go to the press."

"So were you."

"But she was easier to kill. Maybe he thinks it'll be a warning to me. And of course if he can frame Rodney Cork for it he has him out of the way too."

"That's reaching, Rand. Accept the obvious. Rodney Cork killed her."

"Has he been arrested?"

"The police arer questioning him now. He claims he was alone in his room at the time of the killing."

"It certainly has diverted attention from Cork's story." There was a trace of bitterness in Rand's voice.

"I drove out here to tell you personally," Hastings said quietly. "We've been through a great deal together. I don't want our friendship to end like this."

"Tell me one thing, Hastings. Where is Felix Grunning?"

"I don't know."

"And you don't care—right?"

"Grunning wasn't my concern, Rand. He was with counterintelligence."

"And that mill on the Nene where he took Cork?"

"Yes, I know that place. It was a safe house we used occasionally." He spread his hands to Rand. "I'm not condoning what happened to Cork at that mill. What I'm trying to say is that it did happen and it left him mentally unbalanced. He killed

this woman and he might kill again."

Rand had a thought. "If he hasn't been charged yet, you could have him released in your custody."

"Why would I do such a foolish thing?"

"Because I ask you to."

"Rand, what—?"

"I want to take him back to that mill, Hastings. If he's as crazy as you claim, a trip back there should set him off. I'll know if he was capable of killing Milly Martin."

"He might well kill you."

"That's a chance I'll take," Rand said.

It was later in the day, toward evening, when he found himself driving north with Rodney Cork in the seat beside him. The mill on the Nene River was a ninety-minute drive north of London. Hastings had located it on the map for Rand, and then warned him again of the foolhardiness of what he was dong."If you let him escape, Rand, you'll be held personally responsible."

"Why should he try to escape? He's innocent."

But on the long drive north Rand couldn't help questioning Cork about the events of the previous night. Cork had been willing to return to the mill, pausing only long enough to phone the bookshop and tell Ibis he'd be in to work the following day. His release from questioning seemed to buoy his spirits, though Rand was careful to warn him that he wasn't out of the woods yet.

"They still regard you as the prime suspect," he said as the car headed north through the deepening dusk.

"I know that," Cork replied. "But I didn't kill her. I was in my room."

"They found your pay voucher under the body."

"I always keep the check and throw away the voucher."

"Who would have wanted to kill her, Rodney? Might your former wife have been jealous of her?"

"Teresa? Fat chance of that! I told you I haven't laid eyes on her for five years. You were going to see her the other day. Did you?"

"Yes," Rand admitted. "She wasn't too cooperative. She didn't want to get involved in reopening your case."

"Did you meet her husband?"

"Yes."

"What's he like?" Cork asked.

"Nothing special. A fellow named Walter Spann. Tall, ordinary-looking."

Rodney Cork grunted and fell silent. After a time he asked, "Why are you bringing me up here, Rand?"

"I thought I'd told you. I want you to remember more about what happened during that week they interrogated you. By seeing the place again you may be able to fill in important details. Once I have the full story I plan to make it public."

"Oh, they'd never let you do that.

"Hastings wouldn't stop me."

"No, but Felix Grunning would."

"Grunning is gone. He's not in the service any more."

"Grunning will never be gone."

Rand glanced sideways at him, wondering just how much his mind was still affected by what he'd been through five years earlier.

"Why do you say—?"

But Rodney Cork interrupted to tell him, "Here's where you turn. This is the road to the mill."

"You remember."

"I remember."

Rand turned off the pavement and onto a dirt road that led through the trees. It was almost dark now and his headlights illuminated an old building a few hundred feet ahead. He pulled up and parked. "The river is over there," Cork said, pointing beyond the mill. "I used to see it in the mornings when I came awake, before Grunning's men gave me my daily injection and started the questioning."

They left the car and walked up the wooden steps. Rand had brought a flashlight and he pointed it ahead of them. He felt the strands of a cobweb against his face and brushed them aside. "The place hasn't been used in a long time."

The door was unlocked, as Hastings had said it would be. It was no longer a safe house, if it ever had been for people like Rodney Cork. "My bed was in here." Cork said. "I remember that. And when the hallucinations started I was handcuffed to it. Grunning's men said—"

"Quiet!" Rand cautioned. He'd heard a sound, some other

movement in the building. He snapped off his flashlight and listened.

"We're not alone!" Rodney Cork said. "You tricked me into coming here, didn't you, Rand? You still work for them. You brought me here for Grunning!" His voice was rising, out of control.

"Calm down, Rodney. Nothing's going to happen to you. Grunning is far away."

And then a sudden light cut through the darkness, accompanied by a harsh voice. "Not so far away as you might think, Mr. Rand."

Rand felt a chill on his spine. "Who is that?"

"My name is Felix Grunning," the voice behind the light said. Rand started forward and the voice commanded, "Stay there! I have a gun!"

Rand took a deep breath. He couldn't believe Hastings had betrayed them by telling Grunning they were coming to the mill. "You killed Milly Martin," Rand said simply.

"She was stirring up old issues, as were you, Rand. I don't want my face in all the papers."

"You're going to kill us too?" Rand asked.

"The mill will catch fire and burn down. A tragic accident."

Rand felt the weight of the flashlight still in his hand. It was his only weapon.

But before he could move Rodney Cork launched himself forward, shouting, "You killed her, Grunning! And your men destroyed me! Now it's my turn!"

Grunning's gun fired twice and Rand saw Cork's body jerk with the impact of the bullets. But he kept going toward his target.

Then suddenly the mill was ablaze with light and Rand heard Hastings shouting something from behind him. He saw Rodney Cork with his stiff hands slashing at the other's neck.

But most of all he saw that face, the face of Felix Grunning.

It was the face of Mr. Ibis.

"They're both dead," Hastings told him moments later. "My God, Cork kept going with two bullets in his chest. Did you see what he did to Grunning's neck?"

"He killed him the way Grunning killed Milly," Rand said

tiredly. "There are some techniques one never forgets."

"If only we'd gotten here a minute sooner!"

"Did you know Mr. Ibis was Grunning?"

"Ibis? The man Cork worked for?"

"Exactly."

Hastings shook his head. "How could that be?"

"I should have guessed it from that pay voucher they found under Milly's body. If Cork threw it away when he received his check, as he said, Ibis was the most likely one to retrieve it and leave it under the body. He figured he'd get Milly and Cork both out of the way, but when Cork was released and telephoned him he'd be in to work tomorrow, Ibis knew he'd have to intercept us both up here."

"Cork told him he was coming here?"

"He must have." Rand rubbed a hand over his eyes, trying to sort it all out. He was aware that the men with Hastings were taking care of the bodies, but he didn't watch. "Cork told me at the beginning that his questioners were faceless that terrible week. He never saw Grunning's face, never heard Grunning's voice—or he'd have recognized it in the bookshop. It must have been some quirk of Grunning's that made him seek out Cork and offer him that job when the mental hospital released him."

"Do you believe that?" Hastings asked.

"I don't know what to believe," Rand said, wanting to get out of the building, into the fresh air. "I only know three people are dead because I recognized Rodney Cork in a bookshop."

"Don't blame yourself. I should have been here sooner in case something like this happened. But I never expected Grunning to show up." Hastings following Rand outdoors. "Perhaps Grunning and Cork both wanted to die, in their own ways. When Grunning hired Cork out of the mental hospital, he might have been subconsciously hiring his executioner. And when Cork took the job, he might have been subconsciously wanting to commit suicide. If Grunning hadn't killed the woman it might have gone on like that for years—a slow death for both of them."

There was nothing more to say, but Rand thought about Rodeny Cork for many weeks after that. He waited for the full story to come out in the press, but of course it never did.

INTERPOL: THE CASE OF THE DEVIL'S TRIANGLE

by Edward D. Hoch

Mona Furniss was seated on a bar stool in the Voyagers' Club when the man slid onto the stool next to her and ordered a drink. They didn't speak at once, but when the bartender had moved away to chat with a customer at the end of the bar, the man asked, "What did you tell your husband this time?"

Mona glanced at him and smiled. "The usual thing—bridge with the girls. It doesn't matter. The poor dope believes whatever I tell him."

"Good."

She slid her hand over until it covered his on the bar. "I've missed you, Chuck, I've wanted to be with you."

"Careful. You never know who might be watching."

She removed her hand. "Are you free tonight?"

"As soon as I take care of some business at the shop. Want to come along?"

"Sure."

They finished their drinks and she followed him out the back door of the bar onto the Walker Arcade. They turned left and headed toward the street of shops that faced Hamilton Harbor. Chuck always entered through the back door, because his connection with the Front Street Curio Shop was not widely known.

The small Chinese behind the counter nodded as they entered through the beaded curtains and said to Chuck, "American airman waiting to see you."

"Good." Chuck smiled over his shoulder at Mona. "The business never lets up. Thank you, Lin Yang."

She followed him into a private office where a middle-aged man with graying hair and a friendly smile was waiting. He rose and held out his hand. "Mr. Coral? I'm Steve Yardley. Guess I was a bit early for our appointment."

"Perfectly all right, Steve. What airline are you with?"

"Trans-American. Some of the boys told me about you."

Chuck smiled. Then, seeming to remember her presence, he

said, "This is Mona."

"Hi, Mona."

"Hi, Steve." She wondered what he thought their relationship was. Whatever he thought, he'd be surprised to know the truth.

"So," Chuck said, "you're down here on vacation? Looking for a little action?"

"That's right. They tell me you have a special deal for airline pilots. A chance for a little excitement."

"The Bermuda Triangle," Chuck said. "There's nothing like it. Will tomorrow morning be okay? I can explain it all then."

"Fine, Shall I meet you here?"

"Out at the airfield would be best. I have a little flying school near the civil air terminal. I'll be there at eight."

"I'll find it," Yardley said and they shook hands.

Later Mona asked Chuck, "What about that pilot tomorrow?"

"Yardley will be number thirteen. I hope it's not unlucky for him."

As the British Airways jet from London landed at Bermuda Airport, Laura Charme was deciding the islands really did look like those sun-drenched photos they always featured in the travel brochures. It was a Thursday in July, and the airport temperature was a warm 85 when she left the building and hailed a taxi for the guest house in nearby St. George where she'd be staying.

But if she hoped to remain inconspicuous, that hope died early. "Aren't you Laura Charme, from Paris?" a handsome middle-aged man asked as she alighted from the taxi at her destination.

"Yes," she admitted, a bit reluctantly. "Should I know you?"

"George Furniss. We met briefly at the International Investigators Conference in Paris last year."

"Oh, yes, I remember now." All she really remembered was a group of interchangeable men around a table in the bar, praising a talk she'd given on airline crimes.

"So Interpol is finally investigating Bermuda," he said with a broad smile.

"Hardly. I'm here on holiday."

"Oh?" She could see he wasn't convinced. "Staying at the guest house here?"

"Yes." She paid the taxi driver and started up the walk with her suitcase.

"At least let me carry that, like a true Bermuda gentleman."

"Do you live nearby?"

"My wife and I have a small house just down the street. Come see us and meet Mona. You're welcome to use our swimming pool any time."

"Thank you, but I plan to keep pretty much to myself. That's what I take vacations for." She hoped she wasn't sounding rude.

He held open the screen door and let her pass before him. Lowering his voice a bit, he said, "I know I shouldn't have mentioned Interpol. Of course you're here on assignment. Don't worry, I won't breathe a word of it."

"Just what do you do here, Mr. Furniss?"

"Private security guards—I furnish them. Don't you remember? We talked about it in Paris."

"Vaguely," she admitted. "Is business good?"

"The security business is good everywhere these days. Bermuda has crime like everywhere else. You need exact change on the buses now, so the drivers don't need to carry any money. And we have tough laws about drugs and firearms. Even spear guns are illegal."

"But it seems such a peaceful place."

"Looks can be deceiving" He switched to a pleasanter topic. "But you really must let Mona and me show you a bit of the islands. We promise not to intrude on your privacy."

"Thank you," she replied. "You're very kind. Tell me, are there any rental cars to be had here?"

"Not on Bermuda. But most visitors rent bicycles or motor-assisted cycles to get around. And of course there are taxis and buses."

"Thank you." She gave him a smile. "I'll probably be over to see you."

"I hope so."

After she was settled in her room, and before going out to dinner, Laura sent off a cablegram to Sebastian Blue back in Paris.

In the morning she rented a bright-red motor-assisted cycle and listened while a young man gave her brief instructions on its

operation. Once back in France she'd driven a motorcycle, so she had no difficulty mastering this simpler version. Soon she was enjoying the scenery along Mullet Bay Road as if she'd been born on a cycle.

As she neared the airport causeway that led to the main island, she was overtaken by a girl in her early twenties who came cycling up behind her. "Hi! Beautiful day, isn't it?"

"Certainly is!" Laura agreed. "Your first time here?"

"Second, really. I was here last winter with another girl and liked it so much I came back." They'd stopped for the airport traffic and she held out her hand. "I'm June Wallace, from Boston."

"Laura Charme, from Paris."

"You're French!"

"Only half, really. But I work there. I just arrived yesterday."

June Wallace was wearing light green slacks and a striped blouse, and her long brown hair was tied back with a matching green ribbon. Laura thought she was quite attractive. "Have you been to the shops in Hamilton yet?" the girl asked.

"That's where I'm bound for now."

"I can show you a wonderful little place for sports and beach things. And fairly reasonable too."

They continued on together, taking the scenic North Shore Road past the aquarium and museum. "How long will you be here?" the American girl asked.

"A week, I expect," Laura said, feeling the refreshing ocean breeze on her face.

June Wallace swerved to avoid an oncoming bus. "Damn! Can't get used to riding on the left side! Going to kill myself one of these times."

Soon they were in the center of Hamilton's bustling shopping area, and after locking their cycles, were strolling past store windows crammed with exotic tourist lures. "I know a great place to have your fortune told!" June said as they passed a display of horoscopes and tarot cards. "Want to come with me tonight?"

"I'm not much for knowing the future," Laura admitted. "I've enough problems with the present."

"The man I'm going to see could help you. He's a regular wizard."

"Is he one of the tourist attractions?"

"For those in the know. He answers questions and afterwards gives private readings."

Laura smiled. "I guess you've talked me into it."

The meeting that evening was in a room at one of the big beach hotels facing Hamilton Harbor. There were perhaps 200 chairs arranged in neat rows, but the place was less than half full when the speaker, a black-bearded man named Vincent Tartor, appeared. Laura and June were seated in the third row, and Laura was suprised to see George Furniss across the aisle with a woman who apparently was his wife.

There was no doubt of Tartor's speaking ability, or of his knowledge of things mystical. After a brief talk he opened a question period and Laura raised her hand. "Just what is the Bermuda Triangle?"

The bearded man smiled indulgently. "A good question, and someone always asks it. The Bermuda Triangle is the area bounded roughly by a line connecting Bermuda, Puerto Rico, and Miami. A number of ships and planes are said to have vanished in this area, and theories about the disappearance range from magnetic disturbances to actions of extraterrestrial beings. Does that answer your question?"

Before she could reply, Tartor shifted his attention elsewhere. When the meeting finally broke up a half hour later with Tartor's announcement that there would be no personal readings that night, Laura found herself standing with George Furniss and his wife.

"So glad we ran into you here," he said. "Now you can meet Mona."

Mona Furniss smiled and held out a hand. She was a pretty young woman with blonde hair that nicely framed her face. "So pleased to meet you. George said you might join us at the pool."

Furniss suggested a drink at the downstairs bar, and June Wallace joined them with a middle-aged man in tow. "This is Professor Charles Winstead," she said, introducing him to Laura. The Furnisses obviously knew him. "I'm taking a summer course with him at the college here."

"I always come to hear Tartor," the Professor said, speaking in a cultured voice. "Every Friday and Sunday night during the summer. Fascinating man."

When they were seated in the bar downstairs, Laura became aware that Tartor was there too, talking softly to a British-looking man wearing an expensive Bond Street suit. But the man's eyes were on Laura rather than his bearded companion.

"Who's that at the bar with Tartor?" she asked after a few moments.

George Furniss glanced around. "McKnight. Detective Inspector McKnight. I noticed him upstairs."

"Expensive clothes for a policeman," Laura remarked.

Furniss offered no comment. Then the cocktail conversation shifted to the islands, and Laura found a way to bring up the subject of the Bermuda Triangle again. "It's pure superstition," Professor Winstead insisted. "Superstition fostered by an irresponsible press. Planes and ships don't disappear without cause."

"But some have," Laura said. "Even recently. Last month there was that American airline pilot—Steve Yardley, wasn't it? Whatever happened to him?"

"He took off from the Bermuda airport in an old Cessna," George Furniss said, "according to the police reports. Nobody ever found out what he was doing here."

"Interesting," Winstead commented. "There are these occasional happenings that renew one's faith in the unknown."

"I thought you didn't believe!" June scoffed.

"I believe in the unknown. I believe in dark human forces and the corruption of man. I do not believe in Vincent Tartor and his sideshows, fascinating as the man is."

The waiter brought another round of drinks and the conversation shifted to Hamilton's shops and what was available at the various places along Front Street and Reid Street. Finally the party broke up, with June and Laura heading back to their cycles. George Furniss and his wife would be getting a taxi, and Professor Winstead apparently had a place in town.

"Isn't it dangerous on these roads at night?" Laura asked June.

"No, there aren't that many private cars. I've been riding these cycles all summer. Come on!"

"Chuck?"

Coral looked down at her. "Someone might hear us."

"She was asking questions about Yardley. And she's Interpol!"

They were standing together in an alcove off the hotel lobby. Mona knew her voice was betraying the fear she felt, but she

didn't care. Chuck Coral glanced both ways to make certain no one could overhear them, then said, "Get hold of yourself. She doesn't know anything."

"But she might find out! She said she visited a curio shop today!"

"Then arrange something if you're worried. An accident. At your pool."

"I couldn't do that, Chuck. It would be too close to home. Interpol's not dumb. They'd send others."

He took a deep breath. "They only just left, and Laura Charme was on the red cycle. Maybe something can be done tonight."

"By whom?"

"Lin Yang. He can take care of it."

It was toward morning when Laura was awakened by a pounding on her door. She rolled over and glanced at her travel clock, surprised that it was not yet six o'clock. "Who is it?" she called through the door, bundling her robe around her.

"Detective Inspector McKnight. Please open the door."

She opened it just a crack and recognized the man who'd been watching her from the bar, the one who'd been talking with Vincent Tartor. "What do you want? It's not even six o'clock!"

"I'm sorry, but there's been an accident. June Wallace is dead."

"June?" She allowed the door to swing open and he entered. He wasn't wearing the Bond Street suit now, only a pair of faded pants and an open-necked shirt. "What happened?"

"Looks like her cycle went off the road along Barrack Hill."

"But—"

"We think it was hit by a car." A trace of accusation?

"Only residents can have cars here."

"There are taxis," he reminded her. "And buses."

"You said an accident?"

"Looks like it. But then again—" He started over. "You were with her yesterday and last night, Miss Charme. I've established that from witnesses. Did she say anything, imply anything, to make you think she feared for her life?"

Laura shook her head. "No, nothing at all. She seemed like a happy, carefree girl—the little I knew her."

"You came home together from Hamilton last night?"

"Yes. She was staying out on Cut Road, farther along than me. Her cycle was almost out of fuel and the gas stations close at seven, so I let her take my—" Laura froze. "Oh, my God!"

"What is it?"

"She was riding my cycle when she was killed. My red cycle." Laura sat down on the edge of the bed. She tried to get control of herself, so he wouldn't be able to read her thoughts.

They'd been trying to kill her, Laura. June Wallace had died by mistake.

It was nearly noon by the time Laura left the St. George police station and started back to her guest house. She'd told McKnight everything she knew, but had avoided dwelling too long on the change in cycles. If he suspected she was the intended victim, he didn't say so.

The first thing she did was to send another coded cablegram to Sebastian Blue at Interpol's Paris office. Then she sat down to think it through.

The killing had not been done personally by any of the people at the hotel the previous night, because she and June had been wearing different-colored slacks and blouses. Someone who'd seen them together would have recognized June in his car's headlights. But someone instructed by telephone to get the girl on the red cycle might easily have made the mistake. She thought she remembered a car following them at a distance, its headlights mere dots in the darkness.

It was, she knew, her question about Steve Yardley's disappearance that had prompted the desperate action. George Furniss knew she was Interpol, but she'd expected that. She'd chosen the guest house mainly because it was near Furniss's home, and if he hadn't seen her yesterday afternoon when she arrived, she would have found some excuse for a casual meeting.

But Furniss was not the man she sought. Before his disappearance Steve Yardley had mailed a postcard to his girl back in New York, a card that mentioned the name of Chuck Coral. *"Met Chuck Coral at a curio shop. He's arranging for tomorrow's flight."* Those were last words from Yardley.

But it was more of a clue than they'd had in any of the other cases.

Something was luring commercial airline pilots to Bermuda.

Something was bringing them from America and France and England and a half-dozen other countries. Something they didn't like to talk about. On pilot whom Sebastian interviewed in Paris had spoken vaguely of flying into the Bermuda Triangle as a sort of lark, but such motivation seemed unlikely. So far three pilots had disappeared in the area after taking off from Bermuda, and their purpose could only be guessed at. All had listed the flights as sightseeing excursions on their flight plans, and all had failed to return to the Bermuda airport.

Laura Charme had come to find out why.

On the previous day, wandering through the waterfront shops with June, she'd kept an eye out for curio shops. There were only two that used the phrase in their name—the Front Street Curio Shop and the Travelers' Curio Shop. She'd been in the Travelers' yesterday with June and had seen nothing suspicious.

Now, more to keep from thinking of June's death than in any hope of finding a lead, she set off for Hamilton and the Front Street shop. She rode June's bright-blue cycle with some trepidation, though the holstered .38 beneath her billowing blouse provided a measure of reassurance. Whether she could stop a car with a shot from the back of a moving cycle remained uncertain, but the weight of the weapon against her body gave her added courage.

As she entered the curio shop a half-hour later in Hamilton, she saw at once that there were no other customers. The Chinese clerk behind the counter smiled and bowed slightly, then returned to his task of dusting shelves. The air was thick with the odor of incense, but otherwise the shop seemed almost a duplicate of the one she'd visited the previous day. If this was where Yardley had met the man named Chuck Coral, there was nothing here to show it.

She picked up a jade figurine and made a pretense of studying it for a moment, then put it down and turned toward the door. The Chinese had got there before her. He'd locked the door and was flipping a sign in the window to indicate the shop was closed.

"You'll have to let me out," she said quietly.

He smiled, and suddenly she saw the knife in his right hand. "This time I will kill the right one," he said, and lunged forward.

She had no time to reach her gun. She sidestepped, caught him

in the neck with a well-aimed karate chop, and he went down hard.

Laura glanced toward the street, but beaded curtains had effectively hidden the brief flurry of action from outsiders. She kneeled and went quickly through the man's pockets. His name, she learned, was Lin Yang and he lived at a Hamilton address. She felt his pulse and knew he was still alive. Glancing around the shop, she decided to look for Mr. Chuck Coral.

In the back room she found a steep metal staircase leading to the second floor. She slipped the gun out of her waistband holster and started up.

If she'd expected a storeroom, she was surprised. The room above was a miniature studio apartment, complete with bed and kitchenette. She shifted the pistol to her left hand and began searching through the drawers of a dresser set against one wall. There was an assortment of men's clothing and a few feminine undergarments. Beneath these was a thin packet of letters. Laura put down the pistol and began to read them.

They were love letters—passionate, explicit—written to *Chuck* and signed *Mona*. In one of them she read the sentence: *I don't know what George would do if he ever found out about us. Sometimes I think he would kill us both.*

Obviously Mona Furniss's lover was the mysterious Chuck Coral, and this was his apartment.

Continuing her search through the drawers and the single closet, Laura began to wonder. There were some sports clothes and robes, but no shoes or socks. There was toothpaste and a brush, but no books or magazines. The place had more the look of a love nest than of actual living quarters. It was a place where Chuck and Mona met, but not a place where he lived permanently.

Chuck Coral might have another identity—which would explain why she'd been able to discover nothing about him till now. He might even have been one of the men at the hotel last night, watching Mona and her husband together and inwardly gloating.

Laura read through the letters again, searching for some clue to "Chuck's" identity. But there was nothing. Putting down the letters, she took stock of what she knew. Mona Furniss and Chuck Coral were having an affair—in a sense it was another

Bermuda Triangle—and Coral was involved in the disappearance of the pilot Steve Yardley. After her question about Yardley at the hotel last night, either Coral or Mona or both had ordered her murder. The Chinese clerk of the curio shop had been sent to do the job but had killed the wrong woman.

That much she knew. But there were too many unanswered questions. Who was Chuck Coral? And how was he enticing airline pilots to fly into the Bermuda Triangle? Were they really doing it for the pure thrill of it? Could that many intelligent, highly paid men believe in a foolish superstition, a media event?

She returned the letters carefully to their hiding place and went downstairs. No need for Coral to know she'd read them, even if he did know she'd been there.

The Chinese on the floor hadn't stirred, but he was still breathing. She stepped around him and unlocked the front door of the shop.

As she started out she almost ran into a middle-aged man with a friendly smile. "Oh, pardon me!" she said. Then, remembering the body on the floor, she pointed to the sign on the door and added, "The shop is closed."

"Is it? Do you know if Chuck Coral is in there?"

"No, he isn't." She took a deep breath. "But I work very closely with him. Perhaps I could help you."

"Maybe so, Miss. I had a little trouble and I thought I should see Mr. Coral as soon as I got back to Bermuda."

"Who are you?"

"My name is Steve Yardley."

Over a drink at a dockside bar she listened to Yardley's straightforward story. He'd heard about Coral's flying service back in the States and had come here on vacation to give it a try. He'd developed engine trouble about 950 miles southwest of Bermuda and crash-landed in the ocean not far from Cuba. A Cuban patrol boat had rescued him, but had held him for investigation without notifying the American authorities. He'd finally been released in Havana yesterday.

"Then you weren't really missing?"

He smiled at her. "I knew where I was all the time—in a detention center just outside Havana. I guess they thought I was a spy."

"Your family will want to know you're back."

"I've wired them, and I'll try to call tonight."

Laura peered into his smiling face. "Just why did you make that flight in the first place? What was the purpose of it?"

Steve Yardley shrugged. "Adventure, I guess. Flying commercial airliners can be as dull as working in an office, after the first few thousand hours. There's something about the Bermuda Triangle that brings back the old adventure of the first time I flew. Coral's planes are old, for one thing, and can be flown without a copilot."

"Isn't a thousand miles a fairly long range for them? You said you were near Cuba."

"Oh, they can go lots farther than that," he replied casually.

And get back? Laura wondered silently. Aloud, she asked, "Was Chuck Coral alone when you met him at the curio shop?"

"There was a woman with him. I think he called her Mona."

"Can you give me a description of Coral?"

Steve Yardley shrugged. "Middle-aged, sort of ordinary."

She thought of Vincent Tartor. "Did he have a beard?"

"No."

"But you'd know him if you saw him again?"

"Oh, sure."

"Good. Because I'm going to show him to you."

"He's probably out at the airport. I got the idea he hung around there a lot."

"Let's go see." She finished her drink and paid the waiter. Then, remembering her cycle outside, she said, "We'd better take a taxi. But first I have to make a phone call."

While he waited she stepped into a booth and called Detective Inspector McKnight. When his familiar voice came on the line, she identified herself and said, "You can find the man who killed June Wallace at the Front Street Curio Shop. He's Chinese—a clerk in the shop. He'll probably deny everything, but if you examine his car carefully I'm sure you'll find some traces of red paint or other evidence that he hit the cycle."

The voice on the other end hesitated. "Where are you now, Miss Charme?"

"At a little restaurant down the block."

"You'd better wait there till I arrive."

"I don't think I can do that," Laura replied. "I'm not alone.

You can reach me later." She hung up before he could reply.

Steve Yardley was waiting for her by the taxi. She got in and told the driver to take them to the airport.

"Coral's flying school is over there," Yardley said, pointing to a hangar and a low corrugated building that adjoined it. "That's where I left from."

"Let's go," Laura said.

She opened the door and entered a small office area. There were two girls at typewriters looking bored and a man with his back to the door. He turned as they entered and Laura recognized him.

It was Professor Charles Winstead.

"You're Chuck!" she blurted out.

He gave her a puzzled smile. "I beg your pardon?"

"You're Chuck Coral!"

"Oh, hardly. I'm just here seeing about a charter flight to Miami. I don't even know this Coral fellow."

She turned to Yardley for confirmation and the American shook his head. "That's not him."

"But—"

"He doesn't look anything like him."

"All right," she sighed, accepting it. Professor Winstead nodded pleasantly and went out the door.

Laura turned her attention to one of the office girls. "Is Mr. Coral around?"

The girl shook her head. "He doesn't come in very often. Only when there's a flight going out."

"And when's the next one?"

The girl shrugged. "We never know."

Yardley started to say something, but Laura hustled him out. "It's better if they don't know who you are. Not just yet."

"Why's that?" he asked as they walked back across the grass toward the main airport building.

"I don't know exactly," she admitted. "But if they knew you were back, it could be dangerous for you."

The more she thought about June Wallace's death, the more convinced she was that Coral had been one of the men in the bar the previous evening when she asked her question about Steve

Yardley. Those love letters showed that Mona Furniss was a follower, not a leader. She never would have ordered Laura killed on her own—especially since the Chinese obviously worked for Coral. Admittedly Mona might have phoned Coral, who then got in touch with the Chinese, but the time element would hardly have allowed it, especially with Mona's husband present. It would have been much easier for her to say a few casual words to someone in the bar than to have got away for a phone call.

But if it wasn't Professor Winstead, who was it? Vincent Tartor, the bearded mystic with all the answers?

Yardley insisted Coral was clean-shaven, but the beard could be false.

She decided it was time to seek out Tartor next.

"Come on," she told Yardley. "I've someone else for you to meet."

Chuck bent down and kissed Mona. "Sorry I'm late. There was some trouble at the shop."

"What sort of trouble?" she asked.

"Laura Charme found the place somehow."

"Damn!"

"Worse than that. Lin Yang recognized her this time from my description. He had another try at killing her and she flattened him with karate. He was just coming to when I found him. I had to kill him. He was a fool anyway, and this way she'll be blamed for it."

"But what about Laura Charme? If she keeps snooping around she's bound to discover something!"

Chuck took a deep breath. "You're going to have to kill her."

"Me! What about you?"

"We're both in this, Mona. I killed Lin Yang. Now it's your turn."

She stubben out her cigarette and thought about it. "When?"

"Tonight—and the sooner the better. There's another pilot, an Englishman, coming in tomorrow. We want her out of the way before then."

"Will you give me a gun?"

He smiled down at her. "Of course."

Vincent Tartor was staying at the hotel where Laura had seen

him the previous evening. She found him in the dining room, eating alone, and he rose as she approached the table. "Ah, one of last night's questioners—and a pretty one at that!"

"I was wondering if you'll be holding another session tomorrow night. I'd like to bring a friend." She gestured toward Yardley.

"Yes, every Friday and Sunday. Come, by all means."

"Thank you."

He hesitated. "The girl that was with you—she was killed?"

"Yes."

"Strange are the ways of the gods."

"They certainly are," Laura agreed.

When they left the dining room, Yardley looked puzzled. "I don't think it's him, but with that bushy beard I can't be certain."

"You'd better be certain," she warned. On the way in to Hamilton she'd identified herself as an Interpol agent.

"Then I guess it's not him."

She wondered if he was telling the truth. For that matter, trying to remember the blurred photos she'd seen back in Paris, she wondered if he was really Steve Yardley.

When she returned to her guest house, Detective Inspector McKnight was waiting for her. "There are some questions you'll have to answer, Miss Charme," he said.

"About the Chinese who killed June?"

"Yes. His name was Lin Yang, and he's dead,"

"Dead?"

"Apparently your karate blow killed him."

"He was alive and breathing when I left."

"You'll have to come along for questioning. I've no choice. He's dead and you admit striking him."

"Listen, I'm with Interpol. You can check with Sebastian Blue in Paris."

"We'll do that. Come along."

The next several hours were frustrating, full of questioning and confusion. While Laura sat on a hard straight-backed chair and waited, McKnight went through the motions of making contact with Interpol on the special frequency, but Sebastian Blue was not available.

"A fine time for him to be off!" she said impatiently.

"It's Saturday night in Paris, and quite late. They don't expect him to report in before Monday morning."

"Well, you can get through to the Secretary General. He'll tell you who I am and what I'm doing here."

McKnight sat down opposite her. "I already have."

"Then you believe me?"

"I still have a dead man to explain."

"Apparently he was killed by someone else to keep him from talking—by Chuck Coral, I'd say."

"Ah, the elusive Mr. Coral."

"Surely you must know him."

"I've heard the name, but we've never met." He reached into his jacket pocket and took out a small leather pouch. "What do you think of these?" He opened the pouch and spilled a trail of uncut diamonds across the top of the table.

"Diamonds? Are they real?"

"They seem to be."

"Where did you find them?"

"At the curio shop. Well hidden, but I'm a very good searcher."

"Did you find some letters for?"

"From Mona Furniss? Yes, I found them."

"You knew she wrote them?"

He nodded. "I recognized the handwriting. There was a time when she wrote me letters too."

"You?" Suddenly she remembered that McKnight had been in that bar the night before, watching her—or watching Mona?

"She's an odd sort of woman. Her relationship with her husband is most peculiar," he remarked.

"Does George Furniss know about her affair with Coral?"

He shrugged. "Furniss tends pretty much to his security-guard business."

"But you say she wrote letters to you too?"

"Nothing ever came of it. The thing was just a game with her. Mona Furniss's whole life is a game—a game played with the imagination. Mona in Wonderland."

"I wish I knew her better."

"You wouldn't want to." He scooped up the diamonds and returned them to the pouch.

"What are you going to do with those?"

"Evidence."

"Of what?"

He looked at her strangely. "I don't really know."

When McKnight finally released her, close to midnight, Laura felt drained of energy. It had been a long day, with McKnight on both ends of it—though now it seemed ages since he'd awakened her with news of June Wallace's death.

McKnight had brought her to the station in a police car, and he hadn't offered her a ride back. She had to take one of the little Bermuda taxis to where she was staying, then walk quickly along the dark path to the guest house.

As she was unlocking the door she heard a sound behind her. It was no more than the breaking of a twig underfoot, but it was exactly the sort of sound she'd been trained to notice. She dropped to the porch floor as a gun roared behind her. Then she was off the porch, weaving through the darkness toward the person who'd fired the shot.

She saw a dim blur of movement in the bushes and ducked low, waiting for another shot. Then she moved a bit to one side and suddenly charged forward. She managed to grab an arm and was rewarded by a soft feminine scream, but she was off balance and couldn't hold the grip. Laura went down, crushing a bush beneath her, and her assailant ran off through the darkness.

It had been Mona Furniss—Laura was certain of that. But there was no point in pursuing her now. There was something hard on the ground beneath her left knee and Laura felt for it. Mona had dropped the gun when Laura seized her arm.

Laura took it inside and examined it in the light. A .38 caliber police special—a professional weapon and an odd one for a woman like Mona to be carrying around. It was new and there was still a greasy film of cosmoline over parts of the metal.

That made two things which had seemed out of place tonight—McKnight's pouch of diamonds and now this new police revolver.

Perhaps she would pay a Sunday-morning visit to the Furniss pool.

George Furniss was sitting by the pool with Professor Winstead when Laura arrived the following morning. Furniss rose

and came forward to greet her enthusiastically. "Well! Finally found your way over here, did you? It's a great morning for a swim."

"I didn't bring my suit," Laura said, noting that both of them were fully clothed. "But I couldn't pass by without stopping in to say hello."

"Mona!" Furniss called toward the house. "Look who's here!"

Mona pushed open the sliding glass door and stepped outside. "Oh—Miss Charme, isn't it?"

"That's right," Laura said. Mona Furniss seemed a bit pale at the sight of her, and as she came nearer Laura saw a scratch on her arm. The bushes had left their mark.

"Are you going in the pool?"

"Not this morning."

"We were just talking about Miss Wallace's tragic accident," Professor Winstead said. "The funeral is tomorrow morning. Her body is being sent back to Boston today."

"I wonder if McKnight has found out who hit her," Furniss said.

"I hope he finds out something," Laura told them. "This place isn't safe. Someone even took a shot at me last night."

George Furniss looked alarmed. "You mean with a gun?"

"And it didn't miss me by much."

"Didn't anyone hear it and come to help?"

She shook her head. "People in Bermuda must believe in minding their own business."

"I can assign one of my uniformed security guards to your place if you'd like," Furniss offered. "It wouldn't cost you anything."

"No, thanks. I can take care of myself."

"Did you report the shooting to Detective Inspector McKnight?" Mona asked innocently.

"Not yet. I plan to see him today."

I'd advise it," Furniss said.

"And tonight I'm going back to the hotel for another of Tartor's question-and-answer sessions. I'm convinced June was killed because of something that happened there."

"She was probably killed by a drunken driver," Mona suggested. "It happens all the time."

"But not that often in Bermuda," her husband admitted.

"Still, I can't see how Tartor's brand of mysticism can be of much help."

"He answers questions," Laura said. "If I ask the right question, perhaps he'll have the right answer."

There was an awkward silence which Mona finally broke by asking, "Can I get you some coffee? Or a drink?"

"No, thanks. I'm on my way to Hamilton." She paused in her exit to say, "Maybe I'll see you all at Tartor's session tonight."

She wasn't going all the way into Hamilton just yet—only as far as the hotel where she'd hidden Steve Yardley. She'd half expected him to phone her first thing in the morning, and she was a little concerned that she hadn't heard from him. She didn't want anyone else turning up dead like June Wallace and Lin Yang.

Yardley didn't answer her first call to his room, and he still didn't answer her call from the hotel lobby. She checked the coffee shop, then went up to his floor. Some fast talking about a lost key persuaded the chambermaid to unlock his door. By that point she was half expecting a body, but there was none. In fact, there was nothing at all to indicate the room had been occupied the previous night. Steve Yardley had vanished again.

Now she began to wonder if he had ever come back at all.

A few hours later Mona Furniss was at Chuck's side as he interviewed the British airline pilot. He was a typical commercial flyer—a man in his early fifties who still showed the vigor of someone much younger.

"You understand what you have to do?" Chuck asked him.

"Sure. No problem,"

"We've had a score like you fly the Bermuda Triangle. Sometimes things go wrong. Sometimes men and aircraft don't come back."

"I'll take my chances," he said.

"Good!"

"When do I go up?"

Chuck Coral consulted his schedule book. "Tomorrow morning. Seven o'clock."

"Fine with me. The earlier the better."

"You'll see a flying school out near the airport. I'll be there."

When the pilot had left, Chuck walked to the window and stood for a moment staring out. It was unlike him, and Mona

went to his side. "What's the matter, Chuck?"

"I don't know. There's something about him I don't like, something that doesn't ring true. They could send a fake any time, you know—Interpol or even Scotland Yard. This might be him."

"Then let's cancel the flight and lie low for a while."

He smiled down at her. "Do you ever get the feeling they're closing in on us, that it's almost over, that the fun and games are nearly ended?"

"Don't talk like that!"

"It's true, you know. They found the diamonds."

"There are more," she reminded him. "I don't want it to end, Chuck."

"If we could only make a fresh start somewhere—"

"I could have another try at Laura Charme. This time I wouldn't miss."

"She's well named. I think she has a charmed life."

"Give me another gun, tonight at the hotel."

He shook his head. "No. This time I'll be carrying it." Then he kissed her, very gently.

After spending the afternoon searching for the missing Steve Yardley, Laura arrived at the hotel early. Only Detective Inspector McKnight was in the upstairs room, wearing one of his expensive suits. "You have a nice taste in clothes," she told him.

"My brother owns a men's shop."

She suddenly remembered Friday night at the bar, remembered McKnight watching her with Mona Furniss. She hadn't asked Yardley if McKnight could be Chuck Coral.

"The others are arriving," he said. "We'll talk later."

She saw the Furnisses come in with Professor Winstead and some others. There was an even bigger crowd than Friday night, and she took a seat on the side to await Tartor's appearance. Then, glancing back, she saw something that startled her. Steve Yardley had come in with another man, and they stood together near the door.

Where had he been all day, and why was he here now?

Then a door at the front of the room opened and the bearded Vincent Tartor entered. He bowed slightly and said, "My throat is a bit sort this evening, so we'll dispense with the usual talk

and go right to the question period."

Laura's head buzzed.

That voice . . .

It wasn't Vincent Tartor's.

Despite the bushy beard and the dark suit it was someone else.

What was happening? What was going on?

Then suddenly she knew what was expected of her.

"I believe the lady on the side has a question."

She stood on numb legs, as if in a dream, and asked again, "What is the Bermuda Triangle?"

"It is very much akin to the triangle trade of American colonial days," the familiar voice replied, "when molasses came north to New England and rum was shipped out to Africa and slaves were brought back to the Indies. In the Bermuda Triangle, guns are flown out of here to groups in the West Indies. They're traded for narcotics which are then flown into the United States. The triangle is completed by payment in diamonds, to be returned to Bermuda."

Laura's heart was beating faster. "Who is the man behind this traffic?"

"He calls himself Chuck Coral, but his real name is—"

She heard Mona's scream and then it all happened at once. Sebastian Blue pulled the false beard from his face and shouted, "Stop that man!"

Laura saw him draw the pistol and aim at Sebastian. She lifted her own gun and fired at him over the heads of the seated spectators. He turned as the bullet hit him, spun around by its impact.

Then Mona was on her knees by his side, pressing his bleeding body against her own, screaming and crying as they tried to pull her away. Laura knew the man she'd shot was Chuck Coral, but to the others in the room he was still Mona's husband—George Furniss.

Laura downed her second shot of Scotch and said to Sebastian, "I want to go home. Back to Paris."

"We'll go soon enough," he assured her. "You saved my life out there, you know. McKnight's men didn't move fast enough."

"I didn't even know you were on the island, Sebastian. I was sending messages to you in Paris."

"I flew in last night, after you cabled about the first attempt to kill you. We already had a man coming in as a British pilot, so I came along with him. He made contact with Coral this morning and managed to get the whole story."

"These airline pilots were flying the run for George Furniss? Guns and dope and diamonds? A devil's triangle."

Sebastian Blue nodded. "Don't ask me why a commercial airline pilot earning forty of fifty thousand dollars a year would risk his life on such a mission, but we know a great many did. The adventure, I suppose, the sport of it. Something they couldn't get flying a big 747 from London to New York. Out in Texas there's a place where commercial pilots go to fly old World War Two bombers and fighters on their time off, just for kicks. It's much the same thing, I suppose."

"The sport of it. That was Mona and George too," Laura said. "I've read where some married couples play sex games, imagining picking each other up in bars and such. That was Mona and George. He became Chuck Coral to her—Chuck Coral, the demon lover. They even had their own little pad over the curio shop, and she wrote him love letters as if she were cheating on her husband."

"You knew he was Coral?" Sebastian asked.

"When I recognized you behind the false whiskers—in that instant I think I knew everything. Guns and dope and diamonds. McKnight had already found the diamonds, and I remembered the gun Mona dropped last night after she took a shot at me. It was a brand-new police revolver—part of Chuck's next shipment, of course. And that's when I guessed the rest of it. George Furniss was Chuck, buying police weapons in large quantities to supply his force of security guards. He reshipped the guns to his customers in the West Indies and then reordered. A little bribery in the right places would get him past the gun-import regulations, if anyone questioned the duplicate shipments."

"It was a profitable trade," Sebastian confirmed. "I think we'll be finding more diamonds."

"But what about Steve Yardley? What happened to him?"

"What he told you was the truth—up to a point. He was held by the Cubans. But he didn't tell you about the guns and narcotics. When he realized you were Interpol, he decided to get out fast. Happily we recognized him at the airport Saturday

night. He's made a full statement. He was luckier than the other pilots."

"And Furniss?"

"He's still alive. Mona is with him at the hospital. With luck they'll both stand trail."

"McKnight told me once about the games she played."

Sebastian nodded. "When I instructed you to make contact with the Furnisses, I had just the tiniest suspicion. Furniss supplied security guards at the airport—it was such a natural way to make contact with pilots looking for a little adventure."

"What about Tartor?"

"I questioned him today about the accident that killed June Wallace. When he told me of your plan to come here tonight, I borrowed his suit and a false beard. I knew you'd recognize me and ask the right questions, and I guessed correctly that it might shock Furniss into revealing himself."

She was still thinking of Mona and George. "I guess the really loved each other, didn't they?"

"I suppose they did," Sebastian agreed. "In their own way."

Laura could not suppress a shiver.

"Come on. I'm ready to go home."

INTERPOL: THE CASE OF THE MUSICAL BULLET

by Edward D. Hoch

The Air France flight from Paris to Shanghai left twice a week, on Mondays and Thursdays, and these days it was usually crowded. Travel to the world's most populous city had increased, not for the usual tourist reasons but simply because there was money to be made in trade with China.

Thus the flight, especially in the first-class section, was made up almost exclusively of gray-suited businessmen from Common Market countries, their attaché cases full of samples and price lists. It was the last Monday in March, and though spring had come early to Paris this year there was still a dampness of winter about the field at Orly as the big jet taxied out to the far end of the runway for takeoff.

One man, sitting alone with a vacant seat beside him, had taken a small battery-operated tape recorder from his case and was dictating into it, speaking rapidly in French. His voice was low and the other passengers paid no attention. The plane had been waiting ten minutes at the end of the runway for clearance to take off when the stewardess, for want of something better to do, decided to check the passengers' seat belts one more time. As she passed the first-class seat occupied by the man with the tape recorder, she noticed him slumped over, apparently asleep.

"Sir," she said in French, touching his shoulder, "is your seat belt fastened?"

He slumped a bit farther in his seat, and she drew a quick breath. Calmly she walked to the front of the plane and knocked on the cockpit door. When the flight officer opened it she said, "You'd better go back to the gate. We have a dead man on board. I think he's been shot."

When Sebastian Blue was seated in the Secretary-General's office on the top floor of Interpol headquarters, he often found time to study the little art objects and memorabilia that cluttered the room. Just now, while the Secretary-General took a call from some nameless official of the French government,

Sebastian had an opportunity to run his fingers over a gray-white ashtray carved from rock by a Canadian Eskimo. He was just wondering how it might have arrived there when the Secretary-General hung up the phone.

"That was more of the same," he told Sebastian. "The Brider case."

"I must say that two calls from the French government are enough to stir anyone's interest. I'm eager to hear the details."

The Secretary-General cleared his throat and let his fingers play casually with the Eskimo ashtray. "You must realize that this is an extremely delicate affair for Interpol, Sebastian. Our headquarters are here in France, just outside Paris, but we have no connection with the French government. We are not Scotland Yard, we are not the Sûreté Nationale. We never investigate crimes for the French government."

"Of course not."

The Secretary-General spread his hands. "The French government has asked us to investigate a crime."

"Oh?"

"More specifically, they have asked *you* to investigate a crime."

Sebastian Blue registered his surprise. It was less than a year since he'd left his position at Scotland Yard and joined Interpol. Though he'd had a few notable successes during that time, he had no reason to believe the French government even knew of his existence. "Me?" he asked, somewhat incredulously.

A nod. "They've heard you're an expert in all sorts of airline crimes. They need you on a case which may have international significance. I cannot turn down the French government—but needless to say you'll be on detached service from Interpol during the investigation."

"The Brider case?"

"Yes. You may have read the bare details. A man was shot to death in the head on an Air France jet late yesterday as it was preparing to take off for Shanghai. His name was Pierre Brider and he was a civil servant holding a somewhat unique position in the French government. He acted as the liaison man with various foreign governments arranging joint space shots and satellite launchings."

"I didn't reralize there was such a person. But what's so

special about his death?"

"He died, Sebastian, at the beginning of a flight to China. Although the French government refuses to discuss the nature of his mission even with me, I think it's reasonable to assume that he was going to negotiate a joint French-Chinese space project. In any event, the government wants it kept quiet, and they want his murder solved as quickly as possible."

"That shouldn't be difficult. Has the weapon been recovered?"

The Secretary-General shook his head. "It seems there wasn't any weapon—couldn't have been any weapon."

"He was shot, wasn't he?"

"Yes."

"Well then, there had to be a gun."

"Remember the anti-skyjacking precautions? Orly is as strict as American airports. Passengers are checked with metal detectors, all carry-on baggage is searched. No gun could have been taken on board that plane. And even if one was, how do you shoot someone on an airliner without anyone knowing it? The stewardess swears the seat next to him was unoccupied all the time they were taxiing for takeoff."

"Interesting," Sebastian admitted.

"Damned interesting."

"Can I use Laura to help me?"

"Laura Charme? You two have functioned quite well as a team, but we can't really spare her for this. Unless," he smiled slightly, "you find a special need for her talents."

Sebastian Blue nodded. "I'll keep it in mind."

Orly—Aeroport de Paris-Orly—reminded Sebastian of all the other airports he'd ever seen. It reminded him particularly of London's Heathrow, although pilots had told him the two were nothing alike in the arrangement of their landing strips. Still, for Sebastian on this chilly Tuesday morning, there were similarities to be found everywhere—in the shops and the corridors, and especially in the mixture of languages he heard on all sides.

After speaking to the police and the airport security guards, he was introduced to Shana O'Neill, the Air France stewardess who had discovered the body. She was a bright pretty girl who wore her brown hair pulled back so that it didn't obscure the freshness of her face. In some ways she reminded him of Laura, but

perhaps it was only youth that the two had in common.

"You're Irish?" he asked, keeping up with her rapid pace along the corridor to the gate.

"Mostly. But I haven't been back to Dublin since I was a child. I lived in London for a time and then came on to Paris."

"So did I."

She slowed her pace as they approached the anit-skyjacking checkpoints. Like most American airports, the corridor was blocked by a white arch-like metal detector through which passengers had to walk. Purses, brief cases, and carry-on luggage were inspected separately. Sebastian watched the procedure for some moments and commented, "It seems thorough enough."

"Believe me, it is."

A uniformed airport employee stood beyond the archway, watching the wavering needle on the metal detector. Sebastian walked through and the man immediately stopped him. "What's that on your waist, sir?"

Sebastian opened his coat to show the holstered gun. He rarely carried it these days, but he'd brought it today specifically to test out the device. "Pretty good," he admitted. "But suppose I disassembled it and scattered the pieces around my body. Once I was on the plane I could reassemble it and use it."

The man at the machine explained patiently. "This can be adjusted for sensitivity. If it was turned up too high you might get through at some airports, but in fact we keep it sensitive enough to detect even the coins in your pocket."

Sebastian nodded approval. "Let's look at the aircraft, Shana."

She led the way through the gate and down the covered ramp to the field. "This is where the passengers boarded yesterday," she said. "After I discovered he was dead, the plane returned here and the passengers were transferred to another plane. They were searched, of course, but no weapon was found."

"And now they're scattered over half the world," Sebastian observed sadly. "How an I expected to solve this one? And quickly too!"

The stewardess grinned broadly. "I heard the French detective say you were once the best in the business on airline crimes. He said you'd been with Scotland Yard."

"That was a long time ago." Only a year, but a long time

nevertheless. Before his divorce, before he'd come to Paris to start anew at the age of 49. "But I'll want to see the plane. Where is it?"

"In the hangar. The airline is anxious to get it back in service, of course, but they agreed to hold it long enough for your inspection. Not that you'll find anything, of course. The local police have already been over it."

"Nevertheless, a detective must always inspect the scene of the crime."

He followed her up the steps and into the giant jet plane. The first-class section was toward the front, with seats two abreast, and he paused at the seat she pointed out. "He was here, by the window."

"The seat next to him was unoccupied?"

"Yes."

"What about behind him, and across the aisle?"

"Those seats were occupied, but the people saw and heard nothing unusual."

Sebastian grunted and bent to examine the seat more closely. "Is this blood?"

"It could be, but he didn't bleed much. The police said it was a small-caliber bullet. Anywhere but in the head and it might not have killed him."

"Were you the only stewardess in first class?"

"There was another girl, but she was in the galley opening the champagne."

"Oh?"

"We serve it to first-class passengers only," she explained. "The flight was a bit late taking off, so she had started opening the bottles."

"Then you were the only crew member out here when the killing took place?"

"That's correct. I'd noticed the passenger—Mr. Brider—dictating into a small tape recorder. A few moments later he was dead, and I told our captain about it at once."

"Is the rest of the crew here?"

She shook her head. "They took the flight out as scheduled, using another plane. I stayed behind because I had found the body and the police wanted to question me further."

Sebastian straightened up. There was nothing to be found on or under the seat. "Did you know the dead man? Ever see him before?"

"Never."

"What about the rest of the crew? Was there any evidence they knew him?"

"None that I saw. You certainly can't think one of us shot him?"

Sebastian Blue shrugged. "He was killed with a gun. All passengers and carry-on luggage were searched for guns—both before and after the crime. No gun was found. But crew members aren't searched before boarding, are they?"

"No," she admitted slowly. "But everyone, including the crew, was searched afterwards and nothing was found."

"There are many places to hide a gun on a plane this big, and a crew member would know them all."

"I'm sorry you think that. We're not in the habit of murdering our passengers."

They left the plane and walked back to the terminal building. Sebastian suggested a cup of coffee, but Shana O'Neill declined. Her manner had turned suddenly cool since his suggestion that the plane's crew might be involved.

He left her and went back to the airport security office. Duvivier, the French detective assigned to the case, was still there, talking to the airline people. "Did you find anything?" he asked Sebastian, his manner showing that he expected a negative response.

"Perhaps. The stewardess says he was dictating into a small tape recorder just before he died. Do you have it?"

"Of course." Duvivier produced the recorder from his attaché case. It was a popular Japanese model, with Pierre Brider's name printed on the case. "Perhaps the Interpol man can find something we missed," he said with a touch of sarcasm. "Perhaps the tape recorder is rigged to fire a bullet into the speaker's brain."

"Stranger things have happened," Sebastian said. He slipped off the back to inspect the battery, transistors, and self-contained speaker. Obviously the workings hadn't been tampered with. He switched it on and listened to the dead man's voice speaking quickly in French. The language was still a bit

new to Sebastian, and he could catch only scattered phrases. "What's he saying?"

"Listing his itinerary in China. We've been over it and so have the government people. His secretary listened to it when she came to identify the body. No clue there."

But then, with the suddenness of a punctuation, the voice was interrupted in mid-sentence by a series of musical tones. They lasted perhaps two seconds and then there was a grunt from Pierre Brider. Then silence.

"What was that?" Sebastian asked.

"We don't know. None of the passengers or crew remember hearing it."

"Almost as if he'd been shot with a musical bullet."

The detective chuckled. "Is that the best Interpol can come up with? A musical bullet!"

"I'll try to work on something better," Sebastian said. His eyes strayed to the morning newspaper in Duvivier's case. A dim blurred photograph of Brider stared out from beneath a headline that read: *Official Slain on Mystery Mission.* So the press was already suspicious. Sebastian turned back to the French detective and said, "Let me keep this tape recorder for a bit."

"The government man wanted it when we finished."

"I'm investigating for the government. And we're far from finished."

Laura Charme was young enough to be Sebastian's daughter and lovely enough to be his wife. In the year they'd known each other he'd often fantasized both possibilities, though he knew in his heart that each was impossible.

"I'm glad you came by," she said to him now, relaxing over a cup of coffee in the employee lounge. "It's all over the building that you're on detached service with the French government— some sort of special assignment."

"It's not all that special, simply a tough egg that no one can crack. Don't know if I can either. It's that man who was killed on the airliner at Orly yesterday."

"Pierre Brider?"

He nodded. "The Secretary-General said I could use you if I needed to."

Her face brightened like a flower opening to the sun and he realized that she'd been brooding about being left out. "And you need me?"

He produced the tape recorder. "Brider was dictating into this when he was shot. I want you to translate it for me."

"You should know French by now, Sebastian." But she took the tape recorder and switched it on. Pierre Brider's voice spoke again, running through the itinerary of his journey. Laura began simultaneous translation. " 'March 27th: I'm flying from Paris to Shanghai on Air France. This is my first time on a plane bound for the Orient. It's the regular Monday flight, arriving in China on Tuesday their time. My first contact will be with Dr. C. Z. Yen, director of the Chinese Space Institute. During the meetings which follow I will explore the possibilities of cooperation between France and the People's Republic of China on the launching of a communications sat—' "

The voice broke off in mid-word, and Sebastian heard again the musical tones, followed by the dying man's grunt.

"What do you make of it?" he asked Laura. "I suggested a musical bullet, but the police didn't think much of the idea."

"He was actually dictating this at the moment of death?"

"Yes."

"But someone must have seen or heard the shot fired, Sebastian!"

"It was a small-caliber bullet, probably a .22. And the gun could have been equipped with a silencer."

"A silencer would have made it that much more bulky and hard to conceal."

"True," he granted. "Any suggestions?"

She thought about it. "Have you talked to the passengers on the jet?"

"They're all gone. The police couldn't hold them after the initial questioning and search. Only the stewardess who found the body is still in Paris."

"And Brider's secretary?"

"What?"

"Brider's secretary. He must have had one to transcribe this tape. Was she traveling with him?"

"No," Sebastian answered, and then realized he'd spoken too quickly. "At least I don't think so. He was seated alone and I

assumed he was traveling alone. But Duvivier did mention his secretary coming to identify the body."

"Perhaps I'd better check on it," Laura said, and Sebastian knew she was on the case, whether the Secretary-General fully approved or not.

Pierre Brider had worked in a building on the Rue de Temple, not far from the National Archives. Laura found his office without trouble, and asked to see his secretary. Presently a short pale girl appeared in the reception area.

"I'm Clare Bonwell," she said quietly "I was Monsieur Brider's secretary."

Laura nodded sympathetically. "I dislike bothering you at such a time, but there are some questions to be answered. We want very much to find the killer of Monsieur Brider."

"I understand."

"Do you have any idea who might have shot him yesterday?"

"No, none. Everyone liked him."

"Was he traveling to China alone?"

The question seemed to surprise her. "Yes, of course."

"He was dictating into his tape recorder at the time of his death."

"He always did that when he traveled. I transcribed the tapes when he returned home."

"Could I see his office?"

The girl hesitated, then said, "Certainly. Follow me."

They passed through a room lined with computers and another where a number of girls worked at identical desks. "Is this work all connected with the French space program?" Laura asked.

"Yes, though we work mainly through other countries. There have been a number of joint launchings with the United States."

She opened the door to a medium-sized office overlooking the Ile-de-la-Cité and Notre-Dame Cathedral. The office told Laura little about the man who had been killed except that he had been scrupulously neat. The only object on the desk now was a small clock in the shape of Notre-Dame.

"Not much here," Laura conceded. "Tell me about the man, his family, his friends."

"Pierre was divorced long ago. I believe his former wife is now

living in America. There were no children, and his only relative is a brother in the south of France. The body is being shipped there for burial"

"Any girl friends?"

The pale girl blushed. "I could not answer that. I never concerned myself with my employer's personal life."

"The French government is your employer."

"But Monsieur Brider was my immediate superior." She glanced nervously at her watch. "It's almost four and I have much work to do. If you'll let me show you out?"

Something about the girl bothered Laura, but she could not put her finger on it. She allowed herself to be shown out just as Brider's clock began to chime the hour. Outside she crossed the street to a small cafe and sat down at an empty table. She lit a cigarette and ordered a glass of red wine, remaining seated by the window where she had an excellent view of the entrance of the building she had just left.

When Clare Bonwell emerged shortly after five o'clock, Laura followed her.

Sebastian Blue found the man he sought only after some difficulty. The Chinese mission to Paris was notable for its coolness toward outsiders, and even the thaw in relations with the United States had done little to improve their hospitality. Thom Ying was an important man in the delegation, though one would never know it from his pained expression and subdued manner. He greeted Sebastian in the sitting room of the embassy building, dressed all in black and with a small white kitten in his arms.

"I am happy to be of service to Interpol, if I can," he said, speaking in a quiet voice that seemed to wash gently over the listener.

"I'm working with the local police and the French government on this," Sebastian explained. "It's a bit outside Interpol's usual activities. I understand you arranged for Brider's trip to China. Is that correct?"

"I arranged it, yes. We had hoped it would lead to improved relations between our two countries. Naturally we didn't want word of the visit to leak out until there was something substantial to report."

"Was there any opposition to the visit among your people?"

"There is always opposition to contact with the west," he answered with a shrug. "But happily it is growing less important with the passing years. We are learning that we need each other."

Sebastian watched his fingers move gently over the kitten's fur. "Then you have no idea who might have killed him?"

Thom Ying sighed. "I have many ideas, but none that would prove helpful to you, I fear."

"I'd be interested in hearing them anyway."

"There are people who oppose any sort of easing of tensions between east and west. To them Pierre Brider might have appeared an enemy."

"Name me some names."

"Are you familiar with the League of St. George? They imagine themselves to be dragon killers—China killers, if you will."

"I may have heard of them. And how could they have killed Brider?"

"A bullet does not always need a gun."

"What does that mean?"

Thom Ying shrugged. "You are the detective."

Sebastian got to his feet. "Yes, I am. And I should be about my business. Thank you for the help."

As he left the embassy building and walked quickly across the street to his car, he had the strong feeling that Thom Ying's eyes were still watching him.

Clare Bonwell lived in a little walkup apartment on the fringe of the Latin Quarter. Laura Charme had followed her on foot across the Seine and down the narrow, uncertain streets to the building, and now she wondered just why she had come. Was it any more than the vaguest sort of hunch?

After fifteen minutes of standing in the chilly March darkness she had about decided to go home when a small German car pulled up before the apartment. As soon as she saw the man who emerged from it, that same intuition told her to stay where she was. He entered the building and emerged after a few moments with Clare Bonwell at his side. They got into the little car and started off, leaving Laura in a panicky search for a taxi to follow them.

She found one finally, just as their car was disappearing

around a corner. Instructing the driver quickly in French, she settled back to watch their progress. The car ahead, out of sight for a moment, came back into view as they rounded the corner into the Boulevard Saint Germain. Soon the taxi had narrowed the gap between them to a single block.

"Let me off here," she said suddenly to the driver, seeing the car ahead pull into a parking space.

Clare Bonwell and her male escort had already disappeared through a doorway. Laura followed close behind, more certain than ever that she was on the track of something connected with Brider's killing.

She stepped through the doorway and came face to face with Clare Bonwell. "That's the girl from Interpol!" the secretary said.

Laura sensed a movement in the shadows at her side, and shot out her arm in a defense position to meet the attack. The man came on, but off balance from her jab he went down hard on the dusty floor. "I have a gun here," Laura announced. "Please stay where you are."

The League of St. George was not nearly as difficult to locate as Sebastian Blue had imagined it would be. Far from being any sort of secret society, the League maintained offices within two blocks of the Arc de Triomphe, on the Avenue Marceau.

It was late in the day when Sebastian reached the office, and he found only one man in attendance, an elderly fellow with wisps of white hair standing out from an otherwise bald head.

"You've come about the League's business?" the man asked. "I'm sorry my secretary isn't in today."

Sebastian glanced at the covered typewriter and noted the accumulation of dust. He guessed the secretary hadn't been in for many days, if indeed there was a secretary. "I was told the League might be helpful in my investigations."

"Which are?" The old man moved his head sideways to listen with his good ear.

"I'm looking into the murder of Pierre Brider."

"I see."

"My name is Sebastian Blue. Would you be the name on the door—Georges Titre?"

A slight bow of the head. "Yes. I am the Director of the League."

"And its purpose?"

"To oppose any sort of relations with Communist China. To slay the dragon, sir!" The old eyes flashed.

"Were you aware of Pierre Brider's mission to mainland China?"

"Of course."

"It wasn't reported in the press."

A shrug of the old shoulders. "We knew, nevertheless."

"Is it possible that you might have wanted to stop this mission, to sabotage Chinese-French cooperation on a satellite launching?"

"Yes, it is possible."

"And you might have killed Brider to do it?"

The old man raised his tired eyes. "But we would have no reason for killing Pierre Brider. He was one of us—he was a member of the League!"

Clare Bonwell faced the gun that Laura held firmly and said, "Be careful with that thing. I don't want to get shot."

Laura backed up a step and the fallen man struggled to his feet. "Where'd you learn that little trick, Miss?' he asked with something like admiration in his voice.

"I'm asking the questions," Laura said. "Why did you try to attack me?"

"I thought you were attacking us. You followed us in here."

She could barely make out his features in the dim light of the hallway, but he was a Frenchman of indeterminate middle age. She had probably stumbled onto nothing more sinister than an illicit love affair. "Who are you? What's your name?"

He drew himself up. "I am Louis Croire, a friend of the young lady. No further identification is necessary. We are on our way to my apartment upstairs."

"Please, Louis," the girl said, her voice close to a sob. "I don't want trouble."

Laura drew a deep breath and put away her pistol. "All right, go on. I'm sorry to have bothered you."

They went on up the stairs, almost gratefully, and Laura Charme left. She walked for two blocks, deep in thought, before she hailed a taxi and gave the driver the suburban address of Interpol headquarters.

Surprisingly, a light was burning in Sebastian's office when

she arrived. She found him at his desk, poring over a list of names and addresses. He looked up as she entered. "What luck?"

"All bad. I talked to the secretary and got nowhere. She was in the habit of transcribing his tapes after he returned from a journey. I saw his office, and later I followed the girl home."

"You followed her?"

Laura nodded. "Call it a hunch, nothing more. A man picked her up and they went to his apartment. I had a little tussle with him in the front hallway."

Sebastian Blue sighed. "Sometimes you're too fast with that judo and karate. Was he hurt badly?"

Laura chuckled and dropped into the chair opposite his desk. "He could walk. A petty love affair, I suppose. A married man with a second apartment in the city. It happens all the time in Paris." She dug into her purse and came out with a cigarette.

"You smoke too much," Sebastian said.

"I know. What's that list for?"

"The membership of the League of St. George, a rather seedy organization headed by an old man named Georges Titre. Their headquarters is in a dusty little office on the Avenue Marceau."

"We've come a long way from that jet plane."

"Not so long as you might think. Thom Ying suggested the League as a possibility. The League is very much anti-Chinese."

"Enough to kill Brider?"

"Believe it or not, he was a member! Inactive, but still a member. Georges Titre gave me the latest membership list to prove it."

"And all those people belong?"

"The list is four years old, and there are only a hundred and seventy-six names on it. Hardly another Christian Democrats Party."

"Why are you checking it?"

"To see if any members besides Brider were passengers on that jet airliner."

"Wouldn't they use phony names?"

"That's difficult to do when you're traveling outside the country and need a passport. The airliner's first stop was Istanbul."

She watched him going down the list of names, comparing it with the passenger list furnished by Air France. "When you

finish that, remind me to tell you about the clock, Sebastian."

"Which clock?"

"The one on Pierre Brider's desk, in his office. It's a replica of Notre-Dame Cathedral."

"What's so special about it?"

"Well, I suppose it was because of the clock that I followed Clare Bonwell home, though I'll admit I don't exactly see her connection with it."

"Oh?" He looked up from the list, interested now.

"It was almost four, and I had the feeling she was hurrying me out of the office before the clock chimed. And I heard it start to chime as I reached the hall."

"Why would she do a thing like that?"

"It chimed different musical tones—like the Cathedral bells, I suppose. And it sounded like the musical bullet on that tape recording."

Sebastian Blue's face went blank. He simply stared at her, deep in thought. Then he brought out the tape recorder again and played Pierre Brider's last words. "Was that it?" he asked softly when the tape had ended.

"I think it was, Sebastian. I think it was Brider's office clock chiming. But how could that be?"

"I don't know," Sebastian admitted.

"Unless—unless this *isn't* the tape recorder Brider was dictating into! Unless a switch was made after his death!"

"The passengers and crew were all searched, remember? A tape recorder would be more difficult to hide than a gun. And certainly an identical machine with the dead man's name on it would be noticed."

"I suppose so," she admitted.

"There's another possibility, though it's a remote one."

"What?"

"Let me think about it first."

"Are you thinking about how he was shot too?"

"Duvivier phoned with some information about the bullet. A standard .22 short, but without rifling marks on it. That gives me an idea how it was done."

"You *are* being mysterious tonight, Sebastian!"

"Let me finish checking this list first."

"Looking for anyone special?"

He nodded. "The man who occupied the seat directly across the aisle from Brider. But he's not listed as a League member." Sebastian tossed the list aside with a disappointing sigh. "I was hoping."

"What's his name?"

He consulted the passenger list again. "Louis Croire."

"Croire! That's the friend of Brider's secretary, the man I tangled with tonight!"

"You're sure?"

"Of course I'm sure—they're at his apartment right now!"

Sebastian got quickly to his feet. "Phone Duvivier at this number and give him the apartment address. Tell him to meet us there with police."

"You think it's the murderer?"

"We're going to find out."

They were at the apartment in ten minutes, but there was no sign yet of Duvivier. "Should we wait?" Laura asked.

"No. We're going up. Come on."

Louis Croire's apartment was on the second floor. Clare answered the ring and saw Laura. "Are you back again?"

Sebastian's shoulder hit the door, knocking the secretary out of the way. Then he was inside the apartment, with Laura close behind. Louis Croire came out of the bedroom, carrying a suitcase in one hand. "A fast trip back from China?" Sebastian asked.

Croire dropped the bag and went for his gun. He had it out, almost pointing at them, when Sebastian drew his own weapon and fired twice. The Frenchman toppled backward over his suitcase as the bullets struck.

"I think you killed him, Sebastian," Laura said, catching her breath.

"It was no time for fancy shooting. Watch the girl!"

Clare Bonwell had made a move toward the door, but now she stopped, stunned, and stared down at Croire's body. Outside, Duvivier's police car was pulling up in front of the building.

"So it was Croire who killed Pierre Brider?" Laura asked.

"No," Sebastian answered.

"No!" Laura looked blank. "Then who *did* kill Brider?"

Sebastian sighed. "At this point you'd have to say that I killed him. You see, the man on the floor is the real Pierre Brider."

Duvivier turned the metal tube over in his hand. "I don't understand," he said to Sebastian. "An automatic pencil?"

"A metal tube made to look like an automatic pencil by the addition of a pocket clip and the mechanism from a real pencil. Brider—or Croire—still had it in his pocket."

"He shot someone with *this*?" Laura asked. They were in Duvivier's office, down the hall from where Clare Bonwell was being questioned. It was late, but Sebastian had resigned himself to a long night.

"Once on board the jet he assembled it into a deadly little zip gun—not unlike those used by teen-age gangs. This tube became the barrel, fastened to a wooden grip with tape. The firing pin was probably a nail. A man after some practice would assemble it behind his newspaper in a matter of minutes. The metal parts, including the bullet, were inside this tube. The wooden grip and tape were in another pocket, since they wouldn't set off the metal detectors."

"And afterwards?" Duvivier asked. "The passengers were searched."

"The weapon could be disassembled just as quickly. The tape could be balled up and left in the ashtray. The nail and trigger could be stuck into the seat upholstery, the wooden grip left in the overhead baggage rack. Only this metal tube, the barrel, had to be carried off, because the powder burns inside it would quickly identify it as the weapon. And Brider hoped the mystery over the method of murder would keep us too busy to bother much about the victim. It was the best misdirection he could manage, and it almost worked. I suspected a weapon like a zip gun when you told me there were no rifling marks on the bullet. Zip guns usually have smooth barrels, but they're still effective at short range."

"And no one heard the shot?" Laura asked.

"Muffled by a newspaper, a .22 would sound no louder than a popping champagne cork—and remember, they were popping at the time."

"All right," the detective agreed. "But what told you Brider was still alive and had killed someone else in his place?"

Sebastian settled back in his chair. "I hadn't a hint of it until earlier tonight, when Laura told me about the chiming clock in Brider's office. That was our musical bullet, and it proved that

Brider had dictated earlier, *not* on the plane. Yet Brider spoke on the tape of being on the plane, so whatever deception was involved, he was a part of it. And why would Brider sit there pretending to dictate notes that had really been recorded hours or even days before?

"One possibility presented itself—the tape had to be prerecorded because the man pretending to speak to it was *not* Brider, and his voice was nothing like Brider's. Was such a substitution possible?

"The answer was yes. Brider had no family except a supposed brother in the south of France who quickly claimed the body for burial. His secretary identified it, you'll remember. And who was to question the identity? The man died wearing Brider's clothes, carrying Brider's passport, holding Brider's tape recorder. His secretary identified the body, his superiors listened to his taped voice. There was no need for anything like a fingerprint check."

"But what about that passport?"

"I imagine we'll find poor likenesses in the case of both men. They were the same age and general appearance, which was all that mattered. Brider's secretary deliberately furnished a blurred photo to the newspapers—a picture so blurred it satisfied Brider's friends and the airline crew. It could have been either man."

"And the brother who claimed the body?"

"Nonexistent, I'm sure. They couldn't risk anyone else viewing the body. It had to be shipped away quickly."

A detective knocked and entered the office. "Clare Bonwell is making a statement," he said.

They went down the hall to listen to her.

"It was all his idea," she said, speaking softly and without emotion. "I wanted him to marry me and he said he would if I helped him with this. He had motives for killing Louis Croire—first to sabotage the China mission by publicizing it, and second to make himself some money in the process. He already knew Croire, an unemployed journalist living on the income from a family trust fund. They were the same age and general appearance, and that fact undoubtedly suggested the scheme to Pierre.

"He told Louis of his China mission, pretending to fear the press might find out. He suggested they change identities and leave Pairs on the same plane. Louis, posing as Pierre, would

leave the flight at Istanbul to throw the press off the track. The real Pierre would fly on to Shanghai. Louis agreed to help, after a promise that he'd get an exclusive on the eventual story."

"What about the tape recorder?" Duvivier asked.

"Pierre told him to carry it and pretend to be dictating, then leave it behind when he departed from the plane. It would strengthen his identity as Pierre, especially with Pierre's voice prerecorded on the machine. We thought we cut it before the sound of his office clock chiming. It was a shock to me when I heard the clock later on the tape, but of course I couldn't admit what it was. At the office I tried to get the Interpol girl out before she heard and recognized the sound."

"Brider left the plane at Istanbul and flew back to Paris?"

She nodded. "He told me we would go to the country and live on the money from Louis' trust fund. That's why he was at the apartment with me tonight, getting samples of Louis' signature to forge for the check endorsements."

She had more to say, but after a time Sebastian and Laura left. Walking toward their car, Laura said, "He certainly sabotaged the China mission. The press will dig out every detail of it now. But tell me, Sebastian, how did you know it all?"

"When I realized Clare kept quiet about the clock chimes after she heard them on the tape, I knew she was somehow involved. An innocent person would have told Duvivier what the sound was, but she couldn't admit the recording was made earlier at the office. As for the Croire-Brider switch, the tape recording hinted that Brider wasn't Brider. And I was suspicious of Croire's identity when he readily admitted his name to you after that hallway tussle. They must have known we'd have a passenger list showing Croire in the seat opposite Brider. There was a risk admitting to the Croire identity, and I asked myself why he took it. the answer—because he *wasn't* Croire!

"If Brider and Croire *both* had suspicious identities, it seemed likely that they'd swapped places. When I saw the man in the apartment tonight I knew I was right. He looked too much like that blurred newspaper photo of Brider."

Laura slipped into the car's front seat. "I'm disappointed, you know. There was no musical bullet!"

Sebastian Blue grinned. "I'll try to find one for your birthday."

INTERPOL: THE CASE OF THE MODERN MEDUSA

by Edward D. Hoch

She was too beautiful to make a convincing Medusa, even with the terrible wig and its writhing plastic serpents. Gazing at herself in the mirror, Gretchen could only wonder at the chain of events that had caused Dolliman to hire her in the first place. Then the buzzer sounded and it was time to make her entrance.

She rose through a trap door in the floor, effectively masked by a cloud of chemically produced mist. As the mist cleared enough for the audience to see her, there were the usual startled exclamations. Then Toby, playing the part of Perseus, came forward with his sword and shield to slay her. It wasn't exactly according to mythology, but it seemed to please the audience of tourists.

As Toby lifted his sword to strike, her mind was on other things. She was remembering the charter flights to the Far East, the parties and the fun. But most of all she was remembering the gold. It was a great deal to give up, but she'd made her decision.

Toby, following the script they'd played a hundred times before, pushed her down into the swirling mists and grabbed the dummy head of Medusa that was hidden there. The sight of the bloody head always brought a gasp from the crowd, and this day was no exception. Gretchen felt for the trap door and opened it. While the crowd applauded and Toby took his bows, she made her way down the ladder to the lower level.

That was where they found her, an hour later. She was crumpled at the foot of the ladder, her Medusa wig a few feet away. Her throat had been cut with a savage blow, as if by a sword.

The advertisement, in the Paris edition of the English-language *Herald-Tribune*, read simply: *New Medusa wanted for Mythology Fair. Apply Box X-45.*

Laura Charme read it twice and asked, "Sebastian, what's a Mythology Fair?"

Turned around in his chair, Sebastian Blue replied, "An interesting question. The Secretary-General would like an answer, too. A Swiss citizen named Otto Dolliman started it in Geneva about two years age. On the surface it's merely a tourist attraction, but it might be a bit more underneath."

They were in Sebastian's office on the top floor of Interpol headquarters in Saint-Cloud, a suburb of Paris. It was the sort of day when the girls in the translating department ignored the calendar and wore their summer dresses one last time. Laura had started out in the translating department herself, before the Secretary-General teamed her with Sebastian, a middle-aged Englishman formerly of Scotland Yard, and set them to investigating airline crimes around the globe.

"What happened to the old Medusa?" she asked Sebastian.

"She was a West German airline stewardess named Gretchen Spengler. It seems she was murdered two weeks ago."

"Oh, great, and I'll bet I'm supposed to take her place! I've been through this sort of thing before!"

Sebastian smiled across the desk at her. "Blame the Secretary-General. It was his idea. Seems Miss Spengler was believed to be a key link in a gold-smuggling operation which in turn is part of the world-wide narcotics network."

"You'd better explain that to me," Laura said, tossing her long reddish-blonde hair. "Especially if I'm supposed to take her place at this Mythology Fair."

"It seems that a good deal of Mob money—skimmed off the receipts of gambling casinos—finds its way into Swiss banks. It's used to make purchases on the international gold market, and the gold in turn is smuggled from Switzerland to the Far East, where it's then used to buy morphine base and raw opium for the making of heroin. The heroin is then smuggled into the United States, completing the world-wide circle."

"And how was Gretchen Spengler smuggling the gold?"

"Interpol's suspicion is that it traveled in the large metal food containers along with the hot meals for the passengers. Such a hiding place would need the cooperation of a stewardess, of course, so the gold wouldn't be accidentally discovered. Gretchen worked at Otto Dolliman's Mythology Fair in Geneva during her spare time, between flights, and Interpol believes Dolliman or someone else connected with the Fair recruited her for the

gold smuggling. Chances are she was murdered because we were getting too close to her."

Laura nodded. "I can imagine how they'll welcome me if they discover I work for Interpol. And what are you going to be doing while I'm shaking my serpents?"

"I won't be far away," Sebastian promised. "I never am, you know."

Geneva is a city of contrasts—small in size even by Swiss standards, yet still an important world crossroads and headquarters for a half-dozen specialized agencies of the United Nations, plus the International Red Cross and the World Council of Churches. The bustle at the airport reflected this cosmopolitan atmosphere, and Laura Charme was all but swallowed up in a delegation of arriving ministers.

Finally she fought her way to a taxi and gave the address of the Mythology Fair. "I take a great many tourists there." the driver informed her, speaking French. "Are you with a tour?"

"No. I'm looking for a job."

His eyes met hers in the mirror. "French?"

"French-English. Why do you ask?"

"I just wondered. The other girl was German."

"What happened to her?"

The driver shrugged. "She was killed. Such a shame—she was a lovely girl. Like you."

"Who killed her?"

"The police don't know. Some madman, certainly."

He was silent then, until at last he deposited her in front of a large old house overlooking Lake Geneva. Much of the front yard had been paved over and marked off for parking, and a big green tour bus sat empty near the entrance. Laura paid the driver and went up the steps to the open door.

The first person she saw was a gray-haired woman of slender build who seemed to be selling tickets. "Four francs, please," she said in French.

"I answered the advertisement for a new Medusa. I was told to come here for an interview."

"Oh, you must be Laura Charme. Very well, come this way." The woman led her past the ticket table and down a long corridor past framed portraits of various mythic heroes. She

recognized Zeus and Jason and even the winged horse, Pegasus, but was stumped when it came to the women.

The gray-haired woman turned to her and said, in belated introduction, "I'm Helen Dolliman. My husband owns this." She gestured with her hand to include, apparently, the house and entire countryside.

"It's a beautiful place," Laura said. "I do hope I'll be able to work here."

The woman smiled slightly. "Otto liked the picture you sent. And it's difficult to get just the girl we want. I think you'll get the job." She paused before a closed door of heavy oak. "This is his office."

She knocked once and opened the door. The room itself was quite small, with only a single window covered by heavy wire mesh. The furnishings, too, were small and ordinary. But what set the room apart at once was the eight-foot-tall statue of King Neptune that completely dominated the far wall, crowding even the desk behind which a thin-haired middle-aged man was working.

"Otto," his wife announced, "this is Miss Charme, from Paris."

The man put down his pen and looked up, smiling. His face was drawn and his skin chalky-white, but the smile helped. "Ah, so good of you to come all this distance, Miss Charme! I do think you'll make a perfect Medusa."

"Thank you, I guess." Her eyes left his face and returned to the statue.

"You're admiring my Neptune."

"It's certainly . . . large."

He got up and stood beside it. "This is one of a series of the Roman gods, sculptured in the style of Michelangelo's Moses by the Italian Compoli in the last century. The trident that Neptune holds is very real, and quite sharp."

He lifted it from the statue's grasp and held it out to Laura. She saw the three spear-points aimed at her stomach and shuddered inwardly. "Very nice," she managed as he returned the weapon to its resting place with Neptune. "But tell me, just what is the Mythology Fair?"

"It is an exhibit, my dear girl—a live-action exhibit, if you will. All the gods and heroes and demons of myth are repre-

sented here—Greek, Roman, even Norse and Oriental. Our workrooms and dressing rooms are on the lower level. This level and the one above are open to the public for a small admission charge. They view paintings and statues representing the figures of myth—but more than that, they are entertained by live-action tableaux of famous scenes from mythology. Thus we have Ulysses returning to slay the suitors, the wooden horse at the walls of Troy, Perseus slaying Medusa, Cupid and Psyche, King Midas, Venus and Adonis, the labors of Hercules, and many others."

"Quite a bit of violence in some of those."

Otto Dolliman shrugged. "The public buys violence. And if some of our goddesses show a bit of bosom, the public buys that, too."

"I was wondering how someone like me could land the job of Medusa. I always thought she was quite ugly."

"It was the snakes in her hair that turned men to stone, my dear girl. And we will furnish those." He reached into the bottom drawer of his desk and produced a dark wig with a dozen plastic serpents hanging from it. As he held it out to Laura, the snakes began to move, seeming to take on a life of their own. Laura gasped and jumped back.

"They're alive!" she screeched.

"Not really," Mrs. Dolliman said, stepping forward to take the wig from her husband's hand. "We have little magnets in the snakes' heads, positioned so that the heads repel one another. They produce some quite realistic effects at times. See?"

Laura took a deep breath and accepted the wig. It seemed to fit her head well, though the weight of the magnetized serpents was uncomfortably heavy. "How long do I have to wear this thing?" she asked.

"Not more than a few minutes at a time," Dolliman assured her. "You come up through a trap door, hidden by some chemical mist, and Toby kills you with his sword. You fall back into the mist clouds, Toby reaches down, and holds a fake papier-mâché head aloft for the spectators to gasp at. I know it isn't exactly according to the myth—Medusa was asleep at the time of her death, for one thing—but the public enjoys it this way."

"Who's Toby?"

"What?"

"Who's Toby?" Laura repeated. "This fellow with the sword."

"Toby Marchant," Dolliman explained. "He's English, a nice fellow, really. He plays Perseus, and quite well, too. Come on, you might as well meet him."

Laura followed Otto and his wife out of the office and down the corridor to a wing of the great house. They passed a group of tourists, probably from the green bus out front, being guided through the place by a handsome young man, dressed in a black blazer, who bowed slightly as they passed.

"That's Frederick, one of our guides," Helen Dolliman explained. "With the guides and the actors, and a few workmen, we employ a staff of thirty-four people here. Of course many of the actors in the tableaux work only part time, between other jobs."

They paused before one stage, standing behind a dozen or so customers before a curtained stage. As the curtains parted Laura saw a bare-chested man who seemed to have the legs and body of a horse. She could tell it was a fake, but a clever one. "The centaur," Dolliman said. "Very popular with the tours. Ah, here is Toby."

A muscular young man about Laura's age, with shaggy black hair and a beard, came through a service door in the wall. He smiled at Laura, looking her up and down. "Would this be my new Medusa?"

"We have just hired her," Dolliman confirmed. "Laura Charme, meet Toby Marchant."

"A pleasure," she replied, accepting his hand. "But tell me, what have you been doing for a Medusa all these weeks?

Toby Marchant shook his head sadly. "Venus has been filling in, but it's not the same. She has to run back and forth between the two stages. But she was doing it while Gretchen was flying, so she was the logical one to fill in." He glanced at Dolliman and brought his hand out from behind his back, revealing a paper bag. "Speaking of Gretchen—"

"Yes?" Dolliman asked.

Toby opened the bag reluctantly and brought out the head of a young girl, covered with blood. Laura took one look and screamed.

Helen Dolliman motioned her to silence, glancing around to see who had heard the outburst. "It's only the papier-mâché

head we told you about," she explained quickly. "You'll have to learn to control yourself better!"

"What is this place—a chamber of horrors?" Laura asked.

"No, no," Toby said, embarrassed and trying to calm her. "I shouldn't have pulled it out like that. It's just that the head was made to look like Gretchen and now she's dead. We can't use Venus' head. We'll need a new one made for Laura here, or the illusion will be ruined."

"I'll take care of it," Dolliman assured him. "Give me the bag."

Laura took a deep breath. "The taxi driver told me Gretchen was murdered. Did the police find her killer?"

"Not yet," Toby admitted. "But it must have been some sex fiend with one of the tours. Apparently he slipped downstairs and was waiting when she came through the trap door. I was right above her, but I never heard a thing."

"Toby was busy taking bows," Helen Dolliman snorted. "He wouldn't have heard a thing."

They went downstairs, showing Laura the dressing room that would be hers, the ladder leading to the trap door, the stage where she'd be beheaded five or six times daily, depending on the crowds. "Think you can do it?" Toby asked at the conclusion of a quick run-through.

"Sure," Laura said bravely. "Why not?"

A tall redhead wearing too much makeup came by, glancing up at the stage. "Better close that. Another bus just pulled up."

"This is our Venus and part-time Medusa," Toby said, making introductions. "Hilda Aarons."

Hilda grunted something meant to be a greeting and sauntered off. Laura was rapidly deciding that the Mythology Fair wasn't the friendliest place to work.

Sebastian Blue arrived two days after Laura started her chores as Medusa. He came with a group of touring Italians, but managed to separate himself from them, wandering off by himself down one of the side corridors.

"Can I help you?" a pleasant young man in a black blazer asked.

"Just looking around," Sebastian told him.

"I'm Frederick Braun, one of the tour guides. If you've become separated from your group I'd be glad to show you around."

Sebastian thought his blond good looks were strongly Germanic. He was a Hitler Youth, born thirty years too late. "I was looking for the director. I believe his name is Dolliman."

"Certainly. Right this way."

Otto Dolliman greeted Sebastian with a limp handshake and said, "No complaints, I hope."

"Not exactly. I represent the International Criminal Police Organization in Paris."

If possible, Dolliman's face grew even whiter. "Interpol? Is it about that girl's murder?"

"Yes, it is," Sebastian admitted. "We'd had her under limited surveillance in connection with some gold-smuggling activities."

"Gretchen a gold smuggler? I can't believe that!"

"Nevertheless it seems to have been true. Didn't it ever strike you as strange that she continued working as an airline stewardess even after you hired her for your Mythology Fair?"

"Not at all, Mr. Blue. Both positions were essentially part-time. She worked charter flights and nonscheduled trips to the Far East mainly. And of course the bulk of her work here was during the vacation season and on weekends."

"Have you replaced her in the Fair?"

Dolliman nodded. "I hired a French girl just the other day. It's almost time for the next performance. Would you like to see it?"

"Very much."

Sebastian followed him down a hallway to the exhibit proper, where a string of little stages featured recreations of the more spectacular events of mythology. After watching a bearded Zeus hurl a cardboard thunderbolt, they moved on to the Medusa exhibit.

"That's Toby Marchant. He plays Perseus," Dolliman explained. The young man in a brief toga carried a sword and shield in proper Medusa-slaying tradition. He moved carefully through the artificial mist that rose from unseen pipes and acted out his search for the serpent-headed monster. Presently she appeared through the mist, up from the trap door. Sebastian thought Laura looked especially lovely in her brief costume. The snakes in her hair writhed with some realism, but otherwise she was hardly a convincing monster.

Toby Marchant, holding the shield protectively in front of

him, swung out wildly with his sword. It was obvious he came nowhere near her, but Laura fell back into the mist with a convincing gasp. Toby reached down and lifted a bloody head for the spectators to gasp at.

"It was after this that Gretchen was killed," Dolliman explained in a whisper. "She slipped down through the trap door, and somebody was waiting at the foot of the ladder. Hilda found her about an hour later."

"Is it possible that Toby might have actually killed her in full view of the spectators?"

Dolliman shook his head. "The police have been all through this. The throat wound would have killed her almost instantly. She could never have gone through that trap door and down the ladder. Besides, the people would have seen it. There'd have been blood on the stage. She bled a great deal. Besides, his sword is a fake."

"That mist could have washed the blood away."

"No. Whoever killed her, it wasn't Toby. It was someone waiting for her below."

"The police report says the weapon was probably a sword."

"Unfortunately there are nearly fifty swords of various shapes and sizes on the premises. Some are fakes, like Toby's but some are the real thing."

"I'd like to speak to your new Medusa if I could," Sebastian said.

"Certainly. I'll call her."

After a few moments Laura appeared, devoid of snakes and wearing a robe over her Medusa costume. Sebastian motioned her down the corridor, where they could talk in privacy. "How's it going?"

"Terrible," she confessed. "I've had to do that silly stunt five times a day. Yesterday when I came through the trap door that guide, Frederick, was waiting down below to grab my leg. I thought for a minute I was going to be the next victim."

"Oh?"

"He seems fairly harmless, though. I chased him away and he went. How much longer do I have to be here?"

"Till we find out something. Has anyone approached you about smuggling gold?"

She shook her head. "And I even mentioned over breakfast

yesterday that I'd once been an airline stewardess. I think the gold smugglers have switched to a different gimmick, but I don't know what it is."

They'd almost reached Otto Dolliman's office, and suddenly Toby Marchant hurried out. "Have you seen Otto?" he asked Laura. "He's not in his office and I can't find him anywhere."

"We left him not five minutes ago, down by the tableaux."

"Thanks," Toby said, and hurried off in that direction.

"He seemed quite excited," Sebastian remarked.

"He usually is," Laura said. "But he's a good sort."

They paused by the open door of Dolliman's office, and he asked. "Do you think Dolliman is the gold smuggler? Is there any way all this could be going on without his knowledge?"

"It seems unlikely," she admitted. "But if he's behind it, would he kill Gretchen right on the premises and risk all the bad publicity?"

"These days bad publicity can be good publicity. I'll wager the crowds have picked up since the killing."

At that moment Otto Dolliman himself came into view, hurrying along the corridor. "Excuse me," he said. "I have to place an important call."

Toby came along behind him and seemed about to follow him into the office, but Dolliman slammed the big oak door. Toby glanced at Sebastian and Laura, shrugged, and went on his way.

"Now what was that all about?" Laura wondered aloud.

"It's your job to find out, my dear," Sebastian reminded her.

They were just moving away from the closed office door when they heard a sound from inside. It was like a gasp, followed by the begining of a scream.

"What's that?" Laura asked.

"Come on, something's happening in there!" Sebastian reached the office door and opened it.

Otto Dolliman was sprawled in the center of the little office, his eyes open and staring at the ceiling. The trident from King Neptune's statue had been driven into his stomach. There was little doubt that the was dead.

"My God, Sebastian!" Laura gasped.

He'd drawn the gun from his belt holster. "Stay here in the doorway," he cautioned. "Whoever killed him must be still in the room."

His eyes went from the partly open window with its wire-mesh grille to the cluttered desk and the statue of Neptune beside it. Then he stepped carefully back and peered behind the door, but there was no one.

The room was empty except for Otto Dolliman's body ...

"The thing is impossible," Sebastian Blue said later, after the police had come again to the Mythology Fair with their cameras and their questions. "We were outside that door all the time and no one entered or left. The killer might have been hiding behind the desk when Dolliman entered the room, but how did he get out?".

"The window?"

He walked over to examine it again, but he knew no one could have left that way. Though the window itself had been raised a few inches, the wire-mesh grille was firmly bolted in place and intact. Sebastian could barely fit two fingers through the openings. The window faced the back lawn, with a cobblestone walk about five feet below. Obviously the grille was to keep out thieves.

"Nothing here," Sebastian decided. "It's an impossible crime—a locked room, except that the room wasn't actually locked."

"You must have had those at Scotland Yard all the time."

"Only in books, my dear." He frowned at the floor where the body had rested, then looked up at the mocking statue of Neptune.

"An arrow could pass through this grillework," Laura remarked, still studying the window. "And they use arrows in the Ulysses skit."

"But he wasn't killed with an arrow," Sebastian reminded her. "He was killed with a trident, and it was right here in the room with him." He'd examined the weapon at some length before the police took it away, and had found nothing except a slight scratch along its shaft. There were no fingerprints, which ruled out the remote possibility of suicide.

"A device of some sort," she suggested next. "An infernal machine rigged up to kill him as soon as he entered the office."

"A giant rubber band?" Sebastian said with a dry chuckle. "But he was in there for a few minutes before the murderer struck, remember? And besides, what happened to this machine

of yours? There's no trace of it now."

"A secret passage? We know there are trap doors in the floors around here."

"The police went over every square inch. No, it's nothing like that."

"Then how was it done?"

Sebastian was staring up at Neptune's placid face. "Unless that statue came alive long enough to kill him, I don't see any solution." He turned and headed for the door. "But one person I intend to speak to is Toby Marchant."

They found Toby talking with Frederick and Hilda and some of the others in a downstairs dressing room. While Laura still tried to keep up the pretense that Sebastian Blue had merely been questioning her, he turned his attention to Toby, calling him aside.

"All right, Toby, it's time to quit playing games. Two people are dead now, and with Dolliman gone chances are you'll be out of a job anyway. What do you know about this?"

"Nothing, I swear!"

"But you were looking for Dolliman just before he was killed. You told him something that sent him hurrying to his office to make a phone call."

Toby Marchant hesitated. "Yes," he said finally. "I suppose I'll have to tell you about that, Mr. Blue. You see, I came across some information regarding Gretchen's death—information I thought he should know."

"And now he's dead, so should I know it."

Another hesitation. "It's about Hilda Aarons. I caught her going through some of Gretchen's things, apparently looking for something."

Sebastian glanced past his shoulder toward the tall redhead. She was watching them intently. "And you told Otto Dolliman about this?"

Toby nodded. "He'd asked us to watch out for anything suspicious. What I told him about Hilda seemed to confirm some information he already had. He said he had to make a phone call at once."

"But not to the police, apparently. He walked right by me and went into his office."

"He may not have trusted an outsider. Sometimes he acted as

if he trusted only his wife."

"Have you seen Helen Dolliman recently?" Sebastian asked. He'd had only a few words with her before the police arrived.

"She's probably up in her room. Second floor, the far wing."

Sebastian found Helen Dolliman alone in her room, busy packing a single suitcase. Her eyes were red, as if from tears. "Your're leaving?"

"Do I have anything to stay here for?" she countered. "The police will shut us down now. And even if they don't, I have no intention of spending another night in the same house with a double murderer. He killed Otto and I'm probably next on his list."

"Do you have any idea why your husband was murdered?"

The little woman swept a wisp of hair from her eyes. "I suppose for the same reason the girl was."

"Which was?"

"The gold."

"Yes, the gold. What do you know about it?"

"About a year ago Otto caught a man with some small gold bars. He fired him on the spot, but we've always suspected there were others involved."

"Gretchen Spengler?"

"Yes. Before she died she told Otto she was getting out of it."

"Toby says he caught Hilda Aarons going through Gretchen's things after she was killed. He told Otto about it."

She nodded. "My husband discussed it with me. We were going to fire Hilda."

"Might that have caused her to kill him?"

"It might have, if she's a desperate person."

"Apparently he was trying to call someone about it just before he was killed."

"Perhaps," she said with a shrug, subsiding into a sort of willing acceptance.

He could see there was no more to be learned from her. He excused himself and went back down in search of Laura.

She was talking with Frederick Braun at the foot of the stairs, but the blond tour guide excused himself as Sebastian approached. "What was all that?"

"He's still after me," she said with a shrug. "I really think he's a frustrated Pan, speaking in mythological terms."

Sebastian frowned at the young man's retreating back, watching him go out the rear door of the house. Then he said, "We're going to have to move fast. Helen Dolliman is preparing to close the place and leave. Once everybody scatters we'll never get to the bottom of this thing."

"How can we get to the bottom of it anyway, Sebastian? We've got two murders, one of them an impossibility."

"But we've hot a lead, too. Gretchen was killed and the smuggling by aircraft apparently ended. Yet the murderer has stayed on here at the Mythology Fair. We know that because he killed Dolliman, too. I reject for the moment the idea of two independent killers. So what have we? The gold smugglers still at work, but not using aircraft. They have found a new route for their gold, and we must find it, too."

"Let me work on it," Laura Charme said. Staring at an approaching group of tourists, she had suddenly got an idea.

Night came early at this time of year, with the evening sun vanishing behind the distant Alps by a little after six. One of the tour groups was still inside the big house when Laura slipped out the rear door and moved around the cobblestone walk past the window to Dolliman's office. She came out at the far end of the paved parking area, near the single green tour bus that still waited there.

If the Mythology Fair was really closing down, she knew the smuggler would have to move fast to dispose of any remaining gold. And if she'd guessed right about these tour buses, she might see something very interesting as darkness fell.

She'd been standing in the shadows for about twenty minutes when the bus driver appeared from the corner of the building, carrying something heavy in both hands. He paused by the side of the vehicle and opened one of the luggage compartments. But he wasn't stowing luggage. Instead he seemed to be lifting up a portion of the compartment floor, shifting baggage out of the way.

Laura stepped quickly from the shadows and moved up behind him. "What do you have there?" she asked.

The man whirled at the sound of her voice. He cursed softly and grabbed an iron bar that was holding open the luggage compartment door. As the door slammed shut she saw him

coming at her with the bar, raising it high overhead. She dipped, butting him in the stomach, and grabbed his wrist for a quick judo topple that sent him into the bushes by the house.

As he tried to untangle himself and catch his breath, she ripped the wrapper from the object he'd been carrying. Even in the near-darkness she could see the glint of gold.

Then she heard footsteps, and another man rounded the corner of the building. It was Toby Marchant. She rose to her feet and hurried to meet him. "Toby, that bus driver had a bar of gold. He was trying to hide it beneath the luggage compartment."

"What's this?" He hurried over to the bushes with her.

"Toby, I'll keep him here. You go find that Englishman, Sebastian Blue."

Toby turned partly away from her as the bus driver struggled to his feet. "Oh, I don't think we need Blue."

"Of course we need him! He's from Interpol, and so am I!"

"That's interesting to know," Toby said. "But I already suspected it." He turned back toward her and now she saw the gun in his hand. "Don't make a sound, my dear, or you'll end up the way Gretchen and Otto did."

"I—"

"Tie her up, Gunter," he told the driver. "And gag her. We'll stow her in the luggage compartment and take her along for security."

Laura felt rough hands yank her wrists behind her. Then, suddenly, the parking area was flooded with light from overhead. Toby whirled and fired a shot without aiming. There was an answering shot as the bus driver dropped her wrists and started to run. He staggered and went down hard.

"Drop the gun, Toby," Sebastian called out from beyond the spotlights. "We want you alive."

Toby Marchant hesitated, weighing his chances, and then let the gun fall from his fingers.

It was some time later before Laura could get all the facts out of Sebastian Blue. They were driving back to the airport, after Toby Marchant had been turned over to the local police and the bus driver rushed to the hospital.

"How did you manage to get there in the nick of time?" she

asked him. "I didn't tell you of my suspicions about the tour buses."

"No, but you didn't have to. I had my own suspicions of Toby, and I was watching him. I saw him meet the driver and get the gold bar from its hiding place. When I saw him point the gun at you, I switched on the overhead lights and then the shooting started. Luckily for us both, Toby had no idea how many guns were against him, so he chose to surrender."

"But how did you know Toby was involved in the smuggling?"

"I didn't, but I was pretty sure he'd committed both murders, which made him the most likely candidate."

"He killed Otto Dolliman in that locked room? But how?"

"There's only one way it could have been done, ruling out secret passages and invisible men. Remember that scratch along the shaft of the trident? Toby entered the office prior to Dolliman's arrival, removed the trident from the statue of Neptune, and thrust the shaft of it through the wire grating on the window. Remember, the window itself was open a few inches. Thus, the pronged head of the trident was inside the office, but the shaft was sticking out the window.

"Toby then got Otto to enter the office on some pretext— probably telling him to phone for urgent supplies of some sort—left the house, walked around the cobblestone path just outside, and positioned himself at the window. Perhaps Dolliman saw the trident sticking through the grillework and walked over to investigate. Or perhaps Toby called him to the window, pretending to find it like that. In either event, as Dolliman reached the window, Toby drove the trident into his stomach, killing him. He then pushed the shaft all the way through the wire grillework, so the trident remained in Dolliman's body and made it appear that the killer must have been in the room with him."

"But why did he want to kill him in a locked room?"

"He didn't. He was just setting up an alibi for himself, since we saw him leave Dolliman alive. He couldn't foresee that we'd remain outside the door and hear Dolliman's dying gasps. You see, once I figured out the method, Toby had to be the killer. We'd seen him come out of that office ourselves. And the killer had to be in the office prior to the killing to push the trident

through the screen. He couldn't have it sticking out the window for long, risking discovery, so he had to lure Dolliman back to his office.

"That was where Toby made his big mistake. When we surprised him coming out of the office, he had to act as if he was frantically seeking Dolliman to tell him something. Later, when I asked him what it was all about, he had to come up with a good lie. He said he'd told Dolliman he caught Hilda going through Gretchen's things. I suspect that was true, and that it involved your friend Frederick, the guide, *but*—Helen Dolliman later told me her husband had discussed the matter with her."

"Which meant," Laura said, "he must have told Dolliman about it much earlier."

"Exactly. Early enough for Dolliman to discuss it with his wife. And if Toby lied about the reason for luring Dolliman to his office, it figured that he also prepared the trident and killed him with it."

"What about Gretchen?"

"She wanted out of the gold smuggling, so he had to kill her—she knew too much. I suppose Dolliman was suspicious that Toby killed her, so Dolliman had to die, too. Either that, or Dolliman discovered that Toby was now using the tour buses to smuggle the gold out of Switzerland."

"But I thought we decided Toby couldn't have done it because he was still on stage when Gretchen went through the trap door to her death. Don't tell me we have another impossible crime!"

Sebastian shook his head. "Not really. Our mistake was in jumping to the conclusion that the killer was waiting for her. Actually, Toby went downstairs after the act was over and killed her then. I suppose he swung the sword at her in jest, just as he did on stage, only this time it was for real. She wouldn't even have screamed when she saw it coming at her."

"How awful!"

"But what about you? How did you tumble to the fact the tour buses were being used?"

Laura shrugged. "Partly intuition, I suppose. We figured the gold was still leaving the country, and not by plane. It just seemed a likely method. Tour buses cross boundary lines all time, and they're not usually searched too carefully."

They came in sight of the airport and Sebastian said, "I

imagine Paris will look good to you after this. Or did you enjoy playing Medusa?"

She grinned and held up the wig with its writhing snakes. "I brought it along as a souvenir. Just so we'll know the whole thing wasn't a myth."

INTERPOL: THE CASE OF THE TERRORISTS

by Edward D. Hoch

M illie Blake opened the door to the inner office of the Paris
headquarters of Euro-African Airlines and allowed the
bearded man to enter with his painting. "What's it called?" she
asked, studying the abstract design with its embedded bits of
wood and metal.

"It's a collage. I call it *Rivers of Power.* See the tiny battery
and the wires? And this blue is the river."

"You artists!"

He smiled at her. "Where does it hang?"

"Right behind Mr. Truffet's desk. The gallery loans us a new
one each month. He likes variety."

He hung the painting carefully, standing back from time to
time to straighten it. "There you are." he said at last. "I wish
you a good month with it."

"Thank you," Millie answered with a smile.

After he'd gone she stood for a moment studying the collage of
paint and wire and wood. Finally she shrugged and returned to
her desk in the outer office. She'd been typing about twenty
minutes when Felix Truffet returned from lunch. He was a short
man with a tiny mustache, and looked nothing at all like the
pictures she'd seen of his handsome brother, the chairman of
Euro-African. As an employer he'd made her last six months
pleasant enough, but lurking just beneath the surface there was
a sinister quality she didn't like.

"The gallery sent another artist up with his painting," she
announced. "It's unusual."

Truffet stood in his office doorway and grunted. "This abstract
art! I'd be better off with another window!"

"He called it a collage. This little battery symbolizes power."

"Such idiocy! I've a mind to send it back."

She returned to her typewriter. "It's different, anyway."

"With that battery and wires it could be some sort of listening

device." His voice grew farther away as he went to study it. "It could even be a—"

His words merged with a sudden deafening blast that shook the building and sent a tongue of flame shooting out of the office door. She fought her way through the smoke, screaming his name, but it was too late. She ran to the telephone and called for help...

Sebastian Blue was never one to doubt a beautiful girl. Still, as he sat opposite this one he found himself listening to her words as one might weigh the assertions of some television commercial.

"You say he disappeared? People disappear all the time when they're wanted by the police."

Leslie Wallace shook her pretty blonde head. "You don't understand. He vanished more than a month ago—long before this bombing you accuse him of."

She was very British, like Sebastian himself, and displayed the slight superiority that Britons living in Paris often develop as a defense mechanism. His information was that she's met the artist Raoul Sanburn some months earlier and been living with him ever since. "You see, Miss Wallace, he delivered one of his paintings to Felix Truffet and the painting exploded."

"Paintings don't explode!"

"This one did. It had a thin layer of plastic explosives spread across the canvas. Into this was embedded a tiny battery, a timer, and a blasting cap."

"But Raoul didn't even *know* this Felix Truffet. He'd have no reason to kill him—no reason at all."

"He might if he were a member of a terrorist group. We've been trying to check Sanburn's background and he seems to have none before he met you and started selling a few paintings. But in the past few months three officers of Euro-African Airlines have been murdered. There was also an attempt on Truffet's own brother, just two weeks ago. Since the crimes took place in a number of countries, Interpol is coordinating the investigation."

"There's still no way Raoul could be involved. I sometimes wonder if he's even still alive."

"Suppose you tell me how he disappeared," Sebastian prompted.

"About five weeks ago we were out driving north of Lille, near the Belgian border. He told me he had to meet someone at a country inn nearby, and he sent me back to Paris with the car. I never saw him again."

"Did you call the police?"

"Certainly, but they were of no help. The innkeepers in the area knew nothing. The police dismissed it as a lovers' quarrel."

"Was it?"

"Not at all. Our relations were the very best."

"And there's been no word from Raoul since then?"

"None at all."

He passed her his card. "Phone me if you should hear from him." On the way out he said, "I'll be in touch."

Lunching with Laura Charme, Sebastian could not help comparing her with the young lady he'd just left. Laura had been his partner for nearly two years in Interpol's division of airline crimes. Half-French, widowed while still in her twenties, Laura was young enough to be his daughter. Still, to a divorced former Scotland Yard man trying to build a new life in Paris, she often seemed more like the answer to a dream. He especially liked to talk over cases with her, drawing out her innate intelligence and common sense.

"An absent artist," he told her as he sipped his glass of wine. "After being missing for five weeks, Raoul Sanburn returned to Paris with a painting that was a real bomb."

"You're certain it was him?"

Sebastian nodded. "He checked in at the gallery, knowing it was the day they changed the artwork at the Euro-African office."

"Let me see the file."

He handed it to her across the table. "Three murders and one close call. A Euro-African vice-president in their Rome office received a potted plant as a gift. The pot was filled with potassium chlorate and granulated sugar, with a timing device that set it off in one hour. A highly effective fire bomb. The executive burned to death.

"The second attack came a few months ago at Euro-African's world headquarters in Zurich. A man who gained access to the office on a pretext pulled out an automatic and fired a shot at C.

Crown Truffet, the firm's chairman. Luckily the bullet missed him and went out an open window. The would-be assassin fled before the security guards could seize him."

"That's the dead man's brother?"

Sebastian nodded. "The third attack, and second death, came last month in London. Euro-African's operations manager received a statue of a wing-footed Mercury for his office. The statue gave off a poison gas that killed him almost instantly. Now, in Paris, we have Felix Truffet killed by an exploding painting."

"Were any of the other assailants identified?" Laura asked.

"The one who fired the pistol is believed to be a hired terrorist named Cone. Nothing else is known. He simply dropped from sight, the same way our artist Sanburn did. Vanished without a trace."

She smiled at his words. "Off the face of the earth! Like that old British melodrama *The Demon Barber of Fleet Street*. That's the one where the barber chair tipped upside-down and deposited its victims in the basement."

"People *do* disappear without a trace," Sebastian insisted.

"Hardly ever—unless they want to."

"What about Benjamin Bathurst? It's quite a famous case. He was returning from Vienna by carriage on November 15, 1809. While stopping over in the small town of Perleberg, Germany, he walked around the horses to examine them while his secretary and his valet watched—and vanished. Completely and utterly vanished."

Laura Charme gave a laugh of derision. "My God, Sebastian, you've been brought up on Charles Fort just like all your countrymen! Fort—an eccentric American who almost went blind reading old newspaper articles in the British Museum. I know, I know—Chapter sixteen of his book *Lo!* 'He walked around the horses.' Along with 'Was somebody collecting Ambroses?' Two of the most famous sentences in all of Fort. But don't you see—it's simply not true!

"The facts in the disappearance of Benjamin Bathurst are not nearly so mysterious. For one thing, it was night-time on a dark street—a fact Fort conveniently neglects to mention. For another, his servants didn't even realize he was missing till the carriage was ready to leave some time later. He was last seen, quite casually, *near* the horses. But to say he walked around the

horses and vanished is sheer nonsense!

"Several months later articles of his clothing were found near the town, but Fort skips that part, too. Bathurst was only twenty-six at the time. I think it likely he simply decided to walk away from the coach in the dark and start a new life. Or he was lured away and killed by robbers. In either event, he didn't disappear as Fort has led readers to believe all these decades."

Sebastian bowed his head in mock defeat. "I'm helpless before your encyclopedic knowledge. But if you don't believe in mysterious disappearances, how do you explain Raoul Sanburn, and his return as an apparent assassin?"

"That," she said quietly, "is what I intend to find out."

"How?"

"It's summer, and I still look young enough to pass myself off as a touring student, bicycling through the French countryside. I'll take a list of the inns in the area where he was last seen and start from there."

Sebastian had long ago given up arguing with her. Besides, she just might find something.

During the two weeks that followed, Sebastian heard nothing from Laura Charme. She filed no reports with Interpol's headquarters outside Paris, nor did she try to reach him at his apartment. Concerned as he was, Sebastian did nothing to find her. Laura had operated under cover many times before, and for him to go snooping around those country inns might well blow her cover and endanger her life.

So he waited.

And used the time pursuing a number of other avenues of inquiry.

Euro-African Airlines was a publicly owned corporation, though much of the stock had been privately held by the Truffet brothers. C. Crown Truffet had started the airline shortly after World War II, mainly as a cargo carrier to link up a number of emerging African nations with the paternalism of European industry. But the airline had quickly turned its back on the Africans, preferring the more lucrative European tourist trade. When its planes did venture south of the Sahara, it was usually to bring in guns or ferry white mercenaries to the latest bloody conflict.

"Extortion," Sebastian told C. Crown Truffet, seated across from him in the long luxurious boardroom at Euro-African's Zurich headquarters. "That's the most likely motive. Have you received any demands for money?"

"None," the Frenchman replied. He was handsome and middle-aged, with a deeply dimpled chin that women found attractive. As they spoke, a security guard stood near the windows.

"What about your brother, Felix? Any threats there?"

"We know of none."

"Now what about this attack on you?"

He smiled. "Happily, it was not as successful as the others."

"Did you know this man Cone? Ever see him before?"

"No."

"The police reports say the shooting took place in this room."

"Correct. I was standing there by the open window, with Juan here and my secretary. He entered pretending to be a reporter and fired a single shot. I swear I felt the breeze of the bullet as it went by me out the window."

"The reports say the police found no clues, even after a careful search—not even the ejected cartridge from the automatic."

"Nothing," Truffet agreed.

Sebastian frowned. "Was the gunman right- or left-handed?"

Truffet turned to the security guard. "Juan, you were here. Which was he?"

"Right-handed," the guard said immediately. "I was on his other side, and I didn't see the gun till it was almost too late."

"How close were you to your brother's operations, Mr. Truffet?" Sebastian asked next.

"Close? Not very. We rarely saw each other except for the quarterly directors' meetings. I'm here in Zurich and he was in Paris, and I've been traveling a good deal this past year, since my wife and I separated."

"Oh?"

"She's in England now."

"Any reason for her to want revenge on the company?"

"Certainly not. She has a generous settlement."

"These deaths have affected your stock."

"Of course. There's been some selling."

"Could the terrorist activity be aimed at disrupting your arms traffic to Africa?"

C. Crown Truffet chuckled. "That is a typical policeman's question, Mr. Blue. Euro-African has never admitted any connection with traffic in arms, either legal or illegal."

The conversation went nowhere after that. Sebastian departed, glad to be away from that security guard, Juan, whose nervous manner seemed to indicate he wouldn't be caught napping a second time.

Just 16 days after he'd last seen Laura Charme, Sebastian called at the apartment of Millie Blake, the most recent victim's secretary. An unusual summer rainstorm had hit Paris, and as they talked the drops beat against her windows with increasing fury.

Millie was a bright young American girl who'd come to Paris the previous winter in search of adventure, armed with a knowledge of college French and a will to experiment. "It was a cool job," she explained. "The sort of job any American girl just out of college would love."

"What about your boss?" Sebastian asked. "What sort of man was Felix Truffet?"

"He was very considerate, very friendly."

"Ever make advances?"

"What?" She blushed a bit at his question.

"You're an attractive young woman, Miss Blake."

"Not to Mr. Truffet. He was all business."

"What about the airline itself? Was there ever a hint of anything irregular in its operations? Any smuggling?"

"Nothing like that, I'm sure."

"Were there ever any threats made against him? By a disgruntled former employee, perhaps?"

She shook her head. "I've been all over this with the French police. There was nothing."

Sebastian gazed out the window at the slashing rain. "What was Truffet's reaction to the previous killings, especially to the attack on his brother?"

"They were discussed, of course, but he never thought of himself as being in any danger. He felt the attempted shooting of his brother was the work of Crown's former wife."

"Oh?"

"She received a very good divorce settlement—ten percent of

the outstanding stock in Euro-African—but she still felt that Crown had cheated her somehow."

"Did you ever meet him? Crown, I mean."

"No. He never came to the Paris office."

. "What about his former wife?"

"Heavens, no! She wasn't friendly with Felix at all."

"What's her name?"

"Elizabeth Truffet. She went *back* home to England after the divorce, I guess."

"British girl?"

"So I heard."

"Thank you, Miss Blake," Sebastian said. "You've been a big help."

When he left the apartment it was still raining, though the downpour had lessened to a heavy drizzle. He crossed the street quickly and headed for his car.

"Sebastian!"

He heard the sound of his name, barely more than a whisper, from close at hand. He turned and smiled, recognizing Laura Charme as she emerged from a shop doorway. "I was worried about you, Laura. Where have you been all this time?"

"I was—"

She started to speak, but then her hand came out of her raincoat pocket. He saw the small deadly Beretta automatic pointed at his chest.

"Laura!" He gasped as she fired two quick shots.

Then he was falling, into the gutter where the rainwater ran in a thin stream toward the sewer down the block.

Laura Charme had traveled north toward the Belgian border by bicycle, joining the summer throngs headed for youth hostels and camps along the way. She mingled easily with the long-haired boys and bra-less girls, and if her temporary traveling companions wondered about her age, they gave no sign of it.

There were four country inns in the area she'd discussed with Sebastian, and any one of them seemed the likely site of Raoul Sanburn's disappearance. Her only reason for choosing the Gauguin Inn first was its name. It seemed a likely place for an artist to visit. The Gauguin proved to be a quaint country place off the main highway, a rambling one-story building sheltered by trees.

Leaving her traveling companions, Laura parked her bicycle and went in to the bar.

"I seem to have lost my way," she told a burly man wearing a striped pullover shirt. "Am I near the border?"

"Only a few more miles, Miss. Just join any of the groups on the main highway." He went on dusting wine bottles.

"Oh, good!" She started to leave. Then, in seeming afterthought, she asked, "Could I paint this place? It's so lovely!"

"You an artist?"

"Trying to be. A friend of mine named Raoul Sanburn mentioned this place to me once. I remembered the name as I was passing."

"We get a good many painters here," he agreed, "because of our name. Here, let me give you a drink on the house."

"I shouldn't," Laura said.

"One for the road."

"Well, just a little wine." The inn seemed deserted in midafternoon and she supposed he was thankful for the company.

"Come again," the man urged as she set down her glass to leave. "My name is Pierre."

"I'll do that, Pierre. Thank you for the wine."

She turned from the bar and started out the door. Well, that was one inn covered; only three more to go. This one had proved harmless enough.

Suddenly her vision began to blur. That was the last thought she had for some time.

She awakened with a terrible headache, lying on a lumpy cot in a darkened room. Even though she could see very little, she was aware of the man beside the cot. "Oh, wow! Now I know how Benjamin Bathurst felt!" She tried to sit up, then fell back again.

The blinds were suddenly opened and the pale light of a summer's evening flooded the tiny room. She saw the burly man, Pierre, more clearly now. "You know Raoul Sanburn?" he asked.

"What did you slip me, anyway?" She held her throbbing head and tried to sit up again.

"Merely some knockout drops. You'll be all right soon. It's no worse than a bad hangover."

"Thanks!"

He pulled up a straightbacked chair and sat down rather heavily. "Now tell me what you know of Raoul Sanburn."

"I knew him at school," she said, hoping that sounded convincing.

"And you came looking for him?"

"Yes."

"What's your name?"

"Laura Charme." She knew he would have searched her knapsack and found her driver's license. "Are you going to let me go?"

She started to swing her legs off the cot, but he caught them, forcing them back up. "Not quite yet. You're too weak to travel."

"Now look here! I could have the police on you for drugging me!"

Instead of answering he walked to the door and opened it. A bearded man entered and walked over to the cot, staring down at Laura. "Do you know her?" Pierre asked.

"I never saw her before."

But Laura recognized him from a photo the police had obtained from Leslie Wallace. "You're Raoul Sanburn. I met you once with Leslie."

Sanburn turned to the burly man. "She's lying. I don't know her."

"What are you doing here, Miss Charme?" Pierre asked. For the first time his manner seemed threatening.

"Leslie's worried. I came looking for Raoul. She said he disappeared in this area."

"Well, you found me," Sanburn said. "But I'm afraid now we can't let you go." He turned to the other man. "Pierre, keep her locked in here."

Now she was on her feet. "You can't do that! The police—"

Pierre caught her in a rough bear hug and threw her back onto the cot. He was half turned away when she shot out her right leg and caught him in the neck with a well-placed karate kick. He went down hard, and before Sanburn could move she was off the cot and facing him. "You next?"

He chuckled and held up his hands in a gesture of mock surrender. "You're a real tiger when you're angry!"

"Are you going to let me pass?"

"Let's talk about it, shall we? Out in the bar. I promise no tricks."

She followed him out of the room and down a narrow hall to the rear dining room of the inn. Sanburn ordered two glasses of wine from a bartender she hadn't seen before, and when Laura made a face he asked for the bottle instead. "You can pour it yourself," he assured her. "No tricks."

"Thank you."

Then he told the bartender, "Mike, you'd better see about Pierre. He hurt himself in the back room."

"Are you going to tell me what this is all about?" she asked.

Raoul Sanburn leaned back in his chair. "It's about an airline named Euro-African. For years now they've been supplying mercenaries to emerging African nations, running guns, generally stirring up trouble."

"How does that concern you?" Laura asked.

"A group of us have joined together to stop it—Pierre, myself, Mike over there, and a fourth man named Cone whom you haven't met."

"Stop it how—through bombings and terrorism? Yes, Mr. Sanburn, I read the newspapers, too."

"The weapons we use are the only ones available. And they are no worse than the terror inflicted daily on the people of those emerging nations. Euro-African is in this business for money. Lives mean nothing to them. Our objective is to give them a message they can't ignore."

"Laura had heard all the old terrorist arguments before. The IRA, the Arabs, the American student radicals of a few years back—all had spoken these same thoughts. The justification for murder. "Where will your killing end? Who's next?"

"You'll see."

"You tell me all this and trust me to leave here?"

He smiled. "I like the way you handled yourself with Pierre. We could use someone like you."

She sipped her wine. "I told Leslie I'd find you."

"You did find me."

"She wants you back."

"Leslie is a spoiled English girl who's always gotten what she wants. She'll find someone else."

"But why did you disappear without telling her anything?"

"There was work to be done. I didn't want a scene, so I simply left her. If she learned too much, it might go badly with her."

The implication of his words was only too obvious to Laura. "And what about me?"

"I said we could use someone like you. I want you to stay."

She hesitated only a moment. Sanburn was obviously attracted to her, or he wouldn't have told her this much. She could safely stay and learn more. If she left, an accident on the road could be too easily arranged. "I'll stay," she decided.

"Fine! I'll get you a room. Tomorrow you can meet the others."

It was two weeks later, on a bright summer's morning under an old willow tree behind the inn, that Raoul Sanburn told Laura they would have to kill Sebastian Blue. "He's been asking too many questions. He's getting too close."

"Who is he?" she asked innocently.

"One of Interpol's top people, in charge of airline crime investigations. He's a former Scotland Yard Inspector, and not likely to be put off the trail."

"How can you manage it?"

"I've sent Cone to Paris to get a line on him. When he has him spotted he'll phone me for the signal to go ahead."

She was silent for a moment. Then she said, "Raoul?"

"What is it?"

"Raoul, let me kill Sebastian Blue for you."

"You? But why?"

"To prove myself. I see the way I'm watched around here. Those two days you were away, Pierre never let me out of his sight, never let me go near a phone. You're still not sure of me, and I want to prove I can be trusted."

He gazed up at the sky, thinking about it. Finally he said, "All right, I'll let you do it. When Cone calls, we'll drive down to Paris and meet him. I'll give you a gun, and Pierre will back you up with a second gun in the event anything goes wrong."

"Nothing will go wrong," she assured him.

"You're a cool one, Laura."

Two days later, following Cone's call, they drove south through a summer rainstorm to Paris. Pierre was driving, alone in the front seat, while Sanburn sat in the back with her. "Here

is the pistol," he said, passing her a little Beretta automatic. "It's loaded with eight rounds, but you shouldn't need more than two to do the job. Fire at the chest—it's always a bigger target than the head. Pierre will be backing you up from down the block. If you miss he'll finish the job."

"What about you?"

"I'll pick up Cone, then swing back to pick up you and Pierre. This foul weather is perfect for us. The streets should be almost deserted."

"All right," she said, accepting the weapon.

During the past two weeks she'd learned a great deal about the terrorist group that Raoul Sanburn controlled. She knew it was Cone who had made the attempt on C. Crown Truffet's life, and Raoul who had delivered the painting bomb that killed Felix Truffet. She'd learned a great deal about Sanburn himself too, on the first night he'd tried to make love to her.

"It's raining harder," Pierre said from the front seat, peering through the windshield. Though still late afternoon, it seemed almost night-time.

"We'll be there soon," Raoul said.

"Could we stop at a rest room?" Laura asked. "I guess I'm a bit nervous." She slipped the pistol into her raincoat pocket.

When they started up again after the stop, Sanburn was driving. Pierre sat in back with her, and that made her uncomfortable. Ever since that karate kick the burly man had treated her coolly—not really accepting her as one of the small group. She knew he'd like nothing better than a chance to even the score.

The rain had slowed to a heavy drizzle by the time they reached the Paris neighborhood they sought. Raoul slowed the car to a stop at a corner and Cone slid into the front seat. He was a blank-faced gunman with skin as white as a skull's, and Laura knew he shot heroin every morning. "Keep driving," he told Raoul. "Blue's gone to Millie Blake's apartment. It's a few blocks from here."

They drove past the building Cone indicated, and then Raoul said, "You get out, Laura. Wait across the street in the doorway. Cone, you might as well stay with me. We'll drop Pierre farther along the block to cover her."

Cone nodded and said to Laura, "Blue is a big man, in his early fifties, wearing a belted raincoat. You'll know him."

Yes, I'll know him, Laura sighed to herself. I'll know him.

She got out of the car, turning up the collar of her coat, and hurried to the doorway. She couldn't see Pierre from where she stood, but she knew he wasn't far away. Despite Raoul's words of trust, he was covering all the angles. If she tried to warn Sebastian, they might both end up dead.

She'd been standing there about fifteen minutes, waiting, when she saw Sebastian come out of the building across the street. He was walking in her direction, probably headed for his car.

"Sebastian!" she called out.

He turned at the sound of his name, seeing her and smiling in recognition. "I was worried about you, Laura. Where have you been all this time?"

"I was—"

Her hand came out of the raincoat pocket, holding the Beretta.

"Laura!" He gasped as she fired two quick shots.

"Perfect!" Raoul Sanburn said as she slid into the front seat next to him. "Pierre couldn't have done it better himself!"

"That's the first time I ever killed a man," she said quietly.

"The next time will be easier."

"Where to now?"

"Back to the inn." He slowed the car again and Pierre jumped in the back, next to Cone. Then they were speeding away through the dark, wet Paris streets, headed north. "I must go away again for a few days, but now I know you can handle yourself. This time there'll be no need for Pierre's watchful eye."

From the back seat Pierre grunted. "He talked to her."

"What?"

"Blue said something to her before she shot him. He called her by name."

Raoul took his eyes from the road to shoot a glance at Laura. "Is that true?"

"Of course not! How would he know me?"

They drove in silence for a time and she was aware of Pierre's eyes on the back of her head. After about an hour, as they were crossing the bridge over the Somme River, Raoul Sanburn slowed the car.

"Give me the gun," he said. He stepped from the car for a

moment, pulled back his arm, and hurled it far out into the inky water. Then they drove on.

There were only a few cars at the inn when they arrived. Raoul was in better spirits, apparently deciding to ignore Pierre's accusation, and as he led the way to the entrance he said, "This calls for a celebration. We'll open a bottle of champagne."

At first, as they entered, there seemed to be no one behind the bar. Then, suddenly, the figure of Sebastian Blue rose from behind it like a wraith. He held a revolver in each hand and he was smiling. It was the happiest sight Laura Charme had ever seen.

"Please raise your hands, Mr. Sanburn. And the others, too. The French police are in control here."

Pierre turned and tried to run, but Laura skillfully tripped him. Cone had already raised his hands. Raoul Sanburn could only gape. "You're dead—back in Paris!"

"Not quite dead enough, unfortunately for you, Mr. Sanburn. Or should I call you by your real name—Mr. C. Crown Truffet?"

The French police, who'd already seized the bartender and other employees, quickly took charge of Sanburn, Cone, and Pierre.

"Sebastian, you're a wonder," Laura said.

"I had a bit of help from you."

Sanburn, in handcuffs, was smoking a cigarette while they waited for the police cars to be brought from their hiding place. "My attorneys will have me out on bail by morning," he assured them.

"We'll see," Sebastian said. "The Truffet fortune might not stand up against charges of three terrorist killings."

"Why did he do it?" Laura asked.

"His motives have to be pretty much a guess, until we can examine the company's books. But his British ex-wife received ten percent of the outstanding stock in Euro-African as a divorce settlement. It's possible he feared she'd team up with his brother Felix to drive him out of the company. The killings served two purposes—they drove down the price of Euro-African stock, making her holdings worth less, and they eliminated his brother from the scene. So long as the blame was placed on terrorists, he was in the clear

"But how did you know Sanburn was Truffet? For one thing, I thought Sanburn was young and Truffet middle-aged."

"No one ever described Sanburn as young—not even Millie Blake when he brought that painting. Perhaps you merely connected a bearded artist with youth. But the beard is a fake, as I can quickly prove." Sanburn gave a yell as he pulled it off the handcuffed man. "As for knowing Sanburn and Truffet were the same man, I didn't know it till I saw him just now. But there was enough circumstantial evidence to make me strongly suspicious."

"Like what?" she asked.

"For on thing, there was the attempt on Crown Truffet's life. Cone entered the Zurich boardroom and fired one shot at him. But though the police searched the room carefully, they found neither bullet nor ejected cartridge. The bullet may have passed out an open window which was conveniently behind Truffet at the time, but since the testimony was that Cone's weapon was an automatic pistol, there should have been an ejected cartridge. I asked Truffet if the gunman was left-handed, because then the cartridge might have been thrown back into his clothing—a pocket or pants cuff. But Cone fired with his right hand, and that left only one likely explanation. There was no ejected cartridge because the bullet was a blank."

A wide grin had lit up Laura's face as he spoke. "Of course! It's an automatic's recoil that ejects the spent cartridge and jacks a fresh one into the firing chamber. But when a blank is fired, the gases escape out the barrel and there is no recoil. The slide has to be pulled back manually to eject the cartridge."

Sebastian nodded. "That also explains why Cone fired only one shot. So I was convinced the attack on Crown Truffet was a fake. The very nature of that attack had made me suspicious from the beginning, by the way. Felix Truffet and the other two victims all died by clever mechanical means—a fire bomb in a flower pot, an exploding painting, poison gas from a statue. A mere shooting didn't fit the pattern at all—unless it was a fake to turn suspicion away from Truffet when his brother was killed.

"The attempt on my life today was more proof of Truffet's involvement. He was worried by my question about the missing cartridge case. Once I linked Truffet with the supposed terror-

ists, I started looking at him and our absent artist. Truffet was often away on trips, and Sanburn seemed to have no background before Leslie Wallace met him. When I came here tonight, there was at least a possibility they were the same man. The photo of Sanburn did nothing to dispel that possibility, and when I saw him—when he recognized me—I knew."

Laura nodded. "Millie Blake had never seen Crown Truffet, so she wouldn't have recognized him when he delivered his painting. But of course Crown Truffet would be in a position to know his brother's habit of getting a new picture from the gallery every month."

"That was the original purpose of the Sanburn identity," Sebastian added. "To establish himself as an artist so he could get the painting to his brother through the gallery. Felix Truffet's death had to be the key one."

The police cars were pulling up now, and a French detective put a firm hand on Sanburn-Truffet's shoulder. "What about you?" he asked Sebastian, resisting efforts to be led away. "Pierre saw her shoot you, and so did I!"

It was Laura who answered. "When I stopped at that rest room, I used my nail file to pry the lead slugs from the first two bullets. Then I stuffed a wad of toilet paper into the cartridges to keep the powder from falling out. They made effective blanks when I fired them—but I had to work the slide by hand to get the second bullet into the chamber, as we've just explained." She was smiling slightly. "You and Cone know about blank cartridges, don't you, Raoul?"

"And I played dead," Sebastian said. "I trust Laura more than any other person on earth. When she shot at me, I knew someone had to be watching her. I knew what was expected of me, especially when no bullet hit me."

"What if Pierre had fired another shot?" Raoul asked.

"My third bullet was a good one," Laura said. "I'd have killed him, of course. But I wanted to get you all, and that's why it had to be back here."

Sebastian went on. "As soon as you made your getaway, I ordered a helicopter from the French police and got here first. That part came naturally. I once did something similiar in Turkey."

"But—" Sanburn-Truffet was still baffled. "How did you

know where to come?"

"Laura told me," Sebastian said. "She left me a message—*Sanburn at Gauguin Inn.*"

"She couldn't have—Pierre was watching her every minute! She didn't drop anything, and if she had, it might not have been found!"

"I was lucky you gave me an automatic instead of a revolver," Laura told him. "As we've been discussing, there's one thing that's always dropped when you fire an automatic, even if you have to work the slide by hand. And it's something that's always searched for and carefully examined by police at any shooting scene. While I was in that rest room I used the point of my nail file to scratch the message on the cartridge cases my gun would eject."

INTERPOL: THE CASE OF THE FLYING GRAVEYARD

by Edward D. Hoch

The first report of the downed aircraft reached Inspector Geroux as he was finishing his meager breakfast. He disliked being called out so early in the morning, especially for something not strictly his responsibility.

The plane had come down in a heavily wooded area near the Swiss border, sheering off the tops of the trees as it plunged to earth. It was a twin-engined chartered jet bound for London, but that was all the Inspector could establish on the telephone. There was little more to be learned at the scene. He trudged across a plowed field to the edge of the woods, staring at the splintered trees and wounded earth. It was a hell of a way to die.

"No survivors," one of the uniformed officers told him glumly.

"How many aboard?"

"We're checking that now. We've recovered four bodies so far. There may be more."

Geroux grimaced. "Did it explode when it hit?"

The officer shook his head. "There was a fire, but the wings broke off when they hit the trees and the wing tanks didn't go up. The burning plane was a hundred yards away from the wings."

"Not that it helped those poor souls any."

For the next hour the grim task went on. Dr. Billou, the local coroner, arrived and went about his task of tagging the bodies. Charred and severed limbs were collected separately in plastic body bags. Geroux watched from a distance, pitying one whitefaced worker who walked behind a tree to be sick.

"We have a report now," the police officer told him. "It was a charter flight from Rome to London, carrying four businessmen and the pilot."

Presently, as the men were finishing their grisly task, Dr. Billou approached Geroux. "Can we talk out of earshot of the others?" he asked.

"Certainly." Geroux led him away across the newly plowed

fields. "What's troubling you?"

"Did you get a good look at any of those bodies?"

"Only from a distance, Doctor. My stomach is not strong."

"I think you'll have to get a bit closer. There's something strange here."

"Strange? In what way?"

Dr. Billou dropped his voice to a whisper, though there was no one near them. "That's a plane-load of dead men!"

"I should think they are dead, after that crash and fire."

"No, no, you don't understand. They were dead *before* the crash! Dead and perhaps buried. There's no blood in their veins—all five bodies are full of embalming fluid!"

At Interpol's headquarters outside Paris it was a normal busy Tuesday. Sebastian Blue had not seen Laura since the weekend, and at the moment his mind was otherwise occupied. The Secretary-General had passed him a sheaf of press clippings from papers as varied as the London *Sunday Times* and Japan's *Asahi Shimbun*.

"Don't worry about the ones you can't read," the Secretary-General told him. "They all say pretty much the same thing. Interpol is helpless against acts of international terrorism, and may have outlived its usefulness."

"I know we've had political and budgetary problems, but—"

"It's more than that, Sebastian. People are calling us old-fashioned, behind the times. Figures show that fully ninety-five percent of police inquiries in Europe are now conducted directly between police forces, rather than passing through our channels. New groups are being established to do the work we once did. Even your own specialty, airline crime, is being preempted by the new International Association of Airport and Seaport Police."

Sebastian Blue smiled. "Are you saying Interpol no longer needs my services?"

"No, no. I am merely pointing out some of our current image problems. Happily, our new Drug Intelligence Unit has been very well received. Their troubleshooting team has been called on for several foreign assignments. And certainly you and Laura Charme have met with equal success. The concept of team action, available on instant call, may be our hope for the future."

The blinking light on his desk interrupted him, and he pushed the intercom button. Immediately Sebastian heard Laura's familiar voice. "Sorry to intrude, sir, but we need Sebastian Blue."

"What is it?"

"Airline Crimes Unit has an emergency request for aid, from an Inspector Geroux in a town near the Swiss border. It's concerning the crash of a charter jet this morning."

"You'd better see about it, Sebastian," the Secretary-General said.

"Very well, sir,"

He found Laura in her office, studying a map of southern France. "This is where it crashed, Sebastian."

"Did he say why he needed us?"

She shook her head. "But his voice on the telephone seemed quite agitated."

"A case of sabotage, I suppose. We'd better fly down for a look. It would be the responsibility of the nation where the flight originated, of course, but we might be able to lend a hand."

He supposed it was partly the Secretary-General's conversation regarding Interpol's fading image that impelled him to make the decision. Certainly there was nothing the French police inspector could tell him that would justify Interpol's involvement.

Or so he thought.

Six hours later, seated in Geroux's little office, he and Laura knew better. "Dead men?" he repeated, not quite understanding.

"A flying graveyard," Geroux said. All five people on that plane were already dead and embalmed when it crashed."

"Then who was flying it?" Laura asked.

"We don't know."

"Have you told the press about this?" Sebastian asked.

"Certainly not. So far only Dr. Billou and I know."

"The next of kin will want the bodies. Have they been notified?"

The Inspector shook his head. "Frankly, Mr. Blue, we're not at all certain the bodies in the crash were those of the men who boarded the plane in Rome."

"Be almost simpler if they weren't," Sebastian mused.

"How do you mean?"

"I'd rather believe the plane made an unscheduled stop while the five men left and the bodies were put aboard, than try to imagine a method by which five people could be embalmed while in the air."

"In any event, I thought it a job for Interpol," Geroux said.

"And rightly so, since several countries may be involved. But we must keep the press out of this at all costs. They would surely fill their papers with speculation on flying saucers and the like."

"But if it's not flying saucers," Laura saked, "what does that leave us?"

There was a map of southern Europe on the wall of Geroux's little office, and Sebastian walked over to it. "I suppose we must consider the possibility of insurance fraud. Men have pretended death before to collect their own insurance."

"But *five* of them?"

He pointed to the map. "Look here, the most direct air route from Rome to London passes over the Swiss Alps. In order to have crashed where it did, this plane had to have drifted slightly off course to the west. If it had been on course, it would have gone down in the mountains."

They thought about that for a moment and Laura said, "It would have crashed and exploded on a mountainside. The wing tanks would have gone up. There'd be very little left."

"The bits and pieces of bodies would have ended up in a mass grave on a mountainside," Inspector Geroux agreed. "It's sometimes done when the crash site is too difficult to reach."

"And the fact the bodies were embalmed would never have been discovered!" Laura turned to Sebastian. "That's it—the plane was meant to go down in the Alps! But whoever set the automatic controls before bailing out miscalculated a bit."

"I want you to keep this whole thing under wraps," Sebastian instructed Giroux. "Not a word to the press or anyone else. The people behind this must believe their scheme was successful."

"Where do we start looking?" Laura asked. "In England or in Rome?"

"Both," Sebastian decided. "You're going to London, to talk with the next of kin. I'm going to Rome."

Laura Charme tried not to speculate on Sebastian's reason for

sending her to England while he went south. Perhaps he felt she could more readily deal with the bereaved women. Or perhaps he wanted to avoid another encounter with his former wife and her Scotland Yard husband. It had been the collapse of that marriage which brougnt Sebastian Blue to Paris and to Interpol. And to Laura.

Now, breathing in the brisk spring air of London, she pushed Sebastian's motives out of her mind as she boarded a train for the brief journey to Greater Ware, a northern suburb that had been the home of the plane's four passengers. It was the morning after the crash, and she wasn't surprised to learn from a telephone call that the four apparent widows had gathered at the home of one of them.

It was a neat little house near the station, with a yard that would surely produce roses by summer. A red-eyed woman of uncertain middle age answered the door. "Mrs. Smothly? My name is Laura Charme—"

"Another reporter?" The door was about to close on her.

"No, no, I'm an investigator for the French government, looking into the cause of the plane crash. I phoned Mrs. Jenkins and was told she and the other wives were over here." She'd purposely avoided mentioning Interpol's name.

"I know nothing about the crash," the woman said. "Only that Gordie's not coming back to me." Her eyes filled as she spoke.

"May I come in?"

"Just for a few minutes." She stepped aside and Laura entered.

The other three women were in the kitchen, drinking some morning coffee. They did not immediately join Laura and Mrs. Smothly in the living room. "I know it must have been a terrible shock," Laura said.

"It was that," the woman agreed, seating herself on a sofa that was just a little threadbare.

"Can you tell me something about the nature of the trip?"

"Gordie and Tom Jenkins and the other two are all employees of Heath House, Limited. They are engineers whose job is the installation of computer systems in foreign countries."

Laura noted her use of the present tense. Either she hadn't yet accepted the fact of their deaths, or she had reason to know they were still alive. "And they were in Rome to do a computer

installation for the company?"

"Yes. With the necessary equipment and such, it's always been easier to fly down on a chartered jet than on a commercial airline. Heath House has an agreement with the charter company for regular service,"

"Where in Rome was the installation being made?"

"At a Catholic university there. Odd, you don't think of computers very often in connection with the Eternal City."

"No," Laura agreed. "Tell me, Mrs. Smothly, was your husband covered by life insurance?"

The woman nodded. "All of them were. It was a company policy paying 50,000 pounds each in the event of accidental death while traveling on company business."

"That's a great deal of money."

"Oh, yes, it would be for us. Gordie was never paid all that well, you know. They say computer technologists in the States earn a great deal more. And with this inflation and everything—"

One of the other women came in from the kitchen then, carrying her coffee cup. She was younger than Mrs. Smothly, and better-looking, with straight blonde hair that hung to her shoulders. "Are you from the insurance company?" she asked Laura. "I heard you mention the policy. I'm Mrs. Jenkins. My Tom was on the plane too."

"Not insurance," Laura told her. "I'm investigating the crash for the French government."

"Do they think it might have been sabotage? A bomb or something?"

"I have no way of knowing."

Mrs. Jenkins tossed back her long blonde hair. "If that's the case, you should be checking the other end, in Rome. That's the place where the bomb would have come from, not here."

"Stop all this about bombs!" Mrs. Smothly exclaimed. "Let me get you some coffee, Miss Charme. Or would you prefer tea?"

"Coffee would be fine."

When Mrs. Smothly returned from the kitchen the other two women came with her. Like Mrs. Jenkins they were younger and more attractive than Mrs. Smothly. One introduced herself as Rita Blake, while the other was a sullen dark-haired girl named

Younglove. "Alice Younglove." She spoke her name slowly, meeting Laura's eyes as she did so. "Why are you investigating?"

"The government always does in these cases. We try to prevent its happening again."

Rita Blake seated herself next to Laura. "Will that help bring our husbands back?"

It just might, Laura thought to herself. It damn well might! These women were already beginning to get on her nerves. She wished she was with Sebastian, and she wondered what he was doing at that momnet.

Rome, to a professed nonbeliever like Sebastian Blue, had always seemed something of a curiosity. Now in this Holy Year it was a city of pilgrims and tourists, crowded beyond capacity, with special buses running every fifteen minutes between the churches. He could only look and wonder.

The man he first sought out for information about the ill-fated flight was a priest, a boyish-looking American in his thirties who was in charge of purchasing for a large Catholic university. "Certainly," he told Sebastian as they strolled across the tree-shaded campus. "I ordered the computer with the approval of our board of trustees. Heath House had the lowest bid and they won the contract. Most of the hardware was shipped here by freighter, and these four men came down to assemble it and instruct us in its use. They were here about a week in all."

"Did you notice anything unusual during their stay? Any tensions? Any unexplained visitors?" he asked Father Philip.

"Well, of course we didn't keep tabs on their free time. I suppose they toured Rome just like other visitors. I know on Saturday night the four of them went out to a restaurant on the Via Veneto, and later to a somewhat disreputable night club near the Pantheon."

Sebastian made a note of the names. "What about their pilot?"

"I saw nothing of him."

As he was preparing to leave, Sebastian had another thought. He asked the priest, "Where would one go in Rome for some bodies—unclaimed bodies, with no next of kin?"

Father Philip shot him a puzzled glance, then replied, "One of the charity hospitals, I suppose. People die there every day without kin. Mostly old folks, of course."

Sebastian Blue nodded, trying to recall if Geroux had commented on the age of the bodies in the plane wreck. He was sure there'd been no mention of it. Still, the charity hospitals seemed a likely place to begin. "Thank you, Father. You've been a great help."

"I'll pray for the men who died."

Sebastian went first to the restaurant where the four had dined on Saturday evening, but they were only vaguely remembered. He had better luck at the night club near the Pantheon. It was, as the priest had warned, a disreputable place. In the early afternoon there were already of few of Rome's prostitutes lounging at the bar, though they seemed more interested in exchanging pleasantries than in soliciting trade.

"Four Englishmen," Sebastian said to the bartender. "They were here late Saturday night."

The barman stared blankly into space until Sebastian offered him an Italian banknote. Then he said, "I may remember them. They wanted girls."

"Did anyone join them—any other men?"

"I didn't notice."

"Which girls?" He glanced down the length of the bar.

"Maria was one." He indicated a dark-haired girl, a bit overweight but with a friendly smile. "Ask her."

But Maria was too experienced to the ways of police questioning. She wasn't about to risk an arrest for prostitution. "I don't know a thing," she said, speaking so fast in slangy Italian that Sebastian could barely understand. "I sat at their table and talked to them. No law against that, is there?"

"None at all. Did you go anywhere later?"

"Home to bed. Alone."

"Which man did most of the talking?"

"I don't remember."

"Was it Jenkins? Or Smothly? Blake? Younglove?"

"Younglove—that Younglove didn't say anything. I think he was wishing he was home with his wife."

"Did they mention a plane? A pilot?"

"A pilot, yes. They had to meet him later."

"Where?"

"I do not know."

"Think harder."

She tried to stare him down but then looked away. "A hospital was mentioned. The pilot was at a hospital."

"Ill?"

"No, no! Visiting—seeing someone."

"Which hospital?"

"I don't remember. Maybe they didn't say."

Another five minutes and an offer of money convinced him he'd get no further with her. She finished her drink and headed for the door, swinging her white leather purse.

The bartender moved down to Sebastian's spot. "She's a tough baby. She tells nothing."

"You mean she has something to tell?"

The man merely smiled. Sebastian took out another banknote.

"Sure she has something to tell, but you won't get it out of her. The pilot was in here later and she made a date with him."

"You're sure of that?"

"I saw her jot down his name and address in her appointment book. Maria is very efficeint. It's a business, you know?"

Sebastian reached the street in time to see Maria just turning the next corner. He kept her in sight, pausing to glance at a bookstore window while she lingered with two other girls. Then, as she set off once more alone, heading down a narrow side street off the Via del Plebiscito, he spotted two teenagers on a motor scooter. Interpol's reports had made him familiar with the Roman *scippi,* young purse snatchers who gunned their scooters along the curb while the youth behind the driver grabbed handbags from women walking too close to the pavement.

He hailed the youths and showed them a folded banknote. "Could you get that woman's purse for me?"

The driver, a long-haired boy in tight jeans, scoffed. "Are you police?"

"Do I look like it? She is my mistress, and there is evidence in the purse of her unfaithfulness. Come on, do me this favor!"

The youths needed no more persuasion. The one behind the driver snatched Sebastian's bill and said, "Wait here!" And they were off.

He watched from a distance as they followed Maria down the narrow street. Wise in the ways of the city, she was walking near the buildings, away from the curb, but this didn't stop the

scooter bandits. At the proper moment the driver gunned his machine and jumped the low curb, coming up right behind her on the nearly empty sidewalk.

Maria screamed as the bag was torn from her grip and the scooter thieves made their getaway. Sebastian heard her string of profanity following them. Then the scooter vanished from sight around a corner.

Sebastian had to wait ten minutes before one of the youths returned on foot. He slipped the purse out from beneath his shirt and accepted another banknote. "Good luck with her," he said. "She is a wild one."

Sebastian stepped into an alleyway and went quickly through the purse. There was no cash—he assumed the youths had already removed that. But the little appointment book was there. He flipped to last Saturday's date and saw a single name—Dante Matto—together with the room number of a hotel across town.

Dante Matto had been the pilot's name. It was on the list of dead in Sebastian's pocket.

After a day spent questioning the people at Heath House and the friends and neighbors of the four supposed victims, Laura Charme had a number of ideas but no concrete evidence. As evening approached she decided a second visit to one of the grief-stricken widows was called for. She chose the sullen, dark-haired Alice Younglove because she had a hunch the truth might lie closer to the surface with her.

Alice Younglove lived in a modern but modest apartment not far from the Smothly home. It was obvious at once that there were no children here, though the death notice in the papers had referred to a young son.

"He's staying with my mother," Alice answered in response to Laura's question. "He's too young to realize what it's all about, but he misses his daddy."

"I've talked to your husband's coworkers at Heath House. I understand you were having financial difficulties."

"Isn't every young couple, these days?"

"The insurance money will certainly help you."

"Yes, it will."

"Of course there's always the possibility of fraud in such cases."

"Fraud?"

"Insurance fraud. Frankly, Mrs. Younglove, there's some question as to whether the body in the wreck was really that of your husband."

"What do you mean? What are you talking about?" Her sullen exterior had changed to one of near panic.

"He might be still alive. Does that news please you?"

"I—of course!"

"But then again, if he is alive, he might end up in prison."

"What are you doing to me?" the girl demanded, close to tears.

"Only trying to get at the truth."

Alice Younglove rose and went into the kitchen. When she returned after a few moments she was more composed. "I really don't know any more than I've told you. But I'm certain my husband wouldn't have been involved in anything dishonest."

"What if I told you he never intended to return from Rome? That he'd removed some personal effects from his office before the trip?"

"That would be natural for a long trip."

"But the Rome trip was only supposed to be for a week, wasn't it?" Laura pressed on. "And you recently had your passport renewed. Odd that you'd be planning foreign travel if things are so bad financially."

"We often go to Paris in the summer. The passport was expiring, so I renewed it." She was cool again, and Laura realized she had missed the opportunity to break her.

"The insurance company will be watching, you know. If any of you four women try to leave the country and meet secretly with your husbands, you'll be discovered."

Alice Younglove leaned back on the sofa. "Now how could we do that, Miss Charme," she asked with a faint smile, "when our husbands are dead?"

Toward evening Sebastian Blue's long wait was finally rewarded. A tall slender man who might have been the missing pilot crossed the lobby of the Giallo Hotel and asked for his room key. Sebastian had already established that no one named Dante Matto was registered there, but this fact didn't surprise him. A man pretending to be dead would hardly remain registered under his real name.

But the room number was right, and Sebastian followed him

scooter bandits. At the proper moment the driver gunned his machine and jumped the low curb, coming up right behind her on the nearly empty sidewalk.

Maria screamed as the bag was torn from her grip and the scooter thieves made their getaway. Sebastian heard her string of profanity following them. Then the scooter vanished from sight around a corner.

Sebastian had to wait ten minutes before one of the youths returned on foot. He slipped the purse out from beneath his shirt and accepted another banknote. "Good luck with her," he said. "She is a wild one."

Sebastian stepped into an alleyway and went quickly through the purse. There was no cash—he assumed the youths had already removed that. But the little appointment book was there. He flipped to last Saturday's date and saw a single name— Dante Matto—together with the room number of a hotel across town.

Dante Matto had been the pilot's name. It was on the list of dead in Sebastian's pocket.

After a day spent questioning the people at Heath House and the friends and neighbors of the four supposed victims, Laura Charme had a number of ideas but no concrete evidence. As evening approached she decided a second visit to one of the grief-stricken widows was called for. She chose the sullen, dark-haired Alice Younglove because she had a hunch the truth might lie closer to the surface with her.

Alice Younglove lived in a modern but modest apartment not far from the Smothly home. It was obvious at once that there were no children here, though the death notice in the papers had referred to a young son.

"He's staying with my mother," Alice answered in response to Laura's question. "He's too young to realize what it's all about, but he misses his daddy."

"I've talked to your husband's coworkers at Heath House. I understand you were having financial difficulties."

"Isn't every young couple, these days?"

"The insurance money will certainly help you."

"Yes, it will."

"Of course there's always the possibility of fraud in such cases."

"Fraud?"

"Insurance fraud. Frankly, Mrs. Younglove, there's some question as to whether the body in the wreck was really that of your husband."

"What do you mean? What are you talking about?" Her sullen exterior had changed to one of near panic.

"He might be still alive. Does that news please you?"

"I—of course!"

"But then again, if he is alive, he might end up in prison."

"What are you doing to me?" the girl demanded, close to tears.

"Only trying to get at the truth."

Alice Younglove rose and went into the kitchen. When she returned after a few moments she was more composed. "I really don't know any more than I've told you. But I'm certain my husband wouldn't have been involved in anything dishonest."

"What if I told you he never intended to return from Rome? That he'd removed some personal effects from his office before the trip?"

"That would be natural for a long trip."

"But the Rome trip was only supposed to be for a week, wasn't it?" Laura pressed on. "And you recently had your passport renewed. Odd that you'd be planning foreign travel if things are so bad financially."

"We often go to Paris in the summer. The passport was expiring, so I renewed it." She was cool again, and Laura realized she had missed the opportunity to break her.

"The insurance company will be watching, you know. If any of you four women try to leave the country and meet secretly with your husbands, you'll be discovered."

Alice Younglove leaned back on the sofa. "Now how could we do that, Miss Charme," she asked with a faint smile, "when our husbands are dead?"

Toward evening Sebastian Blue's long wait was finally rewarded. A tall slender man who might have been the missing pilot crossed the lobby of the Giallo Hotel and asked for his room key. Sebastian had already established that no one named Dante Matto was registered there, but this fact didn't surprise him. A man pretending to be dead would hardly remain registered under his real name.

But the room number was right, and Sebastian followed him

up the elevator. The man seemed nervous at the sight of another passenger and fidgeted over a cigarette until he finally managed to light it. When he got off at the fourth floor, Sebastian was right behind him.

"You looking for somebody?" he asked finally at the door of his room, turning the key in the lock.

"You, I think," Sebastian said calmly. "You are Dante Matto, aren't you?"

He'd been on guard against some sudden movement, but Matto's punch still caught him off guard. The tall man's fist slammed into his stomach, doubling Sebastian up. He saw the fist coming down for a blow at his unprotected neck and in that instant he wished he'd bothered to learn some of Laura's judo and karate tricks.

He jerked his body away, taking the blow on the shoulder, and rolled with it. Matto started to come down on top of him, but Sebastian grabbed his legs and tumbled him over backward against his partly open door. They ended up on the floor of the hotel room, with Sebastian on top.

"Look here now, I'm too old for this sort of rough and tumble. Any more of it and I'll have to shoot you." He had slipped the small Beretta pistol out of his pocket.

"Who are you?" Matto asked, gasping for breath.

"Sebastian Blue, Interpol. You're in a great deal of trouble, as if you didn't know it."

"I—"

"Tell me about the charter flight for Heath House."

"It was nothing unusual."

Sebastian got off the man's chest and moved back, keeping the Beretta level. "The plane took off from the Rome airport on schedule—I've already checked that. But then you made a completely unscheduled landing somewhere."

"I don't know about that."

"You don't know you're listed among the dead following the crash of that plane in France?"

"I—I wasn't flying it. One of the passengers, Tom Jenkins, wanted to fly it back. He was a licensed pilot, so I saw no harm."

"What would your charter company think of that?"

"Jenkins said he'd make it right. Heath House is our biggest client. I was to stay on in Rome and he'd tell the company I was

sick or something. I met this girl last week—"

"Maria."

"How did you—?"

"Never mind that. Jenkins paid you money, didn't he?"

"Yes."

"A great deal of money. He paid you not to fly the plane and he paid you to get some dead bodies for him."

"That's crazy!"

"Not so crazy. The bodies came from a charity hospital, didn't they?" Sebastian motioned with the gun. "I want a straight story."

Matto licked his lips and eyed the weapon, as if calculating his chances. "Sure," he said finally. "I have a cousin who's an undertaker. He gets some of the city's work at hospitals and the morgue. The bodies were due to be buried in paupers' graves. I loaded them into a truck and took them to an airstrip up near Livorno. It was a joke!"

"A joke," Sebastian repeated distastefully. "How many bodies?"

"Five."

"So there was one for you too."

Matto nodded without answering.

"Where are they now—the four Englishmen?"

He shrugged. "Off to the Greek islands, I think."

"Did Jenkins fly the plane on the last leg of the trip?"

"Yeah. He set the controls and bailed out. He'd done some skydiving, so it was easy for him. Except that the plane didn't crash where they thought it would."

"You might say the joke was on them," Sebastian observed. He picked up the telephone with his free hand and gave the switchboard operator the number of Inspector Pettegolo of the Rome police.

"You're turning me in?" Matto asked.

"I've no choice. As you say, the plane didn't crash where they thought it would."

Laura was in her hotel room when the call from Rome came. She'd been expecting Sebastian to phone, and the sound of his voice gave her a warm, comfortable feeling. "It's started to rain here," she said, glancing at the spots of moisture on the window. "I hope the weather's better where you are."

"Sunny all day. How are you progressing with the widows?"

"About as expected. I've found evidence that every one of the husbands behaved unusually just before the trip—took home personal possessions from the office, picked up travel folders for South America, things like that. But the wives are keeping a united front. They're not admitting a thing."

"What about the funerals?"

"The supposed remains are being brought back in sealed coffins. There's to be a cremation and memorial service tomorrow morning." She hesitated, then poured out her frustrations. "Damn it, this case is so irritating! Nothing's happening here!"

"I'm having better luck here," Sebastian told her. "We've arrested the pilot, Dante Matto. He admits obtaining the dead bodies from a hospital here, through an undertaker who does embalming for the city. In the morning we're opening the five coffins in the cemetery. If the coffins are empty, it'll be the final proof we need that the embalmed bodies were substituted for our Englishmen."

"Any trace of them?"

"Matto claims he hasn't seen them since they left the plane at an airstrip near Livorno. Jenkins flew the plane and bailed out over northern Italy. He was to have met the other three at some undisclosed spot."

"Sebastian, if I stick with the wives I'm certain they'll make contact sooner or later."

"Maybe."

They talked for a bit longer, then hung up. For a time she sat by the window watching the rain fall into puddles of reflected light.

In the morning Sebastian met Inspector Pettagolo of the Rome police and they drove out to the cemetery, to the special area reserved for the burial of strangers and the friendless poor. It was a gloomy place, even in the bright sunshine, and Sebastian followed the Inspector between the rows of sunken plaques with a feeling of deep unease.

There were already two gravediggers at the site of the newly buried coffins, and at a signal from Pettagolo they began to shovel away the earth. "They work fast," the Inspector told Sebastian. "We'll soon know if you're correct about these coffins."

"These were the only ones buried over the weekend?"

He nodded. "These five. It seems odd the undertaker held them until he had so many."

Sebastian nodded. "He needed five, and that's why he had to embalm them. Hospital records show they died over a period of eight days."

Both men were silent as the gravediggers went about their task, occasionally muttering in Italian about the foolishness of digging up bodies so recently buried. Finally, when the first coffin rose into view, the Inspector said, "Seems heavy enough."

"Weighted down with sand, probably."

"Open it," Pettagolo instructed the men, and they began unscrewing the lid. He stepped forward to help them.

As the lid began to rise, the Inspector took one look and closed it again. "I am sorry, Signore Blue, but you are wrong."

"Wrong?"

"Come see for yourself—the body is still here!"

Sebastian arrived in Greater Ware the following day, and Laura was waiting for him at the station. "I thought we'd both be back in Paris by now," she said. "What have you found?"

"The case has changed," he said simply. "I have to meet the widows."

"They went to Rita Blake's house after this morning's memorial service. I've arranged with the mortuary to hold up the cremation, though. And I told the widows you'd be arriving."

"Good." He nodded approval as she led him to her rented car.

Rita Blake's home was an aging brick cottage that had obviously been well cared for. There were three cars in front, and Laura parked behind them. The women must have been watching at the window, because slim brown-haired Rita Blake appeared at the half-open front door as they approached.

"You're Sebastian Blue?" she asked. "Miss Charme told us you'd be coming."

The other three women were seated in the small living room, dressed in black, and there was an air of expectancy. "I'm afraid I have some bad news, ladies," he began. "Your husbands are dead."

"Dead?" The oldest one, whom he knew to be Mrs. Smothly, stood up. "Of course they're dead! We buried them this morning!"

"No I mean really dead. Their bodies are in paupers' graves in a Rome cementery."

One of the women gasped, and Mrs. Smothly looked as if she might faint. "How could that be?" Alcie Younglove asked.

"We're investigating that now. It seems that insurance fraud was the initial plan, but somehow it went far beyond that. The Rome police are holding the plane's pilot, a man named Dante Matto, on four counts of murder, They've recovered the gun he used to kill your husbands."

"But—when did this happen?" Rita Blake asked.

"As near as we can tell, he killed three of them at an airstrip near Livorno, after the five corpses were substituted for the plane's passengers. Then Tom Jenkins took the plane up, set it on a course for the Alps, and bailed out. Matto met him somewhere in the north of Italy and killed him too. Then he transported the four bodies of your husbands back to Rome in the same truck he'd used to bring the embalmed corpses. Your husbands were then embalmed by the undertaker working with Matto, and placed in four of the five empty coffins. The fifth coffin—Matto's coffin—contained sand. The bodies were buried in the paupers' graves set aside for deaths at the charity hospital."

"How awful!" Mrs. Smothly said quietly.

She sat down again, unsteadily, the color drained from her face. "I'll get some water," Rita Blake said, hurrying into the kitchen. The other two hovered over the woman on the couch.

"Sebastian," Laura said, taking advantage of the momentary distraction and speaking in a low tone that wouldn't carry. "Why would Matto go through all that business of substituting dead bodies? If he wanted to kill them he could have sabotaged the plane, or drugged them and left their own bodies to be found in the wreckage. Why did he need the embalmed corpses? And what did he hope to gain from killing them?"

"The corpses were the husbands' idea, of course, when they planned the thing, when they dreamed of a new life in South America with their wives and all the insurance money. Their murder was an afterthought."

"Afterthought? On whose part?"

"The ones who paid Matto to do the killings," Sebastian said. "He's talking now, telling everything."

By then Mrs. Smothly had revived herself, and sipped some of the water she'd been handed. The other three, in their stark black dresses, stood behind and to the side of her. "I feel better now," she said, staring up at Sebastian and Laura. "Suppose we get on with it. Will this new development affect the insurance settlement in any way?"

Sebastian let his gaze rest on each of their faces in turn, taking in the veiled, waiting expressions. Then he said, "Your husbands planned a new life with the insurance money *and with you*. But you four planned a new life with the insurance money *and without them*. I'm sorry, ladies, but there's going to be a considerable problem about collecting on those policies."

INTERPOL: THE CASE OF THE THIRD APOSTLE

by Edward D. Hoch

The saffron-robed figure stood with his arms upraised toward heaven, chanting a hymn in an unknown tongue. He seemed to hover there, at the edge of the airfield, like some great bird which might itself take wing. Finally, as the mammoth jetliner taxied out to the end of the runway, he reached beneath his robe and brought out a single stick of incense. Lighting it, he held it high above his head, like a glowing signal to guide the plane on its path.

When at last the silver jetliner streaked through the evening sky, making a wide circle south of Paris, the man in the saffron robe placed his stick of burning incense carefully at the edge of the runway and walked back across the field to the car which had brought him.

As he walked, he wondered if his prayer would be answered.

When Sebastian Blue entered the sprawling modern building on the Rue Armengaud, he could not help reflecting that the International Criminal Police Organization had come a long way from the unpretentious stone house just off the Avenue Victor Hugo, which had been Interpol's home from 1955 till 1966. This glass-walled building in the western suburbs of Paris, with its rooftop radio transmitters and underground parking, seemed to hum with activity, and there were only the flags at the entrace to remind him of that earlier headquarters.

The Secretary-General spoke English with a decided accent, and he made it obvious that like most Frenchmen he much preferred his native tongue. "Is this your first visit to our new headquarters?" he asked, extending a hand in greeting.

"It is, and I'm quite impressed. I remember calling at the old place back in 1966, just before you moved. This is a vast improvement."

"We must expand with the task," the Secretary-General re-

plied, the overhead lights reflecting off his bald head. "But it is a pleasure to have you here, Mr. Blue. Your former Scotland Yard colleagues speak most highly of you."

"I trust I can be of some service here. They tell me Interpol employs a great many former detectives from the *Surete Nationale* and the Paris *Prefecture.*"

"We do indeed," the Secretary-General confirmed. His eyes narrowed as he studied the tall well-built Englishman opposite him. He might have been wondering what caused a handsome gray-haired Scotland Yard Inspector still in his forties to desert job and country for a new life in Paris. "I must warn you, Mr. Blue, that the work of Interpol is mainly in the fields of information exchange, identification and research. The actual apprehension of international criminals remains the task of member countries. You might find our work somewhat dull after your years with the Yard."

"I hardly think it will be dull, sir."

"Very well. As you know, our headquarters here in Saint-Cloud maintains direct radio communications with nearly one hundred affiliated governments. We serve as a clearing-house for information, with files on more than 250,000 international criminals indexed by physical description, nationality, character traits, and types of crime. Whatever the offense—picking pockets at the Olympic games, smuggling gold into India, stealing art masterpieces from Swiss museums and selling them abroad—if it is international in scope, Interpol is interested."

"And that is why I can be of special service," Sebastian Blue said. "During my years with the Yard I specialized in airline crimes—cargo thefts from Heathrow, bomb threats, smuggling, skyjacking. By its very nature, airline crime often involves the police of several nations. I believe it's time Interpol took a more active role in this field."

The Secretary-General nodded. "We have been thinking along much the same lines, and have had some success already. You may remember the time we uncovered a large shipment of opium hidden in a plane-load of monkeys destined for polio research in America. The odor of the monkeys was used to mask the penetrating smell of the opium."

"I recall the case," Sebastian said. "But that was years ago. Today there are bombings and extortion threats—"

INTERPOL: THE CASE OF THE THIRD APOSTLE

by Edward D. Hoch

The saffron-robed figure stood with his arms upraised toward heaven, chanting a hymn in an unknown tongue. He seemed to hover there, at the edge of the airfield, like some great bird which might itself take wing. Finally, as the mammoth jetliner taxied out to the end of the runway, he reached beneath his robe and brought out a single stick of incense. Lighting it, he held it high above his head, like a glowing signal to guide the plane on its path.

When at last the silver jetliner streaked through the evening sky, making a wide circle south of Paris, the man in the saffron robe placed his stick of burning incense carefully at the edge of the runway and walked back across the field to the car which had brought him.

As he walked, he wondered if his prayer would be answered.

When Sebastian Blue entered the sprawling modern building on the Rue Armengaud, he could not help reflecting that the International Criminal Police Organization had come a long way from the unpretentious stone house just off the Avenue Victor Hugo, which had been Interpol's home from 1955 till 1966. This glass-walled building in the western suburbs of Paris, with its rooftop radio transmitters and underground parking, seemed to hum with activity, and there were only the flags at the entrace to remind him of that earlier headquarters.

The Secretary-General spoke English with a decided accent, and he made it obvious that like most Frenchmen he much preferred his native tongue. "Is this your first visit to our new headquarters?" he asked, extending a hand in greeting.

"It is, and I'm quite impressed. I remember calling at the old place back in 1966, just before you moved. This is a vast improvement."

"We must expand with the task," the Secretary-General re-

plied, the overhead lights reflecting off his bald head. "But it is a pleasure to have you here, Mr. Blue. Your former Scotland Yard colleagues speak most highly of you."

"I trust I can be of some service here. They tell me Interpol employs a great many former detectives from the *Surete Nationale* and the Paris *Prefecture*."

"We do indeed," the Secretary-General confirmed. His eyes narrowed as he studied the tall well-built Englishman opposite him. He might have been wondering what caused a handsome gray-haired Scotland Yard Inspector still in his forties to desert job and country for a new life in Paris. "I must warn you, Mr. Blue, that the work of Interpol is mainly in the fields of information exchange, identification and research. The actual apprehension of international criminals remains the task of member countries. You might find our work somewhat dull after your years with the Yard."

"I hardly think it will be dull, sir."

"Very well. As you know, our headquarters here in Saint-Cloud maintains direct radio communications with nearly one hundred affiliated governments. We serve as a clearing-house for information, with files on more than 250,000 international criminals indexed by physical description, nationality, character traits, and types of crime. Whatever the offense—picking pockets at the Olympic games, smuggling gold into India, stealing art masterpieces from Swiss museums and selling them abroad—if it is international in scope, Interpol is interested."

"And that is why I can be of special service," Sebastian Blue said. "During my years with the Yard I specialized in airline crimes—cargo thefts from Heathrow, bomb threats, smuggling, skyjacking. By its very nature, airline crime often involves the police of several nations. I believe it's time Interpol took a more active role in this field."

The Secretary-General nodded. "We have been thinking along much the same lines, and have had some success already. You may remember the time we uncovered a large shipment of opium hidden in a plane-load of monkeys destined for polio research in America. The odor of the monkeys was used to mask the penetrating smell of the opium."

"I recall the case," Sebastian said. "But that was years ago. Today there are bombings and extortion threats—"

The Secretary-General cut him off. "We may give you an assignment sooner than you expected." He pushed a button and spoke some quick words in French through the intercom. After a few moments a slim young woman with reddish-blonde hair entered the office carrying a folder. "Sebastian Blue, this is Laura Charme, one of our ablest translators."

"Pleased to meet you," the young woman said in surprisingly good English.

Sebastian stood up to acknowledge the introduction, taking in the wide green eyes and lovely lips. "You're not my idea of a translator," he said.

She tossed her head prettily. "Looks can be deceiving," she told him as she handed the folder to the Secretary-General and left the office.

"Is she English?" Sebastian asked the Secretary-General when they were alone.

"Her mother was, but her father is French. Laura is a very versatile young woman." Without explaining further, he opened the folder and asked, "Have you ever heard of the Apostles of the Sun? They are an odd religious cult with headquarters in Istanbul."

"It's a bit out of my line," Sebastian admitted.

"Their main activity in Paris seems to be the raising of funds. You see them out along the Seine in their saffron robes, chanting in some strange tongue and begging money from tourists and students."

"What's your problem with them?"

"It is not really our problem, but the Paris police have asked for help. It seems the Apostles of the Sun refuse to have dealings with banks. As a result, their annual contributions to the world headquarters must be carried to Istanbul by special messengers. Since the sum of money involved is quite large—nearly $100,000 American in all—three messengers are sent from Paris by plane, one week apart. Each carries a third of the contribution."

"Their fund-raising is big business," Sebastian agreed. "But why trust planes and not banks?"

The Secretary-General sighed. "Planes fly nearer the sun, and therefore are good. Banks hide their money in dark vaults and therefore are bad. It is all a part of their religious beliefs."

"I see. And something happened to the messengers?"

"The first two have vanished."

"With the money?"

"With the money. They boarded the planes in their saffron robes, and disappeared in the sky somewhere between Paris and Istanbul. Of course there is no great mystery. On a 747, with hundreds of passengers roaming the aisles and frequenting the lounges, our Apostle could simply have stepped into the lavatory, doffed his robe, covered his shaved head with a wig, and reappeared as a whole new person, taking an empty seat near the rear of the aircraft. The people waiting his arrival in Istanbul would swear there was no Apostle on the plane."

"Then what's the mystery?" Sebastian asked. "It's a simple case of embezzlement."

"The supreme council of the Apostles of the Sun assures the police that embezzlement is out of the question. The two men were among the most trusted and dedicated in the order, and were personally chosen as messengers by the council in Istanbul."

"How does Interpol fit in?"

"Whatever happened, it was between Paris and Istanbul, on that aircraft. Our task is to coordinate the investigations of the French and Turkish police, and to furnish descriptions of the missing men. Would you like to call on the Apostles here in Paris and obtain the information? Photographs would be most helpful, of course."

"How soon do we need it?"

"Time may be important," the Secretary-General said. "The third Apostle leaves for Istanbul tomorrow evening."

The temple of the Apostles of the Sun was a garishly imposing structure squeezed between a bistro and a *boulangerie* on the Left Bank. Sebastian Blue strolled past it twice before entering, and even then he felt a bit self-conscious about walking through a golden door pained to resemble the sun.

A saffron-robed man with a shaved head approached in the inner hall and asked, "Whom do you seek, stranger?"

"Sol Michael, your leader."

The man bowed slightly. "I am Sol George. Follow me."

He led Sebastian down a dim passage to a stark functional

office at the end. The robed man behind the desk rose and extended his hand. "I am Sol Michael. You are Sebastian Blue, from Interpol?"

"Correct. We're working with the French and Turkish police in the matter of your vanished messengers."

The shaved head nodded. Despite the trappings of age, Sol Michael was still a relatively young man—under forty, by Sebastian's reckoning. "What information do you wish?"

"Descriptions and photos of the missing men."

"Very well. I have them here." He handed over a group photo of a half dozen Apostles, with two heads circled. "Sol Robert, the first messenger, who vanished two weeks ago, and Sol Peter, the second messenger, who disappeared last week."

The men in the picture were young, hardly more than boys, and Sebastian wondered at their being entrusted with such large sums of money. "Did you take precautions after the first disappearance?"

"Certainly," Sol Michael said. "I went myself to the airport and offered incense as the plane took off. I prayed that our god would carry Sol Peter safely to his destination."

"Your prayer wasn't answered."

Sol Michael shrugged. "The ways of the gods are often unclear."

"To whom were the Apostles taking the money?"

"Sol David, keeper of our finances, was awaiting them at Istanbul Airport."

"Would he have recognized them without their robes and shaved heads?"

Sol Michael considered that. "Perhaps not. But I assure you these Apostles were trustworthy!"

"Who's the third man, the one who flies tomorrow?"

"Sol George, who brought you to my office."

"And who arranges the flights?"

"I do, personally. We do not announce them to others in advance, nor do we seek publicity in the press. We are a very private group, Mr. Blue, and we wish to remain so. Part of the money we collect goes for good works here in Paris—food for the poor, homes for the elderly. The portion sent to world headquarters likewise serves a good purpose. Who would steal it?"

Sebastian studied the man's youthful face and decided he was

serious. "There are evil men in the world, Sol Michael. But perhaps with luck we can recover your money for you."

The Secretary-General didn't like it. "You plan to be on that plane, flying with the messenger to Istanbul?"

"Exactly, sir. If it happens again, I want to see it happen."

"The plane is a 747, Mr. Blue. It may be difficult to keep your eye on Sol George through the entire trip."

"I'm aware of that," Sebastian said. "I wonder if you could spare that young woman, Laura Charme, for a day or two."

The older man's eyebrows went up. "Might I ask why?"

"I'd like to arrange for her to be an airline stewardess."

The evening flight to Istanbul was less than half full, and the huge 747 seemed even more mammoth with its rows of empty seats. Sebastian Blue had watched Sol Michael with his stick of incense seeing the third Apostle off. Now he was seated ten rows behind the saffron-robed messenger; Sebastian glanced up occasionally from his magazine to verify that the man was still there.

The Secretary-General had reluctantly arranged for Laura Charme to serve as an extra stewardess on the flight. Moving down the aisle in her trim azure pants suit, she was indistinguishable from the dozen or more other flight attendants. Her job was to help watch Sol George, to assure his safe arrival in Istanbul.

The flight was uneventful as an Italian western movie ground along to its predictably bloody fadeout. Then, as Sebastian glanced up once more from his magazine, he saw the shaved head of Sol George begin to rise. The Apostle got to his feet and started back along the aisle, clutching the leather brief case that held the final third of the money. Sebastian waited only a moment before following.

In the rear of the plane the tourist-class lounge was crowded with passengers. Two trim blonde stewardesses were dispensing beer and pretzels along with conversation in assorted languages. He edged past them and stood by Laura Charme as she filled bowls of nuts for the drinkers. "I do believe you girls are all Swedish."

She glanced up without showing recognition and replied, "Not all. I'm French, and there's a Turkish girl up front."

"Do you enjoy your work?"

"Sure. It's a job."

"Is this the only direct flight from Paris to Istanbul?"

She shook her head and began passing out the bowls of nuts. "There are four each day, though this is the only 747."

When Sebastian was sure no one could overhear, he dropped his voice and asked, "Where is he?"

"In the lavatory. Don't worry."

He glanced at his watch. The trip was well past the halfway mark. In another hour they'd be on the ground. "When he comes out, we may not recognize him."

"He won't get by me," she assured him. "I haven't had that door out of my sight."

Sebastian nibbled on a pretzel. "Been in there quite a while."

She nodded. "Robe in the brief case and wig on the head. Shouldn't take so long."

"Think something's happened?"

She eyed the door. "Maybe, but what?"

"Funny if he vanished in there."

"Damn funny! The Secretary-General would never understand."

"Nor would I." Sebastian glanced at his watch. "We'll give him just three more minutes."

"And then?"

"And then we do something."

When three minutes had passed, Laura Charme said, "Well?"

"Come on." Sebastian strode to the narrow lavatory door, checked the *Occupied* sign, and raised his fist to knock.

At that moment the door swung open and Sol George reappeared, still with shaved head and saffron robe, still carrying the brief case. He bowed slightly to Sebastian and edged past him, striding down the aisle to his seat.

"He's still here," Laura said. "Nothing happened to him."

"I'll be damned! I could have sworn that's how the other two vanished."

"Now what?"

Sebastian shrugged. "We wait and see what happens."

The 747 dipped through the night sky toward the beckoning lights of Istanbul Airport, coming in low over the Sea of Mar-

mara. As the wheels touched down, Sebastian Blue checked the shaved head once more and sighed with relief. Whatever had happened to the first two Apostles, this one had arrived safely at his destination.

In the terminal Sebastian watched while Sol George was greeted by another Apostle. "That will be Sol David, the money man," he told Laura Charme when she joined him.

"It was all very dull, Sebastian, though I did enjoy being a stewardess."

"Let me buy you a drink. Put a little excitement into your life.'

She nodded agreement, her eyes still on the two retreating figures in their saffron robes. "That would be nice," she said, but her mind seemed elsewhere.

Over drinks at a little table in the Bosporus Lounge, Sebastian asked, "What brought you to Interpol?"

She smiled at him indulgently. "The same thing, I suppose, that brings a Scotland Yard Inspector."

"That's no answer. I'm fat and middle-aged and looking for a change of scene. You're none of those things."

"I'd hardly call you fat, Sebastian." She studied him through half-veiled green eyes. "I had a wild childhood, back and forth between a mother in London and a father in Paris. My mother died and I married quite young. My husband was killed in Algeria during the trouble there. He was in the army. Well, having lost both mother and husband while still under twenty, and not caring that much about my father, I was more or less forced to strike out on my own.

"I went back to college and earned my degree in languages. For a time I considered joining the French mission to the United Nations in New York, but finally I decided to stay in Paris and work for Interpol. I've never regretted it, though this is the first time I've traveled for them."

"You've crammed a great deal of life into a few years."

"The years aren't so few. I'm twenty-eight. But what about you, Sebastian? You're much too handsome to have gone unmarried all these years."

He sipped his drink before replying. "My wife divorced me last year and married a chap I worked with at the Yard. The situation became intolerable, at least for me. That's why I came to Paris."

"I'm sorry."

He grinned at her sad expression. "We're just a couple of lost souls." Reaching for the check he said, "We'd better see what's happening with the Apostles of the Sun."

"That man who met Sol George—he seemed vaguely familiar."

"Perhaps you saw him in Paris once."

"Maybe," she agreed, still troubled by it.

As they were leaving the lounge, Sebastian spotted a flash of saffron in the crowd at the far end of the airport. "What's that? One of the Apostles has come back?"

The robed man was standing among the travelers, gesturing to an airline reservations clerk. He was much older than the Apostle who had met Sol George, and his lined face was deep with apprehension.

"What seems to be the trouble?" Laura asked in French.

The Apostle looked from her to Sebastian and then back at the clerk, who explained. "I'm trying to tell him the flight from Paris has been on the ground for almost an hour."

"I was to meet a man," the Apostle said. "He is not here."

Sebastian Blue nodded. "Sol George. We traveled with him from Paris. But he was met by someone else, another Apostle."

"Impossible!" The lined face hardened. "I am Sol David, and no one else is authorized to meet the plane! I was delayed by car trouble, but certainly Sol George would not have left the airport without me."

"He did, though," Laura said. "The other Apostle must have told him he was replacing you."

"But the money—".

"Gone," Sebastian said. "Just like the first two."

"That cannot be!"

Laura Charme bit her lower lip. "I just remembered where I saw that man before, Sebastian! Interpol has a file on him. His name is Otto Pucak, and he has a long record in the heroin trade."

"Check the parking lot and see if they noticed his car. I'll go with Sol David to the police. Meet me there in an hour."

She nodded and hurried away. Sebastian gripped the Apostle by the arm and steered him toward the street exit.

The man who faced Sebastian Blue across the desk an hour later was dressed in civilian clothes but had the bearing of a

military person. He spoke English quite well, and the first words out of his mouth confirmed the military look. "I am Colonel Hamul. Interpol told me to expect you."

"I understood I was to speak with the regular police."

Colonel Hamul turned over his hand in a gesture meant to be reassuring. "The military works closely with the police here."

"Just what is your interest in the Apostles of the Sun, Colonel?"

He cupped his hands together and leaned back in the chair until the overhead light reflected off his thick glasses. In some ways he reminded Sebastian of the Secretary-General back in Paris. "They are a very wealthy group, you understand. Money flows here from a dozen cities in Europe and the Far East—perhaps as much as a million American dollars each year, if the contributions from Paris are any indication."

"What is done with all that money?" Sebastian asked. "Back in Paris they spoke of charitable work."

Colonel Hamul snorted. "The Apostles of the Sun own a great deal of farming land in the interior of Turkey, mainly east of Afyon. The farms are a major source of opium poppies."

"Then the Apostles are in violation of the law?"

"Not quite." The hands were working again as he sought to explain. "Until a recent agreement with the United States, opium poppies were a major crop in Turkey. They price was fixed by the government, which bought up the crop from some two hundred thousand growers. But of course there was always overproduction, with some of the crop diverted to the illegal caravans that crossed into Syria. Right now we are phasing out the opium poppies entirely, with money from the United States, but big growers like the Apostles of the Sun present a problem."

"They won't cooperate?"

Colonel Hamul shrugged. "A great deal of money is involved."

"Let me ask you a frank question. Is the entire cult merely a front for the drug business?"

"Certainly not. I have investigated them quite carefully, and the group is a true religion of sun worshippers—a bit anachronistic but still legitimate."

"Then it's time I talked with Sol David again." Sebastian left the colonel and crossed the hall to a room where Sol David was sitting alone.

"I must return to my congregation," the Apostle said, his voice at once soft and sorrowful.

"Soon. The police will escort you. First, though, I must ask you something else. About the growing of opium poppies."

"Yes, yes," Sol David said with a wave of his wrinkled hand. "When we grew poppies it was legal. Now that it is being ended, we end, too. We do nothing against the law."

"But perhaps someone wants the poppy-growing to continue," Sebastian speculated. "Without this money from Paris, the Apostles could be hard-pressed financially. They might be tempted by any offer of easy money."

"There has been no such offer," Sol David insisted.

"Not yet. The third Apostle was met by a man posing as you. Miss Charme identified him as Otto Pucak, a known narcotics dealer. Have you ever heard the name?"

"Never."

"We can assume the first two messengers were also intercepted by Pucak."

Sol David shook his head. "I was at the airport when the other two planes landed. No Apostle was on either flight. Tonight someone tampered with my car, or I would have been here on time."

"Obviously Pucak tampered with the car to delay you. Somehow he has a link to your organization, a person who tipped him off to the arrival times. Perhaps one of the three messengers, if—"

His words were interrupted by Colonel Hamul, who entered carrying a sheet of paper. "This woman, Laura Charme—she came with you?"

Sebastian nodded and glanced at his watch. It was after midnight. "She was supposed to meet me here long before this."

"You had better come with me, Mr. Blue. I fear something has happened to her."

When Laura Charme left Sebastian at the Istanbul Airport, she went first to the parking lot where Otto Pucak would have left his car. The attendant was away, and a shabbily dressed Turkish youth seemed to be collecting the money in his absence. The youth nodded when she described the two men in saffron robes, and for a few French francs he even produced the duplicate

parking ticket on which he'd scrawled their license number.

Laura left the lot on the run, clutching the number, and signaled a taxi. She'd spent a weekend in Istanbul the previous summer, and still remembered her way around. The first thing she needed was a telephone.

"Divan Hotel," she told the driver, giving the name of the hotel where they were staying, then settled back in the seat. Of course Pucak could have used a stolen car, but she was gambling he handn't. She was hoping the license number could be traced before anything happened to Sol George and the money.

After a fast drive along the seaside highway and into the city the driver pulled up in front of the Divan Hotel. She paid him and hurried inside, through a light drizzle of rain that had just begun to fall. Instead of checking the rooms Sebastian had reserved for them, she went at once to the coin telephones in the lobby and called police headquarters. They'd lost an hour on the flight from Paris and now it was almost midnight. The night man on the other end had difficulty understanding her broken Turkish, but when she gave him her Interpol identification number he grew more cooperative.

She read him the auto license number very carefully. "I must have this traced tonight. A man's life may depend on it!"

There was a mumbled consultation on the other end, and the voice said, "We see what we can do. But that office is closed until morning."

"I understand. Look, Sebastian Blue should be there right now, with your chief or someone. Find him, and tell him what I need."

"Hold on," the voice told her. "We check."

Laura tapped her heel impatiently as she waited. She realized suddenly that she still wore the azure pants suit her stewardess role had demanded. Perhaps there'd be time to shower and change into something else— Then the phone crackled in her ear and the line went dead. She jiggled the hook, but nothing happened.

"Please come with me," a voice said behind her. "Step this way and complete your call in the office."

"Oh?" She glanced at the uniformed bellhop, shrugged, and hung up the dead receiver. As she entered the office he indicated, she saw Otto Pucak, still bald but wearing a business suit now

instead of the saffron robe.

Laura whirled, realizing the trap, and caught the bellhop's arm in a judo hold, flinging him against the wall. Pucak barked a quick command in Turkish and as she turned, a man stepped from behind the door and hit her a stunning blow to the side of the head. Her vision blurred and she went down.

Awakening, Laura tried to move her head. Her eyes were closed but not covered, and she was aware at once of movement—the bumpy, jerky movement of a car over the tramlines that stretched almost everywhere in Istanbul's streets. She waited another moment before risking a peek with her left eye, and she saw the postmidnight lights of the city around her. They were crossing Taxim Square, she thought, though she couldn't be certain.

"You are with us again?" a voice asked.

"I—"

"My name is Otto Pucak, but of course you know that. Do not try anything foolish. Your wrists are handcuffed and I have a gun."

She felt the cold restraint of the handcuffs then, and a chill went through her body. "Where are you taking me?"

"North, out of the city." As if to verify his words, the car headed down a slight hill and across the Galata Bridge, leaving the main section of the city behind.

"Are you taking me to Sol George and the other two?" she asked, almost fearing the answer.

"Yes. You shall see them."

There were two men in the front seat, and Pucak rode at her side. Gradually, in the silence that followed, the city lights dwindled and disappeared as they passed through Sisli and into the open countryside. She was too aware that they had not bothered to blindfold her, not caring what she saw of their faces or the route. "How did you find me at the hotel?" she asked finally, staring out at the misty rain.

"The boy at the airport was taking his uncle's place. When he told about giving you the license number, the uncle contacted me at once. I already knew you Interpol people had reservations at the Divan, and I took a chance you would go there."

"That's why you didn't bother with a stolen car," Laura

surmised. "You knew—or thought you knew—that the lot attendant wouldn't talk."

"We have a well-knit organization," Pucak admitted. "Employees at airports and hotels are especially useful."

They fell silent again, until at last the car came to a stop before a large farmhouse some twenty miles north of the city. "Your place?" Laura asked.

"One of them. The license number would have led you here, had you been able to trace it. Come on."

She climbed out of the car with difficulty, holding her handcuffed wrists before her. "Where is Sol George?" she asked.

The driver, a burly Turk, walked around and unlocked the trunk of the car. She had a glimpse of a saffron robe, and then she turned to see the gun in Pucak's hand, coming up steadily like a waking eye.

After that a great many things happened at once. There was a shouted command from the farmhouse and Pucak started to turn. The burly driver fired one wild shot and there was an answering burst of gunfire from the darkened house. Pucak swung the gun back toward Laura just as a bullet ripped through his middle. She screamed and went down on her knees in the mud as he toppled on his face before her.

And then Sebastian Blue was at her side, holding her, helping her to her feet. "It's all right," he kept saying. "We're here. It's all right now."

"Helicopter," Sebastian told her later. "When Colonel Hamul heard of your call and learned you'd been cut off, he told me at once. We traced the license number and took an army helicopter up here. It was a bit tricky at night, and in this rain, and we had no idea if you'd be here, but it was the only lead we had. We were searching the farmhouse when Pucak drove up."

She was rubbing the marks where the handcuffs had been. "What about Sol Geroge?"

"He'll live. They only hit him on the head before stuffing him into the trunk. The first two Apostles weren't so lucky, though. We found them buried out behind the farmhouse. I'm afraid that's what he had in mind for you, too."

"How did he get them off the planes?"

"Pucak told us that much before he died. As we suspected, the first one was lured into disrobing and putting on a wig, on the

pretense of a plot to steal the money at the Istanbul Airport. Once the first man disappeared, it was easy to convince the second messenger that he, too, should change his appearance on the plane to insure his safety. The first two were told that the waiting Sol David was a thief in disguise. The third Apostle was told nothing, and this time the waiting Sol David really was a thief in disguise!"

"Where do the poppy fields fit in?"

"I have an idea about that. Colonel Hamul is checking some things for me now." He leaned over and brushed a bit of dried mud from her face. "You did quite well tonight."

"What? Getting kidnaped?"

"Getting that license number and leading us to Pucak. You have a certain flair for this work. Besides that you're charming, just like your name."

She grinned at him, a bit impishly. "I'm much more mysterious than that. My name means a charm or spell."

"Whatever it means, I like it. Come on, we have to catch the morning plane back to Paris, and report to Sol Michael."

The sun that greeted them in Paris was a sure sign of spring's arrival. Even Sol Michael seemed in good spirits as he met them at the sunburst door of his temple. "Up there in the sky you see a renewal of all hope," he said, leading them down the hall to his little office. "With our prayers, and with Interpol's aid, I believe the Apostles of the Sun are beginning a period of renewal."

Sebastian seated himself opposite the desk, while Laura took a chair to one side. "You know of course that much of the money sent to Turkey went to farms that cultivated opium poppies?"

Sol Michael nodded slightly. "Until quite recently it was a legal crop there, harvested under government controls."

"And now, Colonel Hamul of the Istanbul police advises me, the farms are to be sold. An offer was made by a company owned by Otto Pucak—and Pucak is the man who hijacked your money. He planned to use that same money to buy up some of the Apostles' farmland. Then he would continue growing poppies illegally, avoiding the government ban. Because of the decrease in the illegal traffic his crops would bring an even higher price on the world markets. I'm happy to say Pucak's plot has been crushed."

"You saved us a great deal," Sol Michael said. "But I still do

not understand fully the disappearance of the first two Apostles. If they were wearing wigs and regular suits, how did Pucak identify them as they left the plane?"

"One thing they didn't change was their passports. As they passed through customs, one of Pucak's airport people signaled him. He simply waylaid your messengers, representing himself as a true Apostle, and lured them to their death."

"Terrible," Sol Michael muttered. "Are all the murderers now in custody?"

"All but one," Sebastian said, glancing in Laura's direction. "Someone had to inform Pucak the money was coming. Someone had to persuade Sol Robert and later Sol Peter to take off their robes and put on wigs during the flight to Istanbul. Someone they trusted."

"Who?"

"Sol Michael. It was you who made the flight arrangements. You went out there with your incense to pray for safe passage. But to what god did you pray? Would anyone who worships the sun, who fears the darkness of bank vaults, have sent those three messengers on the *evening flight* to Istanbul when three other daily flights were available? You needed the evening flight because it was the only 747, the only plane large enough for them to change appearance and seats without being noticed. *You* sent them to their death, Sol Michael!"

Sol Michael straightened, smiling slightly, and produced a small Berretta pistol from under his saffron robe. "Too clever, Mr. Blue," he said, and then Laura yanked him off-balance and sent him sprawling.

Sebastian grabbed the fallen gun and chuckled with admiration. "That judo of yours can be useful, my dear."

"I thought you'd like it."

"You probably saved my life just then."

"You did the same for me," she said. "Back in Istanbul."

"We seem to be a team."

She smiled. "The Secretary-General might have ideas about that."

Sebastian Blue glanced down at Sol Michael on the floor and reached for the telephone. "Let's ask him, shall we?"

INTERPOL: THE CASE OF THE FIVE COFFINS

by Edward D. Hoch

Eric Bohn was a man who knew cruise ships better than he knew the back yard of his own home in Wales, probably because he spent more weeks of each year aboard crusie ships than he did at home. His specialty was the type of ship that offered gambling on the high seas—either the official gambling of roulette wheels and dice cages in the promenade-deck sports room, or the unofficial sort with high-stakes poker and bridge games in the forward card room.

A ship like the *Messina Star*, cruising the Mediterranean off the cost of Spain, was the perfect sort for Eric Bohn, since it combined the best of both worlds. There were casino-type games with low house limits to amuse the tourists, presided over by provocatively clad roulette and dice girls, and high-stakes private card games for the professional gamblers. In three days Eric Bohn had managed to net close to £5000.

He was a little man with thin hair and a way of cocking his head to one side while listening to someone speak. It gave the impression his hearing might be impaired but in truth his hearing was very good. Eric Bohn never missed anything that happened around him. That was how he came to notice Claude Jennings, who operated the gambling concession on board the ship and supervised the two roulette girls and four dice and blackjack girls.

At first Bohn thought very little about the man except to wonder how much the house was clearing at the tables. But on the third day out, as the *Messina Star* was crusing in sight of the Spanish coastline, he decided to follow Jennings and see just what he did on the ship when he left the game room. Perhaps, Bohn thought, Jennings might lead him to a really high-stakes game in one of the stateroom.

So he kept his eye on Jennings that evening at the gaming tables, watching him as he mingled with society matrons and overweight bankers. Many of the passengers were widows or retired couples, though there was a pair of honeymooners from

Scotland and a middle-aged man who seemed friendly with one of the roulette girls. Bohn watched them all, making his bets in the casual manner of one who didn't much care whether he won or lost.

At exactly one o'clock Claude Jennings left the tables and hurried along the enclosed promenade to the elevators. It seemed too early for bedtime, and Bohn wondered if he was on his way to a big game. There was nothing above them but the sun deck, so he knew Jennings would be heading down. Bohn took the stairs, keeping his eye on the elevator indicator at each floor. The descending Jennings bypassed the veranda deck, the upper deck, and the main deck, but the elevator paused at A deck. Bohn reached the corridor just in time to see a door closing in the forward part of the ship, near the baggage rooms.

He waited outside the door for several minutes, hearing nothing. Finally he took a chance and tried the knob. The door opened, revealing a lighted compartment used for some sort of storage. There were long boxes draped with canvas and he wondered what they were. He lifted the end of one canvas and saw the polished wood and brass fittings of a coffin.

He looked beneath the other coverings and found the same thing. There were five coffins in the little storeroom.

And no sign of Claude Jennings.

He tried one of the lids and found it was open. The coffin was empty, and there was no sign that its white satin interior had ever been disturbed. He opened the second coffin and found the same thing. And the third.

He opened the fourth coffin.

The knife came up so fast he barely saw it, barely felt the slashing blow to his throat until it was too late. The last question in his mind was why anyone would want to kill him like this.

Sebastian Blue had never been a good sailor.

Even though the *Messina Star* was equipped with the latest gyro-fin stabilizers to minimize rolling and a bulbous bow to reduce pitching, the relatively calm journey through the Mediterranean waters had already given him a queasy stomach. He'd spent most of that third night in his cabin on the upper deck, not even able to check on Laura Charme's operation of the roulette wheel.

Interpol had been investigating crooked gambling aboard cruise ships for the better part of two years, and when Sebastian's airline crime division was expanded to include all modes of international travel, it seemed a likely area for their investigations. Sebastian and Laura had stumbled on a scheme in London last year in which young women were being recruited to operate rigged gambling games aboard ship. Laura had managed to get herself accepted for the position of roulette girl on the *Messina Star's* Mediterranean cruise, and Sebastian had signed on as a passenger.

For anyone who questioned his presence, he told the truth—that he was a lonely divorced male in his mid-fifties trying to strike up new acquaintances. He omitted only the fact that he was a former Scotland Yard inspector now employed by the International Police Organization in Paris, and that the new acquaintances were gamblers and confidence men who preyed on unsuspecting travelers.

Once that night, shortly before one o'clock, he wondered about Laura and how she was doing at the roulette wheel. His stomach was better and he even considered getting dressed and going up to the game room. But then he was drifting back into sleep, deciding Laura could take care of herself, when he was awakened by a knocking on the door of his stateroom.

"Who's there?"

"Captain Archibald, Mr. Blue. It's an urgent matter, I'm afraid."

The captain of the *Messian Star* was the only person on board who knew the identities of Sebastian and Laura. "Has anything happened to her?" he asked as he opened the door.

"Her? Oh, you mean Miss Charme. No, no, this is another matter. A man has been murdered on board. His throat has been cut. I thought you might lend a hand since there's no other law enforcement official with us on this run."

Sebastian showed some reluctance. "That's hardly an Interpol matter. I'd only be exposing my identity in helping you."

Captain Archibald removed his peaked cap and ran a hand through graying hair. "To tell you the truth I need some advice. Of course it's not the first death I've had on board a ship under my command. You get used to these things—expecially on pleasure cruises where you're carrying a great many older retired

folks. And sometimes we bury them at sea, you know, with the next of kin's permission."

"That's out of the question in this case, certainly," Sebastian said.

"I know. And we do carry some coffins on board for situations where the body is kept. But my problem is this—We have no facilities for refrigerating a corpse for the remainder of the voyage. We must put in at a port and turn over the body to the authorities."

"Then do it, man!"

"Right now we're sailing in Spanish coastal waters, but another few hours will bring us into French waters. With your Interpol connection, wouldn't a landing in France be preferable to one in Spain?"

"Aren't you due in Villefranche tomorrow?"

"Yes, shortly after noon."

"Then continue on course. I'll help you with the authorities there."

"And will you come to view the body now?"

Sebastian sighed. There'd be no sleep for a while, but at least his stomach was better.

So five minutes later, after dressing, he descended with Captain Archibald to a narrow corridor on A deck, in the forward portion reserved for the storage of baggage. The ship's doctor and the purser were bending over the body in the corridor, and someone had brought a canvas sheet to cover it.

"Have you identified him?" Sebastian asked, trying for a view of the dead man's face.

"Chap named Eric Bohn. British subject."

"Bohn—of course!"

"You knew him, Mr. Blue?"

"Only by reputation, but I saw him come aboard. He was one of several passengers who interested me."

The captain gazed unhappily at the trail of blood leading from the body. "And what was his reputation?"

"He was a professional gambler, operating mainly on ships like this, separating the tourists from their money."

"Part of the ring you're investigating?"

Sebastian glanced around and lowered his voice. "I'm mainly interested in the people operating rigged games on your ship. A

Interpol had been investigating crooked gambling aboard cruise ships for the better part of two years, and when Sebastian's airline crime division was expanded to include all modes of international travel, it seemed a likely area for their investigations. Sebastian and Laura had stumbled on a scheme in London last year in which young women were being recruited to operate rigged gambling games aboard ship. Laura had managed to get herself accepted for the position of roulette girl on the *Messina Star's* Mediterranean cruise, and Sebastian had signed on as a passenger.

For anyone who questioned his presence, he told the truth— that he was a lonely divorced male in his mid-fifties trying to strike up new acquaintances. He omitted only the fact that he was a former Scotland Yard inspector now employed by the International Police Organization in Paris, and that the new acquaintances were gamblers and confidence men who preyed on unsuspecting travelers.

Once that night, shortly before one o'clock, he wondered about Laura and how she was doing at the roulette wheel. His stomach was better and he even considered getting dressed and going up to the game room. But then he was drifting back into sleep, deciding Laura could take care of herself, when he was awakened by a knocking on the door of his stateroom.

"Who's there?"

"Captain Archibald, Mr. Blue. It's an urgent matter, I'm afraid."

The captain of the *Messian Star* was the only person on board who knew the identities of Sebastian and Laura. "Has anything happened to her?" he asked as he opened the door.

"Her? Oh, you mean Miss Charme. No, no, this is another matter. A man has been murdered on board. His throat has been cut. I thought you might lend a hand since there's no other law enforcement official with us on this run."

Sebastian showed some reluctance. "That's hardly an Interpol matter. I'd only be exposing my identity in helping you."

Captain Archibald removed his peaked cap and ran a hand through graying hair. "To tell you the truth I need some advice. Of course it's not the first death I've had on board a ship under my command. You get used to these things—expecially on pleasure cruises where you're carrying a great many older retired

folks. And sometimes we bury them at sea, you know, with the next of kin's permission."

"That's out of the question in this case, certainly," Sebastian said.

"I know. And we do carry some coffins on board for situations where the body is kept. But my problem is this—We have no facilities for refrigerating a corpse for the remainder of the voyage. We must put in at a port and turn over the body to the authorities."

"Then do it, man!"

"Right now we're sailing in Spanish coastal waters, but another few hours will bring us into French waters. With your Interpol connection, wouldn't a landing in France be preferable to one in Spain?"

"Aren't you due in Villefranche tomorrow?"

"Yes, shortly after noon."

"Then continue on course. I'll help you with the authorities there."

"And will you come to view the body now?"

Sebastian sighed. There'd be no sleep for a while, but at least his stomach was better.

So five minutes later, after dressing, he descended with Captain Archibald to a narrow corridor on A deck, in the forward portion reserved for the storage of baggage. The ship's doctor and the purser were bending over the body in the corridor, and someone had brought a canvas sheet to cover it.

"Have you identified him?" Sebastian asked, trying for a view of the dead man's face.

"Chap named Eric Bohn. British subject."

"Bohn—of course!"

"You knew him, Mr. Blue?"

"Only by reputation, but I saw him come aboard. He was one of several passengers who interested me."

The captain gazed unhappily at the trail of blood leading from the body. "And what was his reputation?"

"He was a professional gambler, operating mainly on ships like this, separating the tourists from their money."

"Part of the ring you're investigating?"

Sebastian glanced around and lowered his voice. "I'm mainly interested in the people operating rigged games on your ship. A

man like Bohn was out for himself, playing against both the house and the other players. It's possible he was killed because he was interfering with their operations, trying to cut himself in."

Captain Archibald was not a man to accept such happenings on his ship. "Do whatever you can to bring these people to justice, Mr. Blue. I'll give you whatever authority is necessary to carry on your investigation."

Sebastian's eyes had followed the trail of blood back from the body toward one of the storeroom doors. "What's in there?" he asked.

"I'm not sure myself. Let's take a look."

The purser cleared his throat. "It's the coffin storage room, sir."

"Thank you, Mr. Kelly. I had forgotten." He opened the door and snapped on the light. Sebastian saw a small room filled with oblong shapes. "We carry five coffins. That's the usual number for most cruise ships of this size. You'll get an occasional burial at sea but in most cases they want the remains sent back home."

Sebastian bent to examine some blood on the floor. "Would Bohn have had any reason to enter this room?"

"Certainly not."

"It looks very much as if he was killed here and then dragged outside. See here—an attempt was made to wipe up the blood."

Captain Archibald turned to the purser. "Mr. Kelly, uncover these coffins and open them, please."

Kelly pulled off the tarps and opened the lid of each coffin. All had white satin interiors unmarked by blood. All were empty. "Nothing here, sir," the purser reported.

"Interesting," Sebastian said. He glanced at his watch and saw it was two o'clock. Laura would be coming off duty.

She gave the wheel a final spin and stepped back. Lane Munday, the girl who relieved her at two, squeezed between a pair of big bettors and joined her behind the table. "How's the crowd, Laura?" she whispered.

A chorus of groans went up as the white ball settled into number 31. "Betting is good but beginning to thin out," Laura answered, raking in the losers' chips and paying off a couple of bets on black. "Watch out for the bald one. He's a pincher."

"I'm used to it," Lane said. The short satin skirts worn by the roulette girls left a good expanse of leg exposed. For some passengers it was too great a temptation, expecially after a few drinks. Laura Charme had never quite learned to handle situations like that without seeming rude, and she secretly admired Lane's cool composure. Laura had enough trouble with her costume as it was. The roulette girls wore a waist sash with a tassel on it, and her tassel had just been pulled off for the second time since the voyage began.

"Mr. Jennings thinks we should shut down at four," Laura said, picking up her purse. "I'm going to bed. I'm bushed!"

Lane Munday gave her a wave. "See you tomorrow."

As Laura headed toward the elevators she smiled to herself, remembering how Lane had come upon her the first night out while she was deep in conversation with Sebastian. She'd been worried at first, but the younger girl simply assumed that Laura had found a wealthy passenger with whom to pass the time. "What we don't take away from them at the wheels we can always get after hours, on our own," she told Laura. "Good luck to you."

Now Laura wondered if she should stop at Sebastian's cabin with a report. Nothing much had happened that night, except that Mrs. Carstairs claimed someone had stolen a bracelet from her stateroom. Kelly, the purser, had investigated and she'd heard him telling Lane later that this sort of thing happened on every trip. "It'll turn up," he predicted. "Unless, of course, she used it to pay off a gambling debt. We've had that happen too, believe me. These old ladies gamble their jewelry away and then report them stolen so they can collect from the insurance company."

Laura liked Kelly, what little she'd seen of him. he mingled easily with the roulette and dice girls, and took a cynical view of life that reflected her own in many things. She supposed his real job was keeping an eye on Claude Jennings and his girls, making certain the ship's owners received their proper share from the gambling, but he went about it in such a pleasant manner that even Jennings himself offered no objections. She found Kelly a welcome relief from the formal stuffiness of Captain Archibald.

As she waited for the elevator the doors slid open and Sebastian Blue stepped out. "I was thinking of stopping by your cabin," she said.

"The captain already did. He got me out of bed to investigate a murder."

"A murder!"

"Eric Bohn, that gambler I pointed out to you. Someone cut his throat."

"My God!"

"The captain decided it was a job for Interpol."

"Then your cover is blown."

"Well, the purser—Kelly—knows who I am. And the ship's doctor was there too. I imagine the word will travel quickly."

She remembered Lane Munday. "That girl on my table—I'd better tell her before she hears it elsewhere. Otherwise my value to this operation will be nil."

"Go ahead. We'd better stay clear of each other for a time."

"What about the body?"

"We dock at Villefranche tomorrow." He remembered the time. "Well, this afternoon, really. They plan to contact the local authorities and put the body ashore there."

"The ship will be swarming with police. If Jennings is trying anything crooked, he'll surely lay low now."

"Nothing yet?"

"Nothing. Oh, Lane and the other girls get what they can from the rich old men, but that's strictly a private affair. Jennings seems to be letting the house odds do the winning for him."

"Perhaps we misjudged him," Sebastian said. "We'll see. You'd better get some sleep now."

In the morning Sebastian rose early, making his way to the purser's office down the corridor from his stateroom on the upper deck. Mrs. Carstairs, the woman who had lost the jewelry, was filling out a report for Kelly. It was the first Sebastian had heard of the theft, and he listened with interest. The woman was tall and angular, with the look of a dowager and the blue-white hair that went with it.

"I'd worn the diamond bracelet while I was gambling the night before," she explained to Kelly. "Everyone saw it on my wrist. And when I was foolish enough not to wear it last night, they must have known it was in my stateroom."

"We maintain strongboxes for valuables," Kelly pointed out. "It should have been left with me." He was the sort who went by the rulebook and expected others to do the same. Sebastian

could see he had little sympathy for Mrs. Carstairs and her missing bracelet.

"Well, it wasn't," she said. "And now I want to know what you intend to do about it."

"Do?"

"Will you search the ship?"

"That would be an impossibly large task."

"You'll certainly search the passengers before they're allowed to leave."

"Customs is quite thorough, Mrs. Carstairs. I'm sure that anyone foolish enough to try would be detected trying to smuggle the bracelet off the ship?"

"But what about these stops along they way? These shore tours? What if someone carried my bracelet off this very afternoon and sold it on shore?"

"I doubt if a fence would be all that accommodating." He turned to Sebastian. "Don't you agree, Mr. Blue?"

"Not completely," Sebastian replied, and saw the purser's face fall. "Villefranche is right on the border of Monaco. Anywhere you have casino gambling you're likely to find a vigorous trade in jewelry and other pawnable items. I'm sure someone needing cash for the gaming tables of Monte Carlo could dispose of Mrs. Carstairs' bracelet in thirty minutes—at a fraction of its true value, of course."

"You see!" She turned on Kelly with renewed vigor. "You simply must search the passengers going ashore at Villefranche."

"That would be impossible," the purser said, turning in his chair to bring the conversation to an end.

Mrs. Carstairs stormed out, muttering dark threats about seeing the captain, and Sebastian gave a sigh of sympathy. "I understand your problems in this job, Mr. Kelly, but I didn't feel I could lie to the woman."

"We have a murder on board and she's worried about her damned bracelet!"

"I'm sure she doesn't know about the murder. Captain Archibald has taken pains to keep it quiet."

"Nevertheless, she's raising more fuss than it's worth. A woman on A deck lost a necklace and she just reported it and that was the end of it."

"A necklace too? Interesting."

"Interesting in what way?"

"Do we have a jewel thief on board the *Messina Star* too, in addition to our murderer?"

At the first opportunity that day Laura Charme sought out Lane Munday on the sun deck where the roulette girls and some of the younger passengers liked to relax while getting a tan. Lane rolled over on her stomach as Laura spoke and lifted the big round sunglasses to her forehead. "Interpol? He's with Interpol?"

"That's what I hear," Laura said. "Can you imagine that? And I thought he had a little money!"

"You'd better get right downstairs and tell Claude," the girl said. "He'll want to know."

"Why would Claude be concerned?" Laura asked innocently.

"Because Interpol interests itself in things like international gambling. Why else would this Sebastian Blue be on board?"

"Perhaps he's merely on vacation."

"Fat chance! You go tell Claude."

Laura decided it might be the wisest course. And it would give her an opportunity to see his reaction. She found Jennings driving golf balls into a net on the promenade deck and went up to him. "Mr. Jennings?"

He put down his club and smiled at her. "Yeah? You're Laura, aren't you? The girl who works with Lane on the roulette wheel?"

"That's me."

"I been meaning to talk with you before now. You're doing a fine job. Keep up the good work."

"Something's come up, Mr. Jennings."

"What's the trouble?"

"There's a man on board I've been seeing. Sebastian Blue is his name."

"What about him?"

"I just found out he's working for Interpol."

Claude Jennings shifted his eyes to meet hers. "Oh, is he? You know, I've never really met one of them. You should introduce us."

"Lane said I should tell you. She was worried."

"Nothing to worry about. Not the slightest bother. Our hands are clean." He reached out and patted her shoulder as he said it, and she had to resist the urge to draw back in alarm.

Sebastian was standing at the rail as the big liner edged its way into the dock at Villefranche. He could see three grim-faced police officials waiting to board, and he knew it was going to be a long afternoon.

He was right.

As the Interpol official on board he was expected to have matters fully under control, yet the French officials were the first to agree that Interpol had absolutely no jurisdiction in the case. At times as the day wore on he was questioned as closely as a suspect might have been, and he began to wonder if they thought Interpol capable of employing paid assassins when all else failed.

"You admit an interest in this man Bohn," the inspector in charge said. His name was Vernir and he seemed pleased at this break in the daily routine.

"I observed him come aboard," Sebastian admitted. "He's a known gambler."

"Are there any other gamblers on board?"

"A man named Claude Jennings has the gambling concession on the ship. He hires the roulette and dice girls and oversees the operation, with a percentage going to the ship's owners."

"And Interpol's interest in all this?" Vernir asked.

"Only to keep it honest. Jennings has a reputation for running a crooked game, at least on dry land."

Vernir questioned him further, but Sebastian made a point of not revealing Laura's identity to the man. Jennings would already be suspicious of her friendship with Sebastian, and she didn't need any more trouble at the moment.

Claude Jennings watched the sway of Laura's hips as she walked away from him. Then he reached over and retrieved his golf club. A charming girl, no doubt about it. He could make good use of her in the organization—something more demanding than a mere roulette girl in a short skirt.

If he could be certain she wasn't an Interpol agent.

The news she'd brought him regarding Sebastian Blue was hardly a surprise. He'd known from the moment Blue stepped on

board that he was an Interpol agent. The man had been pointed out to him once in a Paris café, and Claude Jennings never forgot a face. Blue was a Scotland Yard inspector who'd retired and gone to work for Interpol. Something about marriage difficulties back home.

And of course Jennings had observed his growing friendship with Laura. It was possible she was an Interpol agent too, though he thought it more likely that Blue was trying to get to the organization through her. The murder of that man Bohn had brought Blue into the open and it was difficult to predict what he would do next.

Jennings took a few more swings with the golf club, enjoying the clear air of the harbor, and then decided he really should go ashore. On the port side of the vessel he could see the coffin containing the murdered man's remains being carried off the ship. The passengers must all know about it by now, of course. It would be something to remember of their trip.

The *Messina Star* remained in port overnight while buses transported the passengers to the Monte Carlo casinos and the night life of Cannes. Knowing he was being watched, Jennings made a point of avoiding the casino trip because he knew too many people there. He went instead to a little restaurant near the harbor area and dined alone before returning to the ship.

The gaming tables were closed down while the *Messina Star* was in port, but he knew most of the girls would be lounging by the ship's pool. It was a warm evening, perfect for a relaxing swim. He didn't see Laura at first, but Lane Munday was by the pool's edge, dangling her long legs into the water.

"Hello, Lane."

"Mr. Jennings—I thought you'd gone ashore."

"Just for dinner. It's no holiday for me to go off to Monte Carlo." Her formality in using his last name amused him, since they'd been on a first-name basis back in London. Still, he realized she was doing it for the benefit of the other girls within earshot.

"Did Laura speak to you?" she asked.

"About Mr. Blue? Yes."

"Should we be worried?"

"Oh, I don't think so. Our hands are clean."

"Captain Archibald was here a while ago, looking for you."

Jennings pursed his lips. "What for?"

"He didn't say."

"All right. I'll go find him." As he turned to leave he saw Laura emerge from the pool. He wondered if she'd been close enough to overhear their conversation, but then decided it didn't really matter. He waved to her and went off to find Captain Archibald.

The captain was going over some tidal charts in his office when Jennings knocked and entered. "Good of you to come," he said, glancing up. "I was asking about for you."

Jennings sat down and took out a cigarette. "What can I do for you?"

Captain Archibald put aside his charts. "I've been in radio contact with the home office in London. This whole business is very distressing to them—first an Interpol investigation of gambling on board, then the murder of a known gambling figure."

"You knew of the Interpol investigation?"

"Yes."

"I wish you'd warned me."

"It was not my place to warn you. I assumed you had nothing to fear from such an investigation."

"Nor do I."

"Did you know the dead man?"

"Not at all."

Captain Archibald sighed and leaned back. "I hope you realize that I have no reason to doubt your word. Anything that happens will be London's decision."

"What's going to happen?"

"There's some talk of terminating your gambling concession on board the *Messina Star.*"

"Terminating! They can't do that—I have a contract!"

"A contract with a termination clause," the captain reminded him. "Termination for cause. Even if your games are perfectly legal and above reproach, London feels they are attracting an unsavory element to the ship."

"Unsavory!"

"Eric Bohn seems to have fitted the description. And certainly his murderer fits it as well. My purser, Kelly, reports there have been a number of thefts from staterooms too—jewelry and

valuables. More so than usual. The message is not lost on London, Mr. Jennings. An unsavory element."

"But—"

"We do have the ship's reputation to consider, you know."

"When might this termination take effect?"

"At the conclusion of the voyage, I expect."

Claude Jennings got to his feet. "Thank you for telling me," he said with effort. Then he turned and left the room.

The *Messina Star* sailed the following morning, staying close to the coastline as it headed for its next port. That night Jennings reopened the gaming tables. He checked out the girl's uniforms, chiding Laura about a missing tassel, and had her help him while they dusted off the tables and counted the chips. He didn't mention the captain's threat to terminate the concession.

He waited till the games were under way, watching Laura give the wheel its first spin of the evening. As he was about to step out on deck, one of the women passengers accosted him. "You're Mr. Jennings, aren't you?" she asked. "I'm Mrs. Carstairs."

"Yes?" He'd seen her at the wheel several times, and he was always polite to good customers. "What can I do for you?"

"I've had some jewelry stolen—a bracelet and some rings too, I think. I've reported it to the purser, but he's given me very little satisfaction. One gentleman suggested jewelry is often pawned to pay gambling debts, and it occurred to me that the thief might approach you with it."

"I hardly think so, Mrs. Carstairs."

"But they couldn't risk taking it off the ship themselves!"

"If anyone approaches me with jewelry, you can be assured I'll notify the purser at once."

She hesitated, unwilling to let him pass. "Well, all right."

Jennings smiled and managed to slip by her. God, he was in enough trouble without worrying about stolen jewelry! In two weeks the *Messina Star* would dock in London and his gambling franchise would be ended.

He wondered about that as he went down to his cabin on the main deck. Maybe somebody was trying to get rid of him—killing Bohn and stealing jewelry for the sole purpose of discrediting him and gaining control of the gambling franchise.

No, he decided. If that was the motive, wouldn't it be easier

just to kill him?

He was unlocking the door of his stateroom when he heard a step behind him. He turned, startled. "You gave me a start, coming up behind me like that. What do you—?"

The knife came up almost before he saw it, before he had a chance to wonder if this was how Eric Bohn had died too.

It was Laura who found the body, not more than five minutes later, as she came downstairs on her break. Jennings was sprawled on the floor inside his stateroom, but his right foot had kept the door from closing all the way. She bent to feel for a pulse, already knowing from the horribly gashed throat that there would be none. She remembered wondering two things— why anyone would want to kill Claude Jennings and why the murderer hadn't simply moved his leg so the door could be closed and the body hidden for a time.

She stepped to the telephone, handling it gingerly to avoid fingerprints, and dialed Sebastian's stateroom. He answered on the second ring. "Yes?"

"Sebastian—thank God you're there! Claude Jennings has been murdered. I'm in his stateroom on the main deck."

"What number?"

"M-84."

"I'll be right down. Does anyone else know?"

"Only the killer."

"Stay there," he said, and hung up.

He appeared in less than two minutes, breathing hard. "Is it the same as the other one?" she asked, trying not to look at the body.

"The wound seems similar. You found him like this, with the door ajar?"

"Yes."

"When did you last see him alive?"

"Not a half hour ago. I helped him set everything up and then started the wheel. I saw him having a brief conversation with that Mrs. Carstairs. Then he went out on deck. A minute or two later Lane relieved me and I went on my break. I passed here on the way to my cabin and found him."

"He hasn't been dead more than ten minutes or so. You must have just missed the killer."

"Should we call the captain?"

"I will, but I want you out of here first. I don't want him confusing things by suspecting you of killing Jennings."

"Me!"

Sebastian smiled at her expression. "You'd just started the evening shift at the wheel. Why would you take a break so soon except to follow Jennings down here and kill him?"

"But—"

"That's what they'd think, Laura, if you're found here."

"I told you I'd been helping Jennings set up the games—counting out chips and dusting off the tables. Remember, we were closed down in port last night. I worked three hours straight and I was damned happy to get a half-hour break." But she could see his point, as always. "You're right. I'd better go."

Sebastian spied something by the body and scooped it up. "You lost your belt tassel again. That's known as a clue in this business, and we don't want it found here."

"Thanks." She slipped it into her purse. "I'll see you later."

Then she hurried on to her cabin, trying to sort out the events in her mind. There was something about the murder of Claude Jennings that didn't make sense to her. She knew he'd been wandering around Villefranche alone the previous night. Why hadn't the killer struck then, when the crime might have been blamed on a local mugging? Why wait till he was back on board the ship, out at sea, before striking? Was the killer otherwise occupied last night? Or did the motive not arise until tonight?

She went into her stateroom and washed her face, thinking it might be just as well if she delayed returning to the game room for a few minutes, until after the news had spread.

Ten minutes later, as she was about to leave, there was a knock on the door. It was Lane Munday, wide-eyed and out of breath. "Let me in, Laura. Something's happened!"

"Did you leave the wheel unattended?"

Lane ignored the question. "Claude Jennings is dead! Someone killed him!"

Laura sat down on the bed, acting stunned at the news. "Who could have done it—the same person who killed the other man?"

"I guess so," Lane answered with a shrug. "But where does it leave us? Are we out of a job?"

"I suppose. We worked for Jennings."

"God, Laura, I don't know where I'll find another job. I hate the thought of going back to an office in London ever!"

"I didn't mean to sound heartless, Laura. It's just that—"

Laura opened her purse and saw the tassel from her belt. She crossed to the dressing table to drop it in the drawer and then she froze. Lane Munday was still talking behind her but Laura had stopped listening. She was staring down at the open drawer, seeing her tassel already in it, remembering how it had come off the other day.

The tassel in her hand, the one on the scene of the crime, had to have come from the only other costume exactly like hers.

"What is it?" Lane asked as Laura turned toward her. Then her eyes went to the two tassels and her hand felt for the sash around her waist.

"It's not there," Laura informed her. "It's here in my hand. You killed him, didn't you, Lane? You killed both of them."

The knife came out of Lane's sleeve and she flung herself at Laura.

Their struggle was brief. Laura's karate needed polishing, but it was good enough against someone like Lane. The girl went down hard, arching her back in pain as she hit the floor, just as Sebastian and Captain Archibald burst through the door.

"Are you all right?" Sebastian almost shouted. "I saw her come in and then suddenly the whole thing dawned on me."

"It dawned on me too," Laura said, holding out the two tassels. "This came off her sash, not mine."

Captain Archibald bent to assist the girl on the floor. "Would someone please explain this to me?"

Sebastian kicked the knife out of Lane's reach. "Will you do the honors, Laura, or shall I?"

"I only know that she killed both of them just before relieving me at the roulette table. That way, with a discrepancy of a few minutes in setting the time of death, she'd seem to have an alibi. She purposely left the door to Jennings' room open so I or someone else would find the body. She needed it found while she was safely at the roulette wheel. But I don't really know why she did it."

Sebastian bent down. "Want to tell us, Lane?"

The girl on the floor glared up at Laura. "She's Interpol too?"

"Yes."

"I should have known! Claude suspected her, but he wasn't sure."

"Why did you kill him? Were you fixing the wheel—gaffing it?"

"No." She got to her feet, still holding her back in pain. "It was something else."

Sebastian Blue nodded. "The stolen jewelry. I've realized right along that you girls were in the best position to notice who was wearing what. And you knew what had been left in the stateroom. You were stealing it, weren't you, Lane? Eric Bohn caught you with it, down there in the coffin room, so you killed him. Right?"

She nodded. "I think he was following Claude, but somehow he missed him and cornered me in that room. I was hiding the stolen jewelry in the padded lining of one of the coffins. When I heard Bohn outside I hid in the coffin, but then he came in and started opening them. When he opened mine I slit his throat with the knife I'd brought to cut a slot in the lining for the jewelry. Then I dragged the body into the passageway so attention wouldn't be called to the coffins."

"Thereby calling even more attention to them," Sebastian said. "But why did Jennings have to die?"

She didn't answer at first. Instead she looked away, perhaps trying to think of a suitable answer. Finally she said, "When I realized they were using one of those coffins for Bohn's body, it occurred to me that was the perfect way to get the jewelry I'd stolen off the ship. I could go ashore and remove it from the coffin later, on land. Customs wouldn't do a very careful search of a coffin containing a freshly dead body."

"But the jewels weren't in Bohn's coffins?"

"No. It was one chance out of five, and the odds weren't good enough. And with the body inside it, I couldn't switch the jewels to the right coffin. But now you see there are only four coffins on board. The odds are getting better."

Laura stared at her, stunned and horrified. "You mean you killed Jennings simply to have another dead body? But what if they still hadn't used the right coffin?"

Lane merely smiled, looking from one to the other. "Then there would have only been three coffins left."